Anglo-Saxon Styles

SUNY series in Medieval Studies
Paul E. Szarmach, editor

Anglo-Saxon Styles

EDITED BY

Catherine E. Karkov
and George Hardin Brown

STATE UNIVERSITY OF NEW YORK PRESS

Published by
State University of New York Press, Albany

© 2003 State University of New York

For information, address the State University of New York Press,
90 State Street, Suite 700, Albany, NY 12207

Production by Diane Ganeles
Marketing by Michael Campochiaro

Library of Congress Cataloging-in-Publication Data

Anglo-Saxon styles / edited by Catherine E. Karkov and George
 Hardin Brown.
 p. cm. — (SUNY series in medieval studies)
 Includes bibliographical references and index.
 ISBN 0-7914-5869-5 (alk. paper) — ISBN 0-7914-5870-9
(pbk. : alk. paper)
 1. England—Civilization—To 1066. 2. English language—Old
English, ca. 450–1100—Style. 3. Manuscripts, English (Old)
4. Art, Anglo-Saxon. 5. Anglo-Saxons. I. Karkov, Catherine.
II. Brown, George Hardin, 1931– III. Series.

DA152.2.A755 2003
700'.942'09021—dc21 2002192958

10 9 8 7 6 5 4 3 2 1

Errata

The following text was inadvertently omitted from the bottom of page 158:

just 175 × 105 mm, after ascribing a significance of the first rank to this poem. Many of the vernacular manuscripts have page sizes in the range of 220–90 mm in height, and 160–90 mm in width; and writing areas of around 180–200 mm in width and 120–50 mm in height, regardless of the subject matter. Thus London, British Library, Harley 3271, an eleventh-century miscellany, contains cop-

Contents

Abbreviations

ASE	*Anglo-Saxon England*
ASSAH	Anglo-Saxon Studies in Archaeology and History
BAR	British Archaeological Reports
CCCC	Corpus Christi College Cambridge
CCSL	Corpus Christianorum Series Latina
CLA	E. A. Lowe, *Codices Latini Antiquiones* (Oxford, 1934–71)
CSASE	Cambridge Studies in Anglo-Saxon England
DMLBS	*Dictionary of Medieval Latin from British Sources* (London, 1975–)
DOE	*Dictionary of Old English* (Toronto, 1986–)
EEMF	Early English Manuscripts in Facsimile
EETS	Early English Text Society
EHD	*English Historical Documents*, ed. Dorothy Whitelock, vol. 1 (London and New York, 1953)
Gneuss	Helmut Gneuss, *Handlist of Anglo-Saxon Manuscripts,* Medieval and Renaissance Texts and Studies, vol. 241 (Tempe, AZ, 2001)
HBS	Henry Bradshaw Society
Hist. eccles.	Bertram Colgrave and R. A. B. Mynors, eds., *Bede's Ecclesiastical History of the English People* (Oxford, 1969)
Hist. abb.	Charles Plummer, ed., *Venerabilis Baedae Historium ecclesiasticum gentis Anglorum, Historiam abbatum . . .* , 2 vols. (Oxford, 1896)
JWCI	*Journal of the Warburg and Courtauld Institutes*

Ker	N. R. Ker, *Catalogue of Manuscripts Containing Anglo-Saxon* (Oxford, 1957)
MA	*Medieval Archaeology*
MP	*Modern Philology*
N&Q	*Notes & Queries*
NM	*Neuphilologische Mitteilungen*
OLD	*Old Latin Dictionary*
PBA	*Proceedings of the British Academy*
PL	J.-P. Migne, ed., *Patrologiae cursus completus, Series Latina* (Paris, 1844–82)
PMLA	*Publications of the Modern Language Association*
PQ	*Philological Quarterly*
SC	Sources chrétiennes
YAJ	*Yorkshire Archaeological Journal*

Introduction

In his classic paper "Style," published in 1953, the art historian Meyer Schapiro defined style as "the constant form—and sometimes the constant elements, qualities, and expression—in the art of an individual or group." This definition is cited in a number of the papers included in the present volume as one that is still relevant to stylistic analysis across the disciplines today. Schapiro's essay was originally written for the international conference "Anthropology Today" and appeared in the proceedings published under the same title.[1] The purpose of both the conference and the volume was to document post–World War II developments in anthropology and explore the possibilities offered by the new interest in other lands, other peoples, and the "inter-relatedness of all things."[2] While the search for constants and commonalities was not an invention of the postwar era, it certainly became a dominant part of theory and scholarship at that time. Art historians embraced formalism, the study of color, line, shape, brushstroke, and so on; and form came to constitute style and to serve as the sole carrier for content. Form was something that all works had in common, regardless of the time and culture in which they were produced, or so critics thought. The rise of the New Criticism provided a literary parallel to the art-historical interest in form. What concerned literary critics was the unity and merit of the work, its language, which could not be separated from form or content. Language was a universal in literature, as form was a universal in art, and style was the vehicle through which language and form were expressed. Neither group was particularly interested in the cultural, historical, or personal factors that influenced artists, writers, or scholars. Nor were they interested in the arbitrary, the exceptional, or the fragmentary—though words and marks were, of course, ultimately fragments. Works of art and literature became objects to

be analyzed and researched using methodological tools borrowed
from the sciences. Not surprisingly, the period also saw a dramatic
increase of interest in linguistics.

By the early 1960s critics in both fields were beginning to ask
different questions, and Schapiro's paper made the leap from the
social sciences (anthropology) to the humanities (philosophy) when
it was reprinted in *Aesthetics Today*, published in 1961.[3] In the
1950s philosophers too had been concerned with the language of
philosophy and "unmasking the linguistic confusions" of philosophi-
cal inquiry.[4] Aesthetics, a "value-oriented" branch of philosophy,
was not central to this concern but by 1961 was growing in popu-
larity. The marginal was moving towards the center. Still, there
was much concern with universals, with defining terms, and fields,
and methods of communication. Interestingly, Schapiro's "Style"
was also included in the 1981 revised edition of the book alongside
essays by Edward Said, Michael Fried, Arthur C. Danto, and Jacques
Lacan, essays that called into question or flatly rejected the ideas
of constant form, universal language, linear development, and hu-
manistic unity upon which Schapiro's essay rested.[5] By its very
inclusion in that volume, the paper had not only successfully crossed
disciplines, but also had successfully jumped the divide between
the modern and the postmodern. The reason for this may have
been that at the same time that he searched for universals, Schapiro
charted differences and exceptions; while focusing on form as con-
tent, he never lost sight of the historic, the cultural, and the indi-
vidual as shapers of content; above all, he never lost sight of the
integrity of the object.[6] Anglo-Saxon England was, for Schapiro, one
of the periods in which the complications of style were demon-
strated most clearly. Similarity and difference existed side by side.

Today, with our interest in the personal, the ephemeral, and
the fragmentary, the work as process rather than object, "style" is
a frequently overlooked, if not diminished, critical tool and a prob-
lematic subject of analysis. The papers in this volume demonstrate
just how vital style remains as a methodological and theoretical
prism, regardless of the object, individual, fragment, or process
studied. Like Schapiro's essay, these essays cross disciplines and
media to consider the definitions and implications of style in Anglo-
Saxon culture and in contemporary scholarship, seeking to identify
constants, while at the same time marking out differences. More
importantly, they demonstrate that the whole idea of style as "con-
stant form" has its limitations. How can we talk about "constant
form" in works that may have multiple authors or artists; or works

that were viewed by their creators as works in progress, being augmented or incorporated into new works over years, decades, or even centuries; or works that combine conflicting or competing systems of expression? Schapiro's definition assumes development, but does not account for deliberate change, or for the use of style as propaganda. Moreover, Schapiro did not theorize about the variety of possible meanings carried by style—indeed, he could not have done so in 1953—although he did believe that style carried meaning because it was the product of social structures and historical processes.

Style in Anglo-Saxon culture might best be defined not as the constancy of form, but more generally as "the ordering of forms" (verbal and visual). Such a definition allows for change and manipulation, and is also one with which the Anglo-Saxons themselves may well have agreed. For Augustine, beauty or beautiful style consisted of harmoniously ordered form,[7] and the best works of man, be they visual or verbal, reflected the biblical statement "You have ordered all things in measure, and in number, and in weight" (Wisdom 11:21). While no treatises on art or beauty survive from the Anglo-Saxon era, we can see Augustine's ideas echoed in the writings of Bede, particularly his *De schematibus et tropis* and *De arte metrica*. Scripture, according to Bede, surpasses all other writings, "not merely in authority because it is divine, or in usefulness because it leads to eternal life, but also for its age and *artistic composition.*"[8] But the idea that beauty, or artistic compositions, created through the ordering of forms or words on earth reflected divine order and universal beauty was a commonplace in the Middle Ages.[9] Is there anything that we can identify as characteristically Anglo-Saxon about the ways in which Anglo-Saxon artists and authors chose and ordered form? According to the essays that follow, there is. We cannot speak of one unified Anglo-Saxon style, but we can say that Anglo-Saxon styles in general are characterized by (1) ambiguity, and (2) a love of complex pattern and surface ornament. These are interrelated phenomena.

Ambiguity could carry a number of meanings and serve a variety of functions within Anglo-Saxon culture but, as discussed in the papers that follow, it is clear that it was never purely decorative, but always a vehicle for political or social messages. We are speaking here not of ambiguity as an accident or mistake due to faulty copying, incompetent artists/authors, or muddled ideas, but of ambiguity as a deliberate device designed to make the viewer or reader think about meaning, to deconstruct and reconstruct compositions in order

to understand how their structures conveyed meaning. As a feature
of style, ambiguity in Anglo-Saxon culture could facilitate the trans-
mission of ideas between time periods, cultures, authors/artists, or
sets of religious beliefs (Webster, Farr, Brown); it could denote as-
similation (Michelli, Orchard, Keefer), appropriation (Hawkes and
Howe), or conflict (Orton and Howe). Because ambiguity was the
result of competing systems of beliefs, values, or modes of expres-
sion, it was also symbolic of originary moments: something new
created out of the coming together of traditions, but also something
that referenced the origins of the traditions that had been brought
together. Anglo-Saxon style also placed demands on its audiences,
presenting them with riddles (Webster, Orton, Orchard), comic turns
(Wilcox), or paradoxes (Hawkes, Farr, Keefer, Wilcox) that it was
up to the reader/viewer to solve or resolve. Each viewing or reading
of these works constituted, and still constitutes today, a new
originary moment.

The Anglo-Saxons' love of complex patterns and shimmering
surface effects in both material and textual culture has become
something of a mainstay of Anglo-Saxon studies;[10] but new tools
such as the online databases published by the Toronto Dictionary
of Old English or the Anglo-Saxon Charters Committee now permit
us to explore the ways in which this element of style functioned in
Anglo-Saxon texts with greater precision and sophistication.[11] Pat-
terns of words and phrases (Ruff and Orchard) or grammatical and
syntactic features (Frank) can now be analyzed to map the ways in
which authors ordered their words, and the range of meanings that
were likely to have applied to those words, as well as changes and
developments over time (Momma) and between authors and cul-
tures (Ruff and Orchard). Understanding these patterns is, of course,
an essential part of traditional source study, but verbal patterning
and wordplay is also often riddling in nature and can be under-
stood as a part of the ambiguity discussed by so many of the con-
tributors to this volume. Anglo-Saxon texts were not just meant to
be read but also to be seen and to be listened to, and their layout
(Schipper), use of color (Ruff), script (Brown), and aural patterns
(Momma) are all important elements of their style. When, some-
time about 973, Bishop Æthelwold commissioned his famous
Benedictional (London, British Library, Additional 49598), he re-
quested that it contain "many arches well adorned and filled with
various figures decorated with numerous beautiful colors and with
gold."[12] Æthelwold was not just desirous of a beautiful object, but
of the spiritual beauty and order that a well-made, colorful, and

shining manuscript conveyed. According to the scribe Godeman, the book was a *biblos*, a reflection of The Book, the Bible. Decorated letters and pictures attracted the eye and held the attention, as the story of King Alfred attracted to the book on his mother's knee reveals,[13] and Æthelwold (and Godeman) knew that the style of this book would help in getting its message across to his flock.[14]

The stories of Alfred and his mother's book, and of Æthelwold and the biblical sources of his book, bring us back once again to originary moments, moments that Leslie Webster and Fred Orton argue are inherent to any discussion of style. Webster traces style, motif, and the study of both over time and across media, exploring the ways in which the complexity and dynamics of visual style and language still defy our classifications. Indeed, she defines style as a form of visual language and goes on to explore its grammar and vocabulary. Far from being a passive formal element in the works considered, she shows that style is not only an elite product, but also an aid in producing our image of the elite—especially in the works we so problematically label "minor"—as well as a general carrier of meaning in art. Webster explores the importance of motifs, frames, and the ways in which new images are read through old (or old through new) in the development of what she labels "a particular kind of visual literacy." Style for Webster is both an enabling art-historical tool and historically a facilitator in the transmission of new ideas. Orton, by contrast, considers stylistic studies as limiting as they are enabling in our attempts to understand the past and its monuments. Focusing on the Ruthwell and Bewcastle monuments, he demonstrates how style and classification have served to close down rather than open up meaning, masking what we see with the manner in which it is described. He also provides a way forward by turning our attention to what is actually present on the monuments, as opposed to what we have read or been told is there. Orton agrees with Schapiro (and all the contributors to this book) that style is an essential object of investigation, but he cautions that style is not an objective property but a carrier of meaning that demands interpretation, and is itself the product of interpretation.

Whereas Orton analyzes style as a site of conflict between Rome and Anglo-Saxon England, Jane Hawkes suggests that style can also be a site of appropriation. Whereas Orton emphasizes difference, Hawkes emphasizes similarity. In particular, Hawkes examines architectural style as a reflection of political and ecclesiastical affiliation. Anglo-Saxon stone churches are not simply passive reflections of Roman originals or examples of the reuse of

Roman sites, but public declarations of *romanitas* that helped to establish the Anglo-Saxons as heirs to the Roman world (another originary moment). As with the Ruthwell and Bewcastle monuments, the form, style, and iconography of church, column, and cross are not just vehicles for content but vital producers of content.

Perette Michelli shows us that despite our current distrust of typology and "connoisseurship," style and motif are still essential tools in the project of classification. Using traditional art-historical methods she, like Orton, turns accepted attributions and groupings on their heads, employing conventional stylistic analysis—that is, analysis of form, iconography, and technique—to suggest that a series of ivory carvings do form coherent groups and to try to identify the provenances and the links between those groups. Michelli argues that style in the case of the ivories has been manipulated so successfully that it has led to their neglect.

Carol Farr's "Style in Late Anglo-Saxon England: Questions of Learning and Intention" examines the meaning of copying, recycling, reforming, and rewriting. She asks us to consider what exactly constitutes a copy, and whether assimilation and transformation of style might be the results of a learning process for scribes and artists. Why were styles copied or revived? And, again, what meanings did they carry? As she demonstrates, the circumstances behind each "copy" must be examined on an individual basis. Farr also raises the complication of discussing "style" in works that were or could have been produced by multiple artists. Michelle Brown focuses on a related issue, mapping the limits of connoisseurship and the classification of works by means of style, hand, or motif in her study of style and attribution in a select group of manuscripts. Scribes can be selective and archaizing in their use of scripts, hindering all but the most concerted attempts at classification. Brown demonstrates the "pitfalls and potential" of identifying "house style" in several Anglo-Saxon scriptoria, including the problematic "Lindisfarne scriptorium." Script, like images, can be used to make specific political, historical, or cultural points. The phenomenon of composition as compilation that Brown describes has parallels in the compilation of literary texts as discussed in this volume by Sarah Keefer. Bill Schipper demonstrates that the textual layout of Anglo-Saxon manuscripts is as much a part of their style as script, illustration, or textual content. Schipper explores the possible reasons why scribes (or patrons) might have chosen one type of layout over another, and what the implications of that might be for our understanding of the manuscripts. Examining evidence from a wide

variety of texts, Schipper concludes that the Anglo-Saxons had a marked preference for long-line rather than two-column layout in their vernacular manuscripts, a preference he traces back to the program of education and translation begun by Alfred the Great. Here we might ask further how aware Anglo-Saxon scribes were of the origins of this facet of their style.

Nicholas Howe explores the ways in which style and our understanding of style have come to be defined, passed on, and employed, often uncritically, by scholars. He, like Webster and Orton, draws our attention to the interrelationship between scholarly style and method, and our changing conceptions of Anglo-Saxon style and ideology. As Howe demonstrates, style does cultural work, but is also historically and culturally driven, and the study of style is itself a historical and cultural act. Ultimately, like so many of the contributors to this volume, he stresses that we should not speak of Anglo-Saxon style, but rather of a multiplicity of coexisting styles. While Howe is interested in scholarly process, Sarah Larratt Keefer is interested in poetic process, in what she terms the "either/and" style of Anglo-Saxon Christian poetry. Keefer returns to the notion of a style characterized by ambiguity and the reconciliation of competing or coexisting cultural realities. Having identified what she feels to be an important feature of Anglo-Saxon poetic style, she then demonstrates the way in which it works in the poem *The Dream of the Rood*. Anglo-Saxon poets, Keefer argues, were clearly concerned with resonance and redoubling, in composing unity out of layers of meaning. The result is a reconciliation of disparate elements, but one in which the tension between those elements is fully acknowledged. Reconciliation of and tension between opposites also feature in Jonathan Wilcox's analysis of the literary style of the poem *Andreas*, a poem that combines comedy with the motif of the Eucharist, one of the most serious of Christian subjects. But comedy, as Wilcox demonstrates, is a feature of Anglo-Saxon hagiographic style. The very nature of saints' lives demands a duality conveyed through the opposing visions of the tortured saint and his or her torturers, and comic violence is the point at which the two intersect. Torture, mutilation, and cannibalism—events that might seem disturbing, even horrific, to the modern reader—are often presented as humorous in Anglo-Saxon texts, but they are also signifiers that force us to think and puzzle out the true meaning of the text.

Carin Ruff raises some interesting questions about style and translation in her "Aldhelm's Jewel Tones: Latin Colors through

Anglo-Saxon Eyes." How do the Anglo-Saxon and Latin terms for
colors relate to each other? How much can we rely on their accu-
racy, especially in cases where there seems to be some kind of
discrepancy? And how closely does language capture material real-
ity? As Ruff demonstrates, capturing the visual in the verbal is a
difficult task, no less so for Aldhelm than it is for students today,
and there remains an inexplicable gap between what is seen and
the manner in which it can be described—a point of difference
theorized in Orton's paper. Nevertheless, Old English color words
do emphasize brightness and surface reflectivity, and can be used
themselves to create a shimmer of wordplay within a text. Roberta
Frank also considers words and word choices as elements of liter-
ary style, focusing specifically on the Old English weak adjective,
an often neglected element of Anglo-Saxon poetic style. Her paper
offers a useful classification of weak adjective constructions and
the contexts in which they occur, but she also asks larger questions
about why Anglo-Saxon poets made specific word choices and what
the effect of their choices was on the reader or listener. Frank also
speculates on whether weak adjectives might have added shade or
brightness to the meanings of the lines in which they occur, creat-
ing subtle nuances of meaning that are lost to readers today.

The last two papers in the volume shift to a study of the ways
in which style works in individual authors and can help us to
understand their personal styles. Haruko Momma looks at the
question of authorial style in Anglo-Saxon prose. While recognizing
the difficulties of establishing external criteria, or even a method-
ology for talking about style, she points out that some authors do
have a distinctly personal style of writing, albeit one that can change
between the "stylistically different" genres of prose and poetry. Ælfric
is a case in point, and Momma examines the stylistic changes in
his writing in light of what we know about the chronology of his
writings. She defines style as a "predeliction for certain textual
features—whether linguistic, prosodical, or lexical—which are not
required of the genre of the composition in question," or the avoid-
ance of textual features not prohibited by it. Momma's analysis
identifies a clear distinction between Ælfric's use of "rhythmical
prose" and his use of "alliterative prose" that will no doubt form the
basis for further study. Andy Orchard's "Both Style and Substance:
The Case for Cynewulf" offers an equally useful analysis of formu-
laic phrases in the "Cynewulf-Group" of poems *(Elene, Juliana,
Christ II,* and the *Fates of the Apostles).* Locating style in rhetorical
features is problematic, especially given the influence of Christian

Latin poets on Anglo-Saxon authors, yet formulaic diction is what links the poems of Cynewulf. Orchard's production of a concordance of words used in the four poems and his analysis of that concordance allow for clear progress in a murky field. Orchard's paper not only contributes to our knowledge of Cynewulf's personal style, but also identifies poems in which that style is likely to have been emulated.

Meyer Schapiro ended his 1953 essay with the words: "A theory of style adequate to the psychological and historical problems has still to be created. It waits for a deeper knowledge of the principles of form construction and expression and for a unified theory of the processes of social life in which the practical means of life as well as emotional behavior are comprised."[15] No such unified theory does or could ever exist, yet as the papers in this volume demonstrate, we can still identify commonalities, and they are connected to social processes and historical and cultural acts, though not in unified ways. Style remains as central to the way we understand and interpret the past as it was in Schapiro's day, and the idea of constancy in the past does give us a comforting link with that past. But style is also dangerous territory; it does political and interpretive work. The styles used by the Anglo-Saxons were not used passively, but were designed to make both their contemporary and their modern audiences look and think and unravel their meanings. Anglo-Saxon style is as much today as it was in the Anglo-Saxon era "a style designed for interrogation."[16]

Notes

1. Meyer Schapiro, "Style," in *Anthropology Today: An Encyclopedic Inventory*, ed. A. L. Kroeber (Chicago, 1953), 287–312.

2. P. Fejos, preface to Schapiro, *Anthropology Today*, v.

3. Morris Philipson, ed., *Aesthetics Today: Readings Selected, Edited, and Introduced by Morris Philipson* (Cleveland, 1961), 81–113.

4. Morris Philipson and Paul J. Gudel, eds., *Aesthetics Today*, rev. ed. (New York, 1981), 3.

5. Ibid., 137–71.

6. See Michael Ann Holly, "Schapiro Style," *Journal of Aesthetics and Art Criticism* 55, no. 1 (1997): 6–10.

7. Augustine, *De quantitate animae*, trans. W. H. Stahl, *The Greatness of the Soul* (New York, 1952), 8–11.

8. See Calvin B. Kendall, ed., *De arte metrica et de schematibus et tropis* CCSL 123A (Turnhout, 1975), 142–43; translated in George Hardin Brown, *Bede the Venerable* (Boston, 1987), 33.

9. See, for example, Umberto Eco, *Art and Beauty in the Middle Ages*, trans. Hugh Bredin (New Haven and London, 1986).

10. See, for example, C. R. Dodwell, *Anglo-Saxon Art: A New Perspective* (Ithaca and London, 1982); John Leyerle, "The Interlace Structure of *Beowulf*," *University of Toronto Quarterly* 37 (1967): 1–17.

11. Dictionary of Old English Project, Toronto: *http://www.doe.utoronto.ca/*. Charters Committee homepage: *http://www.trin.cam.ac.uk/chartwww*. The searchable *Regesta Regum Anglorum* was developed by Dr. Sean Miller under the auspices of the Anglo-Saxon Charters Committee.

12. Quoted in Robert Deshman, *The Benedictional of Æthelwold* (Princeton, 1995), 148.

13. *Asser's Life of King Alfred*, ed. W. H. Stevenson (Oxford, 1904), 20; Simon Keynes and Michael Lapidge, *Alfred the Great: Asser's Life of King Alfred and Other Contemporary Sources* (Harmondsworth, 1983), 75.

14. On the relationship of poetic, textual, and pictorial style within the manuscript, and the relationship of Godeman's style to Æthelwold's, see Michael Lapidge, "Æthelwold as Scholar and Teacher," in *Bishop Æthelwold: His Career and Influence*, ed. Barbara Yorke (Woodbridge, 1988), 89–117.

15. Schapiro, "Style," 311.

16. Leslie Webster, this volume, 15.

1

Encrypted Visions:
Style and Sense in the Anglo-Saxon Minor Arts, A.D. 400–900

Leslie Webster

There is an apocryphal saying to the effect that iconographers believe everything is the same, and style historians think everything is different; and as far as Anglo-Saxon style history goes, there is some element of truth in the aphorism, as the radical difference between the art of early (A.D. 400–700) and middle (A.D. 700–900) Anglo-Saxon England seems to imply. What could, for example, the early-sixth-century Chessel Down brooch (fig. 2b) have in common with the early-eighth-century Franks Casket (fig. 7a)—or either of these with an early-ninth-century manuscript such as the Royal Bible (London, British Library, Royal I.E.vi)? And what indeed could be more explicable? The stylistic and iconographic traditions of late antique and early Christian art that entered Anglo-Saxon culture with the conversion produced radical and far-reaching changes in the expression of secular and religious art, which traveled far beyond the religious and aristocratic communities that were the initial foci for these new influences. The highly structured linear analytical motifs of zoomorphic and geometric ornament that characterize fifth- to seventh-century Anglo-Saxon styles disappeared in favor of more legible, naturalistic plant and animal motifs, plastic modeling of form, and classicizing interlace; narrative structure also gave new importance to the human figure, till then a cryptic, virtually absent, aspect of early Anglo-Saxon art; and new media— stone sculpture, manuscripts, bone carving—provided further opportunities for experiment.

No wonder, then, that traditional approaches to the study of the Anglo-Saxon minor arts have tended to support the idea that style is inconstant and changeful; and inasmuch as they have addressed issues of iconography at all, they have, until recently, often appeared to suggest that it is of minor or no interest, particularly where the earlier, preconversion material is concerned. The great analysts of early Anglo-Saxon and Germanic metalwork—Salin, Bakka, and Haseloff, for example—have been more interested in questions of classification, origins, and chronology than of content.[1] This can be attributed in part to long-standing traditions of compartmentalization in Anglo-Saxon art studies. Of course, there have been certain notable exceptions—T. D. Kendrick and Rupert Bruce-Mitford, for example[2]—but on the whole, we who work in the field of Anglo-Saxon art have traditionally tended to center our work in a particular area, be it the early period rather than the later period, or in metalwork, manuscripts, or sculpture, each with its own distinct analytical and critical tradition. Early metalwork research, for example, has been chiefly grounded within the German and Scandinavian archaeological traditions represented by Salin and Haseloff's work; sculpture studies, on the other hand, have equally naturally grown from the Romano-British perspectives underlying Collingwood's work, and the study of late antique art-historical traditions.[3] These circumscribed traditional specializations have provided us with basic typologies and a fairly secure cultural and chronological anchorage; but there is also a sense in which they have served as a constraint, inhibiting a wider and deeper questioning of the evidence. But this is changing now; as those traditional disciplinary boundaries become more elastic, stretched by the iconographical probings of more recent scholars, we may begin to see questions of style in Anglo-Saxon art rather differently.[4] An altered dynamic begins to emerge, recognizably shaped by particular cognitive modes.

A broader sense of the discipline, then, underpins the present review, which looks at some of the ways in which issues surrounding Anglo-Saxon style—in its widest sense—might illuminate our understanding of the ways in which objects deliver meaning, by what means, for whom, and for what purposes. My argument is that we are dealing here with a particular kind of visual literacy, with its own enduring grammar and vocabularies, which is wholly attuned to the reading of complex artifacts from at least the fifth century to the end of the ninth. Anglo-Saxon style, in its widest sense, constitutes a form of visual language developed in the mi-

gration period, which possesses the scope and recombinant flexibility to shape and control the expression of complex ideas in very particular ways. This style language deploys constants of visual grammar and vocabulary that were originally created to be read in the most elliptical and compressed of circumstances, namely, on the dress accessories of the rising Germanic elites of the fifth to seventh centuries, as they began to express a political and social identity through symbols and images of power. The highly elliptical visual language in which this was expressed appears to be grounded in pagan Germanic cosmological tradition and origin myths; yet far from being abandoned when accelerated access to mainstream classical and Christian tradition began to change the face of Anglo-Saxon culture and society in the early seventh century, the visual language was adapted and extended to accommodate new ranges of ideas, new types of artifacts, more complex messages.[5] It will thus be apparent that the "minor" of this paper's title refers to scale, rather than significance. Even relatively small or humble portable objects were often intended to be read as much as seen, sometimes in quite complex ways; we may think by analogy of the British convention of school or other male institutional neckties, of medieval coats of arms, and of the complex insignia of rank and honor that persist even in the less formal military dress of our own day. The same conventions of this style language can also be found in the more complex and ambitious field of sculpture and manuscripts, restating and reframing the conventions of Christian and classical iconography into formats more consistent with the established traditions of Anglo-Saxon visual literacy.[6] Reasons of space and scope constrain what can be said here on these matters; but it will be apparent that much of what follows could apply equally to ecclesiastical as to secular art, and to manuscripts and sculpture as much as to the minor arts on which this examination will focus.

The final introductory point is to emphasize the very striking and surely significant parallel with equivalent strategies developed in the transition from orality to written text; as Katherine O'Brien O'Keeffe and others have demonstrated, close examination of the textual evidence reveals the importance of orally developed modes in the understanding and transmission of the written word.[7] In a way similar to that in which a residual orality shapes the earlier written Anglo-Saxon texts, long-standing modes of visual literacy, developed in an essentially preliterate society, inform the shaping of postconversion art. The passage from this preliterate, visual, pagan Germanic culture to the changed disciplines of the literate

and classically informed new order relied on traditional visual cues and strategies to mediate the meaning of Christian art, alongside the new iconographies. Not least, these strategies of reading new images through old were also involved in the many iconic ways in which texts were used on artifacts and monuments, and of course, most strikingly, in gospel manuscripts, where the Word is made visible in the most graphic way;[8] and in particular, they sustain and extend the Anglo-Saxon use of text as image, not least, in the visually constructed opposition of alphabet, script, and language that plays such an important role on, for example, the Ruthwell and Bewcastle crosses and the Franks Casket.[9]

To turn to the argument in detail. We must first review briefly the elements of the earliest Anglo-Saxon art styles, as they survive in the metalwork of the fifth to seventh centuries. They begin as a style (Style I), essentially based on animal and geometric motifs, which, even in its earliest manifestations, exhibits a highly structured, formal grammar requiring careful decoding. Its origins lie in the forms and styles of late Roman provincial metalwork (fig. 1, a–c); but the dense and elliptical versions, which originated first in southern Scandinavia before being adopted by Anglo-Saxons, are far removed from their prototypes in appearance and, we may suspect, meaning (fig. 1, d–f). As the style survives, it occurs primarily on the dress accessories of high-status women, and latterly, of men. The requirement is for very complex decorative programs, but space on such metalwork is strictly limited; all the more reason to articulate and control this ornament by means of a carefully constructed set of rules.

The fundamental and most immediately striking ground rule is the imposition of an elaborate framework within which the visual language is compartmentalized according to various carefully observed hierarchies.[10] This is rather different from anything in comparable late Roman or contemporary Celtic personal equipment. Ornament is segregated into borders, fields, and panels of a consistent variety of forms, separated by clearly defined frames, which help to control and articulate the highly compressed and schematic ornamental program and its content (fig. 2, a–d). Beyond this practical function, however, frameworks provide a symbolic sense of control and order in this microcosm of teeming images. They act as an aid to reading a complex structured visual code, but they are also, in themselves, an image of boundaries set and defined—a visual statement of order in the cosmos.

Within this controlling framework, a dense hierarchy of crea-
tures, animal and human (and sometimes both) can be distinguished.
Fields of what can seem at first a chaotic jumble of *disjecta mem-
bra* reflect a well-defined vocabulary of forms and combinations,
organized in something like a regular grammatical structure. Paired
creatures in a variety of configurations feature prominently, and
fields of processional animals patrol central areas as if in some
guardian role (fig. 2, a, b, and e). Human and animal masks, either
flanked by beasts or on their own, are a recurrent feature (fig. 2f);
another constant motif is that of conjoined animal heads, yoked
together in downward- or upward-curving configurations (fig. 2, a,
b, and g). Their regular appearance in amuletic contexts has sug-
gested that they very probably had an apotropaic function.

Even at first contact, this is very evidently a style intended to
tease the eye and brain, a style designed for interrogation. But
there is more to it than that. A particular aspect, which Bakka,
Haseloff, and Leigh have in different ways drawn attention to, is
the way in which visual ambiguities play a significant part in the
repertoire; profiled animals recombine to form masks (fig. 3, a, d,
e–g); beasts when rotated turn into men (fig. 3, b and c); or the
most simple of gemstone shapes may represent elements articu-
lated more explicitly in other contexts (fig. 3, b and c).[11] The dislo-
cation of images for apotropaic and other purposes is of course a
phenomenon well attested to in other cultures, other times; we may
also question whether the fascination with shape-shifters, the
melding of man and animal, represents latent ideas about the con-
struct of nature and man's place in it. But beyond questions of
function and meaning, the prominence of this feature in the Anglo-
Saxon stylistic tradition also suggests particular cognitive habits
that deserve further consideration.

Until recently, little serious attention has been given to the
purpose and meaning of this complex hermeneutic decoration as a
whole, other than to suggest that it might simply reflect ethnic
affiliation—as between Angles, Saxons, and Jutes, for instance;[12]
but recent work by a number of Scandinavian and English scholars
has proposed fresh ways in which it might be interpreted. Tania
Dickinson, for example, has explored the possibility that elements
of late Roman decorative vocabulary in female jewelry might indi-
cate an inherited status that ultimately derives from federate male
forebears.[13] John Hines, too, would read status-related messages
into the decoration of some types of these brooches.[14] Lotte Hedeager

and Bente Magnus, on the other hand, have identified origin myths and cosmological themes in the highly decorated Scandinavian counterparts to this body of material, which they interpret (in rather different ways) as constructions and identifiers of a changing political and social reality.[15] In these analyses, Style I animal art develops as a powerful, and widely intelligible, ideological language in the late fifth and sixth centuries. This must remain speculation; but it seems beyond dispute that these carefully composed images deliver messages that somehow relate to political and other status, in which the elliptical signaling of origin myths plays a prominent part. From this we may certainly conclude that in the fifth and sixth centuries, the Anglo-Saxon elite were visually highly literate; and that they had developed a complex and structured iconic language for communicating belief concepts. Great changes were to come in the expression of material culture during the ensuing hundred years; but the underlying dynamics, the style concept, were to remain essentially the same.

Towards the end of the sixth century, new forms of status determinants came into prominence and were in turn linked to and promoted by the processes of the conversion to the Christian religion during the seventh century. Buckles returned to prominence in high-status male dress, female jewelry adopted forms derived from Byzantine usage, different materials and techniques were used in their manufacture, and, above all, a new zoomorphic style of decoration (Style II) superseded the dissected images of the earlier animal style. This sinuous, interlacing style, which like its predecessor, Style I, seems to have originated in southern Scandinavia, appears far removed from the tortured analytical motifs of the earlier style (fig. 4, a–d). Yet it is built on precisely the same embedded structures. Processional creatures and symmetrically ordered pairs of animals, affronted, addorsed, and backbiting, exhibit the gamut of posture and motif that exists in the earlier vocabulary; the same conjoined animal heads and even human masks framed between beasts (as on the Sutton Hoo purse-lid) are also present (fig. 4, a–c, e).

Frames, though more discreet, remain all-important in ordering reading of the new style, as is readily demonstrated by the emphasis on the patrolling border animals on the Sutton Hoo buckle, the carpet-page format of the shoulder clasps, and the concentric gridding of the complex garnet and filigree ornament of the Kingston brooch (fig. 4, a, e, f). Ambiguity continues to be a prominent and significant element, whether in disentangling the boars on the

Sutton Hoo shoulder clasps, in construing the fugitive creatures of the Bacton and Forsbrook pendants, or in identifying the elusive but entirely deliberate cross on the Boss Hall composite brooch (fig. 4g).[16] Of particular interest here is the part this plays in mediating Christian images, shifting effortlessly from a pagan to a Christian cosmological context, as the transition from the pagan iconography of Scandinavian gold bracteates to the technically and visually very similar equivalent Christian gold disc pendants shows.[17] Probably the best-known instance of ambiguity from this period is the Sutton Hoo helmet, where the human face and the animal world engage in powerful mythic interplay (fig. 4, h, i). This entire artifact can in fact be seen as an embodiment of dynastic origin myth, consciously recalling both Roman and Germanic ancestry in its combination of late antique form and North Germanic decorative style, each delivering a carefully composed and very public message. A similar political dynamic has also been argued for other aspects of the new style and form changes that characterize other artifacts of this period, in which Style II itself is seen as an expression of a North Germanic origin affiliation, while decorating artifacts of conspicuously late Roman type.[18] As in the earlier period, we may here detect the function of style as an embodier of social meaning.

Thus far, certain constants emerge; early Anglo-Saxon decorative metalwork, as the principal surviving art vehicle in a preliterate society, is an elite medium, conveying, through style as much as content, structured information to those who could read it. A certain cognitive dexterity was needed to decipher the message, but the formulaic frameworks and motifs by which these constructs were composed aided interpretation and promoted familiarity with decoding visual texts. To what extent can this tradition be seen to play any part in the art of the Christian period?

The new styles and iconographies introduced alongside the gradual processes of conversion in the seventh and early eighth centuries transformed both the secular and the ecclesiastical minor arts as much as more obviously Christian artifacts such as decorated manuscripts and sculpture. But on the other hand, it is also evident that, though forms, modes, materials, and techniques were changing once more, the underlying grammar and vocabulary of Anglo-Saxon style remained hardly altered—rather, they facilitated the transmission of new ideas by rejiggering them in familiar formats. Traditional ways of reading images were thus as influential in ecclesiastical art as in the secular sphere.

Once more, it is immediately apparent that frameworks play a crucial role in defining and ordering content; small fields and panels are a leitmotif of Anglo-Saxon eighth- and ninth-century art as much as in the earlier period (fig. 5, a–d). In manuscripts and sculpture, as much as in the metalwork and bone carving on which I focus, paired symmetrical animals and processions also continue to dominate the stylistic vocabulary, and creatures flanking masks are evident (fig. 5, a, c–e). That this can be more than a mere decorative trope at this stage may be inferred, for example, from the vigor with which the inhabited vine scroll of classical tradition, with its intertwining animals and birds, was adopted in Anglo-Saxon art. Elliptical and ambiguous images also remain a staple; see, for example, the hidden animal masks that are revealed on the Beckley pommel and Northumbrian strap-end when these two objects are inverted (fig. 5, f and g). These hidden images also have a part to play in ecclesiastical metalwork as well as secular, as the Asby Winderwath plaque so nicely demonstrates (fig. 5h).[19]

Equally strikingly, there is a continuing interest in the motif of yoked beast heads—an apotropaic motif that, as noted, has a continuous presence in Anglo-Saxon art from the early fifth century (fig. 6a). Their presence on a well-defined group of eighth-century sword fittings invites particular comment (figs. 5g and 6b), since it brings us once more to the interaction of text and image. One of the St. Ninian's Isle sword chapes, one of a number of items of Anglo-Saxon origin in this Pictish hoard, carries a protective invocation, which can be more or less reconstructed as *in nomine dei summi, res ad fili spiritus sancti*—perhaps a bodged attempt at something approximate to "in the name of God the highest, property of the Son (and) Holy Spirit" (fig. 6b).[20] The inscription is certainly so stylized as to be almost indecipherable: it makes its point as image rather than text as such, a visible charm that gains reinforcement from the stylized supporting beast heads, which appear to offer protection to the blade. This might perhaps seem fanciful, were it not for the example of the York helmet (fig. 6e).[21] Here again we see yoked creatures, which, in this case, watch over the wearer's brow; the image is a lineal descendant of the Sutton Hoo helmet mask (fig. 4, h and i). However, the protective crest that on the Sutton Hoo helmet terminates in a dragon head at each end is here converted into a highly stylized Christian invocation—"In the name of our Lord Jesus, the Holy Spirit, God, and with all we pray. Amen. Oshere. Christ." The prayer itself is set in transversal frames that, significantly, form a cross over the skull, and is defended at each

end by beast heads in pairs, and one large frontal animal mask (fig. 6, c–e). In this translation of the earlier apotropaic crest, the protective text has supplanted the earlier image but, in the process, has itself become an image; thus, in a still largely illiterate world, it could be "read" from its context alone, and for anyone who doubted its significance, the visual cues were there in the traditional form of the paired guardian animal heads.[22]

The Franks Casket suggests another way in which these cognitive traditions underpin the reading of more complicated Christian artifacts (fig. 7a). I have argued recently that the riddling way in which runic and roman, Old English and Latin, clear and encrypted texts are used on the casket—itself a three-dimensional riddle—forms part of a *visual* as well as a verbal message.[23] The texts are set out in a variety of highly structured and decorative ways, which present them as images; but they are also images that signal, by their appearance and layout, something about the reading of the scenes they accompany. Just as significantly, they are also frameworks, defining and signaling the iconographic content of the casket in a way not very far removed from the way in which frameworks define and control the reading of earlier artifacts. Certainly, the casket is based on an early Christian reliquary casket, which itself is constructed on a framework in which border images comment upon the central icons. But on the Franks Casket, this classical tradition is wholly subverted, not only through its uncanonical content, but through the way in which at every turn the viewer is invited to discover and decipher a visual riddle, as well as a textual one. A decoding of this object depends as much upon an understanding of the traditional grammar of Anglo-Saxon style as on an acquaintance with *enigmata* or the iconography of early Christian art.

This is borne out by the example of another work of undoubted ecclesiastical provenance, the Braunschweig Casket.[24] This remarkable object appears at first sight to present a simple ornamental array of zoomorphic and plant motifs (fig. 7b). Closer inspection suggests a more subtle agenda. Its decorative program is both literally and metaphorically framed in a very structured way.[25] The casket itself is constructed, and the front and back panels are divided, according to strict mathematical principles, based on permutations of the divine number three; within this framework, the paired animal motifs represent the divinely ordered creatures of Earth, Air, and Water of Genesis 1, arranged in an intensely symmetrical and hierarchical pattern that denotes the harmony of God's

creation. This carefully framed cosmological image owes at least as much to older Anglo-Saxon traditions of visual literacy as it does to Christian iconography.

Finally, it may be instructive to examine two objects from the very end of the period defined in the title of this paper. The cutoff date of A.D. 900 may seem capricious, but it derives from a fundamental change in the vocabulary and grammar of Anglo-Saxon art that takes place in the early years of the tenth century. A new and very different visual language began to enter Anglo-Saxon England from the Carolingian sphere, and was to be the dominant influence in the ensuing art of the Benedictine Reform movement; that is why the concluding line here is drawn at the end of the ninth century. But before that came the renewals and reforms of Alfred's reign. Prime among a small group of objects that have a claim to be associated with his educational programs are the Fuller Brooch and the Alfred Jewel, both the subject of recent attention (fig. 7, c and d).[26] David Pratt has very convincingly shown that each encapsulates a very specific iconic message about the gaining of spiritual wisdom, closely linked to Alfred's insistence, in his own writings, on the importance of the mind's eyes, *modes eagan*, in this process. The sense of Sight is thus the central one among the Five Senses depicted on the Fuller Brooch, around which images of sentient creation are arrayed; and the eyes are an equally dominant feature of the figure that may represent Solomon in his wisdom on the Alfred Jewel.[27] These are iconographies new to Anglo-Saxon art. Yet on the very cusp of this visible cultural change, both in rather different ways reflect an embedded Anglo-Saxon stylistic grammar. The program of the Fuller Brooch, with its elegant compartmented framework in which symmetrical hierarchies of creation disport themselves around the senses, is, in a way similar to the Braunschweig Casket, a late version of the cosmological myths worked out on the square-headed brooches of the sixth century—equally ingeniously encrypted, and organized with the same careful sense of control and divinely bounded order. The Alfred Jewel takes its inspiration from the prestige metalwork of the Carolingian courts; but it is framed, bounded, and secured by a text that is also first and foremost an image, and itself begins and ends once more in the powerful icon of an animal mask. What could be more appropriate to Alfred's program of renewal, grounded in the vernacular tradition as much as in Latin learning, than artifacts such as these, so firmly rooted in traditional modes of visual literacy and what more symbolic of the transition from reading image to the reading of text?

These carefully framed and cryptically articulated constructions are grounded in a traditional Anglo-Saxon stylistic grammar—however changeful that might superficially seem—which had significant implications for Anglo-Saxon culture at large. This visual language, and the cognitive skills needed to read it, played an important enabling role in the development not only of the minor arts but, it may also be argued, in the construction and interpretation of manuscript illumination and sculpture. In this, we may recognize a visual equivalent to transitional literacy—a readable image, perhaps, to accompany visible song.

Notes

1. Bernhard Salin, *Die Altgermanische Thierornamentik* (Stockholm, 1904; 2d ed., Stockholm, 1935); Egil Bakka, *On the Beginning of Salin's Style I in England*, Universitetet i Bergen Årbok, Historisk-Antikvariske Rekke, 3 (Bergen, 1958); Egil Bakka, *Some English Decorated Metal Objects Found in Norwegian Viking Graves; Contributions to the Art History of the Eighth Century* A.D. Årbok for Universitetet i Bergen; Humanistik Serie,1 (Bergen and Oslo, 1963); Günther Haseloff, "Salin's Style I," *MA* 18 (1974): 1–15; Günther Haseloff, *Die Germanische Tierornamentik der Völkerwanderungszeit: Studien zür Salins Stil 1* (Berlin, 1981).

2. T. D. Kendrick, *Anglo-Saxon Art to* A.D. *900* (London, 1938); T. D. Kendrick, *Late Saxon and Viking Art* (London, 1949); R. L. S. Bruce-Mitford, "Decoration and Miniatures," in *Evangeliorum Quattuor Codex Lindisfarnensis*, ed. T. D. Kendrick, T. J. Brown, R. L. S. Bruce-Mitford (Olten, 1960), 109–258; R. L. S. Bruce-Mitford, "The Reception by the Anglo-Saxons of Mediterranean Art following their Conversion from Ireland and Rome," *Settimane di studio del Centro italiano di studi sull' alto medioevo* 14 (1966): 797–825; R. L. S. Bruce-Mitford, *Aspects of Anglo-Saxon Archaeology* (London, 1974).

3. W. G. Collingwood, *Northumbrian Crosses of the Pre-Norman Age* (London, 1927); Rosemary Cramp et al., eds., *The British Academy Corpus of Anglo-Saxon Stone Sculpture in England*, (Oxford, 1984–).

4. E.g., Karen Høilund Nielsen, "Centrum og periferi i 6.–8. årh.: Territoriale studier af dyrestil og kvindesmykker i yngre germansk jernalder; Syd- og Østkandinavian," in *Høvdingesamfund og Kongemagt. Fra Stamme til Stat I Danmark, 2*, ed. P. Mortensen and B. M. Rasmussen, Jysk Arkæologisk Selskabs Skrifter 22.2 (Højbjerg, 1991), 127–54; Lotte Hedeager, "Cosmological Endurance: Pagan Identities in Early Christian Europe," *Journal of European Archaeology* 13 (1998): 382–96. Jane Hawkes, "Symbolic Lives: The Visual Evidence," in *The Anglo-Saxons from the*

Migration Period to the Eighth Century: An Ethnographic Perspective, ed. John Hines (Woodbridge, 1998), 331–38.

5. Lotte Hedeager, "Myth and Art: A Passport to Political Authority in Scandinavia during the Migration Period," in *The Making of Kingdoms*, ed. Tania Dickinson and David Griffiths, ASSAH 10 (1999), 151–56; Karen Høilund Nielsen, "Animal Art and the Weapon Burial Rite—a Political Badge?" in *Burial and Society: The Chronological and Social Analysis of Archaeological Burial Data*, ed. C. K. Jensen and K. Høilund Nielsen (Århus, 1997), 129–48.

6. As for example, on the Ruthwell cross, where the two separate sets of iconographic programs (inhabited vine-scroll and the figural images) are further distinguished and articulated by frameworks containing separate texts in separate languages and alphabets, inviting an immediate approach to the reading of the visual message.

7. Katherine O'Brien O'Keeffe, *Visible Song: Transitional Literacy in Old English Verse*, CSASE 4 (Cambridge, 1990).

8. For script as symbol, see Marion Archibald, Michelle P. Brown, and Leslie Webster, "Heirs of Rome, the Shaping of Britain A.D. 400–900," in *The Transformation of the Roman World, A.D. 400–900,* ed. Leslie Webster and Michelle Brown (London, 1997), 212, 240–41.

9. See Fred Orton, "Northumbrian Sculpture (the Ruthwell and Bewcastle Monuments): Questions of Difference," in *Northumbria's Golden Age*, ed. Jane Hawkes and Susan Mills (Stroud, 1999), 216–26; Leslie Webster, "The Iconographic Programme of the Franks Casket," in Hawkes and Mills, *Northumbria's Golden Age, 227–46.*

10. See, Bente Magnus, "Monsters and Birds of Prey: Some Reflections on Form and Style of the Migration Period," in Dickinson and Griffiths, *Making of Kingdoms*, 161–72.

11. Bakka, *On the Beginning of Salin's Style 1*; Haseloff, *Die Germanische Tierornamentik*, esp. 111–32; David Leigh, "The Square-headed Brooches of Sixth-Century Kent," (Ph.D. diss., University of Wales, 1980), 327–29; David Leigh, "Ambiguity in Anglo-Saxon Style I Art," *The Antiquaries Journal* 64 (1984): 34–42.

12. E.g., E. T. Leeds, *Early Anglo-Saxon Art and Archaeology* (Oxford, 1936), 79–80.

13. Tania Dickinson, "Material Culture as Social Expression: The Case of Saxon Saucer Brooches with Running Spiral Decoration," *Studien zur Sachsenforschung* 7 (1991): 39–70; see also Julian Richards, "Anglo-Saxon Symbolism," in *The Age of Sutton Hoo: The Seventh Century in North-Western Europe*, ed. Martin Carver (Woodbridge, 1992), 131–47.

14. John Hines, *A New Corpus of Anglo-Saxon Great Square-headed Brooches* (Woodbridge, 1997), esp. 3, 301–10.

15. Bente Magnus, "The Firebed of the Serpent: Myth and Religion in the Migration Period, Mirrored through Some Golden Objects," in Webster and Brown, *Transformation of the Roman World*, 194–207; Magnus, "Monsters and Birds of Prey," 161–72; Hedeager, "Myth and Art," 151–56.

16. George Speake, *Anglo-Saxon Animal Art and Its Germanic Background*, (Oxford, 1980), 50–51, figs. a and b; Leslie Webster and Janet Backhouse, eds., *The Making of England: Anglo-Saxon Art and Culture, A.D. 600–900* (London, 1991), cat. no. 33, pp. 51–53.

17. See Webster and Backhouse, *Making of England*, cat. nos. 8 and 37, compared with Leeds, *Early Anglo-Saxon Art and Archaeology*, pl. 14.

18. Høilund Neilsen, "Animal Art."

19. The plaque is decorated with animals concealed within a Tree of Life; at its center is a disc with a cross, symbol of Christ present in the consecrated Host, on which the faithful feed. Susan Youngs, "A Northumbrian Plaque from Asby Winderwath, Cumbria," in Hawkes and Mills, *Northumbria's Golden Age*, 281–95.

20. D. M. Wilson, "The Treasure," in *St. Ninian's Isle and its Treasure*, ed. Alan Small, Charles Thomas, and D. M. Wilson (Oxford, 1973), 45–148; Michelle P. Brown, cat. no. 102 in *The Work of Angels: Masterpieces of Celtic Metalwork, Sixth to Ninth Centuries A.D.*, ed. Susan Youngs (London, 1989), 110.

21. Dominic Tweddle, *The Anglian Helmet from Coppergate*, The Archaeology of York, The Small Finds, 17/8 (London, 1992).

22. Ibid., figs. 434–439, 441, 444, 445, 598.

23. Leslie Webster, "The Iconographic Programme," in Hawkes and Mills, *Northumbria's Golden Age*.

24. See Webster and Backhouse, *Making of England*, cat. no. 138, 177–79.

25. Leslie Webster, "Style and Content on the Braunschweig Casket," in *Das Gandersheim Runenkästchen: internationales kolloquium, Braunschweig, 24.–26. März, 1999*, ed. Regine Marth and Silke Gatenbröker (Braunschweig, 2000), 63–72.

26. David Pratt, "Persuasion and Invention at the Court of Alfred the Great," in *Court and Culture in the Early Middle Ages: Proceedings of the First York Alcuin Conference,* ed. Catherine Cubitt (Turnhout, forthcoming); Leslie Webster, "Ædifica nova: Treasures of Alfred's Reign," in *Alfred the Great: Papers from the Eleventh Centenary Conferences,* ed. Timothy Reuter (Aldershot, forthcoming).

27. Webster, "Ædificia nova."

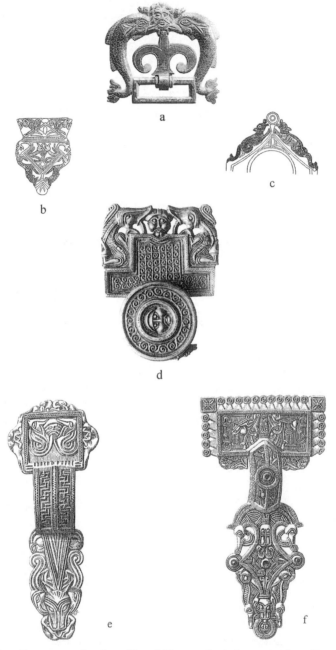

Figure 1. *Late Roman metalwork and late-fifth to early-sixth century Scandinavian brooches*
[a] buckle, Hontheim an der Mosel, Germany; [b] strap-end, Rhenen, Netherlands;
[c] belt-fitting (detail), Enns-Lauriacum, Upper Austria; [d] brooch fragment, Galsted,
N. Slesvig, Denmark; [e] bow-brooch, Lunde, Lista, Norway; [f] relief-brooch, Vedstrup,
Zealand, Denmark.
[a–d] after Haseloff, [e–f] after Salin. Various scales.

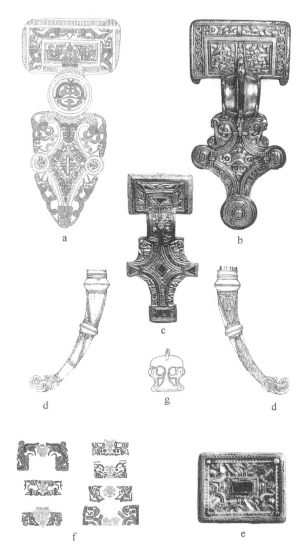

Figure 2. *Anglo-Saxon and related Style I zoomorphic decoration, sixth century*
[a] Anglo-Saxon square-headed brooch, Bifrons, grave 41, Kent; [b] square-headed
brooch, Chessel Down, Isle of Wight; [c] square-headed brooch, Chessel Down, Isle
of Wight; [d] details of drinking-horn terminals, Taplow, Buckinghamshire; [e] Anglo-
Saxon buckle plate; [f] mask and monster motifs from brooches: 1, Galsted, Den-
mark; 2, Donzdorf, grave 78, Germany; 3, Bifrons grave 41, Kent; 4, Gilton grave
48, Kent; 5, Richborough, Kent; 6, Pompey, France; 7, Gönningen, Germany; [g]
pendant, Chessel Down, Isle of Wight.
[a, e, f] after Haseloff; [b–d, g] British Museum, drawings J. Thorne, C. Arnold.
Various scales.

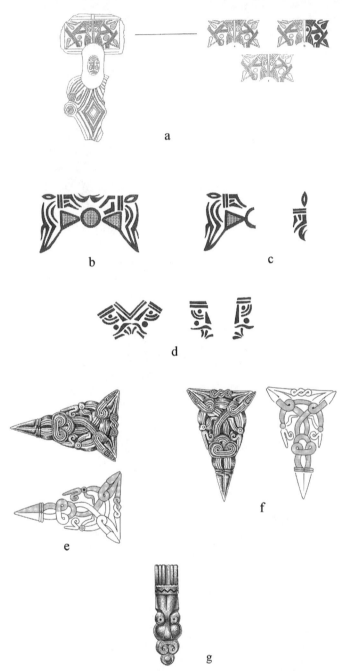

Figure 3. *Details of Anglo-Saxon sixth-century metalwork showing visual ambiguities*
[a] Square-headed brooch, Faversham, Kent; [b, c] animals and masks from square-headed brooch, Dover, Kent; [d] frontal and profile masks from square-headed brooch, Bifrons grave 41, Kent; [e, f] detail from Taplow drinking-horn terminals showing horizontal animals forming a vertical human mask; [g] mask from rim mount of Taplow horns showing similar mouth treatment.
[a] after Haseloff; [b–d] after Leigh; [e–g] British Museum, drawing M. O. Miller. Various scales.

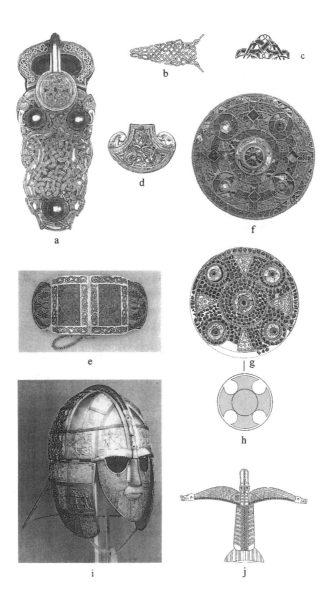

Figure 4. *Anglo-Saxon seventh-century metalwork showing Style II zoomorphic decoration [a–f] and visual ambiguities [e–i]*
[a] Buckle, Sutton Hoo, Suffolk; [b] detail of ornament on buckle, Wickham, Kent; [c] detail of ornament on sword pommel, Crundale, Kent; [d] mount, Barnham, Suffolk; [f] composite brooch, Kingston grave 205, Kent; [g] composite brooch, Boss Hall, Suffolk; [h, i] reconstruction of helmet and detail of flying dragon from the face mask, Sutton Hoo, Suffolk.
[a–e, h, i] British Museum, drawings J. Farrant, M. O. Miller, J. Thorne, E. Eden; [f] Merseyside Museums; [g] Suffolk Archaeological Unit, drawing J. Thorne. Various scales.

Figure 5. *Details of eighth- and ninth-century metalwork showing zoomorphic deco-
ration [a–h] and visual ambiguities [f–h]*
[a] finger-ring, Bologna, Italy; [b] mount, Bjørke, Norway; [c] detail of mount, Fure,
Norway; [d] disc brooch, Pentney, Norfolk; [e] disk brooch, unknown provenance;
[f] strap-end showing birds forming an animal mask when inverted, unknown prov-
enance; [g] sword pommel forming animal mask when inverted, Beckley, Oxfordshire;
[h] mount, and details of hidden animals and birds, Asby Winderwath, Cumbria.
[a] after Kendrick and Hawkes; [b] after Wilson; [c] after Bakka; [d–h] British
Museum, drawings M. O. Miller, J. Farrant. Various scales.

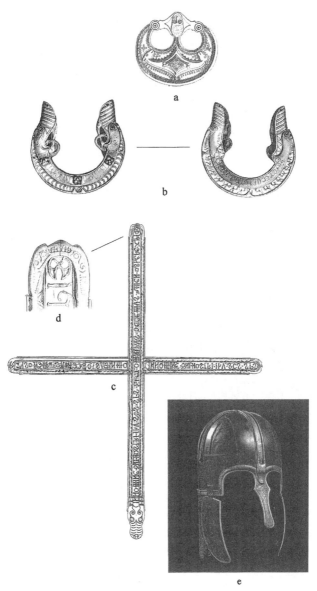

Figure 6. *Eighth-century Anglo-Saxon and related metalwork and apotropaic beast heads*

[a] sword chape, Buskerud, Norway, fifth-century; [b] sword chape, details, St. Ninian's Isle, Shetland; [c–e] helmet from Coppergate, York, and details of crest.

[a] after Salin; [b] National Museum of Scotland, photo British Museum; [c–e] Castle Museum York, drawings after York Archaeological Trust, photo, British Museum. Various scales.

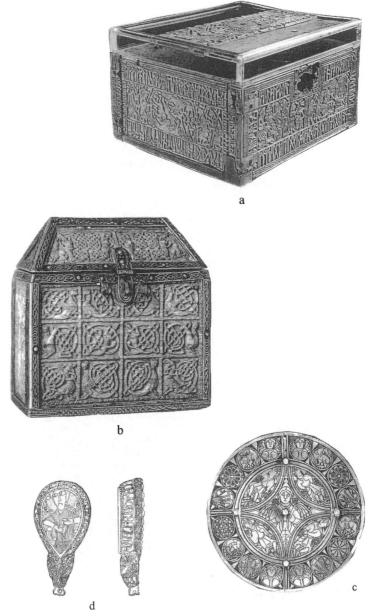

Figure 7. *Eighth- and ninth-century whalebone carvings and metalwork*
[a] Franks Casket; [b] the Braunschweig Casket; [c] the Fuller Brooch; [d] the
Alfred Jewel.
[a, c] British Museum; [b] Herzog Anton-Ulrich Museum, Braunschweig; [d] Ash-
molean Museum, Oxford, after Hinton. Various scales.

2

Rethinking the Ruthwell and Bewcastle Monuments: Some Deprecation of Style; Some Consideration of Form and Ideology

Fred Orton

When scholars commit themselves to working with style, all too often they do so by conferring on it a power it should not possess and cannot carry. One of several characteristically unsettling aspects of the now outdated but still fecund modern texts that laid the foundations for studying Anglo-Saxon stone sculpture of the pre-Norman age is that, though their authors were inclined to put the idea of style to work, they never felt it necessary to define style and, moreover, could be at odds with each other as to which of their objects of study were in or of the same style. One scholar might *see* the Ruthwell and Bewcastle monuments *as* having the same style (figs. 1–6).[1] Another scholar might *see* them *as* having different, even incompatible, styles; indeed, this scholar might see one or other of the monuments as having been made in a style that is made of two different styles.[2] Scholars might also *see* the Ruthwell and Bewcastle monuments *as* evidencing two tendencies or variations within the development of the same style.[3] What are scholars doing when they analyze surviving examples of Anglo-Saxon stone sculpture in terms of style? What unacknowledged or unexplained assumptions are they appropriating and organizing? And to what effect?

Can we agree on this definition? Perhaps. "By STYLE is meant the constant form—and sometimes the constant elements, qualities and expression—in the art of an individual or group. The term is also applied to the whole activity of an individual or society, as in speaking of a 'life-style' or the 'style of a civilisation.'" That was

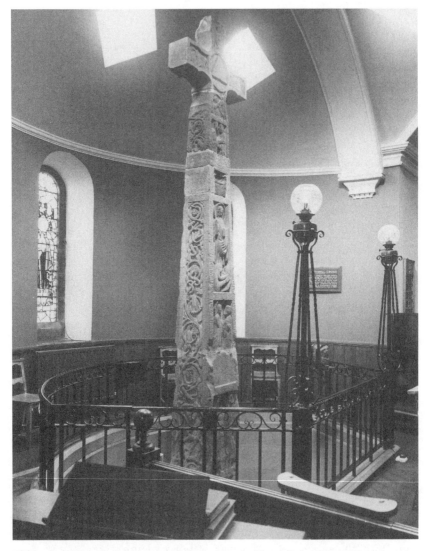

Figure 1. Ruthwell monument, south and west sides (photo: Bryan Brown)

how Meyer Schapiro began the essay on style that he contributed
to *Anthropology Today: An Encyclopedic Inventory* in 1953.[4] Style
is taken to be the continuous, stable, unchanging, persistent, or
reiterated shape or outward appearance of a discrete object or sev-
eral objects; it is also the continuous, stable, unchanging, persis-
tent, or reiterated component parts and distinctive attributes of

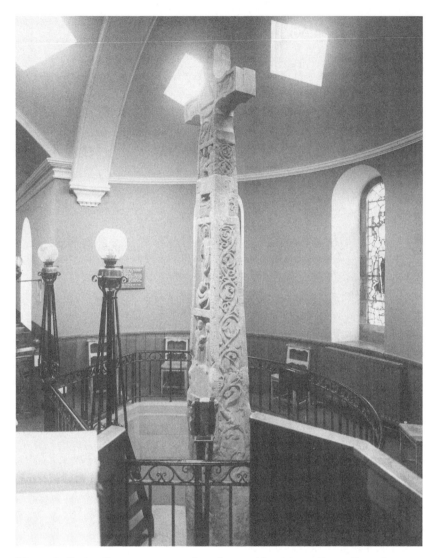

Figure 2. Ruthwell monument, south and east sides (photo: Bryan Brown)

that object or objects, and the way that they represent something or make it known; the term is also used to refer not only to objects but also to the practices of an individual or a society at an advanced stage of development. In this definition, style is not restricted to the constant form and formal components of an object. Concise though it is, Schapiro's is not the usual formalist definition

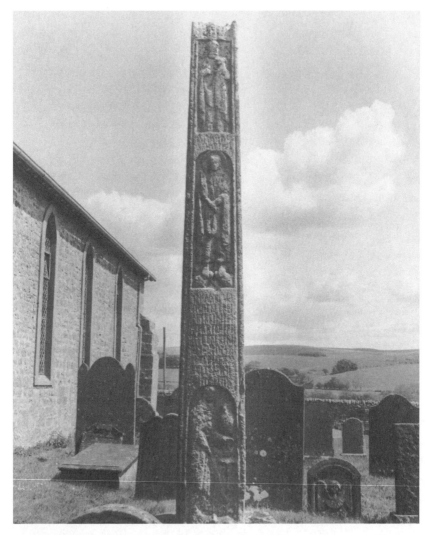

Figure 3. Bewcastle monument, west side (photo: © Department of Archaeology, University of Durham. Photographer T. Middlemass)

of style, for it is not just "sometimes" but *always* turned to comprise both the formal features of an object and what those features mean; it comprises form and content. Here style is the constant form, formal components, and characteristic traits that represent or refer to an object's or objects' historically and culturally specific circumstances of production and use.

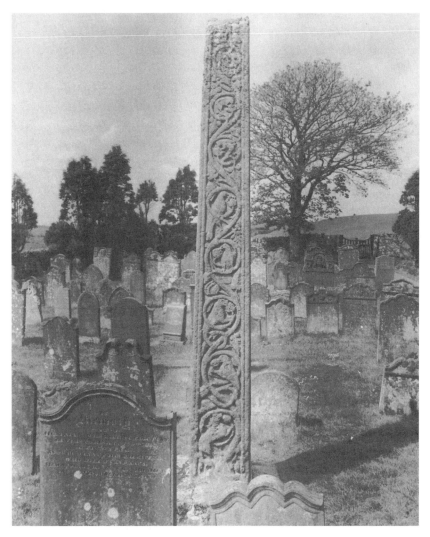

Figure 4. Bewcastle monument, east side (photo: © Department of Archaeology, University of Durham. Photographer T. Middlemass)

In the essay that follows from this definition, Schapiro first introduces us to how style is understood by the archaeologist, the art historian, the synthesizing historian of culture, and the critic.

To the historian of art, style is an essential object of investigation. He studies its inner correspondences, its life-history,

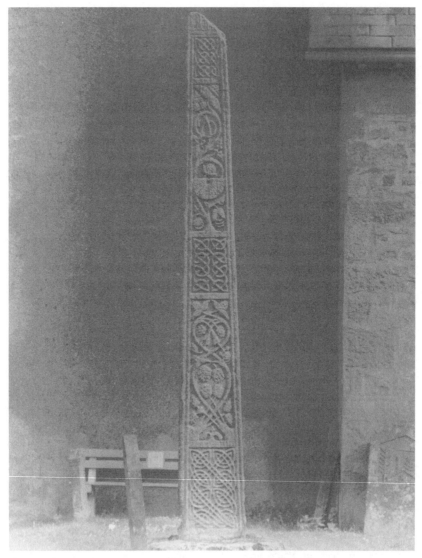

Figure 5. Bewcastle monument, south side (photo: © Department of Archaeology, University of Durham. Photographer T. Middlemass)

and the problems of its formation and change. He, too [like the archaeologist], uses style as a criterion of the date and place of origin of works, and as a means of tracing relationships between schools of art. . . . It is, besides, a common

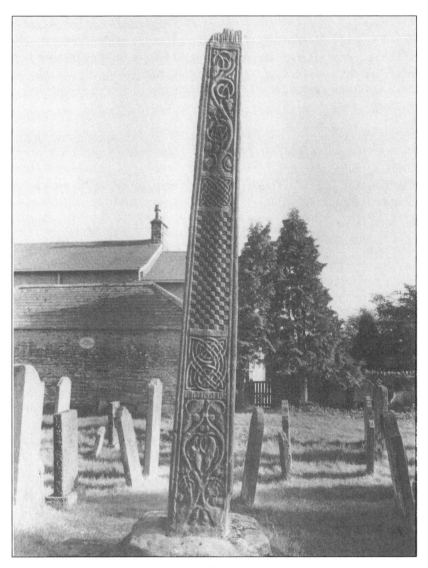

Figure 6. Bewcastle monument, north side (photo: © Department of Archaeology, University of Durham. Photographer T. Middlemass)

ground against which innovations and the individuality of particular works may be measured. By considering the succession of works in time and space and by matching variations of style with historical events and with the varying

features of other fields of culture, the historian of art at-
tempts, with the help of common-sense psychology and social
theory, to account for the changes of style or specific traits.
The historical study of individual and group styles also
discloses typical stages and processes in the development
of forms.[5]

As has been pointed out, "[T]here is, to be sure, much one might
quibble with here. What, after all, is 'common-sense' psychology?
Precisely what sort of 'social theory' does Schapiro have in mind for
his historian of art?"[6] These matters aside, at least for the moment,
Schapiro does, if uncritically, point to the way that the art historian
and the archaeologist study style trying to locate the moment and
manner of its coming into being and subsequent development. Any
discipline that concerns itself with style concerns itself with the
origin or originary moment: that "to which, by virtue of precedence
and unchanging being, everything can be referred for explanation."[7]
 However, as far as Schapiro is concerned, "[S]tyle is, above all,
a system of forms with a quality and a meaningful expression
through which the personality of the artist and the broad outlook
of a group are visible. It is also a vehicle of expression within the
group, communicating and fixing certain values of religious, social,
and moral life through the emotional suggestiveness of forms."[8]
Style is a complex organized whole that conveys and secures, rep-
resents and establishes, individual and social value: religious, moral,
political, and so on.
 Given that the desire to locate origins must necessarily remain
always unsatisfied because it is not a relation to an actual object and
nothing in the world begins without beginning in and from some-
thing other than itself,[9] the main problem for the art historian who
is committed to using the idea of style is how to move from consid-
eration of the constant form and formal analysis to explanation of
how that constant form and its component parts, attributes, or traits
communicates and fixes, disseminates and reiterates, the religious,
moral, philosophical, political, and economic ideas and practices of
its determining "context." Few art historians concerned with style
manage to make this move, especially those whose object of study is
Anglo-Saxon stone sculpture, where a survival's historical and cul-
tural specificity is likely to be unknown or more or less unknown,
and where, partly because of this, attention tends to get restricted
to form or form and iconography rather than be concentrated on
form and content or form as representing the content of social life.

The modern art-historical study of Anglo-Saxon stone sculpture begins with the desire to locate the origin of the tall stone cross and a reliance on the idea of style as a means to placing surviving individual examples in progress of development as series—that is to say, it begins in 1927 with the publication of W. G. Collingwood's *Northumbrian Crosses of the Pre-Norman Age*.[10] Collingwood's insistence that there could be little or no progress in the study of Anglo-Saxon stone sculpture without a comprehensive catalogue of every surviving example, his attempts at classification, and his protocols and procedures provide the basis of *The British Academy Corpus of Anglo-Saxon Stone Sculpture* and the corpus-work of those persons busy compiling it. The effect of Collingwood's work has been considerable. As one scholar of Anglo-Saxon stone sculpture put it: "The shadow of W. G. Collingwood will always fall across modern scholars who work on the pre-Conquest carvings of Northern England, not only because of his synthesis of the subject in his 1927 book, where he laid down a chronology for the monuments based upon stylistic criteria, but also on account of his groundwork in cataloguing the surviving pieces in the northern counties."[11] I find that metaphor of a shadow falling across modern scholars telling: whatever light is provided by Collingwood's work, it puts those persons who use it, and perhaps their objects of study also, in comparative darkness.

Following Collingwood, the *Corpus* project is committed to the idea of style and to the belief that any individual surviving example of Anglo-Saxon stone sculpture cannot be studied in isolation, that the monuments have to be studied together, conceived in series and connection, and that if any individual sculpture is to be understood it has to be understood as one of a class of monuments. However, in place of Collingwood's impressionistic approach of the antiquarian connoisseur, the *Corpus* project has devised and substituted seemingly precise and rigorous linguistic descriptions that effect an aura of science, and proceeds to interpretation on the basis of these. Its work is based in seeing and classifying constant types of forms of monument, ornament, and techniques of carving, and with tabulating these types according to an evident and universal mode. In other words, the project enables an interpretive procedure based on an inventory of fixed relations between observable data and meanings that do not vary with context, a procedure that can be grasped by anyone who can perform the operations specified by the key and by using the key terms. The corpus project moves the study of Anglo-Saxon stone

sculpture away from a commitment to style towards a belief in the value of stylistics.[12]

Needless to say, I am skeptical about that bit of the *Corpus* project that is concerned with style and stylistics. The *Corpus* is a useful resource insofar as it means that we will have a more or less complete photo archive of the surviving Anglo-Saxon stone sculptures. It is enabling of knowledge in that sense. I am also aware that using the *Corpus*'s categories and classifications permits the visibility of an object to pass into discourse, but here I am not sure what the gain for historical interpretation is when one realizes that that system of categories and classifications also tends to order or control or constrain or close down what can be seen and said to a limited taxonomic area of visibility. What is to be done with the typological data that the *Corpus* provides? What interpretive inferences are we to draw from it? Application of the system certainly makes it difficult to proceed from "description" to "discussion" and, all too often, the relation that the *Corpus* establishes between the specification and "description" of form, ornament, and facture and "discussion"—which is, as it must be, largely dependent on archival materials presented in the "references"—seems arbitrary.

One major problem inherent in the idea of style is that a type of form or ornament or facture is *seen* and understood *as* a possession of an object; it is *seen as* existing prior to interpretation. It was pointed out some time ago that formal patterns, and I would add form itself, are themselves products of interpretation, that there are no such things as form and formal patterns, in the sense necessary to the definition of style and stylistics, as being prior to interpretation.[13] This is not to say that there are no such things as forms and formal patterns. There are; but they are always products of a prior interpretive act. Their identification is always an interpretation. The art historian who is concerned with style proceeds *as if* by observing and describing facts—form, ornament, facture, or whatever—and then moves to the interpretation of those facts. The practical fiction there is important, because the art historian is really concerned not with observing and describing facts but with deciding and describing what counts as observable facts. He or she has always to get his or her observation to cohere according to certain seemingly reliable ways of seeing and saying. Identifying form and formal patterns is a thoroughly "theory-laden" undertaking.[14] Observation of an object is determined by prior knowledge of the object and by "the language or notation used to express what

we know, and without which there would be little we could recognize as knowledge."[15] As will become clear, when Rosemary Cramp (the general editor of the *Corpus*), and I observe the Anglo-Saxon monument that survives on the south side of St. Cuthbert's church at Bewcastle, we are not seeing the same thing, even though we are looking at the same object.

"By STYLE is meant the constant form"—the defining characteristic of style is not form but the constancy of form. Those art historians who concern themselves with style assume that the same form or formal pattern can be discerned recurring within an individual object or more usually, and perhaps more problematically, across or between several, often different kinds of objects produced in the same or different places at the same or different historically specific moments. Hence the search for forms and formal patterns that, once found, are claimed to be "practically identical to" or "obviously derived from" or "most closely associated with" or "very reminiscent of" or "corresponding to" or "analogous to" other forms, or which "resemble" or "parallel" them. No wonder style's thesaurus symptomatizes a kind of frustration: the art historian's need to locate and make out the "constant form," the repeated "same" within an individual object or across several objects, like the desire to locate the "origin," can never be satisfied. Why? Because the definition of style implies a much greater spatial and temporal stability of form and form relationships in an object or objects and practice or practices than is the case.[16] The idea of style fixes or freezes into normative types relations that are essentially in process of flux and change; it coordinates and stabilizes what is fundamentally incoordinate and unstable, tentative or provisional. Indeed, it undoes itself in the emphasis it puts on continuity rather than discontinuity and, thereafter, in the inevitable discursive inequality that results from the need to privilege similarity over difference.

The idea of style relies on similarity. But similarity is a thoroughly problematic concept that cannot be equated with, or measured in terms of, the possession of common characteristics, and for that reason it is an unreliable aid to identifying "constant form." Even if two objects could have precisely the same form, the difference between them would be that they were different. While we usually take similarity as offering empirical evidence on which to base metaphors or principles of discrimination and classification, judgments of similarity usually follow from metaphorical modes or

principles of classification already established. Such judgments will merely affirm those types of relationships that have already been established as a means to organize our seeing and saying, observation and description.[17]

It is here that Rosemary Cramp and I can approach the Bewcastle monument together. In the *Corpus* Cramp describes and classifies this monument, catalogued "Bewcastle 1," as a "cross-shaft and base" mainly because that is what it has come to be *seen as* and because, restricted as those scholars who compile *Corpus* entries are to allocating their objects of study according to a typology comprising "free-standing crosses" ("cross-shafts" and "cross-heads"), "tombs and grave markers," and "architectural sculpture and church furnishings," she has no choice but to *see* and classify it *as* a "cross-shaft." The entry given under "Bewcastle 1" for the surviving monument at Bewcastle continually refers to it as "the Bewcastle cross" despite, as the entry under "Bewcastle 2," the "cross-head," makes clear—"Present Location: Lost. Evidence for discovery: None"—there is no evidence for doing so.[18] Though there is evidence that there was once a cavity in the top of the column of the kind that would take a tongue, there is no reason why we should assume that it was put there to take a cross-head rather than some other terminating feature. As I have argued elsewhere, the surviving monument at Bewcastle is probably best *seen* and understood *as* a column or obelisk or as what some Anglo-Saxons would have called a "pyramid," a type of monument that cannot be classified and catalogued within the *Corpus* without disrupting its order of things.[19] It is possible that several of the fragmentary survivals classified and described as Northumbrian "crosses" are and were not crosses but obelisks or columns and were most probably resourced by knowledge of the triumphal columns and obelisks of Rome, such as that which, when the Anglo-Saxons visited the Eternal City, stood by the south side of St. Peter's on the Vatican and now stands in the center of St. Peter's Piazza. Northumbria appropriated the form of an important type of Roman monument to its own imperial project; it saw itself as equivalent to, and perhaps imitated, Rome and Roman power, culture, and civilization.[20]

The Ruthwell and Bewcastle monuments are the two survivals of Anglo-Saxon stone sculpture that are usually *seen* and said *as if* they are similar. No one can deny that there must be a relation of association between their shared inhabited vine-scrolls and the representation of Christ on the beasts with John the Baptist above. But given the foregoing, this should not be taken to constitute similarity be-

tween them. We should note and work with the differences. For example, looking at the two representations of John the Baptist (figs. 7 and 8), and ignoring that the two figures are draped or dressed differently, on the Ruthwell monument the figure of John stands with each foot on a globe, whereas on the Bewcastle monument it possesses no such pied-à-terre; on the Ruthwell monument, John is haloed but on the Bewcastle monument he is not—on the Bewcastle monument the Lamb is haloed. These are not, as the *Corpus* would have it, "minor differences of style"[21] but major differences between signs— signs, moreover, whose meanings should not be viewed abstractly according to the mechanism of analogy but materially according to the actual contexts in which they are used. Though they might share some meaning and value, the specific meaning and value of each John the Baptist must depend on its place within the overall pictorial and textual program of its monument.

Seeing and understanding similarity engenders difference. The problem is one of how to insist on difference and do it with "style," mindful that there *are* forms, motifs, patterns, and so on, that, in a very cutaneous way, can be *seen as* similar and constant. What kind of knowledge would we gain of the two monuments if we insisted on what is uniquely different between them (their dissimilarity) and then moved to consider the difference or dissimilarities (the antinomies or opposite forces of signification) within each monument?

The most obvious difference between the two monuments is that the Ruthwell monument, in its final form, came to have the shape of a cross, whereas the Bewcastle monument may always have been a column or an obelisk. Assuming, however, that, as I have argued elsewhere, the Ruthwell monument began as a column and that the cross was a later addition, it would, at its beginning, have been a different kind of column from that at Bewcastle.[22]

Let us have a look at some other differences between the monuments.[23] The Bewcastle monument rises from a square base, whereas the Ruthwell monument rises from a rectangle. Authorities, ancient and modern, have usually taken the frustum to be an important sign of a monument's meanings and function: a survival with a rectangular frustum is assumed to have been a cross; a survival with a square frustum is assumed to have been a column or an obelisk.[24] The Bewcastle monument's slender, tapering form and arched lower figure panels give it a dynamic upward movement. The Ruthwell monument seems more strictly vertical and horizontal in its effect, less slender and less striving to be free of

Figure 7. Ruthwell monument, upper stone, north side (photo: University of London, Warburg Institute)

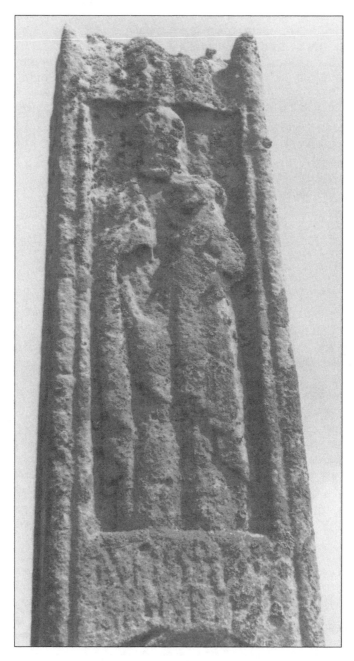

Figure 8. Bewcastle monument, west side, John the Baptist (photo: © Department of Archaeology, University of Durham. Photographer T. Middlemass)

the ground. The form and shape of each monument supports its ornamentation to different effect.

I take it that the sundial, present on the Bewcastle monument (fig. 9) but not on the Ruthwell monument, constitutes an important

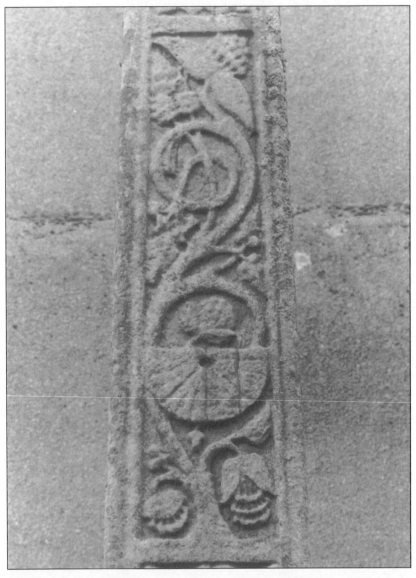

Figure 9. Bewcastle monument, south side, sundial (photo: © Department of Archaeology, University of Durham. Photographer T. Middlemass)

difference between them. Assuming that all its divisions were put in place complete and integral with the erection of the monument, the Bewcastle dial is a perfect example of a rare pre-Conquest type.

> It consists of the lower half a circle, a style-hole, and thirteen radiating lines. Three of these are marked with cross-bars and are wide, V-shaped in section and deeply cut, and divide the day into tides. Each tide is subdivided into three parts by two fine incised lines, the whole day from 6 a.m. to 6 p.m. being thus marked out into hours. Here we see the two systems of time-measurement, the [Anglo-Saxon] octaval and the [Roman or continental European] duodecimal, combined on one dial.[25]

As the *Corpus* points out: "[I]t is impossible to tell whether its twelve divisions were meant to inform a monastic or a lay community."[26] The monastery was one of the first sites of the temporal regulation of the day; an enclosed place, it had a disciplined space and time for everything. The sundial, however, would have been an impractical aid to calculating the date of Easter or the equinox, and a poor and often impossible guide to telling and keeping the canonical hours. No matter what religious significance might have been, or might be, given to the sundial, whoever produced and used the Bewcastle monument seems to have wanted to know what time of day it was or, rather, was concerned to represent an interest in how the passage of time, controlled by the sun, could be shown and conjoined, by the gnomon and its shadow, to the person who needed "to know" the time. This kind of concern with time constitutes a big difference between the Bewcastle and Ruthwell monuments, since the latter, if it has a concept of time, is linked to institutional, and ultimately political, lived-time as mediated and controlled by Roman Easter tables, the canonical hours, and the liturgy rather than more or less directly to solar time like the former. It is not usually pointed out in studies of Anglo-Saxon stone sculpture that the Bewcastle monument's sundial is probably the oldest extant English—that is to say, post-Roman—"time-keeper" or "time-marker,"[27] a reminder of the interest that some eighth-century Northumbrians such as Bede took in the "science" of time.[28] What I am suggesting is that the communities that designed and erected the Bewcastle and Ruthwell monuments took time into account in different ways.

The presence of the checkers and the five individual panels of plain interlace on the Bewcastle monument and their absence from

the monument at Ruthwell must also signify when a relation of
similarity is asserted between the two monuments. These panels,
especially the panels of plain interlace, give the Bewcastle monu-
ment an important value whereby, within its overall scheme of
things, you sometimes find a cross or crosses and sometimes you
don't.[29] Writing and reading something between the lines: repre-
senting something by drawing attention to the fact that you're
hiding it. If those persons who produced and used the Ruthwell
monument possessed these patterns and this skill of picturing and
seeing, writing and reading, then why were they not concerned to
exhibit them—to put them to use—on their monument? If they
didn't possess them: why not? Both columns exhibit a wealth of
inscriptions. The differences here are also important. The Bewcastle
monument's surviving texts are all runic. The Old English personal
name "Cyneburh" has been read on its north side, while on its west
side—and probably on its north side also—there is a Latin form, in
runes, of "Jesus Christ."[30] The longest inscription is located on the
west side between Christ on the beasts and the so-called falconer.
This inscription seems to tell us that the monument was set up by
"Hwætred" and at least two others as a "token of victory" to the
memory of someone named "[A]lcfri[th]"; it is commemorative and
invokes us to prayer.[31] The Ruthwell monument's texts are runic
and Roman. The runic texts are laid out around the vine-scroll on
its narrow east and west sides. These give us four *sententiae* in
verse representing the Crucifixion. The Roman texts are inscribed
around the figure panels on the south and north sides, originally
the west and east faces. On the north side, contrary to the way it
is inscribed on the monument at Bewcastle, we read "Jesus Christ"
in the six-letter Greek abbreviation taken into Roman with the *eta*
given as a minuscule *h*. How do we account for this difference in
the form of the *nomen sacrum?*

Another difference concerns the use of Latin and vernacular on
the Ruthwell monument compared with the use of vernacular on
the monument at Bewcastle. Latin, the language of chant and of
clerics, was becoming the universal instrument of church and state
bureaucracies. Latin is the language of the main sides of the
Ruthwell monument. In contrast, vernacular does its signifying
marginalized on the narrow sides. We find something else at
Bewcastle, where vernacular is the monument's dominant textual
language: it occupies a large part of the west side, and tells us
what we are looking at and how we should behave. What deter-
mined the scope and compass of the dominant textual language of

each monument—the linguistic differences—almost certainly determined its form and content also.

It is here that we can locate what might be the main difference between the two monuments. Though, as we will see, the Ruthwell monument has secular import, its meaning is predominantly ecclesiastical; it is concerned with biblical exegesis and liturgy; its themes are, on one side, the recognition of Christ and, on the other side, the monastic life. The meaning of the Bewcastle monument, however, seems predominantly secular: its main purpose seems to be to commemorate at least one high-ranking secular aristocrat (fig. 10). It would be productive to theorize the Bewcastle monument as a model for and locus of memory and to explain the large inscription on its west face as concerned with the preservation of family memory. Memory is incarnate at Bewcastle: the monument is its material form. The idea of the epitaph evidences not only a need to mark but also a desire to overcome the difference between life and death; that could be an agnostic desire, but as it is represented here, in a relation of contiguous association with representations of Christian ideas and beliefs, it is given some religious and perhaps ecclesiastical significance also. Family memory at Bewcastle may well have been accompanied or facilitated by formal liturgical memory, but I take it that here the bonds made by names transcend liturgical commemoration and that, at the moment of the monument's erection, *genealogia*, as it does now, prevailed over liturgical *memoria*.[32] Both monuments are, then, based in different institutions and practices: the Bewcastle monument is based on and rises from a representation of the secular aristocracy and the institution of the family, tribe, or clan (the bird is an important attribute or sign of a land-enhanced aristocrat: whoever is represented at the base of the column may well have owned the land on which it was raised);[33] the Ruthwell monument is *based* in the power of the ecclesiastical aristocracy and the institution of the church and rises from representations of the Annunciation and the Crucifixion (fig. 11).

Until recently scholars considered that, because the surviving corpus of pre-Viking Anglo-Saxon stone sculpture seemed to have been produced at sites associated with "religious communities," it was best characterized as "in some sense, monastic" or as a "monastic art."[34] That theory has had to be modified by what has come to be understood about the character of Anglo-Saxon monasticism and by what we know of crosses that were sited in locations that were not in the strict sense monastic.[35] In view of the way that I have been theorizing the Ruthwell monument and the Bewcastle

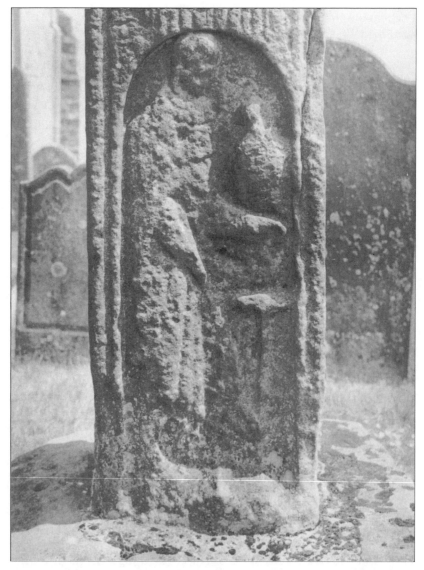

Figure 10. Bewcastle monument, west side, aristocrat/"falconer" (photo: © Department of Archaeology, University of Durham. Photographer T. Middlemass)

column, it may be possible to fine-tune that revision. Surely there were no communities that were producing, or that were capable of producing, stone sculpture that would not have been "religious communities," that would not have been made up of people who

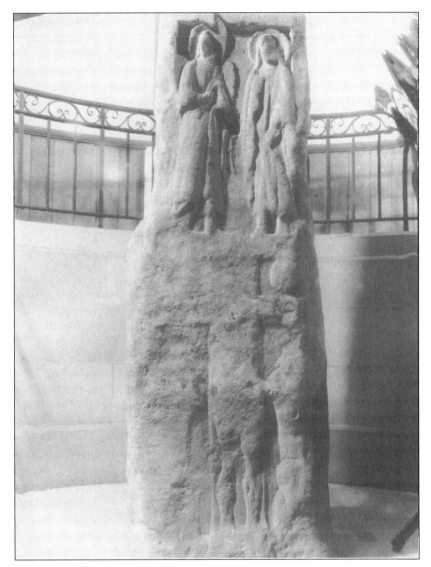

Figure 11. Ruthwell monument, lower stone, south side, Crucifixion and Annunciation (photo: © Department of Archaeology, University of Durham. Photographer T. Middlemass)

were devoted to or who were in some way involved with religion whether or not they belonged to a monastic order. We know from Bede that some monasteries—far too many, it would seem—were being set up by aristocrats who wanted to secure land from the

king that they could bequeath to their descendants.[36] The estates
of these "pious aristocrats" would have been more or less indistin-
guishable from those of the secular nobility. The question is: "Did
they produce stone monuments, and, if so, were those monuments
monastic or aristocratic?" And, though the evidence is slight, we
know that crosses—it is not known whether they were stone
crosses—were erected by aristocrats on secular estates.[37] It seems
to me that the surviving corpus of pre-Viking stone sculpture is
best understood as made up of survivals, some of which have to be
theorized as *of* predominantly ecclesiastical production and use (*of*
the institution of the church or monastery) and some of which have
to be theorized as *of* predominantly secular production and use (*of*
the institution of the family, tribe, or clan). I take it that this differ-
ence between monuments implies a determining difference that might
be represented and reworked within any individual monument.

Form. And content. I have not catalogued all the phenomenal
differences of form and formal pattern between the Ruthwell and
Bewcastle monuments, but I've noted enough for the purpose of
this discussion. I need now to say something about constant ideas,
the continuity of ideas. Seemingly constant ideas or a seemingly
shared concern with certain ideas can be signified through different,
discontinuous forms. The Ruthwell and Bewcastle monuments seem
to share a concern with certain systems of ideas and beliefs that
they represent in different ways and to different effect. For the sake
of space I shall restrict myself to mentioning only what is obvious.

Both monuments are carved and inscribed with representa-
tions of ideas about death and ways of dying. Here I am pointing
not only to concerns shared between the two monuments but also
to shared differences within each monument. I have in mind, for
example, the biblical death as it is represented in the Crucifixion
panel on the Ruthwell monument and the not quite biblical Cruci-
fixion represented in the verses on its east and west sides. Repre-
sentations are actively manufactured renderings of their referents,
produced from available cultural resources; they are constructs made
for use in some activity; they exercise cognitive functions, and those
functions will be related to the objectives, ideas, and beliefs of some
social group.[38] Those persons who composed the verses on the sides
of the Ruthwell monument represented the Crucifixion using not
only what they knew of the biblical Crucifixion but also what they
knew about Anglo-Saxon ways of living and dying, especially what
they knew about how a king or a brave warrior should die, and
made Christ a *guman* who prepares himself as if for battle when,

desiring death, he wants to ascend the gallows.[39] The biblical death of Christ is there on the Bewcastle column also, as it is on the Ruthwell monument, in the form of the Agnus Dei: Christ as ruler of Heaven and Earth holding out the promise of eternal life. As at Ruthwell, this biblical reference to Christ's death has its place in a relation of association with an Anglo-Saxon death, the death of Alcfrith, perhaps a king but certianly an aristocrat and warrior. The Ruthwell monument was erected primarily to commemorate, preserve, and transmit the memory of the human life and afterlife of an eternal being; the Bewcastle column, obelisk, or "pyramid" was erected primarily to commemorate, preserve, and transmit the memory of a temporal being.

Ideas and beliefs about kingship and nobility. Again these ideas and beliefs are of two kinds: they are about eternal and temporal kingship and nobility. I have in mind, of course, the representation of Christ on the Ruthwell monument, made of Mediterranean resources, imperial and "modern" (in the sense of being up-to-date, not lagging behind Rome), a composite of, for the most part, emperor and philosopher, powerful in different ways, commanding respect yet capable of forgiveness and righteous judgment, and, in the verses on the sides, a different kind of king, an Anglo-Saxon character, possessing all the values that attached to a *kyningc*, *hlafard,* and *dryctin*, neither emperor nor philosopher but a terrifyingly brave warrior, imperial perhaps (though, if so, in an Anglo-Saxon way, not a Roman one), commanding respect in life, and, in death, causing persons born noble, *æþþilæ*, presumably his own kith and kin, tribe or clan, to hasten to his corpse. Two lords, the one eternal and the other temporal, have their places on the Ruthwell column where, as at Bewcastle, the biblical king has his metaphorical and metonymical places as emperor-philospher and *gessus kristtus* in relation to the Anglo-Saxon lord, a feudal superior for sure and perhaps a king, metaphorical and metonymical, possibly pictured and named as Alcfrith.

And last but, in this listing, not least, I have in mind the way that ideas about women, about what it was to be a woman, are represented on the two monuments. On the Ruthwell monument images of women function not only in illustrations of Bible stories but also as signs of vivid types of aristocratic Anglo-Saxon female identity: the penitent Mary Magdalen and the Virgin Mary at the Annunciation and during the journey into or out of Egypt on the lower stone; Mary and Martha, the good woman in secular society and the good woman in the monastic community *and* Elizabeth

and Mary, two humble pregnant women, both in secular society but
with one more revered than the other, on the upper stone.[40] Peni-
tence. Probity and virtue. Pregnancy. Maternity. The Ruthwell
monument, unusual in several ways, seems especially unusual in
having so many representations of women pictured and inscribed
on it—women set in a relation of alterity with the male figures of
Christ, John the Baptist, Paul and Anthony. We should note, how-
ever, that references to women are significant by their absence
from the Old English verses representing the Crucifixion.[41] The
representations of women on the Ruthwell monument have their
value in relation to biblical males and Paul and Anthony more than
in relation to the Anglo-Saxon *kyningc* Christ. The significance of
women on the Bewcastle column seems different. Woman is
unpictured but, nevertheless, placed. Present only as a name, "Cyne-
burh," she occupies a particular space—perhaps even a gendered
space—on the column's north side, where she is inscribed in a
contiguous relation of association with the males pictured and in-
scribed on the column's west side.[42] Another "perhaps": perhaps
here we have, as in the verses on the Ruthwell monument, some
evidence of ideas and beliefs about Anglo-Saxon kin and/or affinity
relations and the actions appropriate to them—Cyneburh satisfy-
ing and asserting kin or affinity relations, for there seems little
point to her being inscribed on the monument if she is not kin or
did not have affinity by marriage to Alcfrith. Women seem to have
played a major role in the preservation of memory.[43] A rememberer
remembering remembered, perhaps. That would figure Cyneburh.
 The differences between the two monuments: that one became
a cross and the other seems to have remained a column; that one
is predominantly ecclesiastical in production and use and the other
is predominantly secular; that their schemes of ornament and deco-
ration are different—difference. But there is also similarity in dif-
ference: there is also some shared content that is represented in
and by different forms—a concern with certain ideas and beliefs
about death, eternal and temporal kingship, women, kinship, con-
sanguinity, and/or affinity. What can we make of this? One expla-
nation would be that whoever produced and used each monument
wanted to find and come to terms with, make sense of and rep-
resent, traditional Anglo-Saxon ideas about death, kingship, mas-
culinity and femininity, kinship, consanguinity, and/or affinity
alongside or in the context of their commitment to a kind of Chris-
tianity, institutionally powerful and owing its allegiance to Rome,
that, as we know, in the eighth and ninth centuries was causing

those ideas to be changed, amended, and even abandoned.[44] Here
"make sense of" and "find and come to terms with" might also
mean contest and struggle against. For example, how would it alter
things if we saw the representation of women on the Bewcastle and
Ruthwell monuments as different site-specific attempts to hang
onto and assert the power and presence of women at court and in
the monastery at the moment when that power was being con-
tested and diminished by the power of the Roman church? How
would it alter things if we saw each monument, in its different way,
as concerned to keep certain kinds of familial, kin, and/or affinity
relations in place at the moment that they were being dislocated by
changes in an increasingly complex division of labor, the progress
of the Roman church, and so on? How would it alter things if we
saw each monument as concerned with what it was to be a king (or
an aristocrat or nobleman) in relation to the power and authority
of the church: king, warrior, protector of the population and the
institution of the church, military leader, and, increasingly, the
person responsible for establishing and enforcing a system of legal
relations; a person whose interests were not always in accord with
those of the church; who might, on occasion, get very concerned
about the extent to which the power of prayer facilitated the power
of increased ownership of land—indeed, facilitated the perpetual
alienation of land; who might, occasionally, have to imprison a
bishop or deprive him of his see or reduce his landholdings?

The Ruthwell monument and the Bewcastle column (figs. 1–6).
Style. Forms, qualities, and expression. Similarity and difference.
Ideas and beliefs. Secular and ecclesiastical societies and institu-
tions. Property relations. Land. Power at the determining base.
Class. The scholarship of pre-Viking Anglo-Saxon stone sculpture
usually overlooks the fact that its objects of study are the survivals
of a particular class, the aristocracy, and that that class was com-
prised of two blocs or factions whose interests were related but
were not wholly the same: the secular and the ecclesiastical aris-
tocracy. Hence the relations between the two monuments and the
real differences within the individual monument, for, as we have
just seen, differences between class factions also get represented
and reworked within the individual monument. Each monument
represents the ideas and beliefs of the aristocracy according to the
institutional position of those persons who produced and used it;
this was a position determined by their relation to the forces and
relations of production, the property relations that were giving
Northumbrian society its material character between around the

beginning of the eighth century and the middle of the ninth century. Though the class factional identity of these persons and their institutions may, occasionally, have seemed blurred, nevertheless, those class positions have to be understood as what they were: different and, in certain respects, conflictual. This determining and represented difference and conflict, which characterizes relations not only between monuments but also within individual monuments, brings us to "ideology."

Can we agree on this definition of ideology?[45] Probably not, but let's proceed. Ideologies—for "ideology" must always be plural—are those systems of ideas, beliefs, images, values, and techniques of representation, each with its own structures of closure and disclosure, its own horizons, its own ways of allowing certain perceptions and rendering others impossible, by which particular social classes or factions within a class, in conflict with each other, attempt to naturalize their own special place in history. Every ideology tries to give a quality of inevitability to what is a specific and disputable relation to the forces and relations of production. It represents its interests—for example, with regard to property, to what it is to be a man or a woman, to ways of living and dying—as coherent, natural, eternal. It takes as its material the real substance, the constraints and contradictions of a given historical situation—in this case, Northumbria between about 700 and about 850—and, in the way that it represents them, imagines and images those contradictions solved; imagines and images a particular order of things as validated; makes clear or obscures the differences between two concepts of nobility, two sexes, two liturgies, two kinds of property, two classes. The Ruthwell and Bewcastle monuments: two forms produced by and producing social life; each one *of* a particular class faction, confirming and contesting identities and gender ideals, and its relations with another class faction and other classes. If style is to be located between and within these monuments, it must be *seen* and understood *as* two historically and culturally specific forms of ideology.

Notes

I thank George Hardin Brown, Jane Hawkes, Joyce Hill, Catherine Karkov, Éamonn Ó Carragáin, Mary Swan, and Ian Wood for their comments on this essay or for providing me with references and materials.

1. See, for example, G. Baldwin Brown and A. Blyth Webster, "Report on the Ruthwell Cross with Some References to That at Bewcastle in

Cumberland," in *The Royal Commission on Ancient and Historical Monuments and Constructions of Scotland, Seventh Report with Inventory of the Monuments and Constructions in the County of Dumfries* (Edinburgh, 1920), appendix, 219–86. As far as Baldwin Brown is concerned, the Ruthwell and Bewcastle monuments are siblings (see 219). The latter is the "sister" of the former: "Though there are notable differences between them, the resemblances are so striking;" these "resemblances" are of "style and aesthetic quality." W. G. Collingwood, *Northumbrian Crosses of the Pre-Norman Age* (London, 1927), 112 also refers to the Bewcastle monument as the "sister" of the Ruthwell monument. He *sees* the two monuments *as* of the same school and, reminiscent of "classic Roman sculpture," *as* being in the same "'modern' style" (69–72).

2. Fritz Saxl, "The Ruthwell Cross," *JWCI* 6 (1943): 1–19 *sees* "[t]he Bewcastle Cross with its similar programme and figure types" *as* "obviously . . . closely related to the Ruthwell Cross" (7). However, when he takes "stylistic considerations" into account he thinks that "[t]he Bewcastle master has a style different from that of the Ruthwell Cross. His figures are long and square. Neither the figure of Christ nor that of the Baptist has the round and even bulging forms which characterize Ruthwell. The big fold of the garment, the central motif of the Ruthwell Baptist, is quite incompatible with the Bewcastle style" (8). But Saxl says that matters are more complicated than this for, as far as he is concerned, "two masters, whose styles were very different, worked at Ruthwell. One has a heavy manner, which alters the models radically; while the second, more elegant master's work is closer to the original" (14).

See also Rosemary Cramp, *Early Northumbrian Sculpture,* Jarrow Lecture (Jarrow, 1965), 11 who, though she does not agree with Saxl as to whence they derive, seems to follow him in *seeing* the "Ruthwell style" *as* made of "two tendencies." Interestingly, she *sees* the Ruthwell monument *as* more "homogeneous" than the Bewcastle monument: the latter being *seen as* "a puzzlingly eclectic monument" that "reflects the diversity of the models and motifs circulating on [*sic*] North Northumbria in the early eighth century" (8).

3. See Saxl, "The Ruthwell Cross," 8–10 where he argues that, because the "Bewcastle master" has a style different from that of the Ruthwell Cross, it does not follow that his earlier remark about the close relationship between the two monuments was wrong. "[G]reat differences of style may be found in illustrations of the same manuscript. Ruthwell may be nearer to the last phase of contemporary illumination, the phase of the Lindisfarne Gospels, than Bewcastle" (8). In other words, the two monuments evidence different phases of development within a style—one, the Bewcastle monument, less developed than the other, the Ruthwell monument.

See also Cramp, "Early Northumbrian Sculpture," 10, who, like Saxl, *sees* the Bewcastle and Ruthwell monuments *as* evidencing different phases of development or tendencies within the same style. Cramp takes the

"inhabited vinescroll" as a synecdoche of an individual style and in doing so *sees* some surviving fragments of decorative sculpture at Jarrow and Jedburgh *as* being in the same style as the Ruthwell and Bewcastle monuments (10). She arranges these survivals as "Bewcastle, Ruthwell, Jarrow, Jedburgh, in that order of stylisation" with the fragment at Jarrow *seen as* in "a style intermediate between" the Ruthwell monument and the surviving fragments of a cross from Rothbury. Cramp, strangely omitting the Bewcastle monument from her series, concludes that "one might see this as the Wearmouth/Jarrow style, and chronologically place the Jarrow friezes and Ruthwell near together in date in the eighth century with Jedburgh late eighth to early ninth, and Rothbury late ninth" (11).

4. Meyer Schapiro, "Style," in *Anthropology Today: An Encyclopedic Inventory*, ed. A. L. Kroeber (Chicago, 1953), 287–312; reprinted in Meyer Schapiro, *Theory and Philosophy of Art: Style, Artist, and Society*, vol. 4 of *Selected Papers* (New York, 1994).

5. Schapiro, "Style" (1953), 287.

6. See Alan Wallach, "Meyer Schapiro's Essay on Style: Falling into the Void," *The Journal of Aesthetics and Art Criticism* 55, no. 1 (winter 1997): 12.

7. Edward W. Said, *Beginnings: Intention and Method* (New York, 1975), 174.

8. Schapiro, "Style" (1953), 287.

9. For a critique of the search for origins and the reduction of the complexity proper to every beginning, see the discussions of "origin" in Michel Foucault, *The Archaeology of Knowledge* (1969), trans. A. M. Sheridan Smith (London, 1972). For a study of the importance of beginning and of establishing "beginnings," see Said, *Beginnings*. And for a consideration of these issues with reference to certain areas and canonical texts of Anglo-Saxon studies, see Allen J. Frantzen, *Desire for Origins: New Language, Old English, and Teaching the Tradition* (New Brunswick, N.J., 1990).

10. See Collingwood, *Northumbrian Crosses of the Pre-Norman Age*, preface, and chap. 1, "The Rude Stone Pillar," through chap. 5, "The School of Hexham," where the search for the origin of the tall stone cross is prosecuted. Collingwood's frustrated desire is palpable at the end of chap. 2: "But we have not yet found the origin of the ordinary type of stone cross, that with a rectangular section, or any link between the rough stone pillar of St Peter at Whithorn, and the fully developed Anglian monument. We must try back [*sic*] and consider a group which is usually thought to precede the tall crosses in historical development." It seems to me clear that Collingwood's search is for an object that insists on absolute recognition from him and yet is not independent of himself and his fantasy. Not

surprisingly, when he settles on the so-called Acca's Cross at Hexham, he is uncertain and doubtful: *"If* this cross was the first of its series, it plays the part to perfection, *except* for the wonder that it could have been made at the date (soon after 740) and in 'barbarous' Northumbria (see 30) [emphasis added]."

11. James Lang, "Recent Studies in the Pre-Conquest Sculpture of Northumbria," in *Studies in Medieval Sculpture*, ed. F. H. Thomson. Society of Antiquaries of London, occasional paper n.s., 3, (London, 1983), 177.

12. These remarks on style and stylistics are informed by Stanley Fish, "What Is Stylistics and Why Are They Saying Such Terrible Things about It?" in *Is There a Text in This Class? The Authority of Interpretive Communities* (Cambridge, 1980), 69–71.

13. Ibid., 93–95.

14. On seeing as a "'theory-laden' undertaking" see N. R. Hanson, *Patterns of Discovery: An Inquiry into the Conceptual Foundations of Science* (London, 1972), 5–30, excerpted as "Observation," in *Modernism, Criticism, Realism*, ed. Charles Harrison and Fred Orton (London, 1984), 69–83.

15. Hanson, "Observation," 75.

16. The so-called formalist art critic Michael Fried, "Three American Painters: Kenneth Noland, Jules Olitski, Frank Stella (1965)," in *Art and Objecthood: Essays and Reviews* (Chicago, 1998), 263 n. 15, made this point about Schapiro's definition and what it implied about the kind of modernist painting he valued: the work of the abstract expressionists, Morris Louis, Kenneth Noland, Jules Olitski, and Frank Stella. It seems to me that the point applies to the idea of style per se. Against Fried, I think that we should avoid the term "style" or, at the very least, avoid its uncritical use, in discussions not only of modernist painting and but also of Anglo-Saxon stone sculpture, manuscripts, ivories, metalwork, and so on. Fried's essay was originally published as an exhibition catalogue under the same title (Cambridge, Mass., Fogg Art Museum, 1965).

17. This discussion owes much to Nelson Goodman, "Seven Strictures on Similarity," in *Problems and Projects* (Indianapolis, 1972), 437–46, reprinted in Harrison and Orton, *Modernism, Criticism, Realism*, 85–92. See also Fred Orton, "Northumbrian Sculpture (the Ruthwell and Bewcastle Monuments): Questions of Difference," in *Northumbria's Golden Age*, ed. Jane Hawkes and Susan Mills (Stroud, 1999), 216–26; and idem., "Rethinking the Ruthwell and Bewcastle Monuments: Some Strictures on Similarity; Some Questions of History," in *Theorizing Anglo-Saxon Stone Sculpture*, ed. Catherine E. Karkov and Fred Orton (Morgantown, W. Va., 2003), pp. 65–92.

18. Rosemary Cramp in Richard N. Bailey and Rosemary Cramp, *Corpus of Anglo-Saxon Stone Sculpture*, vol. 2: *Cumberland, Westmorland, and Lancashire North-of-the-Sands* (Oxford, 1988), 72. (Hereafter *Corpus 2*.)

19. See Orton, "Northumbrian Sculpture," 219–20.

20. Ibid., 222. For more on Northumbria's appropriation of Rome and Roman resources, especially in regard to its stone sculpture, see John Mitchell's paper, "High Crosses, Monasticism, and Conversion in Anglo-Saxon England" (n.p., n.d.), and Jane Hawkes's essay in this volume. For something on the St. Peter's obelisk see Éamonn Ó Carragáin, "Between Annunciation and Visitation: Spiritual Birth and the Cycles of the Sun on the Ruthwell Cross: A Response to Fred Orton," in Karkov and Orton, *Theorizing Anglo-Saxon Stone Sculpture*, pp. 131–87.

21. Cramp in *Corpus 2*: 69.

22. See the full discussion in Fred Orton, "Rethinking the Ruthwell Monument: Fragments and Critique; Tradition and History; Tongues and Sockets," *Art History* 21, no. 1 (March 1998): 65–106 and the argument in Orton "Northumbrian Sculpture," 216–26.

23. What follows returns to and restates, uses, develops, and extends, but sometimes with less detail, my previous discussions of the differences between the Ruthwell and Bewcastle monuments in "Northumbrian Sculpture" and especially "Rethinking the Ruthwell and Bewcastle Monuments."

24. See, for example, Baldwin Brown and Webster, "Report on the Ruthwell Cross," 220; and Collingwood, *Northumbrian Crosses of the Pre-Norman Age*, 9.

25. Arthur Robert Green, *Sundials, Incised Dials or Mass-Clocks* (London, 1926), chap. 2 and "Anglo-Saxon Sundials," *The Antiquaries Journal* 7 (1927): 495–96. See also John R. Findlay, "The Construction and Use of Wheel Dials," *The Antiquaries Journal* 8 (1928): 134–38; and Charles K. Aked, "Bewcastle Cross," *Antiquarian Horology* 8 (1973): 501–5.

26. Cramp in *Corpus 2*: 66.

27. Given Anglo-Saxon Northumbria's interest in appropriating Rome for the representation of itself, it is not without interest that a fragment of what seems to be a duodecimal sundial from Vercovicium/Borcovicus (Housesteads) survives in the John Clayton collection at Chesters Museum; see BH131 CH248. E. A. Wallis Budge, who catalogued and exhibited Clayton's collection, was uncertain about the survival and therefore labeled it "Fragment from ?Sundial." Green, "Anglo-Saxon Sundials," 495 was more confident. As far as he was concerned there was no doubt that it was a dial. However, to my eye, the "part of a style-hole" that Green saw is not clearly visible. It is unfortunate that not more of the stone has survived. Despite this, it is difficult to see how the fragment, with its "five

deeply cut, wide lines radiating downwards, the extremities being contained in a circular line" (ibid.) reconstructs except as a sundial, and Green's confidence is probably justified. Also, as Green notes: "That it is Roman there seems no reason to doubt: its place of origin points to this, and the method of time-marking is distinctly Roman and was in constant use throughout the Empire. If this be accepted it follows that it is the oldest perpendicular dial which has so far been found in England" (ibid). The Bewcastle monument was set within a Roman fort, Fanum Codicii, that was connected by road and signal station to Banna (Birdoswald), about six miles to its southeast, and thence to Vercovicium, about eleven miles east. The duodecimal division of the dial on the Bewcastle monument may well be a knowing appropriation, perhaps from a survival in the area, of the Roman method of time-marking.

28. See, for example, Abbot Ceolfrith's letter, ca. A.D. 701, to Nechtan, king of the Picts, about the Roman Easter, in *Hist. eccles.* 5.21, p. 543: "Now the [vernal] equinox . . . usually falls on the twenty-first of March, as we can also prove by inspecting a sundial [*ut etiam ipsi horologica inspectione probamus*]." Colgrave and Mynors point out that "Though this letter is attributed to Ceolfrith there seems little doubt that it is Bede's free version of the original to which Bede probably also contributed" (*Hist. eccles.* p. 534 n. 1). It is possible, then, that this reference to the sundial may date from between 722 and 725, when Bede was working on *De temporum ratione* (The reckoning of time) or, shortly after, around 731, the year he completed his *Ecclesiastical History*. *De temporum ratione* is Bede's scientific masterpiece: it contains five chapters that are concerned with the sundial. See Bede, *The Reckoning of Time*, translated with introduction, notes, and commentary by Faith Wallis (Liverpool, 1999), chap. 30 with its remarks on examining the sundial (*horologica consideratione*) for ensuring that the equinox is correctly assigned to 21 March, and chaps. 31–33, and commentary, pp. 314–17, with their discussion of how the sundial measures time and why the length of the shadow cast by the gnomon varies at different times of the day and at different places. One thing that Bede's *De temporum ratione* and Ceolfrith's letter to Nechtan make clear is that, as Wallis puts it: "In short, Bede was familiar with sundials and expected his readers to be as well" (Bede, *Reckoning of Time*, 316). Whether sundials were common is another matter. My guess is that they were uncommon—objects of "scientific" curiosity, perhaps; ineffective novelties, probably.

For an interesting discussion of this and related topics, see Wesley Stevens *Bede's Scientific Achievement,* Jarrow Lecture (Jarrow, 1985).

Other pre-Conquest sundials in Northumbria include the one on the church at Escombe, County Durham, and those at Aldborough, Edston, Old Byland, and Weaverthorpe, all in Yorkshire.

29. See Robert B. K. Stevenson, "Aspects of Ambiguity in Crosses and Interlace," *Ulster Journal of Archaeology* 44/45 (1981–82): 1–27; and Jane Hawkes, "Symbolic Lives: The Visual Difference," in *The Anglo-Saxons*

from the Migration Period to the Eighth-Century: An Ethnographic Perspective, ed. John Hines, Centre for Interdisciplinary Research on Social Stress, San Marino (Woodbridge, 1997), 311–45, esp. 328–34.

30. See R. I. Page in *Corpus* 2: 61, 2: 63, 2: 65.

31. Page, *Corpus* 2: 61, 2: 63, 2: 65.

32. See Patrick J. Geary, *Phantoms of Remembrance: Memory and Oblivion at the End of the First Millennium* (Princeton, 1994), especially the discussion of family memory, *genealogia*, and liturgical *memoria* in chap. 2, "Men, Women, and Family Memory." Liturgical *memoria* would have been celebrated on the death-day and/or on certain festival days in accordance with the practices of a particular monastic institution. Bewcastle need not have been a monastic site for the Bewcastle monument to have been the site of liturgical *memoria*.

Éamonn Ó Carragáin, "A Liturgical Interpretation of the Bewcastle Cross," in *Medieval Literature and Antiquities: Studies in Honor of Basil Cottle*, ed. Myra Stokes and T. Burton (Woodbridge and Wolfeboro, 1987), 15–42, and Catherine Karkov, "The Bewcastle Cross: Some Iconographic Problems," in *The Insular Tradition*, ed. Catherine E. Karkov, Robert T. Farrell, Michael Ryan (Albany, 1997), come close to touching on these issues. Ó Carragáin suggests that "[t]he 'kynibur*g' inscription, the lost inscriptions on the south face, and the names which seem once to have been inscribed on the panel on the west face, taken together, may indicate that for its original designers their 'sigbecn' was considered . . . a form of *liber vitae* (book of life), recording the most important benefactors and members of a community in such a way as to encourage prayers for their souls" ("A Liturgial Interpretation," 32). And Karkov notes the monument's "dynastic or genealogical" purport and that it could have functioned as a "Book of the Dead [= *liber vitae?*], on which a royal lineage has been recorded" ("The Bewcastle Cross," 21). However, it might be that we can amend these observations. The inscription seems unable to carry the weight of a *liber vitae*. See the rich detail in Elizabeth Briggs, "Religion, Society, and Politics, and the *Liber Vitae* of Durham" (Ph.D. diss., University of Leeds, 1987), especially chap. 2:1, "The Development of '*Libri Vitae*' and Their Place in the Liturgy," 38–62. *Libri vitae* developed as part of the practice, uncertain in its beginnings, of reciting the names of individuals, living or dead, during the Mass. The practice of reciting the names of the dead was established in the Celtic and Roman churches by the seventh century, but *what* dead and *where* in the Mass differed or are not altogether clear even in the Roman rite with its different liturgies for weekdays and Sundays. (In Rome, the recital of names of the dead did not become part of the Sunday Mass until the ninth century or later.) To theorize the inscription on the Bewcastle monument as a *liber vitae* is to give it a specific liturgical function in the Mass. As an inscribed material object, the *liber vitae* developed from the diptych. Evidently the oldest

manuscript *liber vitae* extant is that of Salzburg begun in 784, the last year of the episcopate of Virgilius, the Irish bishop and abbot of Salzburg, and it may be that until then diptychs were in use rather than parchment codices. If so, the *liber vitae* of Durham, the product of St. Cuthbert's community, begun about 800 (and with a likely terminus ad quem of 875), would have been, as it were, "bang up-to-date." The inscription on the Bewcastle monument, dated by Page between about 650 and about 850—see Page, *An Introduction to English Runes* (London, 1973); idem, "Language and Dating in Old English Inscriptions" (1959); and idem, "The Bewcastle Cross" (1960), both in R. I. Page, *Runes and Runic Inscriptions: Collected Essays in Anglo-Saxon and Viking Runes* (Woodbridge, 1995)—has neither the structure nor form of a diptych, nor of any *liber vitae*, up-to-date or otherwise, and is probably best theorized as a more or less straightforward commemorative inscription put on a physical *memoria*—inscription and monument being just the kind of "tool for remembering" (Geary, *Phantoms,* p. 124–28) that Geary has described as providing "documentary continuity in the place of lived memory" (ibid., p. 127).

33. For an extended discussion on behalf of the secular identity of this figure, see Catherine Karkov, "The Bewcastle Cross."

34. See Richard N. Bailey, *Viking Age Sculpture* (London, 1980) and *England's Earliest Sculptors* (Toronto, 1996), 76.

35. I. N. Wood, "Anglo-Saxon Otley: An Archiepiscopal Estate and Its Crosses in a Northumbrian Context," *Northern History* 23 (1987): 20–38.

36. Ibid., 25–6 citing Bede's letter to Ecgbert, *Epistola ad Ecgbertum episcopum*, ed. C. Plummer, *Baedae Opera Historica*, vol. 1 (Oxford, 1896), chaps. 11–14.

37. Wood, "Anglo-Saxon Otley," cites the statement in the *Hodoeporicon* of St. Willibald, trans. C. H. Talbot, in *The Anglo-Saxon Missionaries in Germany* (London, 1954), 154–55 to the effect that Saxon aristocrats erected crosses on their estates as places of prayer. See also C. R. Dodwell, *Anglo-Saxon Art: A New Perspective* (Ithaca, 1982), 111–12.

38. See Barry Barnes, *Interests and the Growth of Knowledge* (London, 1997), 5–6.

39. *Guman* and *dryctin* have their places in the Ruthwell verses as reasonable guesses made, with one eye on what is in the Vercelli Book's *Dream of the Rood*, by David R. Howlett, "A Reconstruction of the Ruthwell Crucifixion Poem," *Studia Neophilologica. A Journal of Germanic and Romance Languages and Literature* 48, no. 1 (1976): 54–58.

40. The image of the two embracing women on the south side of the Ruthwell monument's upper stone is usually theorized as representing *either* Martha and Mary of Bethany *or* the Virgin Mary and her cousin

Elizabeth at the Visitation with the surviving inscription completed as "Martha and Mary meritorious ladies" or, reading the inscription as making an error by confusing Martha with Elizabeth, as "Martha and Mary Mother of the Lord." On behalf of Martha and Mary, see David R. Howlett, "Two Panels on the Ruthwell Cross," *JWCI* 37 (1974): 334; idem, "Inscriptions and Design of the Ruthwell Cross," in *The Ruthwell Cross*, ed. Brendan Cassidy (Princeton, 1992), 73–74; and Paul Meyvaert, "A New Perspective on the Ruthwell Cross: Ecclesia and Vita Monastica," in *Ruthwell Cross*, 138–40. On behalf of the Visitation, see K. E. Haney, "The Christ on the Beasts Panel on the Ruthwell Cross," *ASE* 9 (1985): 228; Robert T. Farrell, "Reflections on the Iconography of the Ruthwell and Bewcastle Crosses," in *Sources of Anglo-Saxon Culture*, ed. Paul E. Szarmach with V. D. Oggins (Kalamazoo, 1986), 365–68; Éamonn Ó Carragáin, "The Ruthwell Crucifixion Poem and Its Iconographic and Liturgical Significance," *Peritia* 6–7 (1987–88): 39–40; idem, "Seeing, Reading, Singing the Ruthwell Cross: Vernacular Poetry, Roman Liturgy, Implied Audience," in *Art and Symbolism*, Medieval Europe 1992, Preprinted Papers (York, 1992), 92–94; and, idem, "The Necessary Distance: *Imitatio Romae* and the Ruthwell Cross," in Hawkes and Mills, *Northumbria's Golden Age*, 196–97, Ó Carragáin argues that "*if* [emphasis added] indeed the name Martha does appear on the Ruthwell Visitation panel" the reference is best understood in a relation of contiguous association to the Visitation by way of the feast of the Dormition or Assumption of the Virgin, one of four new Marian feasts that entered the Roman liturgy in the latter half of the seventh century, and the lection, taken from the story of Martha and Mary, Luke 10:38–42. So much for the *either/or* approach to the image and its inscription as it has been reconstructed. However, we need not stick with it. Rather, we might try to think further the suggestion of Carol Farr, "Worthy Women on the Ruthwell Cross: Woman as Sign in Early Anglo-Saxon Monasticism," in Karkov, Farrell, and Ryan, *Insular Tradition*, 49 who accepts that the inscription reads "Martha and Mary meritorious (= worthy) ladies" and that the image represents Martha and Mary, but Martha and Mary modeled upon an image of the Visitation, thus "creating a resonance with the story in which the Virgin recites the canticle, the *Magnificat*. Such a visual reference to the Visitation in conjunction with the *merentes dominae* title could have modified the significance of Martha and Mary to represent women of high status who are meritorious in the Christian sense, in a way that would be especially relevant to the ongoing process of Christianization in Anglo-Saxon society." With Barnes's *Interests and the Growth of Knowledge*, 5–6, in mind, we can see that Farr's theory accords well with how representations or images actually get made. It might be that the intention of whoever produced the Ruthwell monument's upper stone was to make an image of Martha and Mary of Bethany, an unusual subject at the time, for which there were no—or no known—established pictorial conventions in Northumbria. A resource was available, however, in images of the Visitation; and one or more of these could have been appropriated and

adapted to make the image of Martha and Mary. If so, their image, like all pictorial images, would be made of multiple images. And as sometimes happens, in this case the appropriated and adapted model was perhaps not thoroughly integrated within the image it had resourced, and so disrupted or entered into a dialogue with that image's intended meaning. That is to say that unintentionally, the sign of the Virgin Mary and Elizabeth at the Visitation resonates within the sign Martha and Mary of Bethany. The accompanying inscription seems to identify the characters as Martha and Mary, but if so, it creates one more anomaly on a monument possessing several anomalies, because it breaks with the pattern established on the south side of the lower stone by not quoting from scripture and follows the pattern on the north side, where the inscriptions identify the characters and clarify the actions represented in the accompanying images (Orton, "Rethinking the Ruthwell Monument," 65–84). But, if the inscription was intended to follow the pattern on the north side and the image was intended to be seen and understood not as Martha and Mary but as the Visitation, the inscription is still anomalous, because it neither identifies the characters nor clarifies their actions. However, we should not rule out the possibility that the image and its accompanying text were intended to effect both meanings or, if unintended, that they were welcomed because they did so. It might be that we are faced with a knowing ambiguity beyond the seventh type: a pictorial and linguistic sign that is almost *neither* Martha and Mary *nor* the Visitation but *both* Martha and Mary *and* the Visitation.

41. For an alternative reading, see Éamonn Ó Carragáin, "Liturgical Innovations Associated with Pope Sergius and the Iconography of the Ruthwell and Bewcastle Crosses," in *Bede and Anglo-Saxon England: Papers in Honour of the 1300th Anniversary of the Birth of Bede, Given at Cornell University in 1973 and 1974*, ed. Robert T. Farrell, BAR (Oxford, 1978), 131–47; idem "Crucifixion as Annunciation: The Relation of the 'Dream of the Rood' to the Liturgy Reconsidered," *English Studies* 63, no. 6 (1982): 487–505; and thereafter, for the first of many refinements, idem "The Ruthwell Crucifixion Poem." Ó Carragáin argues: (1) that the Annunciation and Crucifixion panels "are best understood in relation to the introduction into Northumbrian liturgical practice of the feast of the annunciation on 25 March, the anniversary of the crucifixion"; (2) and with reference to lines 90–94 in the Vercelli Book's *Dream of the Rood* (dated on palaeographic evidence to the late tenth century) where the rood compares itself, "honoured . . . over [all other] hill-trees," to Mary "honoured . . . over all the race of women," that in the Ruthwell verses (between about 700 and about 850) the rood "dramatize[s] its experience of the crucifixion in terms of Mary's uncomprehending obedience at the annunciation." Ó Carragáin's explanation of the Ruthwell monument's Annunciation and Crucifixion panels is one whereby, in the context of the liturgy of the Marian feast of the Annunciation, the Crucifixion and Annunciation are inextricably linked.

His explanation of the meaning of the Ruthwell monument's verses is based on the argument that, in *The Dream of the Rood*, the rood *sees* itself *as* similar to Mary and that, in the Ruthwell verses, the rood reacts as Mary reacted at the Annunciation: it is "troubled yet obedient." The Annunciation brings to mind the Crucifixion, and vice versa; both rood and Mary are bearers of Christ. For a critique of Ó Carragáin's reading, see Orton, "Rethinking the Ruthwell and Bewcastle Monuments."

42. Roberta Gilchrist, *Gender and Material Culture: The Archaeology of Religious Women* (London, 1994), on the social construction of gender in mainly later medieval monasticism, especially in chap. 5, "The Meanings of Nunnery Architecture," strikes me as possibly useful for theorizing "Cyneburh" on the Bewcastle monument's north side. Gilchrist notes that a significant number of nunneries in England and Wales situated the cloister, in deviation from the standard monastic plan, to the north of the church, and puzzles the ways in which that position or place might be linked to consideration of gender. Amongst other things, she points out that the north was associated with the characteristics of the night, cold, and the moon, the south with the day, warmth, and the sun (and, one might add, sundials); that the north side of the church was given over to Old Testament symbolism, the south to New Testament symbolism; that Alcuin, *De officiis liber* 3.2, considered the proper positioning of men and women for the reception of the Eucharist to have "men in the southern part, women in the northern part"; and that thinking of the church as a metaphor for the body of Christ would place women at God's right hand. She also argues that the north cloister orientation is associated with the tradition of double houses, the royal lineage of their abbess founders, and the thematics of Saxon royal female piety. Of course, some names in the main inscription on the west side of the Bewcastle monument may well be lost to us, but given that masculinity and femininity are socially constructed and historically specific, it might well be that its north side is gendered in the feminine—which is not to say that all Anglo-Saxon monuments would have been so gendered.

See also Catherine Karkov, "Whitby, Jarrow, and the Commemoration of Death in Northumbria," in Hawkes and Mills, *Northumbria's Golden Age*, 135 n. 5; and idem "Naming and Renaming" in Karkov and Orton, *Theorizing Anglo-Saxon Stone Sculpture*.

43. See Geary, *Phantoms of Remembrance*, chap. 2, "Men, Women, and Family Memory," Though Geary's study does not pertain directly to Northumbria between about 700 and about 850, it presents much material that seems relevant to puzzling the Bewcastle monument, especially with regard to the role of women in remembering, preserving, transmitting, structuring, and molding the past for families, regions, and institutions. In the areas studied by Geary, and perhaps in Northumbria also, remembrance of the dead was the responsibility of "women within the kindred and monks without." Women were responsible for the preservation of fam-

ily memory, for ensuring that the names of their dead menfolk were kept alive by mourning, fasting, paying penance, undertaking charitable acts such as making donations to monasteries, by keeping and protecting the family necrology, and, by making the necessary arrangements with some monastery, ensuring the celebration of liturgical *memoria*. See also Karkov, "Whitby, Jarrow, and the Commemoration of Death."

44. See the discussions of "consanguinity" and "kinship" and of the ways in which the assimilation of Roman Christianity effected a gender-specific identity for Anglo-Saxon aristocratic women in Stephanie Hollis, *Anglo-Saxon Women and the Church: Sharing a Common Fate* (Woodbridge, 1992).

45. This definition owes more or less everything to T. J. Clark's "Preliminary Arguments: Work of Art and Ideology," a discussion paper for the College Art Association session on Marxism and art history (Chicago, 1976). Though it is not to be found in Marx's own writing, it is nevertheless defensible and, in this context, useful for going on.

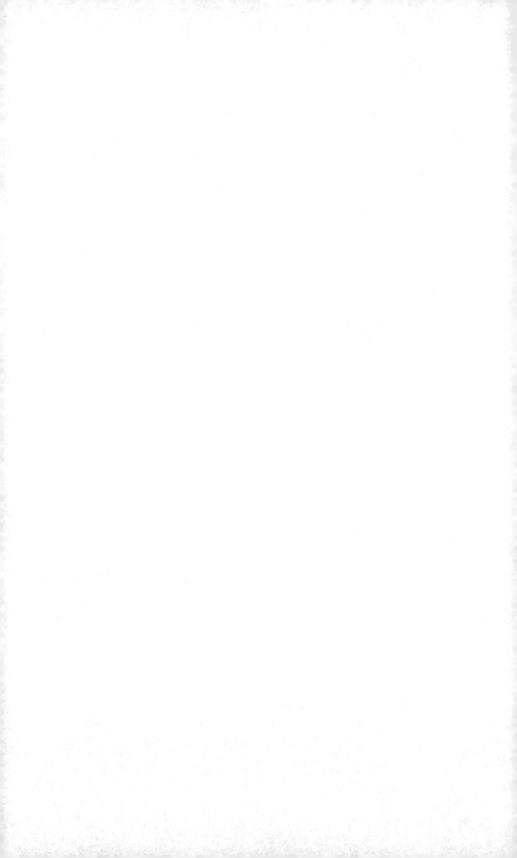

3

Iuxta Morem Romanorum:
Stone and Sculpture in Anglo-Saxon England

Jane Hawkes

"And I say also unto thee, That thou art Peter, and
upon this rock I will build my church"

—Matt. 16:18

For those who study the material culture of the Church in Anglo-
Saxon England it is almost an article of faith that the art of work-
ing in stone (be it building or carving) was reintroduced into the
region by the Christian Church during the course of the seventh
century.[1] The documentary and archaeological evidence for the
ecclesiastical conditions of the reintroduction of the skills of the
mason and sculptor, largely lost in the centuries following the dis-
integration of the Roman Empire, are generally well rehearsed in
the scholarly literature and can be clearly charted from the earliest
phases of Christian activity.

Church and Stone

When the mission headed by Augustine arrived in Kent from Rome
in 597, for instance, it was the renovated remains of the Romano-
British stone church of St. Martin, just to the east of Canterbury,
that were used initially as the place of worship. By 619, a new
stone church (dedicated to Peter and Paul) had been built nearby
from reused Roman material to serve the monastic community.
This was supplemented by the addition of stone churches dedicated

to Mary, the Mother of God (in ca. 620), and St. Pancras, buildings that again incorporated Roman material into their fabric. Within the city walls of Canterbury itself, yet another Romano-British stone church was repaired under the auspices of Augustine and dedicated to the Holy Savior (possibly on the site now occupied by Christchurch Cathedral), and Coronati Quattuor, a new stone church dedicated to the Four Crowned Martyrs, was also subsequently built. Later in the seventh century, in 669, a member of the Canterbury community, Bassa, had a stone church built nine miles away within the confines of the Roman shore fort at Reculver (fig. 1).[2]

In the North, Edwin of Northumbria, "under the instructions of Paulinus," another member of the Canterbury mission, is credited with instigating the earliest stone-building works—at York. Here, "soon after his baptism" in 627, he replaced a wooden (bap-

ERODED BY SEA

Figure 1. Outline drawing showing siting of Anglo-Saxon church within the Roman shore fort of Regulbium at Reculver, Kent (Jane Hawkes)

tismal) church with "a greater and more magnificent church of stone." Soon after this, of course (in 633), Edwin died in battle at Hæthfelth (Hatfield Chase), Paulinus fled south with the queen and the royal children, and the church at York was allowed to fall into disrepair.[3] Some forty years later, in 669, "the ridge of the roof, owing to its age, let the water through; the windows were unglazed and the birds flew in and out, building their nests, while the neglected walls were disgusting to behold owing to all the filth caused by the rain and the birds."[4] Observing this, Wilfrid, then bishop of Lindisfarne, decided to restore it. Beforehand, however, he had begun building with stone at Ripon. Established as abbot in 660, he commenced in 665 to replace the wooden church that had been serving the community there with "a church of dressed stone, supported by various columns and side aisles." At about the time this structure was completed, Wilfrid began work on his third major stone-building project: the abbey church at Hexham, which, between 672 and 678, was built of "wonderfully dressed stone."[5]

Elsewhere in the North, Benedict Biscop, who had accompanied Wilfrid on his first trip to Rome in 652, undertook similar works, first at Wearmouth in 674, where he began building "a stone church in the Roman style he had always loved," and then at Jarrow, where the church dedicated to St. Paul was founded in 682.[6]

Clearly, the introduction of stonework in Anglo-Saxon England was closely linked to the physical establishment of the institution of the Church in the region during the seventh century. As such, the association of Church and stone is a well-established and long-recognized topos in scholarly discussions of the early Church in Anglo-Saxon England. Indeed, the archaeological concentration on the impact of Continental European stone church designs on the development of stone churches in Anglo-Saxon contexts has been almost exclusively determined by this premise.

Nevertheless, despite the documented activities of certain ecclesiastics involved in such projects, it remains the case that the use of stone for the construction of churches remained a relatively unusual phenomenon in the "pre-Viking" period. Even when the vagaries of survival and economic and logistical considerations are taken into account, wooden churches seem always to have been more numerous than stone ones.[7] This "relative" use of stone suggests, therefore, that where stone was used it was employed with some considerable deliberation. In fact, the circumstances in which the stone building-programs were carried out imply that it was not simply "the Church" with which stone in Anglo-Saxon England was

so closely associated. Rather, it seems that stone was being identified and actively employed as a visible expression of the physical establishment of the Church of Rome.

Stone and Rome: The Churches

Initially, in Kent, it was the members of the papal Roman mission, Augustine and then Bassa, who are recorded as having erected stone churches, while Edwin's church at York was constructed under the guidance of Paulinus, a member of that same mission, and moreover, the first recipient of the *pallium* for York, the metropolitan intended by Gregory as an ecclesiastical reclamation of the earlier Roman centers of civil authority in the North.[8]

It is, therefore, probably no coincidence that these initial stone churches were raised in spaces clearly defined and perceived as part of earlier centers of imperial Roman activity: the ruins of the cantonal capital Durovernum Cantiacorum (Canterbury), the deserted shore fort of Regulbium (Reculver), and the Roman fort by the provincial capital of Eburacum.[9] While the early mission's re-use of Roman structures and building fabric at Canterbury could be viewed as actions undertaken in the spirit of necessity, rather than being vested with any hint of symbolic significance, the siting of the church at Reculver in the center of the Roman fort (fig. 1) and the establishment of Edwin and Paulinus's church within Eburacum are less easy to ascribe to the demands of exigency. The siting of these early ecclesiastical stone structures and the circumstances surrounding their foundation suggest that "Rome" was being consciously and deliberately reclaimed, and in the process redefined, by the early Roman missions to the Anglo-Saxons. Indeed, the fact that Constantine himself had been proclaimed Caesar in York in 306 may well have contributed to Gregory and Paulinus's selection of the site as the center of their activities in the North.[10]

Whether this was indeed the case, the self-conscious nature of these acts of appropriation and rearticulation involving stone is clearly expressed in the building at Canterbury of Coronati Quattuor, the one stone church apparently built (rather than "renovated") by the papal mission within the walls of the Romano-British city. As with the dedication of the monastic church of SS. Peter and Paul, and the cathedral church of Holy Savior (this being the original dedication of the cathedral church of Rome established on the Lateran Hill), that of Coronati Quattuor was undoubtedly intended

to preserve associations with Rome; the Roman church of the Coronati Quattuor was converted from a fourth-century *titulus* on the Coelian Hill by Hadrian I at the turn of the seventh century when the relics of the four martyrs in question were brought to Rome and installed there.[11] More significant, however, is the fact that the martyrs commemorated by these dedications (at Rome and Canterbury) were understood to be stonemasons who had suffered under the Diocletian persecutions of the early fourth century. A new stone church dedicated to martyred stonemasons (an extremely rare, if not unique, dedication outside Rome at this time), set up within the confines of the Romano-British cantonal capital at Canterbury, would, in all likelihood, have been understood as a highly symbolic construct with a significance that was more than just "seemingly appropriate."[12] Its situation, dedication, and appearance were together intended to reclaim and redefine imperial Rome for the services of the new Rome, founded on Christ and his martyrs, that was being physically and permanently established in an Anglo-Saxon setting.

With the later documented phases of seventh-century stone church-building (those undertaken by Wilfrid and Benedict Biscop), the same equation, between "Stone and Rome," is also discernible, although in these cases it is not necessarily expressed in terms of strict geographical location and associated imperial "historical" significance. Wilfrid's church at Ripon, for instance, was constructed to serve a monastic center that had previously been under the aegis of monks from Melrose, and so had been part of the Iona-Columba community. It was their refusal to conform to the practices of the Roman Church, favored by their royal patron Alhfrith, that led to their "surrender" of the foundation and the subsequent installation of Wilfrid in 660.[13] His stone church at Ripon thus replaced a wooden building that had served a previous, specifically Columban, community.

Furthermore, his work on this church was not started until 665, five years after he had been established as abbot. In the intervening period a number of not insignificant events had occurred: in 663/4, under the auspices of Alhfrith, he had been consecrated priest by Agilbert, the Frankish bishop of the West Saxons; in 664, he had been selected by Agilbert and Alhfrith to speak for the *Romani* at the Synod of Whitby, and thus had been instrumental in the synod's decision to set aside the practices of the Columban Church in favor of Roman orthodoxy; immediately following the synod he had been appointed bishop of Lindisfarne, and confirmed in that

appointment at his consecration in Gaul by no fewer than twelve "catholic" bishops (as opposed to the "Quartodecimans like the Britons and Scots"). Despite this remarkable validation of his election, however, Wilfrid's consecration had been ignored by Oswiu, and he had returned to Northumbria to discover that he had been replaced by Chad as bishop of Lindisfarne. It was at exactly this point, during his appeal to Rome against Chad's appointment, and while forming alliances with the secular and ecclesiastical powers of Mercia and Kent, that Wilfrid began his stone building work at Ripon.[14]

Thus the circumstances of Wilfrid's building programs at Ripon, Hexham, and York suggest his choice of stone was integral to his somewhat grandiose and deliberate program of Romanizing the Northumbrian Church. When the building at Ripon was completed, in 672, the dedication ceremony was clearly designed to celebrate the triumph of Roman "orthodoxy" in a very material and highly visible manner. For the occasion Wilfrid commissioned an illuminated gospel manuscript written in gold on purple-dyed parchment ("Nam quattuor evangelia de auro purissimo in membranis depurpuratis, coloratis, pro animae suae remedio scribere iussit"), a product redolent of imperial manuscript manufacturing traditions, and strikingly so, as most extant Northumbrian manuscripts of the time are notably lacking in gold and written on whitened parchment.[15] Before the assembled dignitaries, both ecclesiastical and secular, royal and aristocratic, and with this imperial-looking manuscript presumably displayed on the altar, itself dressed in imperial purple cloth woven with gold and silver ("auro et argento purpuraque varia mirifice decoravit"), Wilfrid, the newly confirmed bishop of Lindisfarne, read out a list of the lands donated to the monastery.[16] He would appear to have been stating his case in somewhat less than subtle terms, and the church in which this entire display was staged must have been regarded as integral to that statement. It stood as the highly visible new stone center of the monastery rejected by the "Columban" community and now permanently established in the name of St. Peter, the rock on which the Church (of Rome) was founded.

With Hexham, a similarly significant statement was made: its stone columns, aisles, passages, staircases, and crypts made this church, according to Wilfrid's biographer, "the finest church north of the Alps" (i.e., outside Italy): "My feeble tongue will not permit me to enlarge here upon the depths of the foundations in the earth, and its crypts of wonderfully dressed stone, and the manifold building above ground, supported by various columns and many side

aisles, and adorned with walls of notable length and height, sur-
rounded by various winding passages with spiral stairs leading up
and down."[17] The establishment of this abbey church as a cathedral
in 681, less than ten years after its completion, was presumably
not an entirely inappropriate elevation in status. Five centuries
later, William of Malmesbury was to declare that even in the twelfth
century it was still possible to see at Hexham all the glories of
Rome, and that to achieve this wonder Wilfrid had employed ma-
sons from Rome itself.[18]

At Wearmouth and Jarrow the stone churches built by Benedict
Biscop were also perceived by their patron as "Roman" constructs,
and his deliberate act of *imitatio*—in the design of his churches
and the liturgy celebrated within them—has occasioned much aca-
demic debate. For Bede, however, it was the simple fact that these
ecclesiastical foundations were built in stone that determined their
"Roman-ness." Constructed in this medium they stood in stark
contrast to the church at Lindisfarne that, despite being the seat
of an episcopal see, was fabricated *more Scotorum* (in the "style" of
the Scots)—that is, not of stone in the Roman style *(iuxta morem
Romanorum)*, "but of hewn oak" thatched with reeds.[19]

Visually, the Roman nature of Benedict's churches and monas-
tic buildings would have been clear. Their long, narrow dimensions,
and high-set round-headed windows clearly mirrored those of
churches in Rome, such as Sta. Maria in Cosmedin,[20] while the
opus sectile work of their floors was a decorative feature long
identified with prestigious buildings associated with Rome and its
imperial past. In addition, the covered walkway at Wearmouth,
which seems to have linked the church of St. Peter with the monas-
tic complex to the south, has been recently interpreted by Ó
Carragáin as replicating the covered walkway in Rome that had
been set up by Constantine to shelter pilgrims moving between the
city walls and the memorial church of St. Peter's, while the porticus
of both the Jarrow and Wearmouth churches (as well as those at
Canterbury and Reculver) may also have been regarded as repli-
cating the "Porticus" of Old St. Peter's. Furthermore, the paintings
hung in the church at Wearmouth were imported from Rome, and
to complete the set the choirmaster employed at Wearmouth-Jarrow
was John, precentor of St. Peter's and abbot and archcantor of St.
Martin's in Rome.[21]

While the surviving stone structures erected and used in this
manner by Wilfrid and Benedict Biscop in the latter half of the
seventh century pale into insignificance when compared with the

contemporary churches of Rome and the grandiose "romanesque" structures of the later Middle Ages, it is hard to overestimate their impact in terms of their Anglo-Saxon setting. Being multistoreyed and built of stone they would have stood out impressively, dominating a landscape of settlements composed largely of single-storeyed structures of wood, thatch, wattle, and daub, in which the only other surviving stone structures were the visible ruins of the late Roman world.[22] To contemporary viewers just the appearance of the new stone churches would have sufficed to create an impression of "Rome" rebuilt in Anglo-Saxon England. The documentary accounts of the circumstances underlying their construction, design, and decoration, as such matters were understood by contemporary commentators, indicate that those associations were not merely coincidental. Whether in Kent or Northumbria, the early works in stone were evidently self-conscious and deliberate constructs intended to symbolize, in very real terms, the transplanting of the Church of Rome into the region.

Stone and Rome: The Monuments

Stone churches were not, of course, the only stone constructs in the landscape of seventh- to ninth-century Anglo-Saxon England. There were others: namely, the large-scale public freestanding stone monuments. Unlike with the stone churches, however, there is a resounding silence in the contemporary literature regarding the circumstances of their raising. No documentary accounts survive that allow for reconstructions of the contemporary perceptions and motives involved in their erection.[23] There are, nevertheless, a number of factors related to the Anglo-Saxon stone monuments that suggest the association of "Stone and Church" and the equation of "Stone with Rome," so definitive of the stone church-building projects, were also regarded as relevant to this sphere of activity.

In the first place, of course, the Anglo-Saxon stone monuments of the pre-Viking, "Anglian" period were primarily (if not exclusively) ecclesiastical products, emerging from the same cultural context as the stone buildings. The situation, decoration, and (where present) epigraphy of the large-scale grave-markers (such as that of the priest Herebericht from Wearmouth), the relatively small memorial crosses of Whitby, and the more monumental freestanding columns, shafts, and crosses (such as those at Masham, Yks., Bewcastle, Cu., and Rothbury, Nthd.) clearly indicate the generally

ecclesiastical (if not strictly "monastic") context of carved stone in the pre-Viking period. Furthermore, the appearance of these monuments, being highly visible, constructed of stone, probably brightly colored, and inset with paste glass and metal fittings, indicates that they were, at a very immediate level, intended to impress those who encountered them—whether that encounter occurred within the environs of a stone-built ecclesiastical complex, as at Wearmouth or Whitby, or in the (apparently) more open landscape, as perhaps, at Bewcastle.[24]

A more implicit factor is the very selection of stone as a medium for constructing these prominent public monuments. The number of monuments surviving from the "Anglian" period is far outweighed by those extant from the subsequent "Viking" and "Benedictine Reform" and "Late Saxon" period(s) of the tenth to mid-eleventh centuries. Of the roughly 400 pieces of nonarchitectural carved stones surviving in the region north of the Tees, only 120 are associated with "Anglian" contexts, while over 260 have been assigned to the "Viking" period. Of these, the vast majority of "Anglian" pieces (about 90 of the 120) survive from just six of the twenty-eight sites at which such stones are preserved (at Lindisfarne, Norham, Hartlepool, Hexham, Wearmouth, and Jarrow). By contrast, "Viking age" pieces have survived from some forty-eight sites. Thus, even when issues such as the rates of survival, logistics, and economics are taken into consideration, it seems that the production of stone monuments between the seventh and ninth centuries was never a popular or widespread activity. Furthermore, figural sculpture was an even rarer phenomenon: of the 120 "Anglian" monuments surviving from the North Tees area, only 7 were decorated with figural images. This implies that, as was the case with the selection of stone for churches, the production of carved stone monuments, and particularly figural sculpture, was a deliberate and considered undertaking during the "Anglian" period, a factor that can only have enhanced the impressive nature of their appearance.[25]

Taking this line of observation further, it is possible to hypothesize, from the type, siting, decoration, and iconography of some of the monuments, that in many cases the considerations underlying their erection involved a conscious association with the Church of Rome and that, as part of that process, the material culture of late imperial Rome was being deliberately invoked.

The types of some of the Anglo-Saxon monuments, for instance, seem to recall those prevalent in the late imperial world that may

have survived in the Roman ruins of the Anglo-Saxon landscape, and would certainly have been visible to those who traveled through Gaul and Italy to Rome. The cylindrical shape of the ninth-century monuments that once stood at Reculver (Kent) and Dewsbury (Yks.), and those that still stand at Masham (Yks.; fig. 2) and Wolver-hampton (W. Midlands), with their decoration arranged in horizon-

Figure 2. The ninth-century Anglo-Saxon column at Masham, Yorkshire (Photo: Jane Hawkes)

tal registers running the full length of the column, were, in all probability, intended to replicate the triumphal monumental *columna* of the Roman world. The most famously evident of these is, of course, Trajan's column in Rome itself, but triumphal columns had also been set up in Britannia: at Noviomagus Regnensium (Chichester, Sussex), Corinium Dobunnorum (Cirencester, Gloucs.), Cataractonium (Catterick), and Eburacum (York, Yks.).[26]

The Reculver and Dewsbury columns survive only in fragments, and that at Wolverhampton displays no figural ornament in its repertoire, but the decoration of the Masham column indicates that associations with the late imperial world were not limited to the form of the monument; they were also expressed iconographically (fig. 2). As I have argued elsewhere, the extant images on this column comprise a series of scenes intended to signify the triumph of Christ's victory over death: Samson, as a type of Christ's Harrowing of Hell and Resurrection, carries away the gates of Gaza; David, as a type of Christ's saving victory over death, overcomes the lion; and at the top of the column (as it now survives), Christ, as a latter-day emperor surrounded by his courtiers, sits enthroned and flanked by his disciples, a scheme that iconographically expresses the establishment of Christ's church on earth. Derived ultimately from imperial aulic art, the scheme was well established in the Christian repertoire by the ninth century.[27] Its inclusion at Masham in the context of a distinctive stone monument that also looks back to imperial prototypes could have served to emphasize that derivation. Where the imperial *columna* displayed images recording the triumph of Roman emperors over their enemies and celebrated the establishment of their rule, the Masham column depicts the triumph of the heavenly ruler over Death and the establishment of his Apostolic Church—with the sacraments of that institution signified by the peacocks flanking the chalice.[28]

A more common type of stone monument set up in the Anglo-Saxon landscape was the tapering squared form of the freestanding cross-shaft. There has been much speculation on the inspiration lying behind this distinctive form—primarily as an amalgam of the Columban tradition of erecting wooden crosses that was introduced to the region in the early decades of the seventh century and the techniques developed in the production of carved architectural stonework under the influence of Continental traditions. The impact of the metalwork altar and processional crosses on the form and decoration of the stone cross has also been examined, while the potential role of stone monument forms encountered in Rome (namely, the

obelisk) has been invoked in more recent discussions.[29] As with triumphal *columna*, obelisks "acquired" in Egypt were erected in the Roman world as symbols of imperial triumph. Most notable of these in the early Christian world was that which now stands in the forecourt of St. Peter's in Rome, but which, until 1587, stood to the southwest of the church. This distinctive monument would have been encountered by any visitor to St. Peter's in the seventh and eighth centuries, and its association with the most prestigious church in the Christian West would have been inescapable. It is not impossible, therefore, that the form of the obelisk, which at St. Peter's formed a physical presence linking the old imperial world with the new imperium of Christ, could have played a part in the formulation of the tall tapering stone monuments, square in section, that were surmounted by cross-heads and set up in the Anglo-Saxon landscape during the eighth century.[30]

Whether this was indeed the case, many of the "Anglian" stone cross-shafts were, just like the early stone churches, erected at sites in close proximity to earlier imperial structures surviving in the landscape. The monument at Bewcastle in Cumbria, for instance, was set up in the eighth century in the middle of the Roman fort of Fanum Cocidii just north of Hadrian's Wall (figs. 3 and

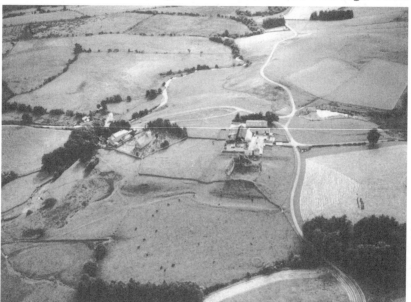

Figure 3. Aerial view of Bewcastle, Cu. (from the northeast), showing area of Roman fort enclosing church and graveyard (Photo: Courtesy of M. Aston)

4). Whether the stone used for the construction of this shaft was quarried from Long Bar, some five miles distant, or Crossgreens, three-quarters of a mile north of Bewcastle, Roman building material from the fort (or from those nearby at Camboglanna-Birdoswald and Nether Denton) was not reused to form the squared tapering shaft of the Anglo-Saxon stone monument. The place selected for its erection was not chosen with an eye to easy access to ready-dressed stone.[31] A similar phenomenon is witnessed at Ilkley in western Yorkshire. Here, three cross-shafts of later-eighth- or early-ninth-century date were apparently set within the confines of the

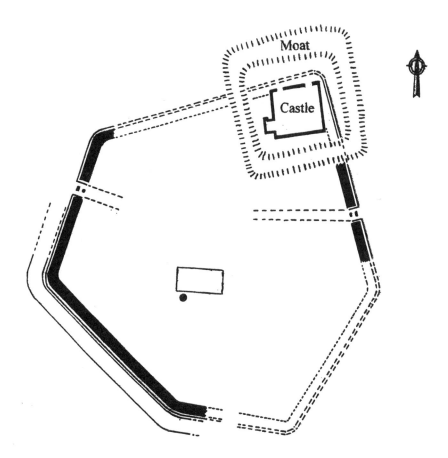

Figure 4. Outline drawing showing siting of Anglo-Saxon shaft within Roman fort of Fanum Cocidii at Bewcastle, Cu. (Jane Hawkes)

Roman fort of Olicana (fig. 5), while the shaft now divided between
Aldborough and Cundall, in North Yorkshire, once stood within the
environs of the Roman cantonal capital of Isurium Brigantum.[32] By
setting these monuments firmly within definable centers of Roman
activity, those responsible for their production would seem to have
been deliberately reclaiming and appropriating that which was Rome
in order to establish it as part of the new Rome of Christ.

Similar associations could also have been intended for other
monuments that, although not set within the confines of Roman

Figure 5. Outline drawing showing the siting of the church and graveyard within
the Roman fort of Olicana at Ilkley, Yorkshire (Jane Hawkes)

centers, were certainly situated close to them: the ninth-century crosses at Otley, for instance, lie barely five miles from Olicana,[33] while those at Ruthwell and Hoddom in Dumfriesshire are within five and two miles (respectively) of the fort of Blatobulgium (Birrens). Furthermore, the monuments of Ruthwell, Bewcastle, and Rothbury, the products of a common "school" of sculpture that can be dated to within a generation of each other, are set at points almost equidistant from each other in a line that straddles Bernicia, echoing that of Hadrian's Wall to the south, and following a network of Roman roads crossing the region at those points (fig. 6).[34] Whether the siting of such monuments reflects the "custom" of the "nobles and good men of the Saxon race" who reputedly erected crosses on their estates "for the convenience of those who wish to pray daily before [them],"[35] the repeated juxtaposition of their situations with sites of earlier Roman activity is unlikely to be coincidental, and may well reflect a desire to physically express the foundation of the new Rome in the place of the old.

As far as the decoration of these monuments is concerned, the impact of late antique art is, of course, a well-established theme in studies of the decoration of Anglo-Saxon sculpture, although it is a theme that has been invoked primarily in terms of the "quality" and "style" of the carving in order to establish chronologies for the material.[36] Beyond the parameters of such discourses, however, it is apparent that not only were specific Roman/late antique images "borrowed" for the decoration of Anglo-Saxon sculpture, they were appropriated for sometimes quite distinct iconographic functions.

The decoration of the cross-head from Rothbury, for instance, was compiled from a selection of motifs familiar on Roman coinage and consular diptychs: the scepter, *mappa,* and crown of victory and immortality. As I have suggested elsewhere, these attributes of imperial power were deliberately adopted at Rothbury to articulate the power and authority of Christ.[37] At Repton, in Derbyshire, a similar process of appropriation of Roman imagery is evident in the depiction of the rider, a secular figure who has been portrayed in the manner of the triumphant emperor. Here, in the apparent absence of a figural iconography of secular power in the Anglo-Saxon world, an image that was well established in imperial art (and one that survives in a number of contexts from Roman Britain) was used and recast as that of a secular Germanic ruler, complete with mustache and shield.[38]

Elsewhere, on a cross-shaft at Collingham, Yorkshire, a much-damaged head, recently identified by Farr as that of a woman,[39]

Figure 6. Map showing Roman and Anglo-Saxon sites in the north of England discussed in the text. — — — — — indicates Roman roads; — • — • — • — indicates line of Stanegate forts (Jane Hawkes)

bears a remarkable resemblance to the portrait of a woman featured on a Romano-British funerary marker at Ilkley-Olicana, fifteen miles west on the Roman road running through the Wharfe Valley (figs. 6–8).[40] The head on the Collingham stone is noticeably different in scale when compared with the other (smaller, but) full-length (male) figures on the shaft; it is also sculpted in much higher relief (fig. 7). While these differences may suggest the presence of more

Figure 7. Head of female figure on the ninth-century Anglo-Saxon shaft at Collingham, Yorkshire (Photo: Jane Hawkes)

than one carver for the monument, it is equally possible that they reveal the use of different models: the female figure being derived from a well-cut and locally available scale model depicted on the Romano-British funerary stone (fig. 8). The differences also serve

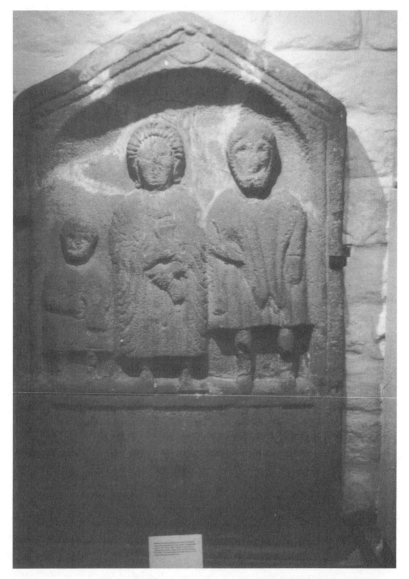

Figure 8. Romano-British funerary stone at Ilkley (Yorkshire), showing female figure (Photo: Jane Hawkes)

to emphasize the female figure, and imply that a female donor or patron was being portrayed at Collingham, a rare phenomenon indeed in the context of pre-Viking Anglo-Saxon sculpture.[41] By analogy with the Repton portrait, this dependence on earlier Roman imagery may imply further that in the absence of an iconography of secular patronage, the Collingham figure was consciously "borrowed" from the Romano-British prototype to facilitate the depiction of a secular (rather than ecclesiastical) female figure. Setting such speculation aside, it does seem that at Collingham, local, earlier Roman art was being used as a source of inspiration for the portrayal of a female figure in the company of a number of male apostolic and/or clerical figures, on a stone monument erected under the aegis of the Church in the region.

Summary

The use of stone in early Christian Anglo-Saxon England was certainly a phenomenon dependent on ecclesiastical activities. The circumstances in which those activities occurred indicates it was, more specifically, regarded as a means of expressing, in very physical terms, the foundation of the Church of Rome. The perceived contrast articulated by Bede, between the stone of Rome and the wood of the *Scoti*, not only influenced decisions to use stone for ecclesiastical buildings, it also informed the stone monuments—in their formulation, situation, and decoration. The impact of these stone constructs in a landscape then dotted with wood-and-thatch buildings and the ruined (stone) memorials of imperial (but demonstrably ephemeral) Rome cannot be overestimated. Indeed, it is probable that its use in such contexts served as a highly visible and permanent expression of the establishment of the Church of St. Peter—the rock on which the universal Church of Christ was literally being founded. In such circumstances the physical manifestations of imperial Rome were apparently regarded as material particularly suited to appropriation and rededication to the service of the new Christian Rome being established in Anglo-Saxon England from the seventh century onwards. Through stone, that most visible and permanent of materials, the outpost of empire was being redefined and established as integral to a new (and everlasting) imperium.

Such understandings of early Anglo-Saxon stone constructs do not, perhaps, coincide clearly with modern art-historical and

archaeological theories of style that have their roots in the "Ur-texts" of the eighteenth-century doctor-turned-curator Joachim Winckelmann, to whose work the genesis of both art history and archaeology (as academic disciplines) have been traced, and which were established more firmly in the canons of art-historical and archaeological analyses of style by Heinrich Wölfflin in the early decades of the twentieth century.[42] These approaches, based on an understanding of "style" as the manner in which the form of a work of art reflects varying historical conditions,[43] are well established in the study of Anglo-Saxon sculpture and have been employed in that time-honored tradition as a means of establishing groups of carvings, and so enabling an identification of works as produced in particular places and at particular times in order to facilitate a distinction of periods, cycles, and cultures within the overall period during which stone was being worked in Anglo-Saxon England: the seventh to eleventh centuries.[44] While existing within the mainstream of the modern academic disciplines concerned, these studies are nevertheless removed from the manner in which stone constructs, be they buildings or carvings, were perceived in eighth-century Anglo-Saxon England. The wording of Bede's statement that something worked in stone *was* something "Roman" implies that in that time and place the "style" of a monument was indistinguishable from its meaning. Here style was apparently more closely related to meaning than is perhaps allowed for in the comparatively strict sense as constructed and understood by the late-twentieth-century academic analyst of style. It explains how, in the eighth century, style was understood to signify the meaning(s) inherent in and determined by the context(s) of the stone constructs.

Notes

Thanks are due to Richard Bailey, Mary Garrison, Catherine Karkov, Matthew Kempshall, Jeanne Nuechterlein, Éamonn Ó Carragáin, Jennifer O'Reilly, Fred Orton, Ross Trench-Jellicoe, and Sue Youngs for their comments, advice, criticisms, and help in the preparation of this paper.

The Latin phrase in the title of this paper is derived from Bede's account of Benedict Biscop's church of St. Peter at Wearmouth: *iuxta Romanorum quem semper amabat morem facerent* (*Hist. abb.* 5, p. 368). The noun *mos*, notoriously fluid in its meaning(s), is usually understood (and is understood in this paper) to include reference to the manner, mode, custom, fashion, and (by extension) style in which an action or object is executed.

1. Richard N. Bailey, *England's Earliest Sculptors* (Toronto, 1996), 23.

2. *Hist. eccles.* 1.25–26, 33, 2.6–7, pp. 74–77, 114–15, 156–59; *Anglo-Saxon Chronicle* 669, in *Two of the Saxon Chronicles Parallel*, ed. C. Plummer and J. Earle, 2 vols. (Oxford, 1892), 1: 34–35. For discussion see, e.g., Richard Gem, *St Augustine's Abbey Canterbury* (London, 1997), 20–21, 90–107; H. M. Taylor and J. Taylor, *Anglo-Saxon Architecture*, 2 vols. (Cambridge, 1965), 1:134–45, 1:148, 2:503–9; Eric Fernie, *The Architecture of the Anglo-Saxons* (London, 1983), 35–42; Richard Morris, *Churches in the Landscape* (London, 1989), 18. It should be noted that the recent excavations carried out towards the west end of the nave of the present cathedral recovered no signs of an early Anglo-Saxon structure reusing Roman material (K. Blockley, M. Sparks, and T. Tatton-Brown, *Canterbury Cathedral Nave* [Canterbury, 1997], 12–23, 95–100). With these foundations the aspirations and dictates of the secular rulers undoubtedly played a part in determining the general areas assigned to the incoming Church in any one region, but decisions regarding the specific sites, choice of fabric, and design of buildings used for worship seems to have rested with the members of the ecclesiastical communities (e.g., Morris, *Churches*, 18; Gem, *St Augustine's*, 19–20; N. J. Higham, *The Convert Kings: Power and Religious Affiliation in Early Anglo-Saxon England* [Manchester, 1997]).

3. *Hist. eccles.* 2.13–14, 20, pp. 186–87, 202–5.

4. *Vita Wilfridi* 16, *The Life of Bishop Wilfrid by Eddius Stephanus,* ed. Bertram Colgrave (Cambridge, 1927), 35. The translation is that provided by D. H. Farmer, "Bede: Lives of the Abbots of Wearmouth and Jarrow," in *The Age of Bede*, ed. D. H. Farmer (New York, 1983), 189.

5. For Wilfrid's work at Ripon, see *Vita Wilfr.* 17, 37; Taylor and Taylor, *Anglo-Saxon Architecture*, 2:516–18; Richard N. Bailey, "St Wilfrid, Ripon, and Hexham," in *Studies in Insular Art and Archaeology*, American Early Medieval Studies 1 (Oxford, OH, 1991), 3–25, esp. 9–11; idem, *St Wilfrid's Crypts at Ripon and Hexham: A Visitor's Guide* (Newcastle upon Tyne, 1993), 1–5; and idem "Seventh-Century Work at Ripon and Hexham," *The Archaeology of Cathedrals*, ed. T. Tatton Brown and J. Mumby (Oxford, 1996), 9–18. For his work at Hexham, see *Vita Wilfr.*, 21, 46–47; Taylor and Taylor, *Anglo-Saxon Architecture*, 1:297–312; Fernie, *Architecture*, 60–63; Bailey, "Ripon and Hexham," 3–11; idem, *St Wilfrid's Crypts*, 6–11; idem, "Seventh-Century Work"; Eric Cambridge and A. Williams, "Hexham Abbey: A Review of Recent Work and its Implications," *Archaeologia Aeliana* 23 (1995): 51–138.

6. *Hist. abb.* 5, p. 368. For discussions, see Taylor and Taylor, *Anglo-Saxon Architecture*, 1:338–49, 2:432–46; Fernie, *Architecture*, 48–54; Rosemary Cramp, "Monkwearmouth and Jarrow: The Archaeological Evidence," in *Famulus Christi: Essays in Commemoration of the Thirteenth Centenary*

of the Birth of the Venerable Bede, ed. Gerald Bonner (London, 1976), 5–18; idem, "Monastic Sites," in *The Archaeology of Anglo-Saxon England*, ed. David M. Wilson (Cambridge, 1976), 201–52, esp. 229–41; and idem, "Monkwearmouth and Jarrow in their Continental Context," in *Churches Built in Ancient Times*, ed. Kenneth Painter (London, 1994), 279–94.

7. E.g., Fernie, *Architecture*, 5, 47, 59, 92, 144–45, 185 n. 25 to chap. 8; Richard K. Morris, *The Church in British Archaeology* (London, 1983), 3, 33, 38-40, 43, 73; Peter Addyman and Richard Morris, eds., *The Archaeological Study of Churches* (London, 1976), 23, 35, 70, 71 n. 4, pl. III.

8. *Hist. eccles.* 1.30, pp. 104–7; see also, e.g., Richard Morris and J. Roxan, "Churches on Roman Buildings," in *Temples, Churches, and Religion: Recent Research in Roman Britain*, ed. Warwick Rodwell (Oxford, 1980), 175–209, esp. 180, 182; Morris, *Churches*, 28–45.

9. The Roman terms are those cited by the Ordnance Survey, *Map of Roman Britain*, 3d ed. (London, 1978); see also M. Millet, *The Romanisation of Britain* (Cambridge, 1990), 65–126. Apart from Bede's use of Roman placenames to refer to many of the Roman sites, the compilation of the "Ravenna Cosmography" in the late seventh century provides further evidence that knowledge of these locations as sites of imperial Roman activity in Britannia was still widely current in the seventh and eighth centuries (I. A. Richmond and O. G. S. Crawford, "The British Section of the Ravenna Cosmography," *Archaeologia* 93 [1949]: 2–50).

10. For Constantine see, e.g., H. H. Scullard, *Roman Britain: Outpost of the Empire* (London, 1979), 68–69. The exact site of Edwin and Paulinus's church at York is still unknown. Excavations have tended to concentrate on the *principium* area of the fort (the site of the present cathedral), but only a substantial graveyard believed to have been attached to the church has been uncovered at this site (D. Phillips and B. Heywood, *Excavations at York Minster*, vol. 1 [London, 1995]; see also Morris and Roxan, "Roman Buildings," 182). The association of Anglo-Saxon stone churches with sites of earlier imperial Roman activity is, of course, not limited to these sites: see also Bradwell-on-Sea, Essex, where Cedd established his church between 653 and 664 literally over the walls of the Roman shore fort of *Othana* (R. G. Collingwood and I. Richmond, *The Archaeology of Roman Britain*, rev. ed. [London, 1969], 49; Gem, *St. Augustine's*, 107; N. J. Higham, "Dynasty and Cult: The Utility of Christian Mission to Northumbrian Kings between 642 and 654," in *Northumbria's Golden Age*, ed. Jane Hawkes and Susan Mills [Stroud, 1999], 95–104, esp. 101–3; and more generally, S. E. Rigold, "*Litus Romanum*—The Shore Forts as Mission Stations," in *The Saxon Shore*, ed. D. E. Johnston [London, 1977], 70–75); Escomb, Co. Durham, where the seventh-century church lies by the Roman fort of Vinovia (Binchester) (Taylor and Taylor, *Anglo-Saxon Architecture*, 1:234–38); Corbridge, Northumberland, where the late-seventh-century church was

set up within yards of the outer perimeter of the Stanegate fort of Corstopitum (Collingwood and Richmond, *Roman Britain*, 73–74; Taylor and Taylor, *Anglo-Saxon Architecture*, 1:172–76); and the church at Upper Denton, Northumberland, set within the *vicus* area adjacent to the Stanegate fort of Nether Denton (Collingwood and Richmond, *Roman Britain*, 74; B. Jones, *Hadrian's Wall from the Air* (Manchester, 1979), 10; N. J. Higham and B. Jones, *The Carvetii* (Gloucester, 1985), 62–67, fig. 30); see Morris and Roxan, "Roman Buildings," 194–203 and Morris, *The Church*, 41–44, for fuller listings. Archaeological studies of the associations between Anglo-Saxon ecclesiastical foundations and earlier Roman activity have tended to regard the matter primarily as a matter of exigency, and/ or have concentrated on the possibility of a continuum of (religious) activity from Romano-British to Anglo-Saxon contexts (e.g., Martin Biddle, "The Archaeology of the Church: A Widening Horizon," in Addyman and Morris, *Archaeological Study*, 65–71; Morris and Roxan, "Roman Buildings," 176–78; Warwick Rodwell, "Churches in the Landscape: Aspects of Topography and Planning," in *Studies in Late Anglo-Saxon Settlement*, ed. M. Faull [Oxford, 1984], 1–24; Morris, *Churches*, 28–45; J. Blair, "Churches in the Early English Landscape: Social and Cultural Contexts," in *Church Archaeology: Research Directions for the Future*, ed. John Blair and C. Pyrah [York, 1996], 6–18; and the most recent summary in T. Bell, "Churches on Roman Buildings: Christian Associations and Roman Masonry in Anglo-Saxon England," *MA* 42 [1998]: 1–18). Exceptions include Gem, who suggests an "iconographic" inference in Bede's association of stone with "Rome" and his presentation of "church" as "holy city," and Cambridge, who explores the relationship between timber and stone and the "monastic" or "secular" nature of the ecclesiastical foundations (Richard Gem, "Towards an Iconography of Anglo-Saxon Architecture," *JWCI* 46 (1983): 1–18, esp. 1–4; idem, "Church Buildings: Cultural Location and Meaning," in Blair and Pyrah, *Church Archaeology*, 1–6; Eric Cambridge, "The Early Church in County Durham: A Reassessment," *Journal of the British Archaeological Association* 137 [1984]: 65–85, esp. 81–82; idem, "Why Did the Community of St Cuthbert Settle at Chester-le-Street," in *St Cuthbert: His Cult and His Community to A.D. 1200*, ed. Gerald Bonner, David Rollason, and Clare Stancliffe (Woodbridge, 1989), 367–86, esp. 371–72). For other alternative views, see, e.g., D. Stocker, "Rubbish Recycled: A Study of the Reuse of Stone in Lincolnshire," in *Stone: Quarrying and Building in England, A.D. 43–1525*, ed. D. Parsons (Chichester, 1990), 83–101; T. Eaton, *Plundering the Past: Roman Stonework in Medieval Britain* (Stroud, 2000).

11. William Levison, *England and the Continent in the Eighth Century* (Oxford, 1946), 34–35; Richard Krautheimer, *Rome: Profile of a City, 312–1308* (Princeton, 1980), 35, 87.

12. *Hist. eccles.*, p. 158n. For a recent discussion of this church and the other foundations in Anglo-Saxon Canterbury, see E. Cambridge, "The

Architecture of the Augustine Mission," in *St Augustine and the Conversion of England*, ed. R. Gameson (Stroud, 1999), 202–36, esp. 231 where he notes that only one other such dedication is known, in the ancient province of Pannonia from which the martyrs originally hailed.

13. *Vita Wilfr.* 8, 16–17; Bede's Prose Life of Cuthbert (hereafter *Vita Pr.*) 7–8, in *Two Lives of Saint Cuthbert: A Life by an Anonymous Monk of Lindisfarne and Bede's Prose Life*, ed. Bertram Colgrave, (Cambridge, 1940), 174–85; *Hist. eccles.* 3.25, pp. 298–99.

14. *Vita Wilfr.* 2, 9–12, 14, pp. 6–7, 18–27, 30–31; *Hist. eccles.* 3.25, pp. 298–309. See D. H. Farmer, "Saint Wilfrid," in *St Wilfrid at Hexham*, ed. D. Kirby (Newcastle upon Tyne, 1974), 35–60.

15. See, J. J. G. Alexander, *Insular Manuscripts, Sixth to the Ninth Century: A Survey of Manuscripts Illuminated in the British Isles* (London, 1978). The notable exception is the *Codex Amiatinus*, one of three bible codices produced at the Wearmouth-Jarrow scriptorium, which itself consciously replicated late antique prototypes (Alexander, *Manuscripts*, 32–35, cat. no. 7; Rupert Bruce-Mitford, *The Art of the Codex Amiatinus*, Jarrow Lecture (Jarrow, 1969); P. J. Nordhagen, *The Codex Amiatinus and the Byzantine Element in the Northumbrian Renaissance*, Jarrow Lecture (Jarrow, 1978); K. Corsano, "The First Quire of the Codex Amiatinus and the 'Institutiones' of Cassiodorus," *Scriptorium* 41 (1987): 3–34; Carol Farr, "The Shape of Learning at Wearmouth-Jarrow: The Diagram Pages in the *Codex Amiatinus*," in Hawkes and Mills, *Northumbria's Golden Age*, 336–44; Perette Michelli, "What's in the Cupboard? Ezra and Matthew Reconsidered," in Hawkes and Mills, *Northumbria's Golden Age*, 345–58).

16. *Vita Wilfr.* 17, pp. 36–37; see also Farmer, "St. Wilfrid," 44–45; M. Roper, "Wilfrid's Landholdings in Northumbria," in Kirby, *Wilfrid*, 61–79.

17. *Vita Wilfr.* 22, pp. 46–47; see also E. Gilbert, "Saint Wilfrid's Church at Hexham," in Kirby, *Wilfrid*, 81–113.

18. *De gestiis Pontificum Anglorum* 225, as cited in Gilbert, "Wilfrid's Church," 113.

19. *Hist. eccles.* 3.25, pp. 294–95; see also Gem, "Towards an Iconography," 1–4. The same distinction is made when Bede describes the church understood to have been built by Ninian at Whithorn. Ninian is described as having received "orthodox instruction at Rome in the faith and the mysteries of the truth," and as a mark of that orthodoxy his episcopal church was dedicated to St. Martin and built of stone "a method unusual among the Britons" (*Hist. eccles.* 3.4, pp. 222–23); for recent discussion, see Peter Hill, ed., *Whithorn and St. Ninian: The Excavations of a Monastic Town, 1984–91* (Stroud, 1997); É. Ó Carragáin, "Rome, Ruthwell, Vercelli: 'The Dream of the Rood' and the Italian Connection," *Vercelli tra oriente ed occidente tra tarda antichita ea mediovo*, ed. V. Dolcetti Corazza (Alisandria,

1999), 59–100, esp. 71–83. For the view of Jarrow and Wearmouth as Roman constructs, see, e.g., Cramp, "Monkwearmouth and Jarrow," 10–11, 15–17; idem, "Monastic Sites," 229–41; idem, "Continental Context"; É. Ó Carragáin, *The City of Rome and the World of Bede*, Jarrow Lecture (Jarrow, 1994); idem, "Rome Pilgrimage, Roman Liturgy, and the Ruthwell Cross," *Akten des XII. Internationalen Kongresses für christliche Archäologie, Bonn, 22. Bis 28. September 1991* 2 (1995): 630–39; idem, "The Term *Porticus* and *Imitatio Romae* in Early Anglo-Saxon England," in *Text and Gloss: Studies in Insular Learning and Literature Presented to Joseph Donovan Pheifer*, ed. Helen Conrad O'Briain, A. M. D'Arcy, and J. Scattergood (Dublin, 1999), 13–34. Although constructed by artisans from Gaul, the equation of "Gaul" with "Rome" is clear in Bede's account of the construction of the Wearmouth-Jarrow complex: "Benedict crossed the sea to *France* to look for masons to build him a stone church in the *Roman manner* he had always loved so much. He found them, took them on and brought them back home with him." (*Hist. abb.* 5, p. 368; emphasis added). With stonework actively being undertaken in Kent (where Benedict had been living until 671) and at Ripon, Hexham, and York, Benedict's decision to hire masons from Gaul may have been inspired more by a desire to be seen to be creating his ecclesiastical complexes *iuxta morem Romanorum* than by the absence of artisans able to work in stone.

20. The nave at Wearmouth was 19.5 m long × 5 m wide and 15 m high, while that at Jarrow was 27 m long × 6 m wide (e.g. Cramp, "Monkwearmouth and Jarrow," 10–14; idem, "Continental Context," 284–85); Sta. Maria in Cosmedin was approximately 30 m long × 7 m wide and 16 m high (G. B. Giovenale, *La Basilica di S. Maria in Cosmedin* [Rome, 1927], 17–36, figs 8, 16; see also Krautheimer, *Rome*, 77–78, 105, fig. 125).

21. *Hist. abb.* 6, p. 369; *Hist. eccles.* 4.18, pp. 388–91; P. Meyvaert, "Bede and the Church paintings at Wearmouth-Jarrow," *Anglo-Saxon England* 8 (1979): 63–77; Ó Carragáin, *City of Rome*. For the various architectural features of Jarrow and Wearmouth, see Cramp, "Monkwearmouth and Jarrow," 10–14; idem, "Continental Context," 284–85, fig. 3; and Gem, "Towards an Iconography," 2–3. For discussion of the walkways and porticus, see Ó Carragáin, *"Porticus."* For the Roman exemplars, see Krautheimer, *Rome*, 28 (25 for the similar Constantinian walkway linking the mausoleum of St. Lawrence with the city walls). For discussions of the general "Roman" appearance of early Anglo-Saxon stone churches, see J. Higgitt, "The Roman Background to Medieval England," *JBAA* 36 (1973): 1–15; R. Cramp, "The Anglo-Saxons and Rome," *Transactions of the Durham and Northumberland Archaeological Society*, n.s., 3 (1974): 27–37, esp. 34–35; and idem, "The Anglo-Saxon Church of Britford and the Italian Connection," in *Arte d'Occidente: Temi e Metodi,* ed. A. Cadei, et al. (Rome, 1999), 35–40.

22. *Hist. eccles.* 1.25–26, 33, pp. 74–77, 114–15; *Vita Anon.* 4.8; *Vita Pr.* 27, pp. 122–23 for references to the visibility of the Roman ruins; see

also (for example), Fernie, *Architecture*; S. E. West, *West Stow: The Anglo-Saxon Village* (Ipswich, 1985), 10–14, 111–22; and Susan Mills, "(Re)constructing Northumbrian Timber Buildings: The Bede's World Experience," in Hawkes and Mills, *Northumbria's Golden Age*, 66–72 for the characteristics of Anglo-Saxon secular architecture.

23. Unlike early medieval Ireland, where documentary references to stone monuments and those involved in working with stone have survived, the extant references from the Anglo-Saxon world either refer to wooden monuments (e.g., Oswald's setting up of a wooden cross prior to the battle at Heavenfield in 634), or, as is the case with the cross credited with restoring the health of the infant Willibald in the eighth century, they do not mention the medium of construction at all (*Hist. eccles.* 3.2, pp. 214–19; *Hodoeporicon*, in *The Anglo-Saxon Missionaries in Germany*, ed. C. H. Talbot (London, 1954), 154–55. For summaries see D. Mac Lean, "The Status of the Sculptor in Old Irish Law and the Evidence of the Crosses," *Peritia* 9 (1995): 125–55; idem, "King Oswald's Wooden Cross at Heavenfield in Context," in *The Insular Tradition*, ed. Catherine Karkov, Michael Ryan, and Robert T. Farrell (New York, 1997), 79–98. Later medieval discussions of Anglo-Saxon monuments do not state the medium of construction and are unclear in their terms of reference. Eadmer's account of Cathedral of Canterbury (ca. 1060–1130), for instance, describes the memorial to Archbishop Odo (d. 958) as a "pyramid" and that set over the grave of Dunstan (d. 988) as a "large and lofty pyramid" (H. M. Taylor, "The Anglo-Saxon Cathedral Church at Canterbury," *Archaeological Journal* 126 [1969]: 101–30, esp. 103; cf. C. R. Dodwell, *Anglo-Saxon Art: A New Perspective* [London, 1982], 113–18 for further discussion of "pyramids" elsewhere in early medieval England).

24. For Herebericht's Stone, see Rosemary Cramp, *Corpus of Anglo-Saxon Stone Sculpture*, vol. 1, *County Durham and Northumberland* (Oxford, 1984), 124, pl. 110,604 (hereafter *Corpus* 1); for Whitby, see Jane Hawkes, "Statements in Stone: Anglo-Saxon Sculpture, Whitby, and the Christianization of the North," in *The Archaeology of Anglo-Saxon England: Basic Readings*, ed. Catherine E. Karkov (New York, 1999), 403–22; for Masham, see Jane Hawkes, "Old Testament Heroes: Iconographies of Insular Sculpture," in *The Worm, the Germ, and the Thorn: Studies Presented to Isabel Henderson*, ed. David Henry (Balgavies, Angus, 1997), 149–58, esp. 155–56; idem, "Anglo-Saxon Sculpture: Questions of Context," in Hawkes and Mills, *Northumbria's Golden Age*, 204–15, esp. 207–11; for Bewcastle, see Richard N. Bailey and Rosemary Cramp, *Corpus of Anglo-Saxon Stone Sculpture*, vol. 2, *Cumberland, Westmoreland, and Lancashire North-of-the-Sands* (Oxford, 1988), 61–72 (hereafter *Corpus* 2); for Rothbury, see Jane Hawkes, "The Rothbury Cross: An Iconographic Bricolage," *Gesta* 35, no. 1 (1996): 73–90; Cramp, *Corpus* 1, 217–21. For discussions of the ecclesiastical context and general appearance of Anglian sculpture, see,

e.g., James Lang, *Anglo-Saxon Sculpture* (Aylesbury, 1988), 6–14; Bailey, *Earliest Sculptors*, 23; Hawkes, "Anglo-Saxon Sculpture," 213–15.

25. See Cramp, *Corpus* 1 for survey of sites and numbers of extant pieces (approximately twenty of the pre-Norman stones from the region are deemed undateable); see also Richard N. Bailey, *Viking Age Sculpture in Northern England* (London, 1980), 24–25; Hawkes, "Anglo-Saxon Sculpture," 204–5; idem, "Statements in Stone." The time taken to construct stone monuments was probably not a limiting factor. Modern reconstructions of a freestanding stone cross (undertaken by a single sculptor, Keith Ashford, at Bede's World, Jarrow) have demonstrated that, once quarried and dressed, the layout of the (figural) decoration and the carving of all four sides of shaft and head can be completed within five weeks.

26. Collingwood and Richmond, *Roman Britain*, 121; F. Lepper and S. Frere, *Trajan's Column* (Gloucester, 1988). For Reculver, see D. Tweddle, Martin Biddle, and Birthe Kjølbye-Biddle, *Corpus of Anglo-Saxon Stone Sculpture*, vol. 4, *South-East England* (Oxford, 1995), 46–61 (hereafter *Corpus* 4); for Dewsbury, see W. G. Collingwood, *Northumbrian Crosses of the Pre-Norman Age* (London, 1927), 6–8; R. Cramp, "The Northumbrian Identity," in Hawkes and Mills, *Northumbria's Golden Age*, 1–11, esp. 9–10; For Masham, see Hawkes, "Old Testament Heroes," 155–56; idem, "Anglo-Saxon Sculpture," 207–11, figs. 17.04, 17.05; for Wolverhampton, see M. Rix, "The Wolverhampton Cross-Shaft," *Archaeological Journal* 117 (1960): 71–81. See also the "Pillar of Eliseg" (Clwyd, Wales), a ninth-century column with an inscription linking the royal dynasty of Powys to Vortigern, Maximus, and Germanus (V. E. Nash-Williams, *The Early Christian Monuments of Wales* [Cardiff, 1950]), 123–25, pls. XXXV–XXXVI; S. Johnson, *Later Roman Britain* [London, 1980], 117).

27. It was preserved most famously in a Christian context in the fourth-century silver *fastigium* donated by Constantine to the basilica of Christ Savior on the Lateran, which featured the life-sized figure of Christ seated and flanked by the standing figures of the twelve apostles (M. Teasdale Smith, "The Lateran *Fastigium*: A Gift of Constantine the Great," *Revista di Archaeologia Cristiana* 46 [1970]: 149–75).

28. Hawkes, "Old Testament Heroes," 155–56; idem, "Anglo-Saxon Sculpture," 207–11, fig. 17.05. In this respect it is interesting to note that the only extant fragments of the columnar shaft at Dewsbury are those illustrating Christ seated in majesty flanked by his apostles; the fragments from that site carved with miracle scenes and the image of the Virgin and Child were part of a shaft, square in section (Collingwood, *Northumbrian Crosses*, 7–8; Cramp, "Northumbrian Identity," 9–10, figs. 1.1–2). For discussion of late imperial antecedents of Christ enthroned with his disciples, see André Grabar, *The Beginnings of Christian Art, 200–395* (London, 1967), 9–15; idem, *Christian Iconography: A Study of its*

Origins (Princeton, 1968), 31–54; M. Gough, *The Origins of Christian Art* (London, 1973), 84–86; and Thomas. F. Mathews, *The Clash of the Gods: A Reinterpretation of Early Christian Art* (Princeton, 1993), 16–22.

29. For discussion of the evolution of the form of the stone crosses as amalgams of the technologies of wood and stone construction, see e.g. Rosemary Cramp, *Early Northumbrian Sculpture*, Jarrow Lecture (Jarrow, 1963), 1–5; Bailey, *Earliest Sculptors*, 23–41; see n. 23 above. For the impact of metalworking processes, see Bailey, *Earliest Sculptors*, 120–24; Jane Hawkes, "A Question of Judgment: The Iconic Program at Sandbach, Cheshire," in *From the Isles of the North*, ed. Cormac Bourke (Belfast, 1995), 213–19, esp. 218; idem, "Reading Stone," in *Theorizing Anglo-Saxon Stone Sculpture*, ed. Catherine E. Karkov and Fred Orton (Morgantown, 2003), pp. 5–30. For recent discussion of the "cross as obelisk," see Fred Orton, "Rethinking the Ruthwell Monument: Fragments and Critique; Tradition and History; Tongues and Sockets," *Art History* 21 (1998): 65–106; idem, "Northumbrian Sculpture (The Ruthwell and Bewcastle Monuments): Questions of Difference," in Hawkes and Mills, *Northumbria's Golden Age*, 216–26, esp. 222; although see Ó Carragáin, *City of Rome*, 40.

30. For the obelisk at St. Peter's, see Krautheimer, *Rome*, 13; idem, *Three Christian Cities: Topography and Politics* (Los Angeles, 1983), 116. Other notable obelisks in Rome included the "Terebinth" on the Vatican Hill and that erected by Augustus outside the Ara Pacis (Krautheimer, *Rome*, 13; Nancy H. Ramage and Andrew Ramage, *Roman Art* [Cambridge, 1991], 105; E. Bianchi, *Ara Pacis Augustae* [Rome, 1994]; see also the obelisk of Theodosius II in Constantinople, referred to in Krautheimer, *Three Christian Cities*, 48–49). It is worth noting in this respect that the description given here of the monumental freestanding stone cross accords with that given of monuments standing in Jerusalem in the eighth century that formed part of the "pilgrimage trail" of that city: "Willibald himself said that in front of the gate of the city stood a tall pillar, on top of which rose a cross" (*Hodoeporicon* 165; see also J. Hawkes, "The Wirksworth Slab: An Iconography of Humilitas," *Peritia* 9 (1995): 246–89, esp. 265–66).

31. Bailey and Cramp, *Corpus* 2:71, 162.

32. For the crosses at Ilkley-Olicana, see W. G. Collingwood, "Anglian and Anglo-Danish Sculpture in the West Riding, with Addenda to the North and East Ridings and York, and a General Review of the Early Christian Monuments of Yorkshire," *YAJ* 23 (1915): 129–299, esp. 185–97; idem, *Northumbrian Crosses*, 48–50; A. M. Woodward, "The Roman Fort at Ilkley," *YAJ* 28 (1926): 137–321; F. R. Pearson, *Roman Yorkshire* (London, 1936); B. R. Hartley, "The Roman Fort at Ilkley, Excavations of 1962," *Proceedings of the Leeds Philosophical and Literary Society*, 12, no. 2 (1966): 23–72. The Ilkley stones, described as lying in the churchyard among Roman pillars by Camden, were placed in front of the church before 1878

(see Collingwood, "Sculpture in the West Riding," 185). For that at Aldborough-Isurium Brigantum, see Aubrey, *Mon.*, 1.70, in *Monumenta Britannica: John Aubrey (1625–97)*, ed. J. Fowles and R. Legg (Dorset, 1980), 111; W. G. Collingwood, "Anglian and Anglo-Danish Sculpture in the North Riding of Yorkshire," *YAJ* 19 (1907): 266–413, esp. 315; idem, "Sculpture in the West Riding," 133–35; idem, *Northumbrian Crosses*, fig. 32; Morris and Roxan, "Roman Buildings," 178; Hawkes, "Anglo-Saxon Sculpture," 210–11. See also the stone column set up in the Anglo-Saxon church within the Roman fort at Reculver early in the ninth century (fig. 1; Tweddle, Biddle, and Kjølbye-Biddle, *Corpus* 4:46–61).

33. Collingwood, "Sculpture in the West Riding," 224–28.

34. Hawkes, "Anglo-Saxon Sculpture," 211–15; Ordnance Survey, *Map of Roman Britain*; I. D. Margary, *Roman Roads in Britain*, 2d ed. (London, 1967); R. Bellhouse, "The Letters of Paul Alexander Wilson," in *Occasional Papers: Cumberland and Westmoreland Antiquarian and Archaeological Society* 98 (1998): 1–6, esp. 2; A. S. Robertson, *Birrens (Blatobulgium)* (Edinburgh, 1975). For Rothbury, see Cramp, *Corpus* 1, 217–21; Hawkes, "Iconographic Bricolage"; for Bewcastle, see Bailey and Cramp, *Corpus* 2:61–72; for Ruthwell, see Brendan Cassidy, ed., *The Ruthwell Cross* (Princeton, 1992).

35. *Hodoeporicon* 155.

36. E.g., Fritz Saxl, "The Ruthwell Cross," *JWCI* 6 (1943): 1–19; Meyer Schapiro, "The Religious Meaning of the Ruthwell Cross," *Art Bulletin* 26 (1944): 232–45; Fritz Saxl and Rudolf Wittkower, *British Art and the Mediterranean* (London, 1948), 15–16; Collingwood, *Northumbrian Crosses*; A. W. Clapham, *English Romanesque Architecture before the Conquest* (Oxford, 1930); T. D. Kendrick, *Anglo-Saxon Art to* A.D. *900* (London, 1938).

37. Hawkes, "Iconographic Bricolage," 80–81; idem, "The Rothbury Cross-Head: An Iconography of the Passion or Power?" in Karkov, Ryan, and Farrell, *Insular Tradition*, 27–44.

38. Martin Biddle and Birthe Kjølbye-Biddle, "The Repton Stone," *ASE* 14 (1985): 233–92, esp. 254–73, 287–90. For Romano-British examples, see Gloucester, Gloucs.; Colchester, Essex (which portrays the rider with a shield and wearing armor very similar in appearance to that depicted on the Repton stone); Bridgeness, Linlithgowshire; and Corbridge, Northumberland, now in Hexham (J. M. C. Toynbee, *Art in Roman Britain* [London, 1962], 157–58, 158, 166, cat. nos. 82, 83, 97, pls. 87, 92, 1020).

39. Carol Farr, "Reception of Word and Image at Whitby and its Daughter Houses," paper delivered at the International Medieval Conference, University of Leeds, July 1996. Dr. Farr's paper developed an identification originally made in an unpublished paper by Jim Lang.

40. Collingwood, "Sculpture in the West Riding," 155–57; idem, *Northumbrian Crosses*, 6, fig. 87.

41. The rarity of such images is best viewed against not just the rarity of figural sculpture itself in the earlier Anglo-Saxon period (see above), but also the numbers of apparently male figures of donors, patrons, and/or founders that themselves should, perhaps, be viewed against the wider background of non-narrative, iconic images surviving in a carved medium from the period. It is possible that carved single figures who are not easily identifiable as Christ, evangelists, or apostles can be regarded as patrons or founders, and there are extant many more of these that are apparently male than there are of female figures. Apart from the female head at Collingham, there is only one other that has been identified as a comparable female image: the fragmentary head at Hackness (Yks.), dated to between the seventh and ninth centuries (J. Lang, *York and Eastern Yorkshire* [Oxford, 1991], 135–41, pl. 454). Determining the gender of the figure once attached to this head, however, is problematic. It is so damaged that it has been identified as female on the basis of the inscription carved on another face of the stone that commemorates "Oedilburga" (Lang, *Eastern Yorkshire*, 140), and it has to be noted that the left side of the head is rather elongated and could be understood as extending into a beard. Clearly male figures include the apparently secular figure at the base of the Bewcastle shaft, Cumbria (Bailey and Cramp, *Corpus* 2, illus. 96; C. Karkov, "The Bewcastle Cross: Some Iconographic Problems," in Karkov, Ryan, and Farrell, *Insular Tradition*, 9–26, a pair of standing secular figures preserved on the shaft fragment from St. Mary's Bishophill Jr, York, dated to the ninth century (Lang, *Eastern Yorkshire*, 83–84, pl. 216), two (possibly secular) figures preserved on the shaft of the ninth-century South Cross at Sandbach, Cheshire (J. Hawkes, *The Sandbach Crosses: Sign and Significance in Anglo-Saxon Sculpture* [Dublin, 2002], fig. 3.5), and the ecclesiastical figures kneeling before angels on the shaft fragments, also dated to the ninth century, from Dewsbury and Otley (Yks.), and Halton, Lancs. (Collingwood, "Sculpture in the W. Riding," 165–67, fig. 166; 224–25, fig. 225; idem, *Northumbrian Crosses*, 73–74, fig. 92). Admittedly, the survival of such figures on only six monuments may itself seem a "rare" phenomenon, but when viewed as part of a corpus of material that presents us with, for example, only three iconic images of the Virgin and Child (at Eyam, Derbys., Sandbach, Ches., and Dewsbury, Yks.: J. Hawkes, "Columban Virgins: Iconic Images of the Virgin and Child in Insular Sculpture," in *Studies in the Cult of Saint Columba*, ed. C. Bourke [Dublin, 1997], 107–35), male donor/founder figures could be regarded as "comparatively common" in a carved medium in pre-Viking Anglo-Saxon England, and the secular female figure at Collingham, a rare phenomenon indeed.

42. J. Winckelmann, *Reflections on the Painting and Sculpture of the Greeks* (1755), translated by H. Fuseli (London, 1765); idem, *The History*

of Ancient Art (1764), translated by H. Lodge (Boston, 1880); H. Wölfflin, *Principles of Art History: The Problem of the Development of Style in Later Art* (1915), translated by M. D. Hottinger (New York, 1960).

43. See E. Panofsky, "Introductory," in *Iconography and Iconology: An Introduction to the Study of Renaissance Art* (New York, 1939), 3–31.

44. See, e.g., Collingwood, *Northumbrian Crosses*; Clapham, *English Romanesque*; Kendrick, *Anglo-Saxon Art*; R. Cramp, *Early Northumbrian Sculpture,* Jarrow Lecture (Jarrow, 1965).

4

Beckwith Revisited:
Some Ivory Carvings from Canterbury

Perette E. Michelli

The material under consideration in this paper lacks the kind of associated information that allows scholars to address it in historical terms. The origins, dates, and purposes of the objects are unknown, and their histories before they were acquired by various relatively late collectors are also mysterious. This, indeed, is probably why the material has tended to be neglected despite its rich implications. Two notable and relatively early exceptions to this scholarly disinterest are the "corpus" scholars Goldschmidt and Beckwith, whose concept of completeness, in accordance with the values of their time, ensured these objects' inclusion in their work. The method they used to classify the material, which is the same method used perforce by any historian faced with objects (not texts) that have become divorced from all useful information pertaining to them, is stylistic analysis. It is perhaps unfortunate that stylistic analysis has become associated, in some scholars' minds, exclusively with the connoisseur's search for "great" works, and that the concept of greatness itself has come to be seen as undesirably elitist. Since the connoisseur and the great artist are both products of a romantic consciousness that favored the production of large-scale, emotionally expressive works of a kind that did not, and could not, exist in the early Middle Ages, it is doubly unfortunate that this perception should undermine the most powerful and useful tool historians (not critics) have available to them, and that the use of this tool should now have to be justified for the benefit of critical theorists.

In this paper, stylistic analysis involves the detailed analysis and comparison of form, iconography, and technology (where visible).

The purpose is to demonstrate that the objects belong together in coherent groups, and that provenances can be suggested for these groups that throw new light on our understanding of the ivory trade, the transmission of ideas and images, and the presentation of royal and institutional identity. The attempt to do so is justified, as I have explained elsewhere,[1] by the documented fact that early medieval art objects were required to declare their raison d'être: that is, to declare the identity of their patron and of the object they decorated, and to declare the grounds that patron and object could claim for jurisdictional authority. I have shown that in practice these declarations were made through the appearance of the objects (that is, through their style and iconography), rather than through associated texts or inscriptions, although these could be added later in the object's history. If this paper successfully argues that the ivories under consideration here are not provincial Continental works (as suggested by Goldschmidt), but Anglo-Saxon ones deriving from Canterbury (as suggested by Beckwith) and possibly also Winchester (my suggestion), and that they belong to the eleventh century rather than the ninth and tenth (my suggestion), then it will have provided grounds on which to attempt a more valid reading of the international political positioning of Anglo-Saxon royalty and its monastic centers than has been possible before.

We already have some idea of the kinds of manuscript work produced at Canterbury before the Conquest, but we presently have very little evidence about work in complementary media, such as metalwork and ivory carving. This paper suggests that the evidence of ivory carving in Canterbury has been overlooked because it shows a range of unidentified and apparently Continental styles. Most of this large group of ivories was presented by Goldschmidt in 1914,[2] and by Beckwith in 1972,[3] but they have tended to be ignored, perhaps because the two scholars came to different conclusions about them. The only example that has attracted any further scholarly attention is a reused plaque decorated with inhabited interlace, and opinions about it also vary.[4] The ivories interest me because some of the later examples remind me forcibly of the attractive plaques from Reims executed in the style of the Utrecht Psalter, but they are flatter in profile and apparently less adroitly executed. As we know, the Utrecht Psalter was in Canterbury being copied at various times during the eleventh and twelfth centuries, and it has always seemed strange to me that this manuscript should have influenced Anglo-Saxon drawing so strongly but apparently had no effect on Anglo-Saxon ivories. Yet almost certainly

it would have had ivories in the Reims style on its covers, and these must have caught the attention of patrons and/or artists.

As currently identified, the group consists of eleven plaques, several of which have been cut down and recarved to produce sixteen carvings altogether. It is not possible to illustrate more than one example of each style here, but the table on the next page may help the reader to match them to the illustrated catalogues by Beckwith and Goldschmidt, to understand their physical relationships to each other, and to keep track of them in the following discussion.

Goldschmidt identified the earlier examples as deriving from widely disparate regions. He saw the inhabited interlace panel (fig. 2), the Angel Waking the Dead (fig. 1), and the Virgin and Apostles (an Ascension or Assumption) as deriving from Tours around 800.[5] But he identified the Majesty with Angels, the Baptism and Ascension panel (fig. 3), and the Baptism and Ascension diptych as "oriental" and dated them in the late seventh or early eighth century.[6] The Transfiguration (fig. 4), the Ascension, the *Traditio Legis* (fig. 5), and the Enthroned Madonna were identified by him as a late

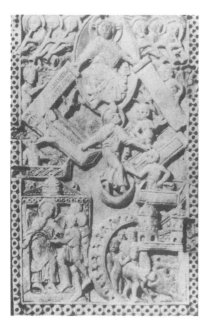

Figure 1. Last Judgment (Angel Waking the Dead), London, Victoria & Albert Museum. (After Beckwith, 1972.)

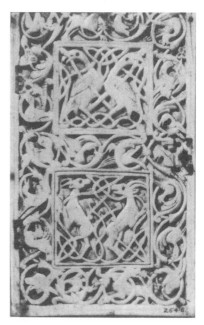

Figure 2. Decorative Panel, London, Victoria & Albert Museum. (After Beckwith, 1972.)

Subject	Location	Beckwith Catalogue	Goldschmidt Catalogue	Fig.
Transfiguration (front)	London, Victoria & Albert Mus. no. 253—1867	21	69	4
Angel waking the dead		4	178	1
Entry into Jerusalem & House of Simon (front)	London, Victoria & Albert Mus. no. 257—1867	—	107	
Baptism and Ascension		5	186	3
Foliate medallions (front)	Paris, Cluny Museum Cl. 139	—	156/7	
Baptism & Ascension diptych		6	183/4	
Majesty with angels (front)	Munich, Bayerisches Nationalmus. no. MA 158	7	185a	
Inside of older diptych, cut down			185b	
Ascension (front)	London, Victoria & Albert Mus. no. 254—1957	22	70	2
Inhabited interlace		8	179	
Virgin and Apostles (front)	Munich, Bayerisches Nationalmus. no. MA 164	9	180	
Inside of older diptych		—	—	
Traditio Legis (unknown)	Paris, Bibliothèque Nationale Cod. lat. 323	23	71a	5
Enthroned Madonna (unknown)	Paris Bibliothèque Nationale Cod. lat. 323	24	71b	
Crucifixion (unknown)	Walters	—	—	6
Arrest of Christ in three tiers (unknown)	Paris, Louvre	—	—	

Figure 3. Baptism and Ascension, London, Victoria & Albert Museum. (After Beckwith, 1972.)

Figure 4. Transfiguration, London, Victoria & Albert Museum. (After Beckwith, 1972.)

Figure 5. *Traditio Legis*, London, Victoria & Albert Museum. (After Beckwith, 1972.)

Figure 6. Crucifixion and Three Women at the Sepulcher, by permission of the Walters Art Museum, Baltimore.

branch of the Reimsian Liuthard group, belonging to the end of the ninth or early tenth century.[7] Finally, he attributed the Entry into Jerusalem to the School of Metz, late ninth or early tenth century.[8] To this set I would add two more plaques that seem to have been unknown to Goldschmidt and Beckwith: the Walters Crucifixion (fig. 6), and the Louvre Arrest of Christ.[9] Presumably attributing the Walters Crucifixion to Goldschmidt's late Liuthard Group, Randall dated it to the later ninth century.

Beckwith saw these works differently. In his *Ivory Carvings in Medieval England*, he identified all but the Entry into Jerusalem as Anglo-Saxon. The first six he placed within the eighth century,[10] and the rest in the late tenth.[11] In 1984, David Wilson accepted the inhabited interlace plaque (fig. 2) as Anglo-Saxon, dating it by implication sometime before the middle of the eighth century,[12] but he commented that some scholars preferred to see it as a "Continental" production. He did not say who these scholars were, but they evidently included David Wright and Leslie Webster. In her catalogue entry for this ivory in *The Making of England*, Webster described the plaque as "Continental, in the Insular style," citing the Virgin and Apostles plaque and the Bischofshofen Cross as comparanda.[13] These had been shown as likely Continental products by David Wright.[14] Webster then commented on the "late Carolingian" carving of the Ascension on the reverse of the inhabited interlace plaque, and mentioned the companion carving of the Transfiguration and the settings for lost hinges and locks on both. She went on to suggest that these plaques had later become the doors of a Carolingian shrine. Thus she rejects Beckwith's Anglo-Saxon thesis for both sides of the plaque and, by implication, for the group as a whole.

On the whole, then, Beckwith's view of the ivories has been rejected. Nonetheless, Beckwith has made a number valid points, and if his thesis were substantiated, we would be provided with an unexpectedly clear indication of the kind of work and range of styles probably produced in Canterbury before the Conquest. A consideration of his identification and chronology is therefore in order.

Beckwith began with the inhabited interlace panel (fig. 2), the Virgin and Apostles, and the Angel Waking the Dead (fig. 1).[15] He made quite strong comparisons between them to suggest that they all derived from a single center. Thus, for example, he compared the treatment of the faces in the Angel Waking the Dead and the Virgin and Apostles panels, allowing us to see similarities between

the finely hatched, short straight hair, the neat eyes with very close brows, and the short straight mouths; to see similarities in the use of a rather flaccid, flat beading in the frame and draperies of the Virgin and Apostles panel, and in the architecture and draperies of the Angel Waking the Dead panel. We might also note the distinctive treatment of wings in these panels: seen from the inside, they have a plain triangular area framed by a thin ridge, and the edges are hatched with chevrons. This might seem like an obvious way to produce notional wings, but in fact it is very rare. The chevroned edge and inner triangle can only be paralleled in early Byzantine ivories.[16] Beckwith then compared the border of the Virgin and Apostles panel with that of the inhabited interlace panel, pointing out the similarities in the treatment of the foliage that branches into horned goat heads, and entangles romping dogs and birds that snap at bunches of grapes. Thus, all three plaques arguably derived from a single center at much the same time.

Beckwith also compared these three panels with four others that are clearly not of the same style.[17] However, they do have a surprising number of features in common. Thus, as Beckwith pointed out, the Angel Waking the Dead and the Baptism and Ascension panels share the use of an open twist in the frame that was made by drilling neat holes at the centers and edges, and the Majesty with Angels duplicates the use of drilled beads also found in the Angel Waking the Dead. It could further be argued that the treatment of the faces in the Baptism and Ascension and the Majesty with Angels panels parallel those in the Angel Waking the Dead and the Virgin and Apostles panels, with their use of closely hatched, short straight hair and etched facial details. All four of these new panels share the use of large lopsided haloes decorated with the same flaccid, flattish beads seen in the previous group. They are also typified by the use of etched lines and punched dots: these can be seen in the mandorlas of both the seated Christ figures, on the tub of the Baptism, and on the robe of the Virgin in the Virgin and Apostles plaque. More generally, the designs are jostlingly full in all seven ivories.

Thus, despite the apparently enormous difference in style, the technical habits of the craftsmen suggest that they were all trained in the same center, and that these ivories should probably all be seen as contemporary. Here I differ from Beckwith, who acknowledged the differences in style and perhaps also in quality by placing the second group some fifty to a hundred years earlier than the first. Thus, he invited us to infer a process of improvement and

change that would have seemed logical in traditional methodological terms. I prefer to pay more attention to the craftsmen's technical habits, which are unlikely to change regardless of whatever style they may choose or be required to use. Whether these ivories are Anglo-Saxon, however, and to what date(s) they should be assigned are the next questions.

Inhabited vine scrolls are well known in Anglo-Saxon England, and Beckwith pointed to a late-eighth-century cross from St. Andrew, Auckland, Co. Durham, and mentioned several other examples too. None of his examples had zoomorphic terminals, however, and these are much harder to find. Something analogous occurs on the Bischofshofen Cross,[18] whose date is not established, but the design is less crowded and less foliate, and the animals lack the long horns found on the ivories. In fact, this feature just does not occur elsewhere very often, and thus it may be yet another argument in favor of a single center of production. Unfortunately, it does not help to date or locate that center. While it is tempting to go along with Beckwith and assume an eighth-century date for these inhabited vine scrolls, it should be remembered that the motif remained common right into the eleventh century, when it is found, for example, on the Basel Antependium.

It is more productive to consider the Angel Waking the Dead (fig. 1). Dating the panel to the late eighth or early ninth century, Beckwith stated that it was the earliest image of the Last Judgment known in the West, but this is worth further consideration. He gave no reason for this date, but perhaps the most valid comparison to emerge from his comparative material (but which he did not discuss in relation to the plaque) is between the dancing angel at the center of the panel and the Luxuria figure in a late-tenth-century manuscript of the *Psychomachia*.[19] But I find the mid-eleventh-century example now in Corpus Christi College Cambridge more compelling, because it combines the cross-legged stance with less frenetic drapery.[20] In fact, the cross-legged stance became common all over Europe in the early eleventh century; one only has to think of figural carvings at Sto. Domingo de Silos, for example, or Toulouse.

But there is a more definitive feature than this. The Jaws of Hell at the base of the panel is an Anglo-Saxon invention, of which an early example can be seen in the New Minster *Liber Vitae* of 1031 where it appears complete with cross-legged angel, and doubled-over naked soul.[21] Even the ball-like shoulder and bulging buttocks are paralleled. Indeed, one might also compare the round

towered city of heaven in the top register of the same page with the similar city behind the mouth of death on the ivory. Comparable features include the turrets with finials, string courses, and paired arched windows. I therefore suggest that the Angel Waking the Dead is Anglo-Saxon, as Beckwith stated, but I find his date implausibly early and prefer to place it in the first half of the eleventh century. By extension, I place the other five ivories (Beckwith's catalogue numbers 5 to 9, inclusive) with it.

This has implications for the remaining members of the group. For example, the Angel Waking the Dead has clearly been reused. Much of the detail is lost because it has been scraped flat, and the edges have been cut down. The same is true of the inhabited interlace panel (fig. 2), whose size is now identical with that of the Angel Waking the Dead. On the backs of these panels are the Transfiguration (fig. 4) and Ascension panels, respectively. These belong to the set Goldschmidt, Wright, Webster, and Randall identify as Carolingian—although, if my argument is convincing, that is no longer tenable. Further, if they are not Carolingian, then there is no particular reason to see them as Continental either.

The ivories do, however, have much in common with both Carolingian and Ottonian carving. They are very reminiscent of the Liuthard group, with which Goldschmidt identified them. The best parallel for the central apostle of the Transfiguration (fig. 4), for example, is found on the Psalter of Charles the Bald, where it appears as the Nathan figure.[22] It reappears as the Psalmist on the Prayerbook of Charles the Bald (Psalm 26), and presumably was quite common.[23] The treatment of the ground on the other cover of the Prayerbook of Charles the Bald looks like a probable stimulus for the treatment of the clouds and ground of the Ascension, too. In more general terms, one might note the outward splay of many figures' hands that is found both in the Reims ivories and in the later ones discussed here, and the tendency to produce squat figures with fat tummies. On another Reims ivory, the Marriage at Cana in the British Museum, the bulging tummies are particularly pronounced, and the two figures of Christ on that panel could even be seen as models for the prophets on the Transfiguration plaque (fig. 4).[24]

The Walters Crucifixion plaque (fig. 6) duplicates the border style of the Transfiguration and the ground style of the Ascension, and seems to use the figure of the Virgin from the Marriage panel as a model for the first Mary. This plaque, however, has an even better parallel in the Reims ivory now on the cover of the Pericopes

of Henry II (Munich, Bayerische Staatsbibliothek, Clm. 4452).[25] This three-tiered design includes a Crucifixion scene, with similar living cross, and similar stances for Stephaton and Longinus, and for the Virgin and John the Evangelist. The sepulcher scene on the lowest tier is also similar.

The last two plaques are the *Traditio Legis* (fig. 5) and Enthroned Madonna, whose borders and haloes duplicate those of the Transfiguration, Ascension, and Walters Crucifixion. Similarities include the inner frame of flat beading on Christ's mandorla in the *Traditio Legis*, which duplicates that in the Ascension scene, and the three-branched trees with lobed foliage under the Madonna's throne, which appear on both the Transfiguration and Ascension plaques. Finally, the Eridanus figure at the base of the *Traditio Legis* panel is a combination of the two personifications at the foot of the Pericopes Crucifixion.

As already mentioned, this group also shows Ottonian influence. This is seen most generally in the relative flatness, which is in noticeable contrast with the Reims ivories. Ottonian ivories also show this flatness, as on the panels from the Magdeburg Antependium of ca. 980, where the enlarged, rimmed haloes and foliate mandorla also appear.[26] Furthermore, the Virgin's throne and footstool reflect Ottonian designs, and can be compared with those of the Registrum Gregorii of 983, for example.[27] These Ottonian features occur throughout the group, which thus emerges with a surprisingly coherent character. I suggest, then, that despite the range of style, this set of carvings too should be seen as deriving from a single center at much the same time, which can be no earlier than the eleventh-century Angel Waking the Dead on the back of the Transfiguration.

Where might that center have been? Beckwith favored Canterbury on no very specific grounds other than suggesting that the plaques might be associated with the copying of Carolingian manuscripts at that center. Beckwith's early dating of the ivories forced him to remain noncommittal about this. But if my suggested later dates are acceptable, it may be possible to strengthen Beckwith's argument. As we know, the Utrecht Psalter was at Canterbury from ca. 1000 A.D., where it was copied at least three times. It seems very likely that it would have had Reims-style ivories on its covers to complement the drawing style inside, and I suggest that these probably stimulated the Pseudo-Carolingian work examined here. As some measure of support for this, it might be noted that the figures on the Reims ivories are stockier and bulgier than the

drawn figures in the Utrecht Psalter itself, and this trait seems to have appealed to the Anglo-Saxon craftsmen, who exaggerated it. It might also be noted that the outwardly splayed hands that are noticeable on the Transfiguration and Ascension plaques are much more common in Reims ivories than in the Utrecht Psalter, where the hands tend to be held parallel. Thus, I suggest with Beckwith that these last ivories were produced at Canterbury, but I place them later than he did, sometime in the eleventh century.

There is much work still to be done, and the evidence needs further consolidation, but the provisional findings may now be summarized. We are presented with a set of ivories that seem to have been produced in two phases. The earliest group seems to date to the first half of the eleventh century and to have been produced at some Anglo-Saxon center. The iconography of the Angel Waking the Dead plaque is so similar to the New Minster *Liber Vitae* that it is tempting at this stage to place the whole group at Winchester. We also know that there was exchange of personnel between Winchester and Canterbury, and it looks as if these first ivories may have been transported to Canterbury sometime during the eleventh century, where several (figs. 1, 3, 2) were speedily reused to produce work reminiscent of Carolingian and Ottonian styles.

In light of the contemporarily documented purpose of art mentioned above, these findings are significant. The use of elephant ivory and of Carolingian and Ottonian figurative styles lays visible claim to international political connections whose potentially public nature argues that the possibility of exploiting those connections was envisaged and provided for. If the findings in this paper are tenable, the potential value of these objects as historical evidence has been much increased.

Notes

1. Perette Michelli, "What's in the Cupboard? Ezra and Matthew Reconsidered," in *Northumbria's Golden Age*, ed. Jane Hawkes and Susan Mills (Stroud, 1999), 345–59, esp. 346–47; idem, "Inscriptions on Pre-Norman Irish Reliquaries," *Proceedings of the Royal Irish Academy* 96 (C), (1996): 1–48, esp. 3–4.

2. Adolf Goldschmidt, *Die Elfenbeinskulpturen aus der Zeit der karolingischen und sachsischen Kaiser, VIII–XI Jahrhundert,* vol. 1 (Berlin 1975), cat. nos. 69, 70 and 179, 71a, 71b, 107 and 186, 156 and 183, 157 and 184, 178, 180, 185a, 185b.

3. John Beckwith, *Ivory Carvings in Early Medieval England* (London, 1972), cat. nos. 4 and 21, 5, 6, 7, 8 and 22, 9, 23, 24.

4. This is ibid., cat. no. 8, discussed by David Wilson, *Anglo-Saxon Art from the Seventh Century to the Norman Conquest* (London, 1984), 67, 64, and by Leslie Webster, in Leslie Webster and Janet Backhouse, eds., *The Making of England: Anglo-Saxon Art and Culture, A.D. 600–900* (London, 1991), cat. no. 140.

5. Goldschmidt, *Die Elfenbeinskulpturen*, vol. 1, cat. nos. 179, 178, 180, respectively.

6. Ibid., cat. nos. 185, 186, 183–84, respectively.

7. Ibid., cat. nos. 69, 70, 71a, 71b, respectively.

8. Ibid., cat. no. 107.

9. R. H. Randall Jr., *Masterpieces of Ivory from the Walters Art Gallery* (New York, 1985), 245.

10. Beckwith, *Ivory Carvings*, cat. nos. 4, 5, 6, 7, 8, 9, respectively.

11. Ibid., cat. nos. 21, 22, 23, 24, respectively.

12. Wilson, *Anglo-Saxon Art*, 67, 64, where he suggests that the designs are earlier than the Ormside bowl, which he dates "tentatively" to the first half of the eighth century.

13. Webster and Backhouse, *Making of England*, cat. no. 140.

14. David Wright, "The Byzantine Model of a Provincial Carolingian Ivory," in *Abstracts of Papers, Eleventh Annual Byzantine Studies Conference, Toronto, Oct. 25–27*, (Toronto, 1985) 10–12.

15. Beckwith, *Ivory Carvings*, 22–25.

16. A ninth-century Evangelist plaque from Ravenna is a particularly clear example. See Goldschmidt, *Die Elfenbeinskulpturen*, vol. 1, cat. no. 33.

17. Beckwith, *Ivory Carvings*, 24–25.

18. See Webster and Backhouse, *Making of England*, cat. no. 133 for a clear detail.

19. See Beckwith, *Ivory Carvings*, 32 fig. 32 and 35 fig. 37.

20. See Hans Holländer, *Early Medieval Art* (London 1974), 184 fig. 151.

21. See Wilson, *Anglo-Saxon Art*, 185 fig. 232.

22. See John Beckwith, *Early Medieval Art, Carolingian, Ottonian, Romanesque* (London, 1974), 47, fig. 37; Goldschmidt, *Die Elfenbein-skulpturen*, 1: 24–25, cat. nos. 40a, b.

23. See Beckwith, *Early Medieval Art*, 49, fig. 40 (both covers, Psalms 26 and 24), or Goldschmidt, *Die Elfenbeinskulpturen*, 1: 26–27, cat. nos. 42, 43 (43 depicts Psalm 26).

24. See Peter Lasko, *Ars Sacra, 800–1200*, 2d ed. (New Haven, 1994), 118, fig. 163, or Goldschmidt, *Die Elfenbeinskulpturen*, vol. 1, cat. no. 46.

25. See Beckwith, *Early Medieval Art*, 48, fig. 3, or Goldschmidt, *Die Elfenbeinskulpturen*, vol. 1, cat. no. 46.

26. Beckwith, *Early Medieval Art*, 126, fig. 107.

27. Ibid., 100, fig. 83.

5

Style in Late Anglo-Saxon England: Questions of Learning and Intention

Carol Farr

Everyone knows that medieval artists and scribes copied models. Eleventh-century Anglo-Saxon artists produced a few examples after surviving works. While a good amount of scholarship has been devoted to the study of their adaptation of iconographic motifs from earlier models, their stylistic responses to these models have received less attention. Could study of various recyclings of older works of art tell us anything about how and why the artists learned and used styles? How aware of style were artists? Were stylistically updated copies of highly valued works meant to refer to the sanctity and power of their older models, or should we understand copying mainly as a method for efficient production of much-needed luxury manuscripts?

Attempts to answer the above questions should begin with a recognition that we have very little idea of Anglo-Saxon consciousness of visual style. This is not to deny that they had any. Visual qualities must have been important to them: ecclesiastic and prestige objects seem to have been created within developed and changing aesthetic senses.[1] The modern art-historical concept of style, however, is itself a historically located discourse of the twentieth- and twenty-first centuries. This discourse, only rarely acknowledging its subjective basis, usually sees itself as scientific in its analytic treatment of works of art, a treatment that centers on visual elements—the kinds of lines, shapes, colors, and three-dimensional forms used. Its analytical method grew up within the need to date and attribute works of art and provides the main evidence where documentation is missing (as it usually is in the Anglo-Saxon period). Moreover, it enables the grouping of works into period or

regional styles. Such period styles often are connected in art-historical thinking with other aspects of the contemporary cultures.[2] The connections may be quite abstract, as in broad comparisons of characteristic visual shapes and forms with the "shapes" of social structures, or they may be made in more concrete ways, for example, arguing that a period's valuation of particular materials or of the artist's facility in specialized skills determines the visual qualities of works of art. An example of the former would be H. P. L'Orange's classic structuralist comparison of the rigid, symmetrical shapes, forms, and compositions of late antique art with late Roman society's increasingly centralized, static, and hierarchical social and political structures.[3] An example of the latter would be Michael Baxandall's account of the "period eye" of the fifteenth-century Florentine art-viewing audience, where social conditioning and experience brought about the appreciation of illusionism (the depiction of three-dimensional forms and volumes).[4]

The modern art historian's concept of style has developed at a fair conceptual remove from the processes of artists, desires of patrons, and expectations of viewers in past historical periods. Understanding how and why tenth- and eleventh-century scribes and painters looked back to older styles and developed new ones involves a use of evidence that differs from the analysis of style and its periodization. It means trying to locate historically the visual sense of artists and the aesthetic, religious, or ideological expectations in which this sense participated. It draws upon more concrete evidence and specific connections with precise historical contexts, on the order of Baxandall's period eye, although without even the sparse documentation of fifteenth-century artists' contracts and treatises about the way art should look and how it should be appreciated, such as Alberti's *Della pittura*. One slim category of evidence for the use of visual style in Anglo-Saxon culture is the recycling and stylistic updating of earlier book art, either by altering an actual earlier manuscript with new illuminations or scripts or stylistically reinterpreting an earlier image with a new painting or drawing. Close inspection and analysis of such examples could give some clues about the ways in which artists and scribes learned styles as well as their awareness of styles. Contexts of production and contemporary use for nearly all surviving examples, however, are unknown, the art and scripts in the manuscripts having been assigned dates and places of origin mainly on the basis of styles by paleographers and art historians, although textually some of them can be associated with particular centers or regions. For this rea-

son, generalization about use of style is very dangerous. Anglo-Saxon book producers and consumers undoubtedly acted with a variety of motives in their use of old books and book art, and these motives changed with the context. The relationship between old and new art styles probably was a dynamic one, subject to and participating in the increasingly developed monastic and ecclesiastic structures and the new social and political alliances of the late tenth and eleventh centuries. The question of intention must be handled carefully, therefore, with attempts to consider possible individual contexts being done as carefully as possible, in a case-by-case account.

In some instances, the models must have been treasured for their holy and authoritative connections. The late-seventh- to early-eighth-century Lindisfarne Gospels (London, British Library, Cotton Nero D.iv, fol. 25v) probably provided a model for the portrait of Matthew accompanied by his symbol in the Copenhagen Gospels (Copenhagen, Kongelige Bibliotek, GL. Kgl. Sml. 10,2°, fol. 17v; see fig. 1).[5] The two resemble each other in the pose of the evangelist figure, the type of floating winged symbol with trumpet, and the gray-haired, haloed figure who peers from behind the red curtain while holding a book with draped hand. While details are not exactly the same, the iconographic features of the two seem clearly and directly connected. The Copenhagen Gospels's text and illuminations apparently were executed in two contexts, separated by either time or space. The usual explanation says that the book was begun and mostly written in the late tenth century, but it was finished probably in the 1020s.[6] Heslop, however, has recently argued for execution of the whole book around 1020 "without serious interruption" and has suggested that it was produced in two centers, with access to and use of gold restricted to the second scribe (B).[7] Scribe B also wrote, among other surviving illuminated manuscripts, the Missal of Robert of Jumièges (Rouen, Bibliothèque Municipale, Y.6), which has been connected with Peterborough because its textual source seems to have been a sacramentary used at the abbey there.[8] Derek Turner pointed out the presence at Durham of the Peterborough monk Æthelric, who was adviser to Edmund, bishop of Durham (1021–ca. 1042), and later became bishop himself (ca. 1042–ca. 1056). Cuthbert's relics, including the Lindisfarne Gospels, had arrived in Durham in 995.[9] Turner implied that the artist or even scribe of the Copenhagen Gospels might have seen either the Lindisfarne Gospels itself or possibly some form of copy—drawings or illuminations—of the evangelist portraits.

Figure 1. Copenhagen Gospels, Portrait of St. Matthew (Copenhagen, Kongelige Bibliotek, GL. Kgl. Sml. 10,2°, fol. 17v). By permission of the Kongelige Bibliotek.

In the Copenhagen Gospels, evidence for a transfer process of some kind exists in the faint stylus indents on the versos of folios that would have preceded each portrait. Although possibly the result of primary drawing without transfer, the indents could have been caused by tracing or transferring, with a stylus, drawings onto the leaves either subsequent to the manuscript's binding or for some reason before binding but with bifolia held in the positions in which they were to be bound. An intermediate drawing would make sense, because the Copenhagen picture does not represent a copy in the strictest sense: it does not emulate the Insular style, and it seems unlikely that the Lindisfarne Gospels (or any late antique model shared by both manuscripts) traveled to southern England. Furthermore, since drawings made of the Lindisfarne

portraits could have predated the Copenhagen ones by years, the proposed explanation involving sketches made from Lindisfarne that were transferred into Copenhagen about 1020, in some connection with Peterborough and Scribe B, does not by itself contradict Heslop's argument and possibly even supports his view that the manuscript was planned as a single campaign and the two scribes "were working contemporaneously, if not quite 'together.' "[10] To take this proposition a step farther, one could suggest that there was no "artist" of the Copenhagen portraits, but rather two or more artists completing the work in stages: (1) sketches after the Lindisfarne portraits, (2) transfer of the sketches to the new leaves, and (3) inking, painting, and application of gold. Each step of stage (3) could in turn have been done by separate hands.[11]

Having considered the probable complexity of the process of copying, one might then ask how important the status of Cuthbert's gospel book—the Lindisfarne Gospels—might have been in this process. Was the artist learning from it how to make a holy image? Or was the purpose more intensely ideological, intending to connect the book and its users in some way with the identity or position of Cuthbert as a powerful saint? When drypoint drawings survive on their own in margins or on blank spaces such as flyleaves in earlier manuscripts, their purposes include learning trials and recordings of subject matter, but these aims could overlap.[12] The fame and prestige of the Lindisfarne Gospels and the rest of Cuthbert's relics, as the recently arrived miracle-workers around which Durham was being built, may have attracted patrons and creators of book art and brought about desires to imitate their decoration as a way of referring to and connecting with objects of status and power. The Copenhagen Gospels could have been made, like some other luxury gospel books, as a gift destined for the Continent, its visual style made appropriate for high-status recipients. The late-twelfth-century neumes added on folios 16 and 16v, contrary to previous opinions, almost certainly are not English, although this liturgical matter appears to have an English origin, opening up the possibility that the manuscript had traveled to the Continent during the eleventh century.[13] If it was made for an English audience, in particular an ecclesiastical one with connections to Durham, references in the evangelist portraits to those of the Lindisfarne Gospels probably would have had a definite significance and impact. If the book was intended as a gift for a Continental recipient without any particular connections to Cuthbert or Durham, then those basing the portraits on the Lindisfarne ones

may not have assumed the references would have been understood without some kind of explanation.

While conclusions about intention must remain speculative, the Copenhagen portraits and the indentions on the versos that preceded them indicate that the process of copying was complex, accomplished in phases by at least two scribes and probably more than one artist. Perhaps this complexity means, too, that adaptation of style and adjustment of details were part of learning and that intention could have had the same diversity as reception.

Another kind of Anglo-Saxon recycling of an older work can be seen in the mid-tenth-century redecoration of an eighth-century Irish pocket gospel book, London, British Library Additional 40618. Allowing its Insular miniature of St. Luke to remain in place, the Anglo-Saxon artist painted on inserted leaves portraits and symbols of Luke and John in tenth-century southern English style (fig. 2). Artist or scribe updated the decoration of initials, too, scraping off the original decorated incipits as well as the smaller initials set in the margin beside the text, repainting them in classicizing golden capitals.[14] The process involved alterations to nearly every page of the manuscript. Besides the questions about why these changes were desired and how they altered the significance or value of this small book, one could also consider how the transformation was accomplished. The scribe in particular probably became very familiar with the manuscript during his finicky replacement of the initials. He could have become aware, if he was not already, of the way that the text was structured by initials and how different this was from the layout and styles of articulation in current use. It is possible that the stylistic transformation was also a learning process. Some scribes must have had a highly developed knowledge of earlier styles of textual presentation. Could artists also have possessed such a precise understanding of formal differences and likenesses in decoration and pictures?

The stylistic changes made to Additional 40618 were not designed to make it more legible: no changes were made to the tiny Irish minuscule in the text block. The scribes and artists of the Harley 603 Psalter (London, British Library, Harley 603), however, changed script styles and inserted word divisions within the three-column format in their interpretation of the Utrecht Psalter (Utrecht, Rijksuniversiteit Bibliotheek, 32). Most of the original artists imitated the style of the Utrecht drawings only in a general way: on most pages they set up the panorama of landscape using ground lines and placed small, expressive line figures within it, following

Figure 2. Recycled Irish pocket gospels, Portrait of St. Luke and the opening of his gospel (London, British Library, Additional 40618, fols. 22v, 23r). By permission of the British Library.

to various degrees the composition of their model. William Noel has analyzed the page layouts and drawings in detail for each of the twelve scribes and artists, and has concluded, among other things, that the intention was not to make a facsimile in the modern sense.[15] Noel points out the scribe Eadui Basan's use of lead point for ruling, an unusual practice in the first quarter of the eleventh century. Eadui used lead point, according to Noel, in his effort to adhere to the column layout of Utrecht's text and to preserve illustration space clear of indentions from ruling. One of the artists of Harley 603 (artist B) had already used lead point to create preparatory drawings.[16] Possibly some of the Harley artists also used lead point to make preparatory sketches from the Utrecht pictures: in the Utrecht Psalter some lead-point sketches are visible around the margins of the drawings.[17]

Eadui Basan was working within an environment of careful study of older, often venerable, manuscripts. Nonetheless, he seems to have been a transformer of styles, a prominent scribe who formulated the script style of English Caroline minuscule, which became the status script in the first quarter of the eleventh century for Latin manuscripts produced in southern England.[18] Eadui's minuscule and capitals are distinctive in form, as seen in the Grimbald Gospels (London, British Library Additional 34890, fol. 12r; fig. 3). Besides unifying two older script styles to form English Caroline minuscule, he also may have known a great deal about precise features of layout of older manuscripts. For example, in these two folios, he has followed Insular articulation of the texts of Matthew and Luke that close the genealogy of Christ. At the top of fol. 12r, the text "Xpi autem generatio sic erat" is written in large gold capitals, the initial "X" larger than nearly any other letters except for the incipits of each gospel.[19] His treatment of the text preserves the great Insular illuminated monograms of Christ at this position in Matthew's gospel. On fol. 79 the initial "I" at Luke 4:1, "I h s autem plenus" is unusually large and there is further elaboration of the incipit with capitals. Although this point marks the beginning of a chapter division as well as a Eusebian section, this articulation is also extraordinary in the manuscript. Possibly the reason for it is that Eadui duplicated the articulation at a point seen in Insular gospel manuscripts, notably the Book of Kells (Dublin, Trinity College, 58, fol. 202v), where the image of the body of Christ as the church is inserted. This iconography, as well, is perhaps repeated in the Grimbald Gospels, but at the incipit of the Gospel of John (fols. 114v–115r) where the frames of the two pages

Figure 3. Grimbald Gospels, Matthew 1:18: XPI AUTEM (London, British Library, Additional 34890, fol. 12r). By permission of the British Library.

are embellished with choirs of saints to surround the statement of the incarnation of Christ (fig. 4).[20] These are not obvious references or responses to earlier book art. The necessary questions as to what viewer or reader would have understood them as intentional references to venerable books can not be answered at present, but it seems clear that Eadui and some of the artists with whom he

124 *Carol Farr*

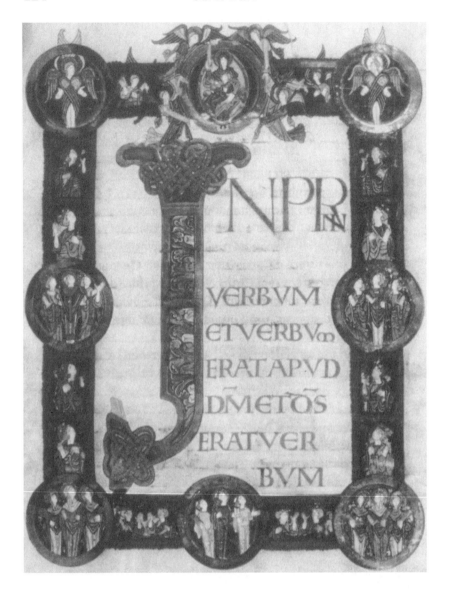

Figure 4. Grimbald Gospels, Opening of the Gospel of St. John (London, British Library, Additional 34890, fol. 115r). By permission of the British Library.

worked had studied earlier book art diligently and used what they knew consciously to create decoration and illumination that were meant as more than copies for the sake of efficient production.

Eadui himself may have been an artist. Two of the manuscripts that Eadui wrote—the Eadui Gospels (Hannover, Kestner Museum, W.M. XXIa, 36) and the Arundel Psalter (London, British Library, Arundel 155, fols. 1–191)—were almost certainly illuminated by the same artist. As Heslop has also pointed out, scrolls and books depicted in the pictures in the two manuscripts present capital letters and minuscule script quite close to Eadui's forms.[21] Furthermore, the unusual iconography of the Hannover portrait of John (fol. 147v; fig. 5), with its inclusion of Arius with his heretical text

Figure 5. Eadui Gospels, Portrait of St. John (Hannover, Kestner Museum, W.M. XXIa, 36, fol. 147v). By permission of the Kestner Museum.

denying Christ's eternity, could be related to that of the portrait in the Grimbald Gospels, which also emphasizes the Incarnation by its depiction of the heavenly church (the heavenly body of Christ) and the longer-than-usual emphasized incipit text.[22] The style of the portrait in the Eadui Gospels clearly differs from that of the Grimbald. The figure is monumental in scale, the lines bolder, and colors warmer. The background is less abstract: it is worked out as a pattern of colored shapes. This visual boldness has often been noted in the picture of St. Benedict in the Arundel Psalter (London, British Library, Arundel 155, fol. 133; fig. 6), which combines drawing with full-color painting with gilding in the same image.[23] The

Figure 6. Arundel Psalter, Portrait of St. Benedict (London, British Library, Arundel 155, fol. 133). By permission of the British Library.

two also share characteristic lines in facial features and hands, as well as treatment of painted background. The vigor of the style has often been compared with that of the drawings in the Harley Psalter, leading to speculation that the artist—especially if Eadui—had been directly influenced by the Utrecht Psalter style.[24]

Visual daring is prominent, moreover, in the historiated initial of Psalm 51 (fol. 93) in the Arundel Psalter.[25] Here the artist has arranged the bold, monumental figures of David and Goliath in an extraordinary composition without ground lines or other spatial structure provided by architecture, furniture, or heavenly clouds— the usual spatial environments of figures in the period, as in the Harley 603 Psalter. The two figures are arranged over an uptilted ground plane, so that their bodies form an expressive swirl of interlocking shapes, with faces and weapons strategically placed for maximum visual impact. If Eadui is the artist here it is possible that this composition represents his response to study not just of the Utrecht Psalter but at least in part of the Vespasian Psalter (London, British Library, Cotton Vespasian A.i), another important earlier manuscript he is known to have seen. Eadui wrote a quire containing "Te Deum," "Quicunque vult," and several prayers inserted at the end of the psalter (fols. 155–60).[26] The Vespasian Psalter provides the earliest examples of historiated initials. Although the initial of David and the Lion (fol. 53) differs from the Arundel figures in its simpler, more rounded shapes and lines, it too shows the figures floating against an uptilted background without ground lines.[27] Eadui may have learned a lesson in composition within the irregular area of an initial shape by studying the Vespasian Psalter's initial.

The initial of Psalm 51 is the only historiated one in the Arundel Psalter, but the two other full-page initials (fols. 12, 53) present decorative forms in their frames that resemble those of the Kederminster Gospels, which is dated to about 1020 (London, British Library, Loan MS 11, fol. 84).[28] For example, both manuscripts place evangelist symbols or portraits (of saints or prophets) in roundels in the sides of the frames. Arundel does so even though it is a psalter. Between them, the two scribes of Kederminster (scribes C and B) also worked on the Missal of Robert of Jumièges (scribe B), the Copenhagen Gospels (B with principal scribe A)—the gospel book with evangelist portraits based on those of the Lindisfarne Gospels—and possibly with Eadui on a lectionary in the Laurentian Library, Florence (MS Plut. xvii.20). Together the two Kederminster Gospels scribes, before 1020, wrote the important gospel book,

London, British Library, Royal 1.D.ix, which was revered at Christ Church, Canterbury, and which the artist of the Kederminster Gospels also painted. Eadui wrote, at the request of Archbishop Lyfing (1013–20), the royal deed of confirmation on the rights of Christ Church on pages before the text of Mark that were originally blank.[29] Royal 1.D.ix and Kederminster are two of four known late Anglo-Saxon gospel books that preserve the Insular emphasis on the monogram of Christ in the text of Matthew, the other two being the Grimbald Gospels, already mentioned, and the Trinity Gospels (Cambridge, Trinity College, B.10.4(215)), which was written by Scribe B (who also worked on Kederminster, Royal 1.D.ix, and Copenhagen). Scribe B was comparable in output and probable status with Eadui, his major work probably having been the Missal of Robert of Jumièges.

Eadui seems, then, to have had extended contact with the work of artists and scribes, whether they were at Christ Church (as seems likely) or at Peterborough (as has been suggested), who like him possessed a detailed knowledge of stylistic and iconographic features of older, often highly valued, manuscripts. Risking being a victim of the accidents of survival, one might conclude that these scribes and artists consciously selected high-status models, which in turn might imply some sort of ideological intention, depending on the context for which any particular manuscript might have been intended. At least one can more safely conclude that these creators of luxurious manuscripts possessed an impressive knowledge of stylistic features of visual images, textual layouts, and scripts as well as iconography of older manuscripts.

Notes

Catherine Karkov and George Brown are due thanks, as are William Noel for his comments on the original paper and Michelle Brown for her help with photographs. I am most grateful as well for the assistance of the staffs of the British Library, London; the Kongelige Bibliotek, Copenhagen; and the Kestner Museum, Hannover.

1. C. R. Dodwell, *Anglo-Saxon Art: A New Perspective* (Manchester, 1982), 24–43.

2. Michael Podro, *The Critical Historians of Art* (New Haven and London, 1982), 61–151; David Carrier, "Art History," in *Critical Terms for Art History*, ed. Robert S. Nelson and Richard Shiff (Chicago, 1996), 133–41.

3. Hans Peter L'Orange, *Art Forms and Civic Life in the Late Roman Empire* (Princeton, 1965), 69–131.

4. Michael Baxandall, *Painting and Experience in Fifteenth-Century Italy: A Primer in the Social History of Pictorial Style* (Oxford, 1972).

5. Janet Backhouse, Derek H. Turner, and Leslie Webster, eds., *The Golden Age of Anglo-Saxon Art, 966–1066* (London, 1984), no. 48, p. 68; Elżbieta Temple, *Anglo-Saxon Manuscripts, 900–1060* (London, 1976), no. 47, p. 69. See J. J. G. Alexander, *Insular Manuscripts, Sixth to Ninth Century* (London, 1978), 38–39, who refutes R. L. S. Bruce-Mitford's argument that the Copenhagen portraits were copied from a late antique model that Eadfrith had used in creating the Lindisfarne evangelists and symbols. Michelle Brown now dates the Lindisfarne Gospels to the late 710s; see Michelle P. Brown, *"In the Beginning Was the Word": Books and Faith in the Age of Bede*, Jarrow Lecture (Jarrow, 2001) 19–20, and idem, *The Lindisfarne Gospels: Society, Spirituality and the Scribe* (Luzern, forthcoming).

6. T. A. M. Bishop, "The Copenhagen Gospel Book," *Nordisk Tidskrift for Bok- och Biblioteksväsen* 54 (1967): 33–41; Temple, *Anglo-Saxon Manuscripts*, p. 69.

7. T. A. Heslop, "The Production of *de luxe* Manuscripts and the Patronage of King Cnut and Queen Emma," *ASE* 19 (1990): 167–69, 188, 191–95; see also William Noel, *The Harley Psalter* (Cambridge, 1995), 60–61.

8. Christopher Hohler, "Les saints insulaires dans le Missal de l'Archevêque Robert," in *Jumièges. Congrés scientifique du XIIIe Centenaire* (Rouen, 1955), 293–303.

9. In Backhouse, Turner, and Webster, *Golden Age*, 68.

10. Heslop, "*De luxe* Manuscripts," 167, 194.

11. Jonathan J. G. Alexander, *Medieval Illuminators and Their Methods of Work* (New Haven, 1992), 40–47; see also Heslop, "*De luxe* Manuscripts," 193–94, who points out Scribe B's application of gold minuscule script on the open pages of Luke's book, which the "artist" had painted white. This unusual sequence (gold was usually applied before painting) is taken to show that Scribe B completed the book. On early use of leadpoint and transfer techniques, see Brown, "*In the Beginning*," 20–24; idem, *Lindisfarne Gospels*.

12. Jonathan J. G. Alexander, "Preliminary Marginal Drawings in Medieval Manuscripts," in *Artistes, artisans et production artistique au moyen age, 3 Fabrication et consommation de l'œuvre*, ed. X Barral I Altet, Colloque international, Centre national de la recherche scientifique, Université de Rennes II—Haute-Bretagne, 2–6 mai 1983 (Paris, 1990), 311.

13. Susan Rankin, personal comment, cited in Patrick McGurk, "Text from *The York Gospels*," in *The York Gospels*, ed. Nicholas Barker (London, 1986), 43; cf. Temple, *Anglo-Saxon Manuscripts*, 69.

14. Backhouse, Turner, and Webster, *Golden Age*, 27; Temple, *Anglo-Saxon Manuscripts*, 43; *CLA*, 2:18.

15. Noel, *Harley Psalter*.

16. Ibid., 32–36, 95–96; see also Richard Gameson, "The Anglo-Saxon Artists of the Harley (603) Psalter," *Journal of the British Archaeological Association* 143 (1990): 29–48; and idem, "Manuscript Art at Christ Church, Canterbury, in the Generation after St Dunstan," in *St. Dunstan: His Life, Times, and Cult*, ed. Nigel Ramsay, Margaret Sparks, and Tim Tatton-Brown (Woodbridge, 1992), 187–220. The lead point is visible in color plate XI (fol. 26).

17. Alexander, *Medieval Illuminators*, 73–76.

18. T. A. M. Bishop, "Notes on Cambridge Manuscripts, Part VII: The Early Minuscule of Christ Church Canterbury," *Transactions of the Cambridge Bibliographical Society* 3, no. 5 (1963): 413–23; idem, *English Caroline Minuscule* (Oxford, 1971); David Dumville, *English Caroline Script and Monastic History: Studies in Benedictinism, A.D. 950–1030* (Woodbridge, 1993), 120–40, 150–57.

19. See also Richard Gameson, *The Role of Art in the Late Anglo-Saxon Church* (Oxford, 1995), 218.

20. Jennifer O'Reilly, "St John as a Figure of the Contemplative Life: Text and Image in the Art of the Anglo-Saxon Benedictine Reform," in Ramsay, Sparks, and Tatton-Brown, *St. Dunstan,* 179–80; Gameson, "Manuscript Art," 216–19.

21. Heslop, *"De luxe* Manuscripts," 176.

22. O'Reilly, "St John," 178–79.

23. Temple, *Anglo-Saxon Manuscripts*, 84–85, 86.

24. Noel, *Harley Psalter*, 142–43; Heslop, *"De luxe* Manuscripts," 176; Temple, *Anglo-Saxon Manuscripts*, 85.

25. Temple, *Anglo-Saxon Manuscripts*, 84–85, illustration 220; Jonathan J. G. Alexander, *The Decorated Letter* (New York, 1978), plate 16.

26. Richard Pfaff, "Eadui Basan: Scriptorum Princeps?" in *England in the Eleventh Century*, ed. Carola Hicks, Harlaxton Medieval Studies, 2 (Stamford, 1992), 276–77.

27. Alexander, *Insular Manuscripts*, illustration 144.

28. Backhouse, Turner, and Webster, *Golden Age*, nos. 51, 69, 70; Temple, *Anglo-Saxon Manuscripts*, illustrations 216, 217.

29. Heslop, *"De luxe* Manuscripts," 181–82; Dumville, *English Caroline*, 139–40; Pfaff, "Eadui Basan"; Temple, *Anglo-Saxon Manuscripts*, 89; Backhouse, Turner, and Webster, *Golden Age*, 69.

6

House Style in the Scriptorium, Scribal Reality, and Scholarly Myth

Michelle P. Brown

In the great palaeographical game of "Cluedo" the telltale clues that are painstakingly pieced together to reveal "whodunnit" are few and far between. Little surprise, then, if such clues are occasionally overconstrued or if, having once successfully deduced that "the Butler did it" he should become the leading suspect in all similar cases. The Butler is of course "house style" in the present context. Having credibly placed a manuscript's production in a particular center, the temptation is to allow that center to act as a magnet to other free-floating hands that exhibit a similar range or proportion of isolated features. Such a methodology is logical enough, provided an objective perspective is maintained and the dissimilarities are given equal weight. What often happens, however, is that a preconceived historical construct is applied and the evidence massaged to fit the matrix.[1]

In this chapter I shall take a few case studies from the realm of Insular manuscripts to illustrate some of the pitfalls and potential of perceived "house style" in the scriptorium, commencing with one of the greatest scholarly constructions of them all: the Lindisfarne scriptorium of the Durham-Echternach Calligrapher and Eadfrith.

The analysis of the Lindisfarne Gospels (London, British Library, Cotton Nero D.iv) undertaken by Julian Brown, Rupert Bruce-Mitford, Thomas Kendrick, and others in the facsimile volumes of 1956 and 1960, followed by that applied to the Durham Gospels (Durham, Cathedral Library, A.II.17) by Chris Verey and others in 1980, resulted in a reconstruction of the Lindisfarne scriptorium around 700 that featured a conscious reform of a half-uncial script

that had been reinvented in a Hiberno-Saxon milieu during the seventh century for high-grade liturgical use.[2] The evolution of this "Phase II reformed half-uncial" was traced, with some contorted time-flipping, through the pages of the Durham, Lindisfarne, and Echternach Gospels (the latter, Paris, Bibliothèque Natonale, lat. 9389, actually employing a lower-grade set minuscule, allegedly because it was a "rushed job"), and in the process two master scribes emerged: the Durham-Echternach Calligrapher (fig. 1) and his younger fellow and possible pupil, Eadfrith, the artist-scribe of the Lindisfarne Gospels (fig. 2).[3] Having constructed such an aesthetically pleasing edifice, the temptation was to fossilize it and to identify canonical features of script and decoration in other works. Thus, Julian Brown could not conceive that the Book of Kells (Dublin, Trinity College Library, 58) could be far removed from Lindisfarne in time or space, because it too employed a reformed half-uncial script.[4] His proximity to the script in its purest form sadly blunted his appreciation of just how influential and long-lived a script style of such consummate artistry could be.

Figure 1. The work of the so-called Durham-Echternach Calligrapher, Durham, Cathedral Library A.II.17, fol. 71v. Photo: courtesy of the Dean and Chapter of Durham Cathedral.

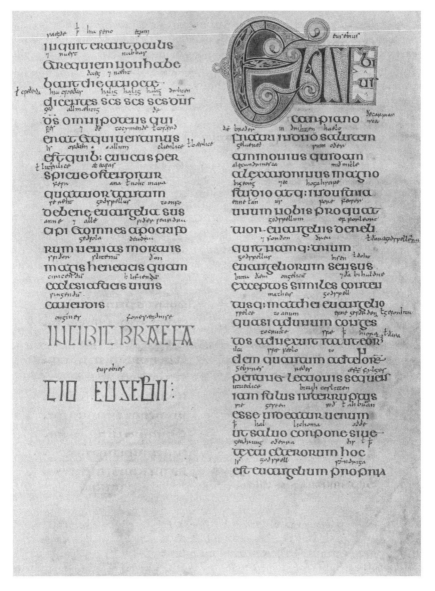

Figure 2. The Lindisfarne Gospels, London, British Library, Cotton Nero D.iv, fol. 8. Photo: courtesy of the British Library Board.

Such an iconic approach could not go unchallenged, and in the succeeding decades attempts have been made by various scholars, notably Dáibhí Ó Cróinín and William O'Sullivan, to

deconstruct the myth but without always adequately addressing the details of the analyses.[5] Their concern has been rather to reappropriate the construct and reset it in an Irish context, with Rath Maelsigi emerging from the mists of time to rival Lindisfarne as the historical focus (as the cradle of the Northumbrian Willibrord's collaborative mission that led to the foundation of Echternach in 698) and as the ultimate home, along with Echternach, of the script style. It took the publication in 1994 of the more measured and detailed work of Nancy Netzer in examining the probable works of the Echternach scriptorium to begin to gain a more realistic, complex, and subtle appreciation of the dynamics of collaboration within the *paruchia* of Columcille.[6] A meticulous reexamination of the manuscripts themselves, rather than disembodied historical interpretation, revealed an initial injection of both Irish and Northumbrian exemplars and personnel into the newly founded center, followed by the gradual establishment during the eighth century of a scriptorium in which both these and local Continental influences merged to form a new house style that, by the ninth century, was indeed a house style—by virtue of its mixed parentage. That is not to say that second- and third-generation scribes in the Echternach scriptorium were methodically taught to write a script that combined Irish, Northumbrian, and Merovingian features; the style evolved as a result of inherited influences and was distinguished thereby from that of other Continental scriptoria. Similarly, as the work of Rosamond McKitterick has shown, the Fulda scriptorium absorbed influences from the Insular minuscule practiced by its founder, St. Boniface, and his circle, manifest in the retention of archaic features such as the distinctive *g* with reversed ductus head-stroke that can still be observed in West Saxon books of the early ninth century, such as Oxford, Bodleian Library, Bodley 426 (Philippus, *Expositio in Job*).[7] Echternach and Fulda may be said to have produced distinctive or "house" styles by virtue of absorbed regional influences induced by historical circumstance.

Another book can usefully be cited when considering the Lindisfarne scriptorium and its legacy. This is one of the deluxe Insular gospel books, now sadly mutilated and split between Corpus Christi College Cambridge, where it is MS 197B, and the British Library, where the charred remains that survived the Ashburnham House fire of 1731 are now Cotton Otho C.v.[8] This is a volume that was cited by Dáibhí Ó Cróinín in support of an Irish origin for the

"Lindisfarne" style, for it exhibited features of script and decoration that were reminiscent of the Echternach and Maihingen Gospels (Augsburg, University Library, Cod. I.2.4°2).[9] A closer analysis of the entire range of surviving evidence reveals, once again, a more complex scenario.

The Cambridge/London Gospels is the work of three scribes who were operating in a scriptorium that was heavily influenced by the stylistic developments and, to some extent, the textual models of the Lindisfarne scriptorium of ca. 700 (as presented by Julian Brown, Rupert Bruce-Mitford, and Christopher Verey).[10]

Lowe, in *Codices Latini Antiquiores*, identified two scribal hands, which were common to both portions of the manuscript. My study has revealed a third hand, which is only represented in the Cotton fragment. The hands are here termed A, B, and C. Their occurrence is as follows:

Scribe A (fig. 3):
197B—pp. 248–64 (Jn 1:1–10:29, passim; ends at a quire break)
Otho—fols. 5 (or 7)–26v (Mt. 16:28–end of the Mk preface)
Scribe B (fig. 4):
197B—pp. 265–315 (Lk. 4:6–23:26, passim)
Otho—fols. 1–4v (or 6v) (Mt. 12:47–16:24)
Scribe C (fig. 5):
Otho—fols. 28–64v (Mk.1:1–16:20)

It should be noted that a firm attribution of fols. 5–6v has not been possible. The fire damage and distortion are considerable at this point and, although the script of these folia resembles that of Scribe B, the decoration is that of Scribe A. Considerations of aspect have not been able to assist greatly here, owing to the distortion.

The variations in the approaches of these three scribes indicates that their scriptorium drew upon several traditions, which could be simultaneously tolerated and fused. Scribe A shows signs of having a more conservative background of a more overtly Irish character, and, although he was the weakest scribe in terms of care of execution (while still an undoubtedly fine calligrapher), he seems to have led the production team and to have been the major artist. He shared the bulk of the work with Scribe B, who was more fully receptive to Phase II developments, particularly those thought to have been introduced by the Lindisfarne scriptorium. These two were responsible for the bulk of the work, leaving only the Gospel

Figure 3. The hand of Scribe A of the Cambridge-London Gospels, from a facsimile of London, British Library, Cotton Otho C.v, fol. 25r, made for Edward Harley before it was burnt in 1731. British Library, Stowe 1061, fol. 36r. Photo: courtesy of the British Library Board.

of Mark (except its prefatory material and major decoration) to Scribe C, who combined elements from both traditions to form his own distinctive style.

Thus Scribes A and B, while sharing many features in common, appear either to represent the products of rather different backgrounds or to emphasize different aspects of a shared corpus of influences. Scribe C has accomplished a fusion of these backgrounds or influences to such a degree that his hand may easily be mistaken, superficially, for that of either Scribe A or B. Yet his

Figure 4. The hand of Scribe B of the Cambridge-London Gospels, London, British Library, Cotton Otho C.v, fol. 3r. Photo: courtesy of the British Library Board.

hand conforms consistently to neither in details of aspect and letter forms, and several features that do not occur in either of the other hands are introduced.

This may suggest that Scribe C represents a new generation within the scriptorium: one that harmonizes divergent earlier traditions as represented in the work of his elders, Scribes A and B. This is the sort of scenario that has been suggested as an explanation of the relationship between the artist-scribe of the Lindisfarne Gospels, Eadfrith, and the "Durham-Echternach Calligrapher."[11]

Figure 5. The hand of Scribe C of the Cambridge-London Gospels, London, British Library, Cotton Otho C.v, fol. 45r. Photo: courtesy of the British Library Board.

The "generation game" is one way of interpreting evidence of this nature, but equally viable is an interpretation that does not depend so heavily upon the assumption of house styles and an ultimately linear progression. A scriptorium with a variety of traditions and models to draw upon might well offer its personnel sufficient flexibility to select or preserve elements from various

backgrounds, while adapting them in accordance with a more general trend. A situation of this sort might well provide a context for the subtle variations within the work of the three scribes of the Cambridge-London Gospels.

Just as Lindisfarne became identified in the scholarly mind with reformed half-uncial, so the perception of Northumbrian manuscript production has been codominated by the uncial script of Monkwearmouth and Jarrow. Elias A. Lowe's groundbreaking study of English uncial established Benedict Biscop's twin foundations, along with Canterbury, as the key producers of this most romanizing element of the Insular system of scripts.[12] Malcolm Parkes followed this with a stimulating discussion not only of Monkwearmouth/Jarrow uncial but of the minuscule developed by these Northumbrian twins as part of a large-scale publishing program in response to the need to disseminate the works of their most accomplished scholarly son, Bede.[13] The two-pronged production schedule having been established, with romanizing uncial for sacred texts such as the Ceolfrith pandects and the St. Cuthbert Gospel of St. John, and with minuscule gradually supplanting it for use in library books, stimulated by production for export, anything that did not fit the model has tended not to be considered as a probable Monkwearmouth/Jarrow work. The possible lack of sophistication of such a tacit assumption can again be demonstrated in the case of Durham A.II.16, a gospel book of the early eighth century.[14] This volume is partly written in uncial of ultimately Monkwearmouth/Jarrow type, and its decoration, with its classicizing anthropomorphic mask as initial head, is redolent of romanization. These would usually be grounds for it to be ascribed to Monkwearmouth/Jarrow, but there has been a reticence in doing so owing to palaeographical and textual complexities.

The uncial hand (fig. 6) interacts in an obvious manner with that of another major scribe who wrote a Phase I irregular half-uncial that was, according to Lowe, "Written presumably in Northumbria by a scribe schooled in the Irish manner" (fig. 7). However, the Gospel of St. John is written in a reformed Phase II half-uncial hand (fig. 8) that has more to do, according to scholarly convention, with Lindisfarne and its paruchia. Thus Lowe, to overcome the historical barriers erected by scholarship, declared that the Gospel of John represented a later phase of work, completing the volume, but implying that it was produced at another center, even though its text adhered to that of the "Amiatinus group,"

Figure 6. The hand of Scribe A of Durham, Cathedral Library, A.II.16, fol. 37r. Photo: courtesy of the Dean and Chapter of Durham Cathedral.

Figure 7. The hand of Scribe B of Durham, Cathedral Library, A.II.16, fol. 91r. Photo: courtesy of the Dean and Chapter of Durham Cathedral.

Figure 8. The hand of Scribe C of Durham, Cathedral Library, A.II.16, fols. 122v–123r. Photo: courtesy of the Dean and Chapter of Durham Cathedral.

while those of the other Gospels exhibit affinities to Irish texts and the Echternach Gospels, but also feature capitula of the "Italo-Northumbrian" type used at Monkwearmouth/Jarrow and Lindisfarne.[15] A detailed examination of the book as a whole reveals, however, that it may even have been produced in one campaign of work. The sections were certainly bound together by the time that lection marks, noted by Lowe, were added throughout, sometime in the eighth century, and probably earlier rather than later. Wherever Durham A.II.16 was made, whether it was in fact at the Monkwearmouth or Jarrow scriptoria or at a center that was very heavily influenced by their uncial script and at least in part by their texts, the scriptorium was evidently capable of tolerating three of its members working in different traditions. Such differences might reflect the scribes' backgrounds and training, but perhaps such a scriptorium in fact employed the whole range of Insular scripts available at the time, without feeling the need to embrace a major script style as its "trademark" or as an index of affiliation. It may even be the case that the famous Monkwearmouth/Jarrow

uncial (fig. 9) is the exception, rather than the norm, even in terms of their own range of production.[16] It represents an almost antiquarian reconstruction of the sort of uncial practiced in the Rome

Figure 9. Fragment of one of the Ceolfrith Bibles, London, British Library, Add. 45025, fol. 11v. Photo: courtesy of the British Library Board.

of Pope Gregory the Great and reaches its zenith in the Ceolfrith Bibles (the Codex Amiatinus, Florence, Biblioteca Medicea-Laurenziana, MS Amiatinus 1; and fragments of another of the three volumes that are now London, British Library, Additional MSS 37777, 45025, and Loan MS 81).[17] Here the script, combined with a text that sought (even if as the result of a heavy editorial process of distillation) to represent Jerome's "Vulgate" and with a classical illusionism and naturalism of painting style achieves an ultimate statement of *romanitas* that led the pope to congratulate Ceolfrith's successor, Hwætberht, and to effectively welcome Monkwearmouth/Jarrow into the *comitatus* of St. Peter.[18] Uncial is employed again, in its capitular form, in the St. Cuthbert Gospel (London, British Library, Loan MS 74; a probable gift from the Monkwearmouth/Jarrow communities to the shrine of St. Cuthbert) contained within a binding that again represents a complete assimilation of Mediterranean technique.[19] What better way of asserting a romanizing element in the heady mix of cultural influences that the cult of St. Cuthbert was to help represent and reconcile in the new Northumbria?

Thus Monkwearmouth/Jarrow uncial, in its display, text, and capitular forms, can be said to represent a house style, and a highly conscious one at that, but as such it was one aspect of the scriptoria's repertoire, geared to a cultural and political agenda and employed where appropriate. For the range of other scripts employed there and spanning the gap between the romanizing uncial and the cursive minuscule used to produce copies of Bede's works, such as the Moore (Cambridge, University Library, Kk.V.16) and St. Petersburg (National Library, Cod. Q.v.I.18) copies of the *Historia ecclesiastica*, we need perhaps to take account of volumes such as Durham A.II.16 and the Durham Cassiodorus (Durham, Cathedral Library, B.II.30). The hybrid minuscule script of the latter volume is as different in style from the Ceolfrith Bibles as are the stylized linearity of its miniatures and the zoomorphic interlace of its initials, yet it is generally considered a possible Monkwearmouth/Jarrow product.[20] For the true "house style" of Monkwearmouth/Jarrow one therefore has to look beyond the consciously devised and employed romanizing uncial style.

Moving South of the Humber, one encounters an example of the construction of a perceived house style developed in accordance with a discernible agenda. This takes the form of what I have termed the "Mannered minuscule" (fig. 10) constructed by a team of scribes working in the scriptorium of Christ Church Canterbury,

Figure 10. The "mannered minuscule" of Christ Church, Canterbury, in a record made during the first half of the ninth century of the Synod of Clofesho, held in 803. London, British Library, Cotton Augustus II.61. Photo: courtesy of the British Library Board.

probably under the supervision of their fellow scribe, Archbishop Wulfred (805–32).[21] A powerful and wealthy Mercian aristocrat, Wulfred set himself the ambitious tasks of introducing some far-

reaching ecclesiastical reforms designed to strengthen the episcopacy and of staving off the encroachment of Mercian royal interest and restoring to Canterbury the jurisdiction, lands, rights, and privileges misappropriated by King Offa (757–96) in favor of his more amenable new archbishopric at Lichfield. To assist him in these aims, Wulfred and his team engaged in the production of impressive documents, such as charters and records of councils and synods, and in the course of his program of litigation he helped to revolutionize the value of written evidence at law in the Anglo-Saxon legal system. These formidable instruments were penned in a virtuoso, ostentatiously elaborate and calligraphic cursive minuscule, abounding with distinctive letter forms, reversals of ductus, monograms, and ligatures. This minuscule is also to be found in Canterbury library books of the early ninth century, such as Paris, Bibliothèque Nationale, lat. 10861, a volume of saints' lives, and, it may be observed, by the second quarter of the century it influenced a similarly calligraphic hybrid minuscule elevated in application for use in a Bible, British Library, Royal 1.E.vi, perhaps reflecting similar developments in the use of minuscule in the Carolingian orbit.[22] Caroline minuscule was certainly not a "house style," but it was one of the West's most influential and long-lived scripts and owed its ascendancy to a conscious program of use geared to dissemination of texts as part of a politically and culturally orientated agenda. In this sense, Canterbury "mannered minuscule" is comparable, and for once we seem to be witnessing a formulated, if short-lived, house style proper.

 Even in a brief examination of a limited regional and temporal range of material it is therefore possible to see that "house style" can be many things: the product of features combined as a result of historical circumstance to produce a distinctive style representative of a foundation's background; one aspect of a scriptorium's production, which can be overemphasized by scholars at the expense of constructing a clear overview of its oeuvre; the result of a conscious program in which script serves a defined agenda; the attempt of scholars to make sense of a bewildering mass of unattributed data by the distillation of diagnostic features; or the result of a tendency on the part of subsequent researchers to be overly constrained and rigid in the application of predetermined criteria, or to overcompensate in their interpretation. As such, "house style" can be, variously, the product of scribal reality, scribal myth, scholarly myth, or, if we are really lucky (and at the very least in accordance with the law of averages), scholarly reality.

Notes

1. Palaeography is by no means the only area of Anglo-Saxon studies where this can be the case. It might equally, for example, be applied on occasion to endeavors to ascribe anonymous texts on the basis of stylistic features of composition and language.

2. For summary descriptions of the manuscripts, see Elias A. Lowe, *Codices Latini Antiquiores,* 11 vols. and suppl. (Oxford, 1934–72), 2:187, and 2:149; see also J. J. G. Alexander, *Insular Manuscripts, Sixth to Ninth Century* (London, 1978), nos. 9 and 10. For fuller discussion, see *Evangeliorum Quattuor Codex Lindisfarnensis,* ed. Thomas D. Kendrick et al., 2 vols. (Olten and Lausanne, 1956–60); and *The Durham Gospels,* ed. Christopher D. Verey et al. (Copenhagen, 1980). For an overview, see Michelle P. Brown, "The Lindisfarne Scriptorium from the Late Seventh to the Early Ninth Century," in *St. Cuthbert, His Cult, and His Community to* A.D. *1200,* ed. Gerald Bonner et al. (Woodbridge, 1989), 151–63.

3. For the Echternach Gospels, see *CLA* 5: 578; Alexander, *Insular Manuscripts,* no. 11. For his view of the relationship between Eadfrith and the Durham-Echternach Calligrapher, see Julian Brown's contribution in Kendrick et al., *Codex Lindisfarnensis,* 102–6.

4. *CLA* 2: 274; Alexander, *Insular Manuscripts,* no. 52; T. Julian Brown, "Northumbria and the Book of Kells," *ASE* 1 (1972): 219–46, reprinted in *A Palaeographer's View: The Selected Writings of Julian Brown,* ed. Janet Bately et al. (London, 1993), 97–124.

5. See especially Dáibhí Ó Cróinín, "Pride and Prejudice," *Peritia* 1 (1982): 352–62; idem, "Rath Maelsigi, Willibrord, and the Earliest Echternach Manuscripts," *Peritia* 3 (1984): 17–49; William O' Sullivan, "Insular Calligraphy: Current State and Problems," *Peritia* 4 (1985): 346–59; and idem, "The Lindisfarne Scriptorium: For and Against," *Peritia* 8 (1994): 80–94. For a refutation of aspects of these arguments, see Christopher D. Verey, "Lindisfarne or Rath Maelsigi? The Evidence of the Texts," in *Northumbria's Golden Age,* ed. Jane Hawkes and Susan Mills (Stroud, 1999), 327–35. See also the work of Nancy Netzer, cited in n. 6 below.

6. Nancy Netzer, "Willibrord's Scriptorium at Echternach and Its Relationship to Ireland and Lindisfarne," in Bonner et al., *St. Cuthbert, His Cult, and His Community,* 203–12. For a fuller exposition see Nancy Netzer, *Cultural Interplay in the Eighth Century: The Trier Gospels and the Making of a Scriptorium at Echternach* (Cambridge, 1994), with conclusions summarized on 113–15. For further working through of details, see also her more recent articles: "Cultural Amalgamation in the Stuttgart Psalter," in *From the Isles of the North: Medieval Art in Ireland and Britain,* ed. C. Bourke (Belfast, 1996), 119–26; and "Die Arbeitsmethoden der insularen

Scriptorien Zwei Fallstudien: Lindisfarne und Echternach," in *Die Abtei Echternach, 698–1998*, ed. J. Schroeder (Luxembourg, 1999), 65–83.

7. *CLA* 2: 234. Rosamond McKitterick, *Anglo-Saxon Missionaries in Germany: Personal Connections and Local Influences*, Brixworth Lecture 8 (Leicester, 1991).

8. *CLA* 2: 125; Alexander, *Insular Manuscripts*, no. 12. A monograph on the Cambridge-London Gospels was commenced a decade or so ago, and important contributions were commissioned of and submitted by Christopher Verey, Timothy Graham, Nancy Netzer, and Michelle Brown, but sadly the text of the volume has never been submitted for publication by its principal editors, Mildred Budny and Ray Page. Some of Verey's findings were summarized in his "Lindisfarne and Rath Maelsigi," and the broad outline of some of my conclusions is given here.

9. *CLA* 8: 1215; Alexander, *Insular Manuscripts*, no. 24; Dáibhí Ó Cróinín, "Is the Augsburg Gospel Codex a Northumbrian Manuscript?" in Bonner et al., *St. Cuthbert, His Cult, and His Community*, 189–202; and idem, *Evangeliarum Epternachense (Universitätsbibliothek Augsburg, Cod. I.2.4°2), Evangelistarium (Erzbischöfliches Priesterseminar St. Peter, Cod. ms. 25): Colour Microfiche Edition* (Munich, 1988). A detailed analysis of the scripts and minor decoration in the Cambridge-London Gospels, which I undertook for the as yet unpublished volume mentioned in n. 8 above, does not support Ó Cróinín's suggestion of a connection with the Echternach scribes Laurentius and Vergilius, despite similarity with the work of Hand A.

10. Herewith a brief summary of some of my observations on the scribal hands of the Cambridge-London Gospels from the unpublished volume mentioned in n. 8, above.

11. See Julian Brown, as n. 3 above.

12. Elias A. Lowe, *English Uncial* (Oxford, 1960). For an updated review of the use of uncial in Britain, see Michelle P. Brown, "The Writing of Early Insular Books: Uncial," in *The Cambridge History of the Book in Britain*, ed. Richard Gameson, vol. 1 (Cambridge, forthcoming).

13. Malcolm B. Parkes, *The Scriptorium of Wearmouth-Jarrow*, Jarrow Lecture (Jarrow, 1982).

14. *CLA* 2: 148; Alexander, *Insular Manuscripts*, no. 16.

15. "Durham MS A.II.16 contains a chapter family that points to a distinct Lindisfarne and Wearmouth-Jarrow usage" (Verey, "Lindisfarne or Rath Maelsigi," 328–29, 333), O'Sullivan described the manuscript as a product of Monkwearmouth/Jarrow ("Lindisfarne Scriptorium," 81), but without explaining his reasons for so thinking.

16. See n. 3 above; Verey, "Lindisfarne or Rath Maelsigi," 328–33, does not consider this volume to contain uncial of "Wearmouth-Jarrow type," although without discussion. Lowe, *English Uncial,* 20 described this as Northumbrian uncial in decline, and in *CLA* 2: 148 he sees it as "presumably written in Northumbria." It adheres in its general features to "Wearmouth-Jarrow type" (see Brown, "Uncial"), but is less disciplined in its consistent application of details such as serifs.

17. *CLA* 3: 299, 2: 177. For coverage of all the fragments, see *The Making of England. Anglo-Saxon Art and Culture. A.D. 600–900,* ed. Leslie Webster and Janet Backhouse (London, 1991), nos. 87–88; and for discussion, see Michelle P. Brown, *The Book of Cerne: Prayer, Patronage and Power in Ninth-Century England* (London and Toronto, 1996), 166. On Wearmouth-Jarrow uncial generally, see Lowe, *English Uncial*; Parkes, "Scriptorium of Wearmouth-Jarrow"; Brown, "Uncial"; and *The Stonyhurst Gospel of St. John,* ed. T. Julian Brown (London, 1969). The identification of these fragments as part of the Ceolfrith Pandects has been challenged by Richard Marsden, *The Text of the Old Testament in Anglo-Saxon England,* CSASE 15 (Cambridge, 1995), 90–98, 123–29.

18. Brown, "Uncial"; Ian Wood, *The Most Holy Abbot Ceolfrid,* Jarrow Lecture (Jarrow, 1995), 13–14. For an introduction to some of the complex considerations of the text of the Ceolfrid Bibles, see Marsden, *Text of the Old Testament.* For some lines of thought concerning aspects of *romanitas,* perceived and otherwise, in Anglo-Saxon England, along with other early medieval societies, see *The Transformation of the Roman World, A.D. 400–900,* ed. Leslie Webster and Michelle P. Brown (London, 1997). For some similar considerations in approaches to architectural and sculptural monuments, see Jane Hawkes's contribution to the present volume.

19. For grades of uncial, see Michelle P. Brown as in n. 12.

20. Parkes, *Scriptorium of Wearmouth-Jarrow.* Respectively *CLA* 2: 139, 11: 1621, 2: 148, 2: 152; and Alexander, *Insular Manuscripts,* nos. 19, 16, and 17. For the Cassiodorus manuscript, see also Webster and Backhouse, *Making of England,* no. 89, where it is described as a Northumbrian MS copied from a Monkwearmouth/Jarrow exemplar (presumably because of its "uncanonical" style of script and decoration); Webster and Brown, *Transformation of the Roman World,* 226; and Lowe, *English Uncial,* 24, where it is accepted as a probable Monkwearmouth/Jarrow work. Above all, on the case for a Monkwearmouth/Jarrow origin, see Richard N. Bailey, *The Durham Cassiodorus,* Jarrow Lecture (Jarrow, 1978), esp. 23–24.

21. On mannered minuscule, see Michelle P. Brown, "Paris, Bibliothèque Nationale, lat. 10861 and the Scriptorium of Christ Church, Canterbury," *ASE* 15 (1987): 119–37, and idem, *Book of Cerne,* 162–72.

22. *CLA* 2: 244; Alexander, *Insular Manuscripts*, no. 32; Brown, *Book of Cerne*, 162–72; Mildred O. Budny, "London, British Library MS. Royal 1.E.vi: The Anatomy of an Anglo-Saxon Bible Fragment," (Ph.D. dissertation, London University, 1985).

7

Style and Layout of Anglo-Saxon Manuscripts

William Schipper

It has long puzzled me why very nearly all extant manuscripts containing Old English texts as their primary text are laid out in "long lines," when extant Latin codices produced in England during the same period are found in long-line, double-column, and occasionally multiple-column formats. This difference is entirely a question of "style," a set of principles that guided the designers of medieval books, and that give them their distinctive appearance. This style, moreover, is immediately identifiable with a particular historical period or geographical area and, as the Old English manuscripts suggest, is closely associated with political and cultural factors. In effect, layout style is a cultural phenomenon in the same way that other styles—artistic, musical, literary—are carriers of cultural values. Manuscript layout style incorporates a series of choices made at the very beginning of the process of making a manuscript book that determines what the final product will look like. These choices are conditioned by a variety of practical and other considerations: intended contents, size, tradition, convention, purpose, the urgency behind a particular production, the experience of the people involved in the production, and sometimes even the desire to experiment with something new. This paper examines why the style of manuscripts from Anglo-Saxon England containing vernacular texts seems overwhelmingly to have included a choice for "long lines," so that we can in fact see an "Anglo-Saxon Vernacular Layout Style" in use from the time of King Alfred in the late ninth century to the last productions of vernacular Old English manuscripts in the twelfth century. I would also like to speculate on why this particular style emerged as the style of choice during the late ninth century, despite the presence of

a Latin layout tradition that included both long-line and double-column manuscripts.

The Latin tradition of book design provides a context for this vernacular layout style. J. P. Gumbert, in a 1993 paper entitled " 'Typography' in the Manuscript Book," succinctly summarizes the way text has normally been arranged in manuscripts:

> Since time immemorial text has been arranged, on rectangular pages, in a rectangular space. But this principle has aesthetic, not structural reasons. From time to time one finds text in different shapes: triangles, hourglass shapes, crosses, but this also is done to achieve a more pleasant aspect, or to suggest some meaning outside of the text, and not to structure the text itself. [1]

Manuscript book design is, of course, a question of "style"; every thing about the layout of a manuscript, from the size of the vellum and the choice of script to the layout of the text, is a matter of choice, limited only by current styles and traditions. The aesthetic principle that guided the designer of a manuscript in selecting one layout over another, and that prevented the selection of aesthetically unpleasing ones (Gumbert goes so far as to call them "ugly" ones)[2], was almost invariably paired with a principle of "utility." The use to which a manuscript was to be put—whether it was to be a gift for a prominent person, as in the case of the Codex Amiatinus; in memory of a famous person, such as the Lindisfarne Gospels; a book for private devotions; a collection of homilies for publication; a collection of poems; or a book for some other purpose— the principle of utility along with aesthetics always determined what layout would be adopted for the book being designed.

Manuscripts containing Latin texts are extant in a variety of formats. In size they range from the very tiny to the enormous.[3] And in layout they vary from "long-line manuscripts" to multiple-column formats. Few if any original designers of surviving manuscript books have, as far as I know, left notes on what guided their decision to adopt one layout over another, but the principles can to a large extent be recovered from the surviving evidence.[4] The process would of necessity have begun with a choice of contents and purpose, followed by a decision about size, guided by whether the book was for public use (such as a service book or a gospel book) or private (such as a school text or collection of homilies), since that

would determine such things as how many sheets and the dimensions of parchment needed.

Whether a book was to be laid out in columns or in long lines was dictated in part by the size of the volume. The Codex Amiatinus, one of the very largest productions from Northumbria, measures more than 500 mm (nearly 20 inches) in height, and 340–45 mm (13 inches) in width.[5] Unless the letters were very large, a double-column format seems a natural choice, especially when the text is also set out *per cola et commata*. The Harley Psalter (London, British Library, Harley 603),[6] a copy of the Utrecht Psalter (measuring 376 mm × 312 mm; written space 248 mm × 224 mm) is laid out in three columns, a decision clearly prompted by its exemplar.[7] On a much smaller scale is an Irish pocket gospel (London, British Library, Add. 40618): it measures just 130 mm by 105 mm (5¹⁄₈ by 4¹⁄₈ inches); but it is still laid out in double columns, perhaps because it is a gospel book, even though possibly intended for private rather than public use.[8] So size did not always dictate layout. Among English examples where size was apparently not a consideration are the St. Petersburg Bede (formerly "Leningrad Bede") and the Moore Bede. The former (St. Petersburg, National Library, Lat.Q.v.18; see fig. 1) measures 270 × 190 mm (writing area 225 x 160), but is laid out in double columns;[9] the latter (Cambridge, University Library, Kk.v.16; see fig. 2) measures 292 × 215 (writing area 255 × 190), but is written in long lines.[10] Since these manuscripts have similar dates (Lowe gives "s. VIII med" for the St. Petersburg Bede and "ca. 737" for the Moore Bede), and since the Moore Bede has a writing area about 34 percent larger than the St. Petersburg Bede, size cannot have been a factor. If nothing else, they demonstrate that both formats were available and used for Latin texts at more or less the same time.[11]

E. A. Lowe, in two studies published in the 1920s on the oldest Latin manuscripts, provides a useful overview of the earliest manuscripts under a number of headings.[12] His evidence suggests that the most common layout of manuscripts was in double columns. The very earliest are sometimes in four columns and no doubt imitate the appearance of a roll. One of these, British Library, Additional 40165A.1, a fourth-century fragment of Cyprian's letters, may have been in England as early as the eighth century, judging from some corrections and expansions, and might well have served as a model for manuscripts of this kind in England.[13] According to E. A. Lowe, the closer one comes to the time when the

Figure 1. St. Petersburg, National Library, MS Lat.Q.v.18, fol. 107. (By permission of the National Library.)

Figure 2. Cambridge, University Library, Kk.v.16. (By permission of the Syndics of the Cambridge University Library.)

roll dominated as book form, the more frequently does one find manuscripts copied in two or more columns.[14] And mutatis mutandis, the further one moves in time from the roll the more frequently one finds manuscripts written in long lines, so that by the ninth century and later the proportion of long-line manuscripts to double-column ones is roughly 2:1.[15] Not until the twelfth century do two- and three-column manuscripts become dominant again.

Such, then, is the background for the production of vernacular Anglo-Saxon manuscripts: the Latin codex, whether directly imported from Italy, France, or Ireland, was the model on which the appearance of all vernacular English manuscripts was based. There are almost no vernacular manuscripts that predate the late ninth century. The only two exceptions Ker lists in his catalogue—the Corpus and Épinal glossaries—date from the eighth century, and unlike any of the text manuscripts from later in the period they are very specialized books in their content and purpose. Although Bede tells us in his *Ecclesiastical History* that the earliest Kentish laws were put into writing during the early seventh century, according to the custom of the Romans,[16] and copies of the laws of Æthelberht and his successors surface in West Saxon manuscripts several centuries later,[17] not a single early fragment has, to the best of my knowledge, survived. Nor has anything survived of Bede's own plan for translating portions of the Bible into English.[18] Even the book of English poetry that, according to Asser, King Alfred's mother offered as a prize to the first of her sons who would "learn" its contents, and which was won by Alfred himself, has not survived, and although it suggests that books in English were available, it seems surprising that not the smallest fragment has come down to us, even as a binding fragment.[19]

This is not to say that English could not or was not written, as we can see from the copy of Cædmon's hymn in the lower margin of folio 107v of the St. Petersburg Bede (fig. 1).[20] Although this copy of the hymn may be a paraphrase of the Latin that appears on the same page, as Kevin Kiernan argued some years ago,[21] the significance of its appearance, in the same hand as the main Latin text, indicates clearly that English could be, and was, written during the eighth century. For a twentieth-century audience it seems all the more striking that not a single scrap of a single manuscript primarily containing English text has survived from before the reign of King Alfred, since we tend to assign a primacy to texts in vernacular languages in this period, if not to Old English poetry. But during the first few centuries after the Roman mission to

England, English seems to have been largely a secondary language for writing, one that the population at large spoke, but that required a written form only as a means to an end, as an adjunct to Latin.[22]

With the reign of King Alfred we begin to find manuscripts with texts in English as their primary contents. Of the surviving manuscripts Ker describes in his catalogue, very nearly all are written in "long lines." There are some exceptions, of course. I have already mentioned the Corpus and Épinal glossaries: the former is in double columns of thirty-three lines, the latter in six columns of thirty-eight to thirty-nine lines. Other exceptions are London, British Library, Cotton Vitellius C.iii (fig. 3) and Oxford, Bodleian Library, Hatton 76, both containing pseudo-Apuleius, *Herbarium*; Dioscorides, *Liber medicinae* and *Medicina de quadripedibus*, whose format may have been determined by an immediate Latin exemplar. London, British Library, Royal 12.G.xii, containing among other things a fragmentary copy of Ælfric's *Grammar*, is in double columns, as is London, British Library, Harley 55 (fols. 3–4), with the second and third law codes of Edgar. Best known, if only for its peculiar dimensions, is the Paris Psalter (Bibliothèque Nationale, lat. 8824).[23] Its dimensions (page size 526 × 186 mm; writing area 419 mm × 95 mm) make it taller than the Codex Amiatinus, but the pages, and hence the writing area, are extremely narrow; and one wonders what was going through the mind of the person who designed a book that was so deliberately out of keeping with the usual proportions of a book, and one that must have been awkward to handle at the best of times. Its layout in double columns on the other hand suits its contents perfectly, with the Latin text of the psalter on the left and the prose translation on the right.[24] Yet another manuscript, Durham, Cathedral Library, B.III.32, a liturgical and grammatical miscellany assembled over a period of time, is partly in double columns, partly in long lines.[25]

These exceptions serve only to confirm the general rule that Anglo-Saxon manuscripts containing vernacular texts are overwhelmingly long-line manuscripts. As I have indicated, the choice in designing Latin manuscripts was determined to some extent by size and by purpose (whether for public or private use, for example), and to some extent this applies to vernacular manuscripts as well. Many of them are not very large compared to their Latin counterparts. Many students of Old English have no doubt experienced the "Beowulf phenomenon"—the shock of first seeing London, British Library, Cotton Vitellius A.xv, with its writing area of

Figure 3. London, British Library, Cotton Vitellius C.iii. (By permission of the British Library.)

ies of a variety of texts: grammatical notes, the Tribal Hidage, Ælfric's *Grammar*, prognostics, computus notes, a Latin grammar, part of the prose and verse versions of Abbo of Saint-Germain's *Bella Parisiacae urbis*, glossary material, a sermon by Ælfric and excerpts of his letter to Sigeweard, and a copy of *De initio creaturae*; the manuscript measures 271 × 179 mm, with a writing area of about 215 × 137 mm. But British Library, Royal 7.C.xii, the well-known copy of Ælfric's *Catholic Homilies*[26] with corrections in his own hand (fig. 4), a larger book measuring 310 × 205, with a writing area of 237 × 145, is also in single columns, as is the two-volume collection of Ælfric homilies in Oxford, Bodleian Library, Bodley MS 340 and 342, which is comparable in size. Latin manuscripts of this size are often in double columns.

The earliest manuscripts containing vernacular texts date from the end of Alfred's reign, and are the product of his program for making certain books more widely available in English translations; these must have had Latin models not just as exemplars from which the translations were made, but also as models for the layout. Among the earliest of these are copies of Alfred's translation of Gregory the Great's *Pastoral Care*, London, British Library, Cotton Tiberius B.xi, which has been identified as the possible exemplar for the copies Alfred intended to be sent to the various bishoprics in England,[27] and Oxford, Bodleian Library, Hatton 20, the copy sent to Worcester shortly after it was made.[28] The original size of Tiberius B.xi, unfortunately almost completely destroyed in the 1731 Cotton Library fire, can still be determined from the single leaf preserved in the Gesamthochschulbibliothek in Kassel (4° MS. theol. 131): that leaf measures 276 × 218 mm, with a writing area of 220 x 165 mm, which is almost identical with the measurements of Hatton 20: 274 × 215 mm with a writing area measuring 223 × 175 mm. That is not so very large, and might explain why it is in long lines. Another copy made about a century later, however, Cambridge, Corpus Christi College 12, is much larger: the page size is 409 × 262 mm, writing area 305 × 148 mm, and the manuscript appears, from the size of its margins and the impressive surface of each page, as well as the size of the script, to be a deluxe production, yet it is still in long lines. This is also true of tenth- and eleventh-century manuscripts such as the homiletic manuscripts preserved in Corpus Christi College Cambridge, which measure 253–97 × 168–203 mm (the smallest of these is CCCC 302, the largest is CCCC 162). Within this same range are other homiletic manuscripts: London, British Library, Cotton Julius E.vii (Ælfric's

Figure 4. British Library, Royal 7.C.xii. (By permission of the British Library.)

Lives of Saints); Oxford, Bodleian Library, Hatton MSS 113, 114, 115, and 116 (all Ælfric manuscripts); and Oxford, Bodleian Library, Junius 121 (a Wulfstan manuscript). When we look at the four surviving poetic codices, we note the following: the largest of these is the Junius manuscript (323 × 196 mm; writing area 225

× 135 mm); then comes the Exeter Book (310 × 218 mm; writing area 240 × 160 mm); third in size is the Vercelli Book (310 × 205 mm; writing area 220 × 143 mm in quires 1–4 and 230 × 152 mm in quires 15–19); and the smallest is the Beowulf codex (195 × 115 mm; writing area 175 × 105 mm).

If size determined whether a manuscript was to be set out in columns or in long lines, the Junius manuscript might have been a candidate for the former; and among the prose manuscripts some of the larger homiletic manuscripts, or the deluxe copy of the *Pastoral Care* (CCCC 12), might have been candidates for double-column layout. But in fact, very few manuscripts are in two or more columns, and each one of them turns out to be a special case of sorts:[29] Cambridge, Corpus Christi College, 144 (the Corpus Glossary) and Épinal, Bibliothèque Municipale, 72 (the Épinal Glossary) are both glossaries, and hence specialized books; the Vitellius manuscript and Hatton 76 are medicinal compilations; the Durham and Royal manuscripts contain much more than just Old English vernacular texts; and the Paris Psalter is in a category by itself as far as its layout is concerned. Even when the Old English text is added at the end of a manuscript otherwise containing nothing but Latin, and laid out in double columns, the Old English tends to be in long lines. One of the more interesting examples is London, British Library, Cotton Nero E.i, vol. 2,[30] a two-volume compilation containing, among other things, Byrhtferth's lives of S. Oswaldi and S. Ecgwini, Lantfred's *Translatio et miracula s. Swithuni*, an office and mass for St. Nicholas, and a Worcester cartulary, all in Latin. Folios 185–86 contain eleventh-century additions consisting of the fourth law code of Edgar, and office lections, the former in English. Folio 185r, a blank leaf near the end of a gathering, is ruled in dry point for double columns. The scribe who added the Old English text used the impression of the double-column ruling from the recto for the long lines on the verso. On folio 186v, there is also a double-column dry point ruling, made on that side of the leaf, which the scribe uses as it stands for the long lines. On folio 186r, he again uses the impression of the double-column ruling for his long lines.[31] What this indicates is that the scribe chose long lines for his Old English additions, despite the fact that the sheets had already been ruled for double columns; and that he made no effort to modify the ruling. This supports the impression one receives from the vernacular manuscripts that their layout style is overwhelmingly in long lines, even when it might have been easier or advisable to use double columns.

The source of what I have been calling the "Anglo-Saxon Vernacular Layout Style" would appear to be King Alfred the Great and the circle of learned men he gathered about him. More than anyone else, he initiated the use of English for a variety of written purposes. Most students of Old English are familiar with Alfred's preface to the translation of the *Pastoral Care*. What he says there is instructive: learning had declined so thoroughly in England that there were very few men on this side (= the south side) of the Humber who could understand their divine services in English, or even translate a single letter from Latin into English.[32] And he goes on to lament the fact that although the English churches were "filled with treasure and books," they "derived very little benefit from those books, because they could understand nothing of them, since they were not written in their own language." He then resolved to provide translations of "certain books which are the most necessary for all men to know," since the "knowledge of Latin had previously decayed throughout England, and yet many could still read things written in English." He then began to translate Gregory's *Pastoralis*, as he had been taught to do by Plegmund his archbishop, Asser his bishop, and Grimbald and John, his "masspriests." Asser in his *Life of Alfred* also describes how eager Alfred was to make the knowledge contained in Latin books more widely known. He recounts, to cite just one example, how one day he was reading and explicating something to the king, when the latter insisted that Asser copy the passage he had just read into a book. Asser instead suggested a new gathering, and in the course of the day added several more passages. At this point Asser notes: "Now as soon as that first passage had been copied, he was eager to read it at once and to translate it into English, and thereupon to instruct many others, just as we are admonished by example of that fortunate thief" crucified next to Christ.[33]

Asser's description of Alfred's love of books and of learning, and of the program of translation the king initiated, along with the king's own words in the prefaces to some of the works he translated, suggests that the program had considerable urgency. It is precisely this urgency that contributed to the development of the "Vernacular Layout Style" we see in nearly all English vernacular manuscripts. The paleography of Hatton 20 makes clear that there was a lot of experimentation with letter forms during the production of this manuscript, no doubt because such a large venture of producing vernacular manuscripts had not been attempted before.[34]

Moreover, the urgency may in part have dictated long lines as the style of choice, because it is easier and quicker to design a book with long lines than double columns. Although Asser writes frequently of how eager Alfred was to have books read to him in both Latin and English, the absence of any surviving fragments prior to the late ninth century of such books in English is striking, and suggests that this "reading" to the king may have consisted of actual reading in Latin, with translation of significant passages into English. This urgency to produce vernacular manuscripts may, moreover, have led to the decision to produce books in a format that was easier to design than double-column books. Once the style had been accepted and widely disseminated, it would have seemed like a "natural" format for all later productions.

A second reason for the format is the relative worth and authority that must have been assigned to English as opposed to Latin manuscripts. To think of Old English as the primary vehicle for writing during the Anglo-Saxon period is, as we quickly learn, a distortion of the actual situation that prevailed. For nearly three hundred years after the conversion of the English, a process that also entailed the introduction of literacy at least to a select group, Latin was the primary vehicle for the written word, as can be seen from the works of Aldhelm, Bede, and Alcuin. In this, England was no different from the rest of Christian Western Europe. As we can see, for example, from the fragments of Old English that survive in the margins of manuscripts from before the ninth century, or in the form of glossaries and glossed texts, written English was treated as a secondary or marginal language. It is surely no accident that Alfred is concerned in his preface to the *Pastoral Care* with the lack of ability to read and translate Latin, while there were many who could still read English. Thus, when Alfred initiated his translation program, along with the production of manuscripts containing such translations, those in charge of book production ensured that English vernacular texts would be presented in a layout style that differentiated it immediately from the Latin book tradition, and distinguished books in the vernacular from those in Latin. This style, originating with Alfred the Great, is not a mere scribal convenience. Although it has its origin in the urgency associated with his translation program, it also embodies some of his cultural and political notions about the distinctiveness of the English. With his translation program he initiated a distinctively English layout style for vernacular manuscripts that embodies his political and

cultural ideas as clearly as does the distinctive script that was developed in his scriptorium.

Notes

I would like to thank the following for comments made both during the session in which this paper was presented, and in subsequent discussions and correspondence: Catherine Karkov, George Brown, Michael Tweedie, John Niles, Sarah Keefer, Jane Toswell, Michelle Brown, Michael Lapidge, Barbara Bordalejo, Greg Rose, Bruce Gilchrist, and Füsun Atalay. I am particularly grateful to Catherine and George for inviting me to contribute a paper to the series they were organizing.

1. J. P. Gumbert, " 'Typography' in the Manuscript Book," *Journal of the Printing Historical Society* 22 (1993): 7; for a list of further studies, see ibid., 5 n. 1.

2. Ibid., 6.

3. For a classification by size of early manuscripts see M. E. G. Turner, "Towards a Typology of the Early Codex (Third–Sixth Centuries A.D.): Classification by Outward Characteristics," in *La Paléographie hébraïque médiévale Paris, 11–13, septembre 1972,* ed. Jean Glénisson and Colette Sirat, Colloques Internationaux du Centre National de la Recherche Scientifique, no. 547 (Paris, 1974), 137–51.

4. But see the description of how to design and lay out a page in two columns in Paris, Bibliothèque Nationale, lat. 11884. The text was printed in E. K. Rand, *The Earliest Book of Tours with Supplementary Descriptions of Other Manuscripts of Tours* (Cambridge, Mass., 1934), 2: 88. It is also printed (with French translation) in Jacques Lemaire, *Introduction à la codicologie* (Louvain, 1989), 127. Lemaire discusses a number of methods for laying out pages on 127–49, with further references.

5. Data from *CLA*, 299.

6. See Michelle Brown, *Anglo-Saxon Manuscripts* (London, 1991), pl. 73; for a full discussion of this manuscript, see William Noel, *The Harley Psalter* (Cambridge, 1995); and see especially his many plates for other examples of the three-column layout as represented in the Harley Psalter.

7. See Bernard Bischoff, *Latin Palaeography: Antiquity and the Middle Ages,* trans. Dáibhí Ó Crónín and David Ganz (Cambridge, 1990), 28 and n. 70, for some remarks on early three-column books.

8. Illustrated in Brown, *Anglo-Saxon Manuscripts,* pl. 69.

9. *CLA*, 1621; Gneuss 846. Facsimile ed. Olof Arngart, *The Leningrad Bede: An Eighth Century Manuscript of the Venerable Bede's "Historia*

ecclesiastica gentis Anglorum" in the *Public Library, Leningrad,* EEMF 2 (Copenhagen, 1952).

10. *CLA*, 139; Gneuss 25. Facsimile ed. Peter Hunter Blair, *The Moore Bede: Cambridge University Library MS Kk.5.16,* EEMF 9 (Copenhagen, 1959).

11. Michael Lapidge believes that both manuscripts are copied from an exemplar that was either Bede's own autograph or a close copy. If he is right, then both layout styles were clearly available in Bede's scriptorium. The different choices in this case may have been dictated by the need to produce a copy quickly in the case of the Moore Bede (which has all the earmarks of being a hasty copy), perhaps for presentation. I am grateful to Professor Lapidge for answering my question so promptly.

12. E. A. Lowe, "Some Facts about our Oldest Latin Manuscripts," *Classical Quarterly* 19 (1925): 197–208; reprinted in Lowe, *Palaeographical Papers, 1907–1965,* ed. Ludwig Bieler (Oxford, 1972), 1: 187–202; idem, "More Facts about our Oldest Latin Manuscripts," *Classical Quarterly* 22 (1928): 43–62; reprinted in idem, *Palaeographical Papers,* 1: 251–76.

13. *CLA* 178; Gneuss 297. M. Bévenot, "The Oldest Surviving Manuscript of St Cyprian Now in the British Library," *Journal of Theological Studies,* n.s., 31 (1980): 368–70 discusses this particular manuscript and its connections to England from the eleventh century. I am preparing a study of this particular manuscript and its connections with Anglo-Saxon England.

14. See Colin H. Roberts and T. C. Skeat, *The Birth of the Codex* (Oxford, 1985); and Joseph van Haelst, "Les origines du codex," in *Les Debuts du codex,* ed. A. Blanchard, Bibliologia (Turnhout, 1988). See also Robert Marichal, "Du *volumen* au *codex,*" in *Mise en page et mise en texte du livre manuscrit,* ed. Henri-Jean Martin and Jean Vezin (Paris, 1990), 45–54, with plates. For an interesting discussion of the significance of the adoption by the Christian Church of the codex as the technological basis for dissemination of its teachings see James J. O'Donnell, *Avatars of the Word* (Cambridge, Mass., 1998), 50–57.

15. This ratio is based on data from *CLA* 3 and 4 (Italian libraries). Counting only the manuscripts and leaves that have survived intact, or for which the original layout can be reconstructed, we find the following: there are four parchment rolls, 174 MSS in long lines, seventy-five in two columns, two in three columns, one in four columns, three uncertain, and two mixed. See also the remarks of Linda Nix, "Manuscript Layout and Re-Production of the Text in Anglo-Saxon England: A Preliminary Examination," *Gazette du livre médiéval* 25 (1994): 19.

16. *Hist. eccles.* 2.5, writing of King Æthelbert of Kent: "Qui inter cetera bona quae genti suae consulendo conferebat, etiam decreta illi

iudiciorum *iuxta exempla Romanorum* cum consilio sapientium constituit; quae *conscripta Anglorum sermone* hactenus habentur et obseruantur ab ea" (italics mine).

17. Felix Liebermann, *Die Gesetze der Angelsachsen* (Halle, 1903–16) 1:1–14.

18. See Bede's own letter to Cuthbert (*EHD*, 1:801); cf. George H. Brown, *Bede the Venerable* (Boston, 1987), 76–77. See also Abbot Cuthbert's letter on the death of Bede (*Hist. eccles.*, pp. 582–83).

19. *Asser's Life of King Alfred*, ed. W. H. Stevenson (Oxford, 1904), chap. 23 (p. 20); *Alfred the Great*, ed. Simon Keynes and Michael Lapidge (Harmondsworth, 1983), 75.

20. *The Leningrad Bede*, fol. 107. For a full discussion of the layout of Old English poetic manuscripts, see especially Katherine O'Brien O'Keeffe, *Visible Song: Traditional Literacy in Old English Verse*, CSASE 4 (Cambridge, 1990). For her remarks on the text of Caedmon's Hymn in this manuscript, see 34–46.

21. Kevin Kiernan, "Reading Caedmon's 'Hymn' with Someone Else's Glosses," *Representations* 32 (1990): 157–74. Although the English version of the Hymn in the St. Petersburg Bede is in the same hand as the Latin text on folio 107, the smaller size of the script makes the text seem less significant than the main text.

22. For a discussion of some works that may have been composed in English prior to Alfred's reign, see especially Janet Bately, "Old English Prose before and during the Reign of Alfred," *ASE* 17 (1988): 93–138, with further references to earlier studies.

23. Facsimile: *The Paris Psalter: MS Bibliothèque nationale, fonds latin 8824*, ed. Bertram Colgrave, EEMF 8 (Copenhagen, 1958). For a discussion of the layout of this manuscript, see especially Jane Toswell, "The Format of Bibliothèque Nationale MS Lat. 8824: The Paris Psalter," *N&Q* 241 (1996): 130–33. On the scribe of the Paris Psalter, "Wulfwinus," see Richard Emms, "The Scribe of the Paris Psalter," *ASE* 28 (1999): 179–83.

24. Toswell, "Format," 131, gives a list of other manuscripts of similar size. Of these, British Library, Harley 5431 ("Regula sancti Benedicti") and Leiden, Bibliotheek der Rijksuniversiteit, Scaliger 69 (the *Cosmographica* of Aethicus Ister), were both at St. Augustine's Abbey, Canterbury, and may have inspired this peculiar format; cf. Emms, "The Scribe," 180.

25. Ker 107. Part A, containing hymns, canticles, and, on originally blank supply leaves, a collection of proverbs in Latin and Old English, is laid out in double columns; Part B, containing a copy of Ælfric's *Grammar*, is laid out in long lines.

26. Facsimile: *Ælfric's First Series of Catholic Homilies, British Museum, Royal 7 C.xii, fols. 4–218,* ed. Norman Eliason and Peter Clemoes, EEMF 13 (Copenhagen, 1966).

27. We have it on Humphrey Wanley's authority that the place in Alfred's preface where the name of the recipient was to appear was left blank in Tiberius B.xi (*Librorum Veterum Septentrionalium Catalogus Historico-Criticus* (Oxford, 1705), 217. See Alfred P. Smyth, *King Alfred the Great* (Oxford, 1995), 559: "Cotton Tiberius B.xi . . . may have been used as a master copy in the king's writing office." See also Kenneth Sisam, "The Publication of Alfred's *Pastoral Care*," in his *Studies in the History of Old English Literature* (Oxford, 1953), 140–47; N. R. Ker's remarks in the introduction to the EEMF facsimile of MS Hatton 20 (see note 25 above); Jennifer Morrish, "King Alfred's Letter as a Source on Learning in England in the Ninth Century," in *Studies in Earlier Old English Prose,* ed. Paul E. Szarmach (Binghamton, 1986), 88; Dorothy M. Horgan, "The Old English *Pastoral Care:* The Scribal Contribution," in Szarmach, *Studies,* 109–27.

28. Facsimile: *King Alfred's Translation of St. Gregory's "Regula pastoralis": Ms. Hatton 20 in the Bodleian Library,* ed. N. R. Ker, EEMF 6 (Copenhagen, 1956).

29. The following MSS containing Old English vernacular texts of one kind or another are laid out in two or more columns: Cambridge, Corpus Christi College, 144 ("Corpus Glossary"; Ker 36; Gneuss 45; *CLA*, 2: 122); Durham, Cathedral Library, B.III.32 (Ker 107A; Gneuss 244); Épinal, Bibliothèque Municipale, 72 (2) (Ker 114; Gneuss 824); London, BL, Cotton Vitellius C.iii (Ker 219; Gneuss 402) [ps-Apuleius, etc.]; London, BL, Harley 55 (Ker 226; Gneuss 412); London, BL, Royal 12.G.xii (Ker 265; Gneuss 480; fols. 2–9 include a copy of Ælfric's *Grammar*); Oxford, Bodl. Lib., Hatton 76 (Ker 328; Gneuss 632–634; Gregory, *Dialogues* [fragm]; ps-Apuleius, etc.); Paris, Bibliothèque Nationale, lat. 8824 ("Paris Psalter"; Ker 367; Gneuss 891).

30. Ker 344; Gneuss 344–45.

31. I am grateful to Andrew Prescott of the British Library for checking the rulings in this part of Cotton Nero E.i for me. The rulings are very faint, as I was able to confirm in a personal examination of the manuscript in May 1999, and would not lend themselves to being photographed clearly.

32. Keynes and Lapidge, *Alfred the Great,* 125–26. The Old English text reads as follows: "Swæ clæne hio wæs oðfeallenu on Angelcynne ðæt swiðe feawa wæron behionan Humbre ðe hiora ðeninga cuðen understondan on Englisc oððe furðum an ærendgewrit of Lædene on Englisc areccean; ond ic wene ðætte noht monige begiondan Humbre næren" (from Bruce Mitchell and Fred C. Robinson, *A Guide to Old English,* 5th ed. [Oxford, 1992], 205).

33. Stevenson, *Asser's Life of King Alfred,* chap. 89, p. 75: "Nam primo illo testimonio scripto, confestim legere et in Saxonica lingua interpretari, atque inde perplures instituere studuit, ac veluti de illo felici latrone cautum est. . . ." Translation in Keynes and Lapidge, *Alfred the Great,* 100.

34. On the paleography of Hatton 20, see N. R. Ker's introduction to the EEMF facsimile.

8

What We Talk about
When We Talk about Style

Nicholas Howe

Reading someone from the outside reading our field can be a sobering and illuminating experience, especially if the outsider is not situated at too great a distance. It is best if she is close enough to earn our attention because of her general expertise as a medievalist, and distant enough to see something about us that we have failed to see or, more revealingly, have failed to remember. Such was my response on reading the discussion of Old English literature in Marcia Colish's 1997 book, *Medieval Foundations of the Western Intellectual Tradition, 400–1400*. This magisterial survey contains an extended section on vernacular culture, thus signaling the author's recognition that the Western intellectual tradition was made at least in part with languages other than Latin.

When she discusses the Germanic vernaculars, and more specifically Old English, Colish explains that Anglo-Saxon Christian poets wrote a variety of "epics," including "biblical rewrites and saints' lives." Such poems were composed by Cædmon and Cynewulf and their followers:

> Poets in both schools used earlier Latin Christian works, both patristic and Anglo-Saxon. The Cynewulfians are more learned and achieve a more thoroughgoing integration of Christian content and Germanic form, enhanced by Celtic and classical devices. The Caedmonians reflect a more conservative Germanic viewpoint.[1]

One immediate response to these claims would be to say that they sound about fifty years out of date, especially in reifying the

Cædmonian and the Cynewulfian schools. Investigating Colish's footnotes and bibliography supports that estimate, for her account of Old English poetry relies almost exclusively on George K. Anderson's *The Literature of the Anglo-Saxons*, revised in 1966 but published originally in 1949. Note, for example, her debt to Anderson's remark that "we shall find example after example among the Cædmonian and Cynewulfian poems of how the older bardic epic tradition was adapted to Christian story and doctrine."[2]

Reading Colish reading Anderson is a way to consider how disciplinary ideas about a subject such as style get codified and then passed on in general handbooks of medieval culture—even when these ideas no longer enjoy circulation in the discipline itself, in fact, when they have been all but forgotten. Consider, for example, how dissonant this passage from Anderson's introductory section on Anglo-Saxon poetry sounds today:

> As is the case with all such formalistic poetry, the devices [e.g., alliteration] frequently get in the way of the poetic spirit, and technique often supplants essential poetry. The exigencies of alliteration, much more formidable than those of simple end-rime, require that the poet use words which alliterate, whether or not the alliterating words are the best that could be used. The repetitiousness clogs the syntax, to say nothing of the metrical movement, of the verses and gives a curious cloudiness or muddiness to many lines of the poetry.[3]

With practitioners like this, one is tempted to ask, what discipline needs enemies? Or, what can one say about Old English poetic style after seeming to dismiss those of its features that are usually denoted as its characteristic strengths, such as a supple use of alliteration and the deft handling of variation?

If Anderson talks about Old English poetics in this dismissive vein early in his study, he returns to the category of style later to make a larger—though, significantly, a nonstylistic—claim:

> It is evident that this Cynewulfian cycle is of later date than that of Caedmon. In the passage of something more than a half-century, the churchly tradition has advanced the Anglo-Saxon considerably along the road to a greater knowledge and imitation of classical literature; at least the poems of Cynewulf and his group are more Virgilian than

their predecessors. They are vigorous, straightforward, from a literary point of view more artistic achievements; one is more likely here than in the Caedmonian poems to be aware of a conscious designer at work in his art.[4]

Style becomes for Anderson less a means of descriptive analysis than a criterion for dating Old English poetry: the more straightforward, more vigorous a poem is in its style, the more likely it is to be later rather than earlier. When Anderson talks about style, then, he is in fact talking about how to approach the persistent problem in Old English studies of establishing a chronology or even a simple sequence for the poems. On a larger scale, the categories of Cædmonian and Cynewulfian style in Anderson's book can be read as attempts to solve another persistent problem in Old English studies: what it means to work with a largely anonymous body of poems and thus to lack the modern conveniences that come with known authors (as concern biography, intentionality, and corpus). This last point suggests in turn that when Colish talks about Cædmonian and Cynewulfian styles she is trying to identify authors or at least namable sources of *auctoritas*. In that way, her treatment of vernacular culture might thus seem more of a piece with her sections on Abelard, Ambrose, Anselm, Aquinas, Aristotle, Augustine, and Averroës, to cite only the famous A's in her index.

Dismissing Anderson's, and by implication Colish's, reliance on style to do other forms of analysis is easy. Too easy. I have quoted Anderson at length because I admire his attempt to make style serve as a vehicle for critical and historical study, for doing cultural work. His study matters less in its assertions, most of which are problematic at best, than in its faith that style can yield something more than descriptive or taxonomic categories.

To clarify this claim, let me take a brief detour into art history as a discipline, a detour that will also prepare for much of what I say about how we Anglo-Saxonists talk about style. In his highly polemical and overdramatic—one is tempted to say overstylized—study, *Vision and Painting: The Logic of the Gaze* (1983), Norman Bryson argues that art history as a discipline has traditionally sought to exclude or minimize style. In order to do so, the discipline has defined style as a "personal deviation" from the true end of art, which is perfect representation, that is, painting's desire to achieve the "Essential Copy." Style, in this version of the discipline, "appears as an inert and functionless deposit encrusting the apparatus of communication." Style is, in short, "noise" in a process where

noise is very much not to be desired.[5] Bryson argues that this disciplinary vision of art, what he calls the "natural attitude," is marked by five principles that include "Absence of the dimension of history" and "Style as limitation."[6] Later I will quote some art historians who put to the test Bryson's polemic about his discipline's reading of style, but I want now to isolate these two claims: that style is seen as a flaw, a limitation or a kind of "noise"; and that this sense of style proceeds by ignoring history.

Bryson's allegations about the place of style in art history are relevant to Old English literary studies on style. Or, to return to the opening of this piece, they suggest that Anderson's arguments about style are easy to dismiss because they run helter-skelter through the dimension of history (or at least one of its dimensions) and because they obscure the ways in which style affects the reading of Old English poetry. Remember Anderson's claim that certain stylistic features impart "a curious cloudiness or muddiness to many lines of the poetry." Anderson gets into trouble, because he charges into territory that we as a literary discipline usually avoid when we talk about style. Rather than offer a partial or biased characterization of how style has been treated in Old English studies, I will follow the lead of two scholars in the field. In her essay "Rhetoric and Style" in Robert E. Bjork and John D. Niles's *Beowulf Handbook*, Ursula Schaefer observes: "First, even a cursory look reveals— by no means only with regard to *Beowulf*—that scholars only vaguely agree what these categories refer to. The smallest common denominator in their use (either in everyday or in scholarly application) is that *style* refers to the 'linguistic how' of a verbal utterance while *rhetoric* deals with the question of 'to what end' that 'linguistic how' is used."[7] The close association between style and language accurately noted by Schaefer is amply borne out by Daniel Calder in his exhaustive survey of stylistic studies of Old English poetry.[8]

Calder's survey was published in 1979 as an introduction to a volume containing essays by E. G. Stanley, Stanley B. Greenfield, Roy F. Leslie, Fred C. Robinson, and Peter Clemoes. (Reading this list puts one in mind of the phrase *enta geweorc*.) Calder's essay covers almost two centuries of scholarship, and his bibliography lists over 115 items, mainly in English and German. Throughout his survey, as well as most of the essays in the volume, style is essentially taken as a matter for linguistic or philological analysis. In its various guises, style serves as a way of talking about the use of language in poetry. Style matters because language matters in the history of the discipline as a philological enterprise.[9] History

rarely appears as a criterion or factor—and certainly not as Bryson-like "noise"—in the works surveyed by Calder, though more ambitious claims for style are implicit in Clemoes's essay "Action in *Beowulf* and Our Perception of It" and in Robinson's "Two Aspects of Variation in Old English Poetry."[10] The latter reads now as a forerunner to Robinson's *Beowulf and the Appositive Style*, one of the signal successes in the discipline at relating style to historical matters. More precisely, his book suggestively identifies apposition as articulating the historical and historicizing relation between the paganism of the poem's characters and the Christianity of its original audience.[11] While *Beowulf and the Appositive Style* has influenced thematic readings of the poem, it has had less influence on how Anglo-Saxonists might read Old English style as doing historical and cultural work in the poetry.[12]

This circumscribed sense of style within the discipline of Old English literature is curious and difficult to explain (as well as to accept), especially when one thinks that an allied field from which literary scholars draw heavily has had a much more engaged and demanding concept of style. I refer to the historians of Anglo-Saxon art. And here I will cite several scholars who put Bryson's claims about painting to the test, though he might well respond that he refers to postmedieval art far more than to medieval art (the usual response when a medievalist speaks up to complicate things).

I start with an art historian well known to readers of Old English poetry because of his work on the Ruthwell cross and *The Dream of the Rood*, namely, Meyer Schapiro.[13] In a famous essay on style, originally published in 1953 in *Anthropology Today: An Encyclopedic Inventory*, Schapiro offers a series of observations about style that cross cultures, media, and disciplines. One of the theoretical questions he raises about style is its currency in a given period or culture.[14] Is there such a thing as "period style" that holds across the arts and characterizes an era, he asks, in a question that was especially pressing for a critic like Schapiro who had been on the radical Left in the 1930s.[15] The Marxist answer to the question, or at least the doctrinaire Marxist answer of that time, would be that there must be a period style because of the hegemony of the state, the locomotive of History, etc., etc. Schapiro offers a far more fascinating response to the question, however, by citing Anglo-Saxon England as his example of a period without a single or unified style:

> In England, the drawing and painting of the tenth and eleventh centuries—a time of great accomplishment, when

England was a leader in European art—are characterized
by an enthusiastic linear style of energetic, ecstatic move-
ment, while the architecture of the same period is inert,
massive, and closed and is organized on other principles.
Such variety has been explained as a sign of immaturity;
but one can point to similar contrasts between two arts in
later times, for example, in Holland in the seventeenth
century where Rembrandt and his school were contempo-
rary with classicistic Renaissance buildings.[16]

Schapiro illustrates this claim with the image of the *Three Marys
at the Tomb* from the Benedictional of Æthelwold (London, British
Library, Additional 49598, fol. 51v) and the south face of the church
tower at Barton-on-Humber in Lincolnshire. The larger point that
Schapiro makes with this juxtaposition is central to thinking about
style and history: that divergent styles can coexist in the same
time and place, that one need not give way to another in a model
of progress or evolution (e.g., Cædmonian followed by Cynewulfian).
Indeed, the point of Schapiro's juxtaposition might be taken to be
that the style of Anglo-Saxon art is made up of complementary
though divergent modes or forms. To talk about style is thus to talk
about a plurality or multivocality of styles and their relation to one
another. To argue the simultaneous existence of differing styles
rather than a progression from one style to the next does, of course,
make yet more complicated the analysis of poetic style in a corpus
that does not allow for easy or secure dating of individual texts.

 In a notable confluence, one that makes a skeptic almost be-
lieve in period style, Erwin Panofsky made a very similar argu-
ment about English art in an essay published in 1963.[17] Panofsky
sets up a juxtaposition of manuscript illustration and church archi-
tecture much like Schapiro's, though from later in the medieval
period: the curvilinear style of the *Majestas Domini* leaf in the
Rutland Psalter and the perpendicular style of the east window of
the church at Hawton, Nottinghamshire. Tracing this relation of
styles back to Anglo-Saxon England leads Panofsky to posit

a strong admixture of the Celtic element—tending toward
hyperbole, involved and "nonobjective" movement and un-
bridled imagination—in the very centers of ecclesiastical
and secular culture; and, on the other, the unparalleled
continuity of a classical tradition which, upon an island
far removed from the Mediterranean and never Latinized

in its entirety, tended to assume the character of an "invisible lodge."[18]

This complex cultural moment, with an admixture of styles that defeats easy or strict taxonomies, can be related, according to Panofsky, to the "peculiar British attitude toward classical antiquity" that makes it part of the national heritage yet also sees it as "far removed from palpable reality in space and time."[19] His most striking example of this "peculiar British attitude" for our purposes is "one of the earliest monuments of Anglo-Saxon literature—that amazing poem, *The Ruin*—[in which] Roman ruins (presumably those of Bath) are interpreted as a symbol of the destructive forces of destiny, reducing to rubble the proudest efforts of man while yet appealing to the aesthetic perception."[20] The notion that English art and literature (though the former is far more Panofsky's focus) exhibit a characteristic duality of style might seem, on a hasty reading, to verge on a racialist theory of national essence. What saves the essay from that error is Panofsky's erudition as well as his personal experience at the hands of a regime that practiced such racialist theories—that of Nazi Germany, which he fled in the 1930s.[21] And lest anyone take his claims about Englishness too solemnly, he calls his essay "The Ideological Antecedents of the Rolls-Royce Radiator" to evoke the upright severity of the marque's grill and the swoopy sensuality of the Flying Lady who rides it. Panofsky's title is itself, one might add, an exercise in style and an additional reminder that the study of style is a historical and cultural act that speaks to ideology in deep and sometimes witty ways.

If space permitted, one could trace this concern with style and ideology in the writings of art historians focusing specifically on Anglo-Saxon materials. Most notably, one might expand on the paragraphs about patterns in drawings and their relation to monasticism from Francis Wormald's *English Drawings of the Tenth and Eleventh Centuries* (1952);[22] or, closer to our moment, the subtle and learned analysis of "ideology as well as aesthetics" in Robert Deshman's *The Benedictional of Æthelwold* (1995).[23] More extended analysis of these two works would only make more evident the implicit burden of this study: that those who write about style in Anglo-Saxon art have by and large seized larger cultural phenomena as their subjects than have those who write about style in Old English poetry.

Perhaps this assessment is simply a case of disciplinary envy: were I an art historian, I might reverse my claim in favor of those

who study literary style.[24] I suspect, however, that is not the case, for the simple reason that Schapiro's and Panofsky's claims about style in art resonate for the poetry in ways that most studies of poetic style would not resonate for the art. That is largely because the art historians seem more attuned to ambivalence, to the simultaneous existence of differing styles, to the continuous pressure history exerts on style. Or, to turn Bryson's claim in another direction, that historians of Anglo-Saxon art seem more attuned to the "noise" made by its style.

My title alludes to a painful story by the late Raymond Carver entitled "What We Talk about When We Talk about Love." In it, two couples sit around a table as afternoon gives way to evening; they drink too much gin and talk too much about love. Written in Carver's spare but unsparing style, the story depicts these two men and two women as they talk about what they hardly know how to talk about. At the end, the narrator can only say: "I could hear my heart beating. I could hear everyone's heart. I could hear the human noise we sat there making, not one of us moving, not even when the room went dark."[25] When we talk about style, we are in some measure trying to talk about the "human noise" we hear in the textual and visual materials of Anglo-Saxon England. That is why it is so very hard to talk about style, and why we keep trying to do so.

Notes

1. Marcia Colish, *Medieval Foundations of the Western Intellectual Tradition, 400–1400* (New Haven, 1997), 105–6.

2. George K. Anderson, *The Literature of the Anglo-Saxons* (Princeton, 1949; rev. ed., 1966), 57. I quote throughout from the 1949 edition.

3. Ibid., 49.

4. Ibid., 111.

5. Norman Bryson, *Vision and Painting: The Logic of the Gaze* (New Haven, 1983), 7. For a similar argument, advanced by a painter rather than an art historian, see Julian Bell, *What is Painting? Representation and Modern Art* (London, 1999), 32–36.

6. Bryson, *Vision and Painting*, 10–12.

7. Ursula Schaefer, "Rhetoric and Style," in *A Beowulf Handbook*, ed. Robert E. Bjork and John D. Niles (Lincoln, 1997), 107.

8. Daniel G. Calder, "The Study of Style in Old English Poetry: A Historical Introduction," in *Old English Poetry: Essays on Style*, ed. Daniel G. Calder (Berkeley, 1979), 1–65.

9. In this regard, see further Daniel Donoghue, *Style in Old English Poetry: The Test of the Auxiliary* (New Haven, 1987); and Carol Braun Pasternack, *The Textuality of Old English Poetry* (Cambridge, 1995), esp. 92–94.

10. In Calder, *Old English Poetry*, 147–68, 127–45.

11. Fred C. Robinson, *Beowulf and the Appositive Style* (Knoxville, 1985), esp. chap. 1.

12. My study of the Old English *Exodus* follows in Robinson's methodological path; see *Migration and Mythmaking in Anglo-Saxon England* (New Haven, 1989), chap. 3.

13. Meyer Schapiro, "The Religious Meaning of the Ruthwell Cross," *Art Bulletin* 26 (1944): 232–45; reprinted with better plates in Schapiro, *Late Antique, Early Christian, and Mediaeval Art* (New York, 1979), 150–95.

14. Meyer Schapiro, "Style," reprinted with changes in the text in Schapiro, *Theory and Philosophy of Art: Style, Artist, and Society* (New York, 1994), 51–102. Schapiro develops some of these ideas about style in his "Words and Pictures: On the Literal and the Symbolic in the Illustration of a Text," in his *Words, Script, and Pictures: Semiotics of Visual Language* (New York, 1996), esp. 69–95.

15. See Michael Camille, " 'How New York Stole the Idea of Romanesque Art': Medieval, Modern, and Postmodern in Meyer Schapiro," *Oxford Art Journal* 17 (1994): 65–75.

16. Schapiro, "Style," 66.

17. Erwin Panofsky, "The Ideological Antecedents of the Rolls-Royce Radiator," *Proceedings of the American Philosophical Society* 107 (1963): 273–88; reprinted with other relevant essays in Panofsky, *Three Essays on Style*, ed. Irving Lavin (Cambridge, Mass., 1997), 129–66. I quote the essay from this volume. To the confluence of Schapiro and Panofsky, one should add Nikolaus Pevsner, *The Englishness of English Art* (New York, 1978). This study, originally delivered as a series of radio talks in 1955, has chapters entitled "Perpendicular England" and "Blake and the Flaming Line" that contribute significantly to the discussion on style offered by Schapiro and Panofsky.

18. Panofsky, "The Ideological Antecedents," 154.

19. Ibid., 154.

20. Ibid., 155.

21. On this issue, see the discussion by Lavin in Panofsky, *Three Essays on Style*, 12–13.

22. Francis Wormald, *English Drawings of the Tenth and Eleventh Centuries* (London, 1952), 58. His other significant comments on style appear on 26–35 and 41.

23. Robert Deshman, *The Benedictional of Æthelwold* (Princeton, 1995), 250. The whole of his chap. 7, "The Benedictional and the Winchester Style," is relevant to this discussion.

24. Indeed, Leslie Webster does exactly that in her exciting contribution to this volume, "Encrypted Visions: Style and Sense in the Anglo-Saxon Minor Arts, A.D. 400–900," by using the work of Katherine O'Brien O'Keeffe and other literary scholars on residual orality to explore her ideas on the ways "long-standing modes of visual literacy inform the shaping of post-Conversion art."

25. Raymond Carver, "What We Talk about When We Talk about Love," in *What We Talk about When We Talk about Love* (New York, 1982), 154. By a strange coincidence, in the same week that I read an earlier version of this study at Kalamazoo, the *New Yorker* ran a parody of Carver's story called "What We Talk about When We Talk about Doughnuts" (10 May, 1999, 51). Only those interested in how one can imitate a writer's style and utterly miss its genius should bother to read this flat-footed parody.

9

"Either/And" as "Style" in Anglo-Saxon Christian Poetry

Sarah Larratt Keefer

Right from the beginning of their conversion to the faith that would make them scholars and thinkers, the Anglo-Saxon people possessed a contradictive polarity in their culture that serves as a hallmark of their understanding of reality as it was expressed in the arts and letters of the period. By this I mean that for Anglo-Saxon England, nothing was necessarily and solely black or white in and of itself, but black could often be a component part of white, while white could be a reinterpretation of, replacement for, or inverse reality of black. While the interconnections of semantic fields for any language can always successfully be described as polysemous, the "Anglo-Saxon awareness," as it was inherited by those writing and reading texts, contained this contradictive polarity from the outside as well. Gregory's letter to Abbot Mellitus contains a useful paradigm that displays this phenomenon well: "dicite ei [Augustinum] quid diu mecum de causa Anglorum cogitans tractaui; uidelicet quia fana idolorum destrui in eadem gente minime debeant, sed ipsa quae in eis sunt idola destruantur" [tell {Augustine} what I have decided after long deliberation about the English people, namely that the idol temples of that race should by no means be destroyed, but only the idols in them].[1] Thus the temples (the outer housing or *modus articulandi*) remained intact while the idols (the beliefs, concepts or archetypal equations) were replaced by Christian ideology. Therefore two discrete cultural realities were allowed to coexist instead of mutually excluding one another, but because of their very different natures they remained unstable within this uneasy union and were forever tending to displace one another, or

be themselves displaced by other manifestations from either side. The slippery duality that arises out of such a union can best be termed "either/and" as opposed to the more conventional term "either/or." This so-called either/and therefore seems an integral part of the cultural patterning that runs through much of the creative expression of the pre-Conquest period. Because it does not appear static, I believe it differs from multivalence, polysemy, or metonymy:[2] I regard it as pointing instead to a pulsing movement between the two disparate elements, shifting from one to the other and examining the one in light of the other. The poet's creative interest lies centered first and foremost on that process of definition and redefinition, and for this reason Anglo-Saxon verse at times can seem astonishingly self-referential. Yet it is not necessarily a conscious ideology, nor does it signal self-awareness of its own duality in any specific fashion, but instead seems to have been an expression that was natural for the poets of the Anglo-Saxon culture.[3]

We know of the attraction for the newly literate Anglo-Saxons of the elegance of ideological dichotomies that they would have discovered within patristic writings concerning obedience, the power of the word, or the *vita activa et contemplativa*. Other early inroads into Germanic awareness of book-learning came from Iona, and Celtic intellectual and aesthetic ideology brought a variety of cultural approaches into natural combination in texts like the Durham Gospels.[4] However, I suggest that none of these "new" Christian elements, nor even the total of them working together, created anything culturally unfamiliar for the Anglo-Saxons. A preference for letting disparate and discrete strands of ideas lie together in tension seems to have been a natural point of departure. A native energy, able to encompass a number of truths at once, was thus brought by the Anglo-Saxons to their enthusiastic adoption of learning and letters, permitting them to create a flavor, or style, that remained uniquely their own.

Within Christian vernacular verse from Anglo-Saxon England, this "either/and" finds articulation in both the marriage and the innovative thinking about the process effecting that marriage, of praiseworthy action in Germanic epic, and obedient acceptance in Christianity. The latter was of course learned from the liturgy, Holy Scripture, and patristic teaching, while the former was part of the cultural understanding of the Anglo-Saxons themselves, the fertile matrix in which the Christian concepts took new form. As we shall see, some aspects of this duality are traceable within the theological or liturgical texts of the time, but as Leclercq has told

us, creative expressions of faith are frequently drawn from the soul's hitherto-unarticulated experience with the power of God.[5] If any part of the Anglo-Saxons' "either/and" aesthetic was deliberate, it was this fascination with what God is able to do: the rest of the elements that belong to it were not self-consciously presented, but developed in concert with the natural tendencies of the Anglo-Saxon mindset.

As a result of Gregory's exhortation that the English mission subsume the cultural values of their Germanic flock into the larger landscape of Christianity, we therefore find an untrammeled blending of heroic action and ascetic obedience presented in vernacular verse as something absolutely natural: as such, the form of artistic impulse that expresses this blend would have been attractive to both Christian Anglo-Saxon or Germanic convert either of the continent or the Danelaw. Nor is this without other precedent: in the patristic writers' intensive studies of *activa* and *contemplativa* on the models of Leah and Rachel or Martha and Mary, ultimately blended in the Virgin, there stands another naturally occurring tension and reciprocity between deed and thought, between obedient determinism in the form of taking action and obedient self-control that appears at first to embody passivity. But within the duality of "either/and" as it is expressed in Anglo-Saxon England, there is an element that does not seem to derive from any certain source: the Anglo-Saxon culture fixes readily on neither the one nor the other, but instead on the perceived *process* by which the two are related, and by which the one changes into the other, deepening the meaning of both as a result. Thus within the tension of one of these "either/and" binaries, we find the full force of a poem's focus invariably given to an exploration of the nature of the process uniting them; and we frequently find that the poetic actualization of this process entails a superimposition of one reality onto another, a forced contiguity by which to measure congruence. The impulse behind the process is always the omnipotence of God, which is articulated consciously and deliberately within the cosmos of the work, and it is the process itself, which allows the "either/and" to operate, that is evidently of paramount importance to those who conceived of the works themselves.

The frame narrative of the poem called *Kentish Psalm 50* opens with an example of just such a superimposition through the process of God's will; it creates what at first may seem like a paradox but is in fact an "either/and," changing the imperfect into that which has been perfected through the power of God, and sacrificing

nothing but sin along the way. It does so with two phrases standing seven lines apart: *Criste liofost*, "most dear to Christ," (3b) and *soð sigecempa*, "[a] true victory-champion" (10a), a pair of constructions that stand as complements to a shared subject, "David," and by the principle of syllogism, thus refer to one another. *Cempa* is a term most frequently found as a translation for "soldier"; as such it is not remarkable, but it does bear within it the potential once again for an "either/and." In order to realize that potential and follow the polarities bound up in this pair of phrases that both point to David, one must know, as the Anglo-Saxons did, the traditional story behind the genesis of Psalm 50. In his youth, David had slain Goliath and was God's champion by his actions. For his faith, he was rewarded by God with the kingship of Israel. But during a time of war, his lust for his captain's wife, Bathsheba, caused him to seduce and impregnate her; he then attempted to cover his tracks by recalling her husband, Uriah, from the front and encouraging him to sleep with his wife. Uriah's loyalty to his lord forbade him this luxury. David finally ordered him betrayed in the battle-lines so that he would be killed. God revealed to Nathan the prophet what David had done, and Nathan confronted the king with the parable of the ewe-lamb. In horror and guilt, David confessed to the seduction and murder, and composed the great Miserere to atone for his sin.[6]

Where does the "either/and" for Anglo-Saxon aesthetic sensibility lie here? It begins with the apparent anachronism of *Criste liofost* for David, who lived well before Christ's time and is, by the genealogy in Matt. 1:1–17, his ancestor. David was the *sigecempa* of the God of Israel, His warrior, who did mighty deeds on the battlefield in His name. But superimposed onto that earlier image is the image of King David's own *sigecempa*, Uriah, whose loyalty he rewarded with betrayal and seduction. Yet, through divine intervention in the form of God's prophet, David countered evil deed with words of faith and actions of the body, and the sinful will with repentance of the soul and of the heart. The psalms that he composed became central to the devotions of the Christian Church, and to Benedictinism as it was practiced in tenth-century Anglo-Saxon England when this poem was most likely composed.[7] Through the power of God, then, David abandoned warfare and became one who witnessed with words. The temporal aspect of the frame narrative moves us from the present of the poem's construction *(Criste liofost)* to David's own past *(soð sigecempa)*, alerting the reader that we must make a similar journey within cultural remembrance in order to understand how the latter became the former. Where before he

had been God's champion in deed against Goliath, David became Christ's champion in song, with his actions that belonged to the world of the Old Testament perfected into meditation for the life that began in the New Testament. The process by which the one became the other, the power of God, and God's operation on the human soul form the subject material of the Great Miserere, and of course of *Kentish Psalm 50* itself.

This example in *Kentish Psalm 50* consists of only two phrases directing the opening of one of the more obscure Old English poems. *The Dream of the Rood*, a far better known example of Anglo-Saxon poetic composition which is supported by related verses preserved on the Ruthwell cross,[8] is a masterpiece of craftsmanship that represents a gold mine for this kind of exploration. It is not a dream but a vision, and, as such, of the province of contemplative mysticism. There are a number of "perceptual spaces" within the poem that are variously superimposed one on another and considered as mirror images while in that state of contiguity: the *beornas* or *secgas* (warriors), who play minor roles, the Blessed Virgin Mary, Christ the Redeemer, the Rood as central speaker, and the narrator whom I term "Mystic" rather than "Dreamer."[9] However, in addition to all of these, I suggest that the perceptual space of the "Reader/Hearer" is an important presence that should not be left unexplored. These "spaces" of which I speak are conveyed and enhanced through use of vocabulary with the semantic property of "speech and word" held in an "either/and" tension with vocabulary whose semantic property pertains to "deed and action." Yet throughout the poem, the primary focus lies not on the doublings themselves but instead on process; this process pertains to the ways by which each pair is either related or repeated with variation, or by which change occurs from one "into" the other through some form of semantic, phonological, thematic, or visual contiguity, to create a flowing together of realities. These pairs are always made up of content words, though they are not always the same part of speech. It is in the realm of meaning that we find the superimpositions that we noted a moment ago: a deliberate creation of a contiguous state whereby two discrete elements are matched against one another, asking the same questions every time: what have these two in common? how do we perceive a similarity? what is the process by which the reality of the one becomes in turn the reality of the other? what can we learn from understanding the contiguity that links the two?

When the reader has moved into the "Mystic's space" in the opening lines, he tells us, *Geseah ic þæt fuse beacen / wendan*

wædum and bleom: hwilum hit wæs mid wætan bestemed / beswyled mid swates gange, hwilum mid since gegyrwed: [I saw that shining beacon / Change its garments and color; at times it was drenched with moisture, / soaked with a flow of blood, at times adorned with treasure] (21b–23). This dramatic "either/and" is the first of two conundrums, and functions like a gateway facing the past and the present simultaneously as part of the same truth. We then find that onto the Rood are superimposed a number of other shapes, presented in different ways: those of the men who carry it; that of Mary,[10] woman become Theotokos who, like the Cross, bore Christ; ultimately that of the Mystic; but primarily and centrally, and most completely, that of Christ Himself. The entire act of seeing and hearing that makes up the vision extends past the Mystic to those of us who are listening to his words, since the ultimate superimposition lines up his experiences with our own through the process of passing the vision and its concomitant injunction on to us in the words that we have just heard or read.

The central focus in this poem is the power of God as a process of transformation between each set of pairs; this power is manifest for the purposes of *The Dream of the Rood* not so much in the Incarnation as it is in the Resurrection, and the reasons for this will become clear.[11] Christ was born to redeem humanity, yet only a handful knew of His birth (the shepherds, the Magi, the suspicious Herod); but Christ went to the Cross and was raised from the dead after He had had direct, conscious, and public influence on the people of Judea, Jew and gentile: the process by which He had an effect on humanity and humanity had responded in kind had begun. Thus, voluntarily allowing the resurrected Christ into one's life, through the desire to be converted or baptized, to return in penance or to profess monastic vows, would begin an eruptive— indeed, a disruptive—process whereby one reality would ultimately be overlaid by another, because such an acceptance made provision for the transformation of the Resurrection as well. The first reality does not lose its nature but is instead perfected and made something more pleasing to God, through God's own will. I submit that in this very complex poem, we can find the themes of conversion to Christianity and of adult baptism, or a return to the Church of the penitent[12] running at a deeper level through the process that is tracked here, but that there may indeed be another important theme that belongs to the same process, and that is the theme of the profession of faith, of moving from the secular life to a monastic one.[13]

Within *The Dream of the Rood* there even seems to be a duality of structure. This was proposed by the poem's earlier editors, Dickins and Ross, as the creation of an original to line 77 with interpolations and additions made in later years;[14] recent scholars, however, have argued more coherently that artistic integrity need not require single authorship, and that unity is, in any case, discrete in meaning to any given cultural aesthetic.[15] But one can make a case for something like a pivot that does occur at the end of line 77, virtually the middle of the piece, with the first half looking at what happened before the Resurrection, the second half looking at what happened after it.[16] This seems consonant with the visual "morphing" that occurs in the early part of the vision, between Cross as gallows-tree and Cross as emblem of salvation. The Resurrection seems the key to the process here, since the obedience to God that led Christ to Good Friday and thence to Easter Sunday was in one sense wholly active and, in another, wholly passive.

Lines 1–77 introduce the Mystic, moving us the readers into his "space" so that we are able to experience through his eyes the vision of the Rood that he has: thus by the invitation to "see" and "hear" what he in turn sees and hears, we have our senses reshaped and superimposed onto his senses like the two halves of a pair of congruent geometric designs. The Rood addresses the Mystic, in turn inviting him into its own "space" but in the process also addressing us as in some way contiguous with the Mystic. In this first half of the poem, then, the Rood speaks of the past and the beginning of the process of literal conversion, the changing of one thing into another.

So we the readers are moved into the Mystic's reality with his own words creating sensory experience for us. But within this exterior and fictional superimposition lie a considerable number of binary pairs, all belonging to the same conclusion that "either/and" brings with it: that both alternatives must be true. Some of these pairs are linguistic and would have benefited from oral performance. In line 4b *syllicre treow* (a more rare tree), that odd comparative adjectival form accompanying the neuter noun, creates a split-second echo whereby, were the noun *treow* feminine, "faith," instead of neuter, "tree," the accompanying adjective with its "re" ending could be plausibly feminine as well, although genitive or dative instead of the accusative that *gesawe* (I saw) demands grammatically. I am here suggesting no reinterpretation of the line, only that a phonological echo occurs to create a polysemy, a semantic "second level" that is not at odds with the import of the poem. The

word *eaxlgespanne* of line 9a refers to the "cross-beam" of the Rood, but in some way personifies it: the Cross has shoulders (Old English *eaxl*, "shoulder"). Twenty-three lines later, in line 32a, we find *bæron me ðær beornas on eaxlum* [soldiers bore me there/at that time on their shoulders]; the same lexical root links the man-shaped Cross with those soldiers who bore it to Golgotha in preparation for what— and whom—it was about to bear itself. Indeed, the verb *beran* (carry, bear) begins a progressive development in polarities: in this half of the poem we see the Rood bear Christ so that both are buried in death, but in the second half, the faithful must ultimately bear "on their breasts the best of signs," *in breostum . . . beacna selest, either* as the spiritual faith (semantic of the feminine noun *treow*, "belief") in the Redeemer and His Redemption, *and* as the physical emblem of that faith (semantic of the neuter noun *treow*, "tree"), the mark of the Cross given in chrism at Holy Baptism or signed over the novice during profession; thus the catechumen or the novice is raised to life eternal in this second bearing. In line 30a, the Rood is cut off from its *stefn*, "root," but that act engenders another process by which, like the grieving disciples of lines 70–71, it finds a *stefn*, "voice," with which to relate and witness, and to continue the ultimate process of redemption and conversion that God Himself began.

The visual polarities begin, not with the changing form of the Rood that the Mystic sees, but even before that, in the contentious lines 9b–10a: the Vercelli manuscript reads *beheoldon þær engeldryht / -nes ealle fægere þurh forð gesceaft.*[17] The bound morpheme "-es" with the preceding consonant "n" stands on the line below *engeldryht*, and modern editors have seen no fit reason to emend this word, as earlier editors have done, to *engeldryhte*, abandoning what appears to be a perfectly acceptable genitive singular in order to create a nominative plural substantive; indeed, *wæs* in line 10b can be better understood if one assumes an implied subject *he* for it, referring back to the masculine noun *engel*; thus *hine*, line 11a, makes the same reference back to an already-identified substantive with a matching grammatical gender (again, *engel*). That way the following lines can be read "he [understood, and referring to *engel dryhtnes*, i.e. the Rood] was not in that place the gallows of a criminal. But the holy spirits, living men on earth, and all this glorious creation beheld him [*engel dryhtnes*, i.e. the Rood] there." Allowing the noun phrase *engel dryhtnes* to stand unemended, then, makes it the direct object of *beheoldon* in line 9b, with *fægere þurh forðgesceaft* as another noun phrase serving as subject. All three

levels of spiritual creation are brought into play here, echoing the
Prayer poem of Cotton Julius A.ii: the Church Militant, the Church
Triumphant, and the Heavenly Host.[18] Thus all that are fair through
creation—or through the process of creation—gaze, in this moment
of stasis, upon the Rood, which is called "angel of the Lord" or, to
point to its etymological origin, *angelus (domini)*, from the Greek
word for "messenger." That is exactly what the Rood becomes
through the paradoxical polarities of "either/and"; it is cut from its
root yet acquiring a voice, the shape of a man and yet not a man,
the tree that becomes a mark of faith to be borne by men because
it bore Christ. This moment of stasis, too, finds its parallel later in
the poem when the followers of Christ gaze on Him after receiving
Him down from the Rood following the Crucifixion. Ó Carragáin
points to this latter moment as a "station," based on early Roman
liturgy, as "a eucharistic setting, in which Christ's followers at
Ruthwell not merely receive the *corpus domini* from the Cross, but
recognize him in the *fractio panis* as Christ, and adore him as the
Agnus Dei."[19] So the Rood as *engel dryhtnes* or "messenger/evange-
list" (the word of God) is seen to occupy the same space as the Body
of Christ Himself (the Word of God), preparing the way of the Lord
in the second half of the poem.

In his work on *Dream of the Rood* and *Elene*,[20] Martin Irvine
has elegantly argued for an Anglo-Saxon stance on literary theory
and textuality over and against what Colin Chase once called the
"painful labor" of source study;[21] in short, he has asked the same
question of style that I approach here but has sought to answer it
from the locus of *grammatica*. When he considers *The Dream of the
Rood*, he does so through the lens of the *aenigma* element in this
poem, noting that it "is highly indebted to the rhetoric of the riddle—
the trope of enigma—and to the related trope of prosopopoeia,"[22]
which he associates with the code of typology. I take the same
starting point but a different direction, since I do not think you can
divorce what Anglo-Saxon poets theorized from what they had to
work with, and thus I argue that study of source and study of
literary theory can run in tandem to create something to do with
an aesthetic that may be termed "style" in its own right. By my
suggestion, instead of antitype and type, we are here presented,
over and over, with two things that a reader may perceive as dis-
crete, but which are brought together to challenge mortal and
imperfect assumptions about reality. Through the operation of God,
tree within God's service becomes faith, gallows within God's ser-
vice becomes Rood, which in turn becomes man who must bear

Christ; the severing of one's physical roots and obedience by being rooted in God provides a voice with which a mere man-shape becomes a messenger of God and can give testimony to His omnipotence for the benefit of others. The source from which this derives is the faith of Western Christendom itself that shaped Anglo-Saxon beliefs, so it is a larger ideological source and not a specific identifiable one, that I use here. But its very articulation is drawn from the Anglo-Saxons' delight in riddles and conundrums that they learned from the same patristic and cultural fountainhead as their faith.

The image that remains engraved upon the mind after only one reading of this poem is that of *Frean mancynnes / efstan elne micle þæt he me wolde on gestigan . . . Ongyrede hine þa geong Hæleð þæt wæs God ælmihtig / strang ond stiðmod* [{I saw} then the Lord of Mankind / Hasten with great zeal, that he would ascend on me / . . . the young Hero then stripped himself (that was almighty God) / Strong and resolute] (33b–34, 39–40a). We can learn about Anglo-Saxon sensibilities when we examine this image for the process that it represents. In this poem where the active invariably gives way to the contemplative, the work to the word, here instead we have the Word become the Warrior, and the act of redemption set out in verbs that denote purpose, action, intent, self-direction: *efstan* (hasten, 34a), *wolde . . . gestigan* (would . . . ascend, 34b), *ongyrede* (stripped, 39a), *gestah* (climbed up, 40b), *ymbclypte* (embraced, 42b). Instead of the ultimate sacrifice alone, then, the Crucifixion becomes a process whereby Christ is High Priest who actively undertakes His own death, more reminiscent of the Christus Rex figure on a crucifix than of the more traditional Corpus of the crucified Christ. By comparison, the Rood, shadow-shape of the Man who ascends to hang there, assumes the passive role, forbidden *ofer Dryhtnes word* to take any action whatsoever. Four times we are told that the Rood stands under constraint, *ne dorste ic* (35a, 42b, 45b, 47b), not to do injury to anyone; for both Christ and Cross, obedience to God is what allows the process of redemption and transformation to take place. It is as though the Mystic and his audience are being told by the Rood that "there are two kinds of obedience, taking action in response to a command, and remaining passive within the will of God. The first belongs to the world, but the second is eternal. The riddle at the heart of my narrative is that true action is absolute obedience to God's will and God's power." The Warrior on the Cross, assigned the dual pronoun *unc* by the Rood, embodies the second conundrum: Christ the active,

nailed to the passive Rood has become a sacrament redefined: the inward and spiritual grace manifested as the outward and visible sign within temporal history. Here we see actualized the two central elements of the poem, the Active Word that is Christ and the Passive Agent of Death that is the Cross, standing in physical contiguity. They point to the process whereby active loyalty and duty to avenge must give way to Christian obedience through conversion in the faith; at the same time they suggest the tension between the values of the *vita activa* of this world in relation to those of the *vita contemplativa* that leads to the next.

What follows that theorized break at line 77 is what will be, over against what has already been, again from the Rood's narrative space. With the interwoven patterns of superimposition and contiguity now established, the Rood begins a more personal address to the Mystic, drawing him more completely into that space just as we the audience have already been drawn into the Mystic's space through appeal to the two basic senses of vision and hearing. The Mystic is invited first to hear (*Nu ðu miht gehyran hæleð min se leofa*, 78) and then to speak (*Nu ic þe hate hæleð min se leofa / þæt ðu þas gesyhðe secge mannum:* [Now must thou hear, O warrior my beloved . . . now I adjure thee, O warrior my beloved, that thou announce this vision to mankind] (95–96), becoming an angel of the Lord and an agent of the process of redemption himself through obedience to the Rood's command—once again embodying the active and passive simultaneously. His task is to receive the tale from the Rood and pass it on to mankind. As the Rood was obedient to God's command not to injure, so the Mystic becomes obedient to the Rood's command that he bear witness to what he has seen. By this act of *obedientia*, which was a primary virtue of the practice of Benedictinism, the Mystic becomes like the Rood itself, transformed from gallows to most honored tree as the Christ-bearer, through its own deliberate act of obedience in accord with *Dryhtnes word*. But the Mystic also becomes like the Blessed Virgin, the perfectly obedient *ancilla domini*, who answered an injunction with the words *fiat mihi secundum verbum tuum*; we are told that *ælmihtig God . . . his modor eac . . . geweorðode ofer eall wifa cynn* [almighty God also honored his mother above all womankind] (92–94). Mary is transformed from woman to Theotokos by the union within her of the *vita activa* in her nurturing of the Holy Child, and the *vita contemplativa* in her pondering of the mysteries of His life.

Along with others, most notably Éamonn Ó Carragáin, I believe that conversion and adult baptism are somehow implicit here;

linked with baptism may also be a reference to the Lenten penance
practice of the earlier Roman church (although penitents were
"readmitted . . . to the eucharist on Holy Thursday morning")[23] in
that the Mystic assesses himself in contrast to the brilliant vision
in the binary tension, *Syllic wæs se sigebeam and ic synnum fah*
[marvelous was the Tree of Victory, and I was stained with sins]
early in the poem (13). If we continue the theory of superimposed
elements—riddlic figures because of the complex process that has
caused their contiguity—to yet another level and include baptism
in our consideration, we find that the Rood occupies the same
position as that of an adult catechumen, waiting within the liminal
space between Good Friday and the Easter celebration; the peni-
tent, already baptized, would still be preparing for Easter but would
no longer be liminal. Like the catechumen, the Rood has been
witness to the Crucifixion only: indeed, an occasion inspiring this
poem may well be the vigil throughout Holy Saturday night that
was customarily kept by those about to be baptized.[24] However, at
this moment the catechumen knows only what has already hap-
pened through narration: until the mystery of faith can be revealed
in the Easter Mass with the reading of the Easter Gospel and the
celebration of the Paschal Feast, he remains in liminality and in
process, waiting for the operation of God's power to make him a
novus homo and perfect what was begun with his conversion. Thus
with the Rood: where it spoke with authority of the Crucifixion, it
can only speak of the Resurrection in the formula that is closely
linked to individual faith and to baptism itself, the Apostles' Creed.
From its astonishingly personal account of the Crucifixion, the Rood
moves to words that are no longer those of the eyewitness but
instead the words of those "who have not seen, and yet believe"
(John 20:29):

> Deað he þær byrigde; hwæðere eft Dryhten aras
> mid his miclan mihte mannum to helpe.
> He ða on heofonas astag. Hider eft fundaþ
> On þysne middangeard mancynn secan
> On domdæge dryhten sylfa
> ælmihtig god ond his englas mid
> þæt he þonne wile deman se ah domes geweald
> anra gehwylcum swa he him aerur her
> on þyssum lænum life geearnaþ.

[Death he there tasted {but could also mean "buried," see
Wulfstan}[25] but afterwards the Lord arose / with His great

strength as a help to mankind. / He then ascended into the heavens. Hither again He shall come / to seek mankind on this middle-earth / on Judgement Day, and his angels with Him / so that He who has the power of doom will then judge / everyone as to how he for himself formerly here / in this transitory life will have earned during his lifetime.] (Lines 101–9)

With these words from the Creed as a bridge between what the Rood has seen and what the Rood believes will happen, we move to a tallying of the many superimpositions, brought into force by the Rood's address to the Mystic, *hæleð min se leofa* [O Warrior my beloved] (78b, 95b), evocative of God's words at the moment of Christ's own baptism: "my beloved son." The process that these superimpositions represent is all-important, for it is God in action, not man in action, that changes the human soul and prepares it for heaven. The process of God's power at work in the world has been the impulse behind the Rood's narrative: that which was once forest-tree/gallows has been identified with the *beornas* who carried it to Golgotha, where the process of redemption began; both, perhaps, are man-shaped and both contribute to execution, but neither as of yet understands the implications of one particular such execution. There on Calvary, the Rood and the Redeemer were superimposed when the Word turned Warrior measured Himself against the man-shape of the Cross, determinant active contiguous with obedient passive. Thereafter the Rood submitted the body of the Lord—described not as dead but only at rest (64b–65a, 69b)— to the hands of men—*secgum* in line 59b. Thus, like the priest who administers (but, it is important to note, does *not* consecrate) the sacrament of the body of Christ on Good Friday to the faithful,[26] the Rood submits the body of the *ælmihtigne God* (60b) to his followers, and prefigures this devotion. The word *secgas* has a similar semantic to *beornas,* with which it is then paralleled (66a), recalling the earlier *beornas,* who were soldiers obedient to commands; all belong to the pre-Resurrection landscape of the poem, which serves as a metaphor for the *vita activa* of this world. At line 78, the Rood, which has had all of these superimpositions—the physical, the lexical, the phonological—laid upon it, now begins to work the same variety of superimpositions onto the Mystic in turn: where before he was one of the *secgas,* the doers, he is now to *secgan,* speak forth, become active in words only, *onwreoh wordum þæt hit is wuldres beam / se ðe ælmihtig God on þrowode / for*

mancynnes manegum synnum [Reveal in words that it is the Tree of Glory / on which Almighty God suffered / For the many sins of mankind] (97–99).

Because these lines are immediately followed by the Creed passage described above, it may be that the Mystic is being exhorted to recite the words of the Apostles' Creed, witnessing to his faith either through baptism or for another reason. However, I also think that monastic profession may be implicit in this poem as well. Ruthwell may have been the site of an early Anglo-Saxon monastic settlement,[27] and thus the enduring relationship between stone cross design and Vercelli Book poem must be central to our consideration. For this reason, although the Vercelli poem and its "either/and" style are of primary interest here, it is important to consider at this point in our discussion the Ruthwell cross and its iconography with all the recent work done on it. Beginning in the 1980s, studies suggested that the Ruthwell cross had been designed with the relationship between the secular and monastic lifestyles in mind.[28] Ó Carragáin suggests that the Ruthwell Crucifixion Poem may well have been intended as a series of *sententiae* on which members of the Ruthwell monastic community were to meditate.[29] The relationship and sequence of the Ruthwell Crucifixion Poem and *The Dream of the Rood* is too complicated a concern for much detailed debate in this forum, and it is well to remember Ó Carragáin's caveats about assuming that the former is simply an incomplete version of the latter;[30] nevertheless, there is clearly some link between the two by what Ó Carragáin calls "the Vercelli hypothesis"[31] whereby he suggests that "the Vercelli *Dream of the rood* [*sic*] should be seen as a manuscript version developed (perhaps through many stages) for 'private devotional reading,' as distinct from the 'public' text on the monument at Ruthwell."[32] If this is in fact a valid proposal, as I believe it is, then it may be possible to postulate that the "manuscript version," much expanded perhaps through that "devotional" perspective, nevertheless carried forward a sense of Vita Monastica with profession and centered contemplation at its heart, from the monastic milieu in which the Ruthwell poem was created.

Through the words of the Rood and the vision he is given, the Mystic's whole life is changed: one of the *orationes* at monastic profession concludes, "[E]xoramus ut eiusdem domini nostri Iesu Christi gratiam super hunc famulum suum abrenuntiationem seculi profitentum, clementer respicere dignetur, per quem in spiritu mentis suę renovatus, veterem hominem cum actibus suis exuat et novum, qui secundum te creatus est, induere mereatur" [we pray

that by the grace of the same Lord Jesus Christ upon this his servant confessing his renunciation of the world, he may be worthy to depend upon thy mercy, through which, spiritually renewed in his meditations, he may lay aside the old man with his acts, and be worthy to don the new that has been created according to Thy will].[33] Although the movement of God runs contrary to the rest of the poem, from Word to Warrior, from creative speech to redemptive deed, it seems as though that movement is intended to set in motion the process that enables all of His creation to move from obedience in deeds, to the obedience of contemplation where actions cease and only articulated thought remains. Once again the Rood itself is the central example: it is no longer *wita heardost* (bitterest of torments) by the use to which it was put, but now it has become a *beacen* (sign) to be understood as a meaning, through which the power of God is now active instead. And it is in this same passage that we find Mary, whom God *geweorðode ofer eall wifa cynn* (honored above all womankind); Mary "combine[s] the virtues not only of Mary and Martha," traditionally associated with the contemplative and active lives, respectively, "but also of other biblical pairs with whom Mary and Martha [are] likewise compared."[34] The Ruthwell cross itself preserves a panel that some modern scholars believe may represent Mary and Martha,[35] and "this representation has been associated with the monastic life which embraced both action and contemplation."[36]

For the Anglo-Saxons, however, these two lives were again not a matter of either/or, a division, but were instead a process again, an "either/and." The early fathers Ambrose and Augustine saw equality between these sisters. Augustine would have it that "in Martha was the image of the present, in Mary, of the future; that which Martha did is what we are; that which Mary did is what we hope for."[37] Gregory notes that Christ praised Mary but did not condemn Martha, "because the merits of the active life are great but those of the contemplative life are preferable [*potiora*], wherefore Mary's part is said never to be taken away because the works of the active life pass with the body but the joys of the contemplative life become greater [*convalescunt*] after the end."[38] For Origen, "action and contemplation do not exist one without the other."[39] The process that sees the transformation of one thing into another without loss is exactly this progression from active to contemplative, from this life to that of the next world. It stands in harmony with the equally viable interpretation of transformation, through baptism, of what a man wishes to believe into what he does in fact believe.

The Rood ends its speech within the poem with the statement that is in one sense a call, like a vocation, to the Mystic to speak in words to the other speech-bearers (who may in turn also speak thus) about the centrality of the Cross to belief:

> Ne þearf ðær þonne ænig anforht wesan
> þe him ær in breostum bereð beacna selest.
> Ac ðurh ða rode sceal rice gesecan
> of eorðwege æghwylc sawl
> seo þe mid Wealdende wunian þenceð.

[There is no need for any to be afraid / who bears on his breast {or in his heart} the best of signs. / But through the Rood shall every soul who thinks to dwell with the Lord, seek the Kingdom from the earth.] (Lines 117–21)

Whether this refers to a physical cross worn as an amulet, to the sign of the Cross given in chrism at one's baptism, or to the faith that the *treow / treow* pun represents has been much disputed. Roberts points to Riddle 9 of Tatwine called *De cruce Xristi*, whose solution is the cross, and notes that it shares significant elements with the early lines of *Dream of the Rood:* that riddle ends with the words *Propterea sapiens optat me in fronte tenere* [for this reason the wise man chooses to hold me on {his} forehead].[40] Sandra McEntire suggested that the practice of "praying with arms extended," making the signing of the cross as an act done with the whole body rather than just the hands, originated with the monks of the Célí De reform in eighth-century Ireland.[41] In *The Sacramentary of Echternach*, dated by its editor to the last decade of the ninth century and perhaps indicative of early baptismal practice, the priest marks the sign of the cross with chrism onto the forehead of the adult catechumen at the very moment of baptism;[42] in the late-tenth-century *Winchcombe Sacramentary*, this signing takes place directly before the catechism of the Creed and the question *vis baptizari,* to which the reply is *volo.*[43] Here we see the sign of the Cross and the Apostles' Creed standing together within liturgical formulation, suggesting an association that may be made within the poem. In the rubrics at the profession of a monk according to the *Ritual of Fleury*, the vesting of the new brother is accompanied by the abbot signing the cross over him.[44]

However, what is more to the point is that the verb *bereð*, which I mentioned as a developing polarity earlier in the poem, is central to this passage, for he who bears the Cross also bears Christ, for the Rood bore Christ; and he who bears Christ is like Mary the Theotokos, who combines within herself *activa* and *contemplativa*. "Contemplation must follow teaching and moral exhortation,"[45] and so we find the Mystic at the poem's end, in prayer at the foot of the Cross as Mary of Bethany sat at Christ's feet to learn perfection. When he has reached the end of the process, he has moved entirely into the space of the Rood, and, like the Rood, has taken on the likeness, the shape, of Christ his Redeemer. The Rood has told him that it is the way to eternal life, *ic him lifes weg / ryhtne gerymde*, [I for them {*reordberendum* in line 89b, 'speech-bearers,' i.e., 'humanity'} opened the right way of life] (88b–89a), yet from John 14:6 comes Christ's "I am the Way, the Truth, and the Life" and in the monastic profession liturgy Christ is hailed as *via veritas et vita*.[46] The Mystic, in contiguity with the Rood, also becomes like Christ, and thus, through obedience, an agent for God's process of redemption. Like Christ awaiting His Resurrection after His ordeal on the Cross, the Mystic at the poem's conclusion *ana wæs / mæte werede* [was alone with scant {i.e., no} company] (123b–124a): this deliberate reduplication of the litotes construction found first in line 69b, *reste he ðær mæte weorode* [he rested there, with scant company] is yet another phonological superimposition, again implying process: no abandonment a human may suffer can be something that the Redeemer has not Himself already experienced, and all speech-bearers can draw comfort from that fact as we convert our manners and become more like Him. If the Mystic can fulfill the injunction that the Rood lays upon him, he will indeed become another *engel dryhtnes*, opening the way to salvation for those who hear his words.

Such complex patterns within this "either/and" framework are not confined to *The Dream of the Rood* but can be found in other vernacular Christian verse, from *Kentish Psalm 50* to some of the more explicitly liturgical poetry written in the eleventh century. There is in every case the same thread that binds all of the echoing layers fast into a unity: the choice is "either/and," not "either/or," because the process of transformation from one image to the other allows for both to exist simultaneously and be two truths with individual semantics and resonances, while they are part of that transformation. The end result is not one, as would be the case in

the choice of either/or, but instead three: the first, the second, and their sum that creates a third brought into being through the process that here represents the power of God. And so the circle is completed, and the conversion philosophy that permitted the contradictive duality of "pagan temples become Christian shrines" is given new invigoration through the creative articulation by the descendants of those converts for whom "either/and" has become a cultural identity and a cultural identifier.

Notes

1. B. Colgrave and R.A.B. Mynors, eds., *Bede's Ecclesiastical History* (Oxford, 1969), 1.30, p. 106.

2. In *Textuality in Old English Poetry* (Cambridge, 1995), Carol Braun Pasternack defines metonymy as stressing the "principle of contiguity." She says that "elements placed side by side are related by association rather than equivalence," referring to her own "Stylistic Disjunctions in *The Dream of the Rood*" (*ASE* 13 [1984]: 167–86), where she argued for "a turn toward the divine, representing a desire for a final unity not possible in the world of human experience and perception." In turn she cites Gillian Overing (*Language, Sign and Gender in Beowulf* [Carbondale, 1990]) and two of R. Jakobson's studies in describing differing uses of metonymy: still identified with "contiguity," the former "insists on . . . the metonymic irresolution of the *experience* of the text," while with the latter, "[metonymy] refers to a syntactical sort of structure in which subject leads to verb to object"; for discussion of the foregoing, see Pasternack, *Textuality*, 23–24, n. 87.

3. George H. Brown approaches this same phenomenon to be found within Anglo-Saxon Christian verse, though focusing on elements other than process, in his article "Old English Verse as a Medium for Christian Theology," in *Modes of Interpretation in Old English Literature: Essays in Honour of Stanley B. Greenfield*, ed. Phyllis R. Brown et al. (Toronto, 1986), 15–28.

4. See Christopher Verey et al., eds., *The Durham Gospels*, EEMF 20 (Copenhagen, 1980), 19–23.

5. See Jean Leclercq on "reminiscence" in *The Love of Learning and the Desire for God*, trans. C. Misrahi (New York, 1961), 79–80.

6. In the Vulgate version of the Psalter, this psalm is entitled *in finem psalmus David cum venit ad eum Nathan propheta quando intravit ad Bethsabee* (*Biblia Sacra iuxta Vulgatam versionem*, ed. R. Weber [Stuttgart, 1969], 1.830); the account of David's transgression and repentance is told in 2 Sam. 11–12.

7. "Dum omnimodis id adtendat, ut omni ebdomada psalterium ex integro numero centum quinquaginta psalmorum psallatur, et Dominico die semper a capite reprendatur ad Vigilias" [So long as he to whom it pertains takes care, above all, that the whole hundred and fifty psalms of the Psalter be chanted every week, and be always begun again at Night Office on Sunday] (*The Rule of St. Benedict*, ed. and trans. R. Crotty [Nedlands, 1963], 34–35).

8. For some of the recent controversy surrounding this monument see Fred Orton, this volume.

9. I follow Jane Roberts ("Some Relationships between *The Dream of the Rood* and the Cross at Ruthwell," forthcoming) in asserting that the poem recounts a vision, not a dream: the poet is not asleep as others are said to be. Roberts notes that there is no waking scene, nor indeed "detail of falling asleep," and suggests that the term "dream" in this poem is more likely consonant with Anglo-Saxon literary *visiones* like those of Cædmon in Bede, Constantine in Elene, or Guthlac in Felix's saint's life.

10. See É. Ó Carragáin, "Crucifixion as Annunciation: The Relation of 'The Dream of the Rood' to the Liturgy Reconsidered," *English Studies* 63 (1982): 487–505, esp. 492–94, 497–98, 504–5.

11. On the relationship between the Annunciation and the Crucifixion, see, however, É. Ó Carragáin, "Seeing, Reading, Singing the Ruthwell Cross: Vernacular Poetry, Old Roman Liturgy, Implied Audience," in *Art and Symbolism* (York, 1992), 91–92; and idem, "Rome Pilgrimage, Roman Liturgy, and the Ruthwell Cross," *Akten des XII. Internationalen Kongresses für Christliche Archäologie* (Münster, 1995), 630.

12. See Ó Carragáin, "Rome Pilgrimage," 631–34.

13. John Fleming argues that the poem "is about monastic life" (" 'The Dream of the Rood' and Anglo-Saxon Monasticism," *Traditio* 22 [1966]: 57), though not specifically focusing on the theme of profession as a movement from one state to another.

14. See B. Dickins and A. S. C. Ross, eds., *The Dream of the Rood* (London, 1934), 18. In "Doctrinal Influences in 'The Dream of the Rood,' " *Medium Ævum* 27 (1958): 137–53, Rosemary Woolf also supports this notion of the poem's section after line 78 as a later addition, by arguing for a Christocentric core to the poem (143–44). John Fleming rehearses these views in " 'The Dream of the Rood' and Anglo-Saxon Monasticism," 54–55, and suggests that he "should like to make the point that no arguments of any substance have been advanced against [unity]" (54).

15. Roberts outlines first the artistic integrity of the Ruthwell cross, then that of *The Dream of the Rood*, in "Some Relationships."

16. The "pivot" seems formal as well: in the Vercelli Book, the "new section" begins with the word "Nu," carrying a capital and placed at the beginning of a new line in the manuscript, although there is enough room for that word at the end of the previous line.

17. The argument in favor of leaving the text unemended is rehearsed below; its translation would read "All [those who are] fair through creation beheld there the angel of the Lord."

18. See Sarah Larratt Keefer on the three orders in "Respect for the Book: A Reconsideration of 'Form,' 'Content,' and 'Context' in Two Vernacular Poems," in *New Approaches to Editing Old English Verse*, ed. Sarah Larratt Keefer and Katherine O'Brien O'Keeffe (Woodbridge, 1998), 41–42.

19. Ó Carragáin, "Rome Pilgrimage," 638.

20. Martin Irvine, "Anglo-Saxon Literary Theory Exemplified in Old English Poems: Interpreting the Cross in *The Dream of the Rood* and *Elene*," in *Old English Shorter Poems: Basic Readings*, ed. Katherine O'Brien O'Keeffe (New York, 1994), 31–63.

21. Colin Chase, "Source Study as a Trick with Mirrors: Annihilation of Meaning in the Old English 'Mary of Egypt,'" in *Sources of Anglo-Saxon Culture*, ed. Paul Szarmach with V. D. Oggins (Kalamazoo, 1986), 24.

22. Irvine, "Anglo-Saxon Literary Theory," 51.

23. Ó Carragáin, "Rome Pilgrimage," 631.

24. See Kenneth Paul Quinn, "The Use of the Baptismal Liturgy in Three Old English Poems" (Ph.D dissertation, S.U.N.Y. at Stony Brook, 1986), 34, 36, and especially 45–49 where he cites Burton Scott Easton, *The Apostolic Tradition of Hippolytus* (Cambridge, 1934) on the Easter Vigil and adult baptism (25–26).

25. Compare with Wulfstan's translation of the relevant passage of the Apostles' Creed ("To Eallum Folke," in *The Homilies of Wulfstan*, ed. Dorothy Bethurum [Oxford, 1957], 167): "ond hine to deaðe acwealde ond hine syððan on eorðan bebyrigde. . . . And we gelyfað þæt he syððan of deaðe arise. And we gelyfað þæt he æfter þam to heofonum astige. And we gelyfað ond georne witan þæt he on domes dæg to ðam miclan dome cymð . . . And we gelyfað þæt ða godan ond wel cristenan þe her on worulde Gode wel gecwemdon þonne on an sculon into heofonum faran" [and did Him to death and afterwards buried Him in the earth . . . and we believe that He afterwards rose from death. And we believe that after that He ascended into heaven. And we believe and earnestly anticipate that He will come on Doomsday to the Great Judgement . . . and we believe that the good and righteous Christians who here on earth served God well will then go to heaven].

26. See Ó Carragáin, "Rome Pilgrimage," 635.

27. Roberts, "Some Relationships,"; Ruthwell is described by Ó Carragáin as a "stable and intellectually lively monastic community" ("The Ruthwell Crucifixion Poem in its Iconographic and Liturgical Contexts," *Peritia* 6/7 [1987–88]: 7).

28. See Paul Meyvaert, "An Apocalypse Panel on the Ruthwell Cross," in *Medieval and Renaissance Studies*, ed. F. Tirro (Durham, N.C., 1982), 3–32; and idem, "A New Perspective on the Ruthwell Cross: Ecclesia and Vita Monastica," in *The Ruthwell Cross*, ed. B. Cassidy (Princeton, 1992), 95–166; but also Richard Bailey, "The Ruthwell Cross: A Non-problem," *Antiquaries' Journal* 73 (1999): 141–48.

29. Ó Carragáin, "Ruthwell Crucifixion Poem," 9–29.

30. Ibid., 3–9.

31. Ibid., 13.

32. Ibid., 14.

33. Dom Anselm Davril, ed., *The Monastic Ritual of Fleury*, HBS 105 (London, 1990), 123; my translation.

34. Giles Constable, *Three Studies of Medieval Religious and Social Thought* (Cambridge, 1995), 9.

35. Carol A. Farr ("Worthy Women on the Ruthwell Cross," in *The Insular Tradition*, ed. Catherine E. Karkov, Robert T. Farrell, and Michael Ryan [Albany, 1997], 45–61) refers to David R. Howlett ("Inscriptions and Design of the Ruthwell Cross," in *The Ruthwell Cross*, ed. Brendan Cassidy [Princeton, 1992], 71–93, esp. 73–75) in considering the question of whether the panel represents Mary and Martha or the Visitation (49).

36. Constable, *Three Studies,* 26.

37. PL 38-39: 618: Sermo CIV.iii, my translation.

38. CCSL CXLIII (Turnhout, 1953); Gregory, Moralia 6: 37, 60–61, p. 331; quoted in, and translated by Constable, *Three Studies,* 20.

39. H. Crouzel, ed., *Homélies sur s. Luc: texte latin et fragments grecs,* SC 87 (Paris, 1962), fragment 72, 521–22, translation Constable, *Three Studies,* 20.

40. Roberts, "Some Relationships," citing D. G. Calder and M. J. B. Allen, *Sources and Analogues of Old English Poetry* (Cambridge, 1976), 56.

41. Sandra McEntire, "The Devotional Context of the Cross before A.D. 1000," in Szarmach with Oggins, *Sources of Anglo-Saxon Culture,* 348.

42. Y. Hen, ed., *The Sacramentary of Echternach*, HBS 110 (London, 1997), 158.

43. Dom Anselm Davril, *The Winchcombe Sacramentary*, HBS 109 (London, 1995), 92–93.

44. Davril, *Monastic Ritual of Fleury*, 125.

45. Constable, *Three Studies,* 15, quoting Crouzel, *Homélies*, 521–22.

46. Davril, *Monastic Ritual of Fleury*, 124.

10

Eating People Is Wrong:
Funny Style in *Andreas* and its Analogues

Jonathan Wilcox

As the mystery at the center of the liturgy, consumption of the body and blood of a man is a sober miracle at the heart of Christianity— and so, one might think, no laughing matter. Still, the Old English poem *Andreas* repeatedly plays with this event in comic terms: as the saintly hero, Andrew, offers to the unrecognized Christ a heavenly loaf; as a story of pagans who make a habit of eating all people who come to their realm, threatening to include the visiting saint, until they are converted and eat instead the Eucharist; and as the pagans are consumed by a flood, presented as a really heavy drinking session, before they are brought back to life to drink instead the blood of the Lord. Comedy involving the Eucharist is part of a general pattern of humor in *Andreas*. While this poem is exceptional for the degree of its playfulness, I will argue that saints' lives, for all that they constitute a pious genre, are more riddled with humor than most commentators have allowed. Analysis of the style of this particular life shows up something fundamental about the genre.

I will argue, then, that style is a site for humor and is important for an understanding of genre. Style in this sense primarily constitutes choices in the use of language and in the structuring of storytelling elements—the play of signifiers within a work in contradistinction to the thing signified. Such aspects of style were particularly well attended to by New Critics, but have also been the province of much subsequent formalist criticism.[1] Genre is a vexed, if enduring, category for critics. It has been particularly fruitful for reception theorists as a way to build up the horizon of expectations against which a reader interprets a work.[2] Hagiography

as a genre has escaped the attention of modern theorists, perhaps because it is so characteristically medieval.

Saints' lives are an awkward genre to define. Written in prose or verse (or, later, as drama), they can be classified through subject matter as *passiones* or *vitae* or *miracula*, depending whether they deal with the death, life, or miracles of a saint.[3] The genre derives from and is centered on the liturgical celebration of a saint's nativity, yet the massive circulation in the Middle Ages of vernacular lives suggests that they occupied a place in the popular imagination beyond other elements of the liturgy.[4] Their appeal is often lost on a modern audience, for whom the genre is all too predictable. What is more, as both E. Gordon Whatley and Hugh Magennis have recently shown, the authors of Old English saints' lives demonstrably work to flatten out the potential for human interest in the stories they recount, instead seeking to emphasize the general and the edifying.[5] That edifying content is best explained in typological terms and has been effectively explicated by critics of the 1970s and 1980s, who have demonstrated how incidents in the lives of saints replicate incidents in the life of Christ and how apparently anomolous details in a narrative can often be understood as allusions to the liturgy.[6] Such an emphasis on typology has its dangers, since it can discourage a reading of the narrative and style of a life, all the more so since such features seem so unengaging to a modern reader. Yet the pleasure of that surface narrative probably explains in part the popular appeal of saints' lives in the Middle Ages.

The didactic nature of the genre might encourage modern readers to assume that saints' lives are necessarily monologic. I suggest, however, that saints' lives are fundamentally ironic, being premised upon a duality of vision. The tormentors and the worldly see things one way, the saint and the saved (and the perceptive audience) see them in another. From the perspective of this world, the saint has a rough time of it indeed, generally suffering extremes of torture and bodily torment leading to a pain-wracked death. Yet, from the perspective of the final reckoning, all such torment is ultimately irrelevant, as the saint well recognizes. This duality is particularly apparent in the attitude to the body and in the presentation of violence. Gory and extensive violence is a necessary part of the story of martyrs and yet is always presented in a paradoxical manner: on the one hand, the violence is to be taken seriously, pushed to an extreme to show the extreme suffering of the saint; on the other hand, the violence is not ultimately serious,

since it is the vehicle for the persecuted martyr's sanctity, the fortunate ill for which God will reward the saint. Just such a duality is also a necessary, if never in itself sufficient, cause for humor.[7] The very tension about the relative meaningfulness or unimportance of surfaces combines with the lack of human interest to allow for a distinctive playfulness in the genre in even the most unlikely circumstances. In this essay, I propose to get at an underremarked aspect of the style of Old English saints' lives, namely their use of comic violence, by centering on the example of *Andreas* and its prose cognate.

My discussion of hagiographical style will center on two Old English translations of a single work—the *Acts of Andrew and Matthias in the City of the Cannibals*—one translated into prose, the other into the poem known as *Andreas*. The *Acts*, probably composed originally in Greek around A.D. 400, belongs to the tradition of Apocryphal Acts of the Apostles, but abounds with enough hagiographical conventions to be usefully considered as a saint's life. The work is full of extensive torture scenes, miraculous intervention by God on behalf of the saint, miracles performed by the saint, intervention by the devil, and conversions of the onlookers. Although no Latin version survives from Anglo-Saxon England, there are two distinct Old English translations. The one into prose survives in fragmentary form at the end of the manuscript of the Blickling Homilies (of s. x/xi) and in a complete version among early additions in Cambridge Corpus Christi College 198 (of s. xi[1]).[8] Such contexts suggest a quasi-homiletic use for the work—vernacular hagiography within its most liturgical context—perhaps for reading on the saint's festival of 30 November, and the story is duly abbreviated.[9] An independent translation into Old English verse, the poem *Andreas*, survives in the Vercelli Book (of s. x/xi).[10] Here the manuscript context suggests the work was used for pious reading,[11] but the form of the translation takes the life in the direction of heroic poetry, as the following analysis will make clear, and exploits the overlap with that genre for comic effect.

Critics have attended to *Andreas* before, of course, but the major critical currents have not been sympathetic to reading humor in the poem. As with other saints' lives, the major critical flow has been to explicate the typological undercurrents of the poem, and this has been done very well.[12] Such interpretation necessarily downplays attention to the style of the surface narrative, which is of interest only as a vehicle for carrying more fundamental, and more serious, ideas. A second, smaller stream of criticism is provided

by those who read the poem in a New Critical way as a contained and consistent narrative.[13] Such readings are particularly attentive to style, although the most notable such exponent, Edward B. Irving Jr., plays up the consistent heroic tenor of the poem and so downplays the comedy. An eddying crosscurrent of recent criticism comes from John P. Hermann. He returns to the surface level of this and other poetic saints' lives in Old English and points to the significant level of serious violence exploited there: "[C]ritics," he objects, "have ignored or sublated the literal violence implicated in the final coherence."[14]

Hermann's reading of the surface is a salutory reminder of the violence that can be too easily suppressed through a typological reading. Nevertheless, I want to suggest that such disregard for violence is encouraged by the hagiographers' tone. Indeed, one way for a modern reader to revivify a surface otherwise too quickly sublated by typological criticism is to unpack the humor contained there. Through a reading of stylistic features that create humor, I want to steer a critical path between the Scylla of too thorough a turn towards typology and the Charybdis of a preoccupation with the literal that leads only to horror or annoyance.

The story of the *Acts of Andrew* springs from the fate of the twelfth of the apostles, Matthias, about whom the canonical record is slight indeed.[15] Matthias has been sent to proselytize the land of the Mermedonians—a rather unfortunate assignment, since the Mermedonians are cannibals, who have duly captured him to augment their food supply. Mermedonian custom is to blind foreigners, give them a mind-destroying potion that makes them like animals, and then to hold them for thirty days before slaughtering them for food. Matthias, however, does not lose his wits and is miraculously cured of his blindness. He is also miraculously reassured that the Lord will save him by sending his fellow apostle Andrew.

On the twenty-seventh day of Matthias's captivity, the Lord comes to Andrew in the city of Achaia and explains his mission. Andrew hesitates over the initial practical difficulty—how could he get to Mermedonia in time?—suggesting that the Lord's angels could achieve what he cannot. After this initial hesitation of faith, Andrew takes on the task. He goes with some followers to the seashore, where he finds a boat and steersman fortuitously bound for Mermedonia. The steersman, who is Jesus in disguise, encourages Andrew to recount his experience as an apostle to his followers within earshot of his unrecognized Lord. After a further exchange, Andrew and his companions sleep and are miraculously

conveyed to the walls of Mermedonia. Awakening, he realizes the true nature of the steersman, and his companions recount their own confirmatory visions.

In Mermedonia, Andrew soon sets Matthias and the other captives free, who then leave the story along with Andrew's companions. The Mermedonians, now discomfited by the lack of dinner, draw lots to decide who of their own to sacrifice for the good of the collective meat supply. Spurred on by the devil in disguise, they capture Andrew and torture him for three days. Although tormented by being dragged around the town, Andrew's body is miraculously restored. Then, instead of the expected scene of his death, Andrew summons up a huge flood that kills many of the Mermedonians. Realizing the folly of their ways, the remainder decide to convert to his faith and appeal to his God. The flood stops and is reversed; the slain are brought back to life; and the Mermedonians convert en masse. Andrew becomes their spiritual leader, preaching to them before returning to the city of Achaia.

Such, in abbreviated form, was presumably the story facing Anglo-Saxon hagiographers, variously adapted by the Old English homilist and the poet. No clear source text survives from Anglo-Saxon England, but the story can be reconstructed from the fullest early version to survive—the *Praxeis Andreou kai Matheian eis ten Polin ton Anthropophagon* (Acts of Andrew and Matthias in the city of the cannibals), composed in Greek, perhaps by an anonymous Egyptian monk, about A.D. 400 and conveniently translated by Robert Boenig[16]—along with a full Latin prose version found in the twelfth-century MS Rome, Biblioteca Casanatense 1104, fols. 26–43, and a fragment in an eleventh-century palimpsest, Rome, Biblioteca Vallicelliana, plut. I, tom. iii, fols. 44a–b.[17] Further Latin versions are more remote from the Old English reflexes, but attest to occasional details that may derive from an earlier, now lost, Latin source. That lost Latin source is generally best reconstructed from the Greek.[18]

The Anglo-Saxon treatment of that source, and the point of this essay, is illustrated well by a minor incident toward the end of the poem *Andreas*. Once Andrew has been returned to prison after a second day of torture, "a terrible monster [*atol æglæca*], intending evil, a wicked lord of crime shrouded in darkness, the deadly-cruel devil" comes with seven attendant demons to further discomfit the saint.[19] The devil commands his minions—"þegnum þryðfullum" [strength-endowed thanes] (1329a)—to humble the saint's *gylp* (boast, 1333b) in the language of heroic battle poetry:

Lætað gares ord,
earh attre gemæl, in gedufan
in fæges ferð.

[Let the spear's point, the arrow stained with poison, pierce
into the heart of the doomed one.] (*Andreas* 1330b–32a)

Things look bad for Andrew as the *reowe* (cruel, 1334a) demons
rush on him with avaricious grasps. But a reader need have no
fear:

 Hine God forstod,
staðulfæst steorend, þurh his strangan miht;
syððan hie oncneowon Cristes rode
on his mægwlite, mære tacen,
wurdon hie ða acle on þam onfenge,
forhte, afærde ond on fleam numen.

[God, the steadfast helmsman, defended him through his
strong might; after they perceived the cross of Christ, the
glorious sign, on his countenance, they were then terrified
in that attack, fearful, afraid, and put to flight] (*Andreas*
1335b–40)

The devil's henchmen, far from mounting the glorious battle the
poetry has been so emphatically building up to, run away.

Their instant defeat makes sense in the doctrinal context. They
are scared by the sign of the cross visible on Andrew's forehead. In
a poem obsessed with the implications of the liturgies of baptism
and of mass, the sign of the cross made at baptism—the *sphragis*—
is here seen performing its proper function of repelling the devil.
The typological meaning of this moment has been explained con-
vincingly by Thomas Hill: "[T]he sign of the cross which appears on
Andreas's *mægwlite* recalls the *sphragis* and its apotropaic power,
that is, its power as a sign which demons fear. . . . The miracle
consists in making visibly apparent the *sphragis* which Andreas
and all other baptised Christians bear. And this sign is by itself
enough to defeat the devil and his hosts."[20] This is deeply informa-
tive to a reading of the incident, and yet it fails to acknowledge
something that I hope my mock-heroic retelling has hinted: the
scene is also, surely, at a narrative level, funny. Both the structure
and style of telling the incident make for humor. The troop of

demons are built up as big, strong, heroic warriors in vocabulary that anticipates a fight scene, but, incongruously, they are turned around without a blow being exchanged at the mere sight of a token *(tacen)*. The humor is played up through the poet's heavily heroic vocabulary of onslaught ("Hie wæron reowe, ræsdon on sona / gifrum grapum," 1334–35a) and then the emphatic synonymy of the demons' immediate fear *(acle, forhte, afærde*, 1339–40). The poet's application of heroic style to the incident creates humor.

Incongruity of language and action continues as the demon troop report back to the lead devil that they can't succeed, adding unheroically "Do it yourself!" ("Ga þe sylfa to," 1348b), a retort unthinkable at Maldon. Instead of an attack, the troop decide to insult Andrew, "to have words ready, all prepared, against that monster *[þam æglæcan]*."[21] Such a rapid shift from deeds to words (rather than the other way round, as in the heroic struggle at Maldon or the deeds of Beowulf) is strikingly anticlimactic, while the demons' term for the sleeping Andrew—*þam æglæcan*—is arrestingly inappropriate: the beast to go around aggressively sleeping like that! The devil loses the ensuing verbal exchange; after a single speech by Andrew, "that one who previously once grimly mounted a feud against God was put to flight."[22] Even in a war of words, the devil is physically routed and sent ignominiously *on fleame* with bathetic ease.[23]

Comic discomfiture by devils is unsurprising. They are incongruous almost by definition: on the one hand, figures of such apparent power that they entered into a feud with God; on the other hand, easily put to flight at God's will by even the slightest action of a saint. The scene between Juliana and the devil works in analogous ways in that saint's poem, and the devils are one of the major comic elements in the later Corpus Christi plays.[24] The language of their upset in *Andreas* illustrates the thesis of this essay: hagiographical style, a style that works on multiple levels, allows and sometimes exploits a surface that is deliberately, detectably, and definably funny.

The location of the humor in this instance can be captured by a consideration of the different versions. The essential action is contained in the source, as attested by both Greek and Latin versions, but, with the exception of the cheeky retort of the ancillary devils to their lord, the source text lacks the comic development of the Old English poem. The Old English homilist plays up the mockery in the scene—the devils are "bismriende mid myclere bismre" [mocking with much mockery] and that mockery is here

explicitly cited.[25] In a strikingly physical action, the devils hurl themselves (*blæstan*) on the saint but are repulsed by the sight of Christ's *rodetacen on his onsiene* [sign of the cross on his visage], which makes them *onweg flugon* (flee away).[26] After reporting back to their leader in serious mode, a brief statement by Andrew leads all the devils to run away again. The scene has some incongruous slapstick, but is not as comically developed as the Old English poet's full-blown mock-heroic treatment. Humor is implicit and slight in the original narrative, slightly developed in the Old English homiletic version, and blown up into epic proportions in the Old English poem. Since the mock-heroic treatment is so dependent on the conventions of Old English heroic poetry, it is highly unlikely that this style comes from the lost Latin source. In the case of this minor scene, then, the full comic treatment of the narrative can be attributed to the Old English poet. In the remainder of this essay, I will consider two more comic scenes and show how humor is partly present in numerous versions, but is most fully developed by the Old English poet.

The presence of Christ himself as pilot of the boat that takes Andrew and his followers to Mermedonia is a comic irony in all the versions. In the Greek *Praxeis*, the exchange between Andrew and the Lord in disguise is a lengthy one.[27] The Lord/steersman feeds Andrew and his disciples bread, hinting at the eucharistic theme in the rest of the work, but the disciples cannot eat the bread because of seasickness. Andrew insists on sharing with his host in the name of the Lord, with a heavy dose of irony: "And Andrew answered and said to Jesus, not knowing he was Jesus, 'Brother, the Lord will provide you heavenly bread out of his kingdom. So eat, brother.' "[28] The most important irony occurs when the disguised Jesus goads Andrew into telling his disciples in his hearing about Jesus' own ministry. The story Andrew tells, in a boat tossed at sea guided by Christ as helmsman, is appropriately enough the miracle of Jesus' calming the sea of Galilee (Matt. 8:23–27, Mark 4:35–40). With accumulating irony, Andrew praises the Lord for his steering and also for his perceptive recognition of the power of Jesus[29] before moving on to other issues. The ironies are palpable, but not played up as heavily comic by the Greek hagiographer, and the same is true of the Latin of the *Casanatensis* version.[30]

The Old English homily understates the ironies here, as this is one of the scenes the homilist radically abbreviates. All that remains is the central irony of Andrew recounting to his disciples the story of Jesus' calming of the seas[31] in the approving earshot of

the steersman, who is the Lord Jesus Christ (emphatically and repeatedly called "Drihten Hælend Crist"[32]). Even in his radical abbreviating, the homilist recognized this episode as central. The Old English poet, on the other hand, plays this scene to the full. Arranging and embarking on the sea journey is amplified in the full heroic tradition as an example of the hero on the beach type-scene.[33] The whole incident is expanded, with a particular amplification of comic incongruities.

One particularly interesting detail is the question of payment for the sea journey. In the Greek *Praxeis*, Andrew observes "[D]o not think that it is out of dishonesty that we do not give you our passage money,"[34] and in the Latin of the *Casanatensis*, he comments on the lack of passage money, "[D]o you perhaps think that I am deceiving you through pride or some clever trick?"[35] In the Old English poem alone, Andrew takes the offensive on this issue. He gently berates the steersman (i.e., Christ) for *his* apparent pride for not sharing his God-given gifts with the needy—

> "Ne gedafenað þe, nu þe dryhten geaf
> welan ond wiste ond woruldspede,
> ðæt ðu ondsware mid oferhygdum
> sece, sarcwide"

> [It is not fitting for you, now the Lord has given you wealth and prosperity and success in the world, that you seek an answer with pride, a bitter retort] (*Andreas* 317–20a)

—before observing, with *Beowulf*ian sententiousness and breath-taking incongruity:

> selre bið æghwam
> þæt he eaðmedum ellorfusne
> oncnawe cuðlice, swa þæt Crist bebead,
> þeoden þrymfæst.

> [it is better for everyone that humbly he may acknowledge openly the one eager to depart, just as Christ, the glorious Lord, ordered it.] (*Andreas* 320b–23a)

In other words, Andrew, the Lord's apostle, brandishes a pointed generalization at a boat operator who happens to be the Lord himself that rather than fussing about payment he had better be humble

and ought to acknowledge openly those who are eager to go about the business that Christ commanded of them! The poet has massively escalated the ironic potential of the scene by having Andrew put the Lord-as-steersman in his place in the name of the Lord.

Andrew's offer of bread to the steersman presents this event, already resonant in the analogues, in language that drips with additional ironies:

> Ðe þissa swæsenda soðfæst meotud,
> lifes leohtfruma, lean forgilde,
> weoruda waldend, ond þe wist gife,
> heofonlicne hlaf, swa ðu hyldo wið me
> ofer firigendstream, freode, gecyðdest!

[May the steadfast creator, the light-giver of life, the ruler of hosts, pay you back for this meal, and give you sustenance, a heavenly loaf, as you have showed kindness, love, towards me on the mighty ocean.] (*Andreas* 386–90)

The piling up of variation for the Lord is striking, since the terms all have special significance: the *soðfæst meotud* (literally: "truth-secure creator") is not so *fæst* in his *soð* but that he can deceive one of his disciples; the *lifes leohtfruma* (light-giver of life) is taking Andrew to a land where visitors lose sight of the light through blinding and then are deprived of life; the *weoruda waldend* (ruler of hosts) is present with a particularly small host, there on his own, and is unrecognized by one who belongs to his broader host. Andrew invokes for Christ-the-steersman *heofonlicne hlaf*, the heavenly bread that is Christ himself in John 6:32–59 ("Ic eom lybbende hlaf þe of heofonum com" according to John 6:51 in the Old English Version of the Gospels).[36] He conjures for him *wist*, the sustenance that has been eaten, but also the spiritual sustenance that so much opposes the craven corporeality in the eating habits of the Mermedonians.

Ironies continue in the poem's emphasis on the violence of the sea journey. The account of the sea is far more embellished in the poem than in other versions:

> Frecne þuhton
> egle ealada, eagorstreamas
> beoton bordstæðu, brim oft oncwæð,
> yð oðerre; hwilum upp astod

of brimes bosme on bates fæðm
egesa ofer yðlid.

[The frightful water-paths seemed terrible. The ocean cur-
rents beat the seashores, the sea often cried out, one wave
after another; sometimes terror rose up from the bosom of
the sea into the embrace of the boat over the wave-traveler.]
(*Andreas* 440b–45a)

The storm creates fear in the apostles, as in all the versions, but
is here presented in terms that resonate with so much Anglo-Saxon
sea poetry. Indeed, the forceful description of the sea breaking on
the shore requires an impressionistic leap from the literal ship at
sea that editors of the poem have been unable to make.[37] This
emphasis on the power of the sea continues throughout Andrew's
ironic praise of the steersman's exceptional skills. The metaphori-
cal valence of such sea imagery is expressed by the steersman/
Jesus:

 Flodwylm ne mæg
 manna ænigne ofer meotudes est
 lungre gelettan

[The surge of the flood cannot at all harm any person against
the Creator's grace.] (*Andreas* 516b–18a)

The rampant ironies of this whole passage are amplified by their
expansion into the characteristic language and image patterns of
Old English poetry. The emphasis on the flood anticipates the poem's
gushing denouement, where the surprisingly humorous style surges
with most force.

The events of that climax can be summarized from the Greek
source.[38] Andrew is tortured for three days and dragged through
the streets by the Mermedonians. At the end of the third day, he
summons up a flood, a deluge of Noachian proportions, which is
reasonably read as baptismal by typological critics.[39] The saint prays
that an alabaster statue on a pillar may bring forth water: "and the
water was raised up upon the earth, and it was exceedingly salty,
devouring the flesh of men."[40] The water kills the people's flocks
and herds and children, like one of the plagues of Moses (Exodus
7–11). Andrew then prays that the Lord build a wall of fire around

the city so that the people cannot evade the flood. Again the flames carry figural significance: Hill points to "the references in the gospels to the baptism of fire and water which Christ will bring (Matthew 3:11; Luke 3:16)."[41] Thus hemmed in, the Mermedonians realize they are dying for their inhospitability to the visitor and so come to him praying to his God. Andrew orders the statue to stop the flow of water. He walks out of the prison, with the water flowing from his feet (as in Moses' crossing of the Red Sea);[42] causes the flood waters and the fifteen most wicked of the Mermedonians to be swallowed up by the earth; then prays for the rest of the Mermedonian dead to rise up alive. After all of which, the Mermedonians duly convert and a church is built. The *Praxeis* thus climaxes in a melodramatic but serious and edifying incident.

Essentially the same form of the story recurs in the Latin of the *Casanatensis* text.[43] There is a little more ironic but unfunny play on the salty nature of the flood waters, flowing here from the mouth of a marble statue: "And that water was salt because of the eating of human flesh so that even those who earlier had been the eaters were killed by this water" (Boenig, p. 51);[44] in other words, the eaters of human flesh explicitly have their flesh eaten alive through the corrosive nature of this water. In such a context, there is further punning when Andrew prays "and immediately the earth opened its mouth and swallowed the water down with the executioners,"[45] since the just Christian comeuppance for the wickedest of the cannibals is being eaten up by the earth.

The Old English prose version works in ways similar to this Latin text. The homilist plays up the ironies of good and bad eating, with salt water flowing from the mouth of the statue (in this case made of stone):

> hraþe sio stænene onlicnes sendde mycel wæter þurh hiora muþ swa sealt, and hit æt manna lichaman.

> [quickly the stone statue sent much water through its mouth thus salty, and it ate the bodies of the people.][46]

Those people who ate the bodies of visitors and would have tormented and then eaten the body of Andrew find instead that their bodies are eaten by the corrosive flood of salt water, the same element that earlier seemed to present a barrier to Andrew and his companions from ever making it to Mermedonia, but which proved to be so easily controlled by the power of the Lord. The paradoxical

eating is played up, since it is repeated in the description of the flood ("þæt wæter weox oþ mannes swuran and swiþe hit æt hyra lichaman" [the water grew up to men's necks and greatly it ate their bodies].[47]) When the Mermedonians appeal for Andrew's mercy, the flood retreats, to be swallowed (forswealh)[48] by the earth. The impressed Mermedonians duly convert, whereupon they will swallow the body of Christ when mass is celebrated in the newly constructed church on the site of this miracle.[49] The homilist emphasizes this play on eating to such an extent that the scribe of CCCC 198 makes a telling mistake in describing those who watch Andrew pass through the flood as "þa þær to hlafe wæron"[50] [those who were there in respect of the loaf] instead of "þa þær to lafe wæron" [those who were there as a remnant], anticipating the expectation of the remaining Mermedonians serving as food if they do not appease Andrew, along with hinting at their eucharistic hopes if they do.[51]

The Old English poet adds to the punning of this climax. The flood is anticipated in some details of the torture scene that expand upon the source. Whereas, in the Greek, on the first day of torture, Andrew is dragged through the streets "and his blood was a stream just as water is upon the earth,"[52] in the Old English poem, a storm arises and the saint's body flows with redundant emphasis:

> Wæs þæs halgan lic
> sarbennum soden, swate bestemed,
> banhus abrocen; blod yðum weoll,
> haton heolfre.

[The body of the holy one was sodden with grievous wounds, drenched in blood, the bone-house broken; blood surged in waves in hot gore.] (Andreas 1238b–41a)

On day two, the flow continues. The Greek has only, "and again . . . his blood was a stream."[53] In the Old English poem, there is yet more emphasis on a carnivalesque excess of outpouring blood and tears:

> Swat yðum weoll
> þurh bancofan, blod lifrum swealg,
> hatan heolfre . . .
> þa cwom wopes hring
> þurh þæs beornes breost blat ut faran,
> weoll waðuman stream.

[The bile surged in waves through the bone-chamber, the blood poured out in thick streams,[54] in hot gore. . . . Then the ring of weeping came over the breast of the man, the pale drops came to run out, the stream surged in floods.] (*Andreas* 1275b–80a)

This all seems anything but funny, and the overlap with *Beowulf* hints at the serious way in which these images can resonate.[55] In *Andreas*, though, the audience should know that the saint will not come to ultimate harm—saints never do—and so the suffering approaches grand guignol, with the overemphasis on flow anticipating what will happen next. Rather than harm, the trail of tears, blood, and body parts turns literally into a primrose way, as the Lord miraculously consoles the saint and restores his body (lines 1469–77).

After a climax-signaling pause while the poet parades an inadequacy topos (lines 1478–89a), Andrew commands the stone pillars to pour forth:

<div style="text-align:center">Stream ut aweoll,</div>

fleow ofer foldan; famige walcan
mid ærdæge eorðan þehton,
myclade mereflod. Meoduscerwen wearð
æfter symbeldæge; slæpe tobrugdon
searuhæbbende. Sund grunde onfeng,
deope gedrefed; duguð wearð afyrhted
þurh þæs flodes fær. Fæge swulton,
geonge on geofone guðræs fornam
þurh sealtes swelg; þæt wæs sorgbyrþen,
biter beorþegu. Byrlas ne gældon,
ombehtþegnas; þær wæs ælcum genog
fram dæges orde drync sona gearu.

[The stream surged out, flowed over the earth; the foamy billows engulfed the earth with the break of day, the sea-flood increased. There was a serving of mead {or a deprivation of mead} after the day of feasting; the armed men started from sleep. The water engulfed the ground, deeply stirred up; the troop was all frightened through the sudden attack of the flood. The doomed died, the battle-rush took off the young ones in the ocean through the swallowing of the salt water; that was a brewing of sorrow, a bitter beer drinking. The cupbearers, the serving men, did not delay;

there was enough drink immediately ready for each from
the beginning of the day.] (*Andreas* 1523b–1535)

This scene provides a climax of comic incongruity. The flood is here
conceived as a really heavy drinking session. The first sentence
sees the flood as an excessive sea surge. Then, however, it gets
figured as *meoduscerwen*, either "a serving of mead"[56] in an exces-
sive act of hospitality by the Mermedonians who have shown so
little hospitality, or "a deprivation of mead"[57] in a heavily ironic
comment on the lack of sustenance-providing drink for the Merme-
donians drowning in an excess of water. Whatever the precise
valence of *meoduscerwen, æfter symbeldæge* (line 1527a) is also
ironic: the day before was a perverse holiday for the Mermedonians
insofar as they festively watched the torture of Andrew and was
certainly no "feast-day," since they were torturing Andrew precisely
because he had deprived them of their food supply. As so often in
Andreas, the event is seen in terms of appropriately inappropriate
battle imagery. In this case, the *guðræs* is an unconventional battle
onslaught against which those possessing armor *(searuhæbbende)*
are ill-equipped. If Brooks's emendation of line 1532a is accepted,
the *sealtes swelg* is surely as much "the swallowing of the salt" as
"the abyss of salt water."[58] The ironic feast inversion is then ex-
ploited most fully at lines 1532b–35: Brooks suggests a metathetic
"brewing of sorrow" for *sorgbyrþen*, clearly in keeping with the
biter beorþegu, "bitter beer-partaking," that ironically conveys the
unfestive consumption of salt water, or consumption by salt water,
that is substituting for hospitable beer-sharing.[59] The excessive
consumption is expressed in terms reminiscent of Holofernes's
overdrinking in *Judith*. Variation stresses the imaginary presence of
serving folk—*byrlas, ombehtþegnas* (lines 1523b, 1524a)—who pro-
vide their abundance with temporal alacrity—*fram dæges orde, sona*
(line 1535). The fundamental litotes—"þær wæs ælcum genog . . .
drync . . . gearu" [there was enough drink ready for each]—is embed-
ded in such an ironically fatal context that it surely constitutes a
killer case of Old English understatement. On the one hand, this
whole counterfeast emphasizes the hospitality not shown by the
Mermedonians to their guests; on the other hand, the excess here
plays into the whole thematics of good and bad consumption. Eat-
ing people is wrong; eating the Eucharist, as the Mermedonians
will do at the end of the poem, is right. Now the partying is hap-
pening to excess, as the drinking proves to be a consumption of the
Mermedonians themselves, eaten by the salt water.[60]

This vision of the flood as an excess of serving by eager servants is the element unique to the Old English poem that most clearly pushes the climax into comedy. At one level, drowning is no laughing matter, and it is incongruous at a literal level to describe a flood as an excessive party. The way that description resonates with the broader themes of the poem and with the details of the moment make it, however, an appropriate incongruity. Such appropriate incongruity is the essential kernel of humor, and therefore encourages a reading of this scene as funny. That a set of grave issues—cannibalism and torture, death and conversion—are here figured through something as ungravid and indecorous as a heavy drinking session provides the kind of gulf that humor thrives on.

This is the scene that most clearly plays into my central thesis: that saints' lives have such a disengaged surface style that they allow for humor in the presentation of violence. Few audience members should be identifying with the Mermedonians. Laughing at their agony may therefore directly parallel laughing at the devil's discomfiture earlier in the poem. But even any unease about laughing at the pain of these torturing cannibals is dispelled by Andrew's subsequent miracle of bringing the drowned back to life. In tone this is as if, after the Red Queen's peremptory command of "Off with their heads!," the Red King were to offer a mumbled reprieve.[61]

While hagiographic humor may puncture modern expectations of decorum, it is not so surprising in a context where the priorities of this world ultimately count for naught. In this way, *Andreas*, like all saints' lives, brings a double perspective to its story. That duality is most evident in the presentation of violence where, from a worldly perspective, humor is entirely inappropriate, yet, from a higher perspective, laughing is one of the few responses that make sense. Such humor illustrates something essential about hagiographic style: hagiographic style is always ironic in view of the duality of vision in saints' lives; at its best it is also comic, as the otherwise insignificant details of this world undergo a move from irony to comedy. A final irony of hagiographic style is that, for all its duality of vision, and despite the irony and humor, it is not at all subversive, but rather is ultimately monologic in viewpoint. Laughing at the scenes of torture may only be possible from an ideology of Christian triumphalism, but that is precisely the ideology of saints' lives.

One way to revivify a narrative style otherwise too quickly sublated by typological criticism or too easily dismissed for its unpalatable surface is to unpack the humor contained there. Such

an attempt is peculiarly fruitful in the case of *Andreas*, where a poet has refigured the conventional elements of a saint's life by drawing upon the language and forms of heroic poetry. The bitter beer-drinking of the Mermedonians floundering in an excess of salt water can be a delight to a contemporary audience attuned to the playfulness of hagiographic style.

Notes

1. For a discussion of the changing attitude to style in Old English literature, see Nicholas Howe's contribution to this volume. Useful surveys of what is meant by style in relation to Old English literature are Daniel G. Calder, "The Study of Style in Old English Poetry: A Historical Introduction," in *Old English Poetry: Essays on Style*, ed. Daniel G. Calder (Berkeley, 1979), 1–65; and Ursula Schaefer, "Rhetoric and Style," in *A Beowulf Handbook*, ed. Robert E. Bjork and John D. Niles (Lincoln, 1997), 105–24.

2. See the work of Hans Robert Jauss, particularly *Toward an Aesthetic of Reception*, trans. Timothy Bahti (Minneapolis, 1982). For the application of reception theory to Anglo-Saxon literature, see Clare A. Lees, "Working with Patristic Sources: Language and Context in Old English Homilies"; and Martin Irvine, "Medieval Textuality and the Archaeology of Textual Culture," in *Speaking Two Languages: Traditional Disciplines and Contemporary Theory in Medieval Studies*, ed. Allen J. Frantzen (Albany, 1991), 157–80, 181–210.

3. For good introductions to Old English saints' lives, see Michael Lapidge, "The Saintly Life in Anglo-Saxon England," in *The Cambridge Companion to Old English Literature*, ed. Malcolm Godden and Michael Lapidge (Cambridge, 1991), 24–63; and the volume *Holy Men and Holy Women: Old English Prose Saints' Lives and Their Contexts*, ed. Paul E. Szarmach (Albany, 1996).

4. For a study of the development of saints' cults in later medieval England, see Ronald C. Finucane, *Miracles and Pilgrims: Popular Beliefs in Medieval England* (Totowa, 1977), who shows well the ways in which such cults were propagated both top-down by official action and bottom-up by popular involvement.

5. E. Gordon Whatley, "Lost in Translation: Omission of Episodes in Some Old English Prose Saints' Legends," *ASE* 26 (1997): 187–208; Hugh Magennis, "A Funny Thing Happened on the Way to Heaven: Humorous Incongruity in Old English Saints' Lives," in *Humor in Anglo-Saxon Literature: An Essay Collection*, ed. Jonathan Wilcox (Cambridge, 2000), 137–57, where Magennis is concerned with an exception to the general pattern,

namely, the anonymous Legend of the Seven Sleepers. For the latter, see Walter W. Skeat, ed. *Ælfric's Lives of Saints*, EETS, o.s., 76, 82, 94, 114 (1881–1900; reprint, 2 vols., London, 1966), homily xxiii.

6. For the general point, see James W. Earl, "Typology and Iconographic Style in Early Medieval Hagiography," *Studies in the Literary Imagination* 8 (1975): 15–46.

7. See my introduction to Wilcox, *Humor in Anglo-Saxon Literature*, 1–10, for a discussion of theories of humor.

8. R. Morris, *The Blickling Homilies*, EETS, o.s., 58, 63, 73 (1874–80; reprint, 1 vol., London, 1967), 228–49, edits the Blickling version (with lacunae filled from CCCC 198) with a facing translation. F. G. Cassidy and Richard N. Ringler, *Bright's Old English Grammar and Reader*, 3d ed. (New York, 1971), 203–19, edit the CCCC 198 version with an introduction and notes.

9. A very different homiletic version of the saint's life is recounted by Ælfric, CH I.38 (see Peter Clemoes, ed. *Ælfric's Catholic Homilies: The First Series*, EETS, s.s., 17 [Oxford, 1997], 507–19), drawing on a distinct *Passio Andreae*. This has no overlap with the version under discussion.

10. Kenneth R. Brooks, ed. *Andreas and the Fates of the Apostles* (1961; reprint, Oxford, 1998); George Philip Krapp, ed. *The Vercelli Book*, ASPR 2 (New York, 1932), 3–51.

11. See D. G. Scragg, "The Compilation of the Vercelli Book," *ASE* 2 (1973): 189–207.

12. Typological and exegetical studies of *Andreas* began with Thomas D. Hill, "Figural Narrative in *Andreas*: The Conversion of the Mermedonians," *NM* 70 (1969): 261–72, and continued with Penn R. Szittya, "The Living Stone and the Patriarchs: Typological Imagery in *Andreas*, lines 706–810," *Journal of English and Germanic Philology* 72 (1973): 167–74; John Casteen, "*Andreas*: Mermedonian Cannibalism and Figural Narration," *NM* 75 (1974): 74–78; Constance B. Hieatt, "The Harrowing of Mermedonia: Typological Patterns in the Old English 'Andreas,'" *NM* 77 (1976): 49–62; Marie Michelle Walsh, "The Baptismal Flood in the OE 'Andreas' Liturgical and Typological Depths," *Traditio* 33 (1977): 137–58; James W. Earl, "The Typological Structure of *Andreas*," in *Old English Literature in Context*, ed. John D. Niles (Cambridge, 1980): 66–89; Lisa J. Kiser, "*Andreas* and the *Lifes Weg*: Convention and Innovation in Old English Metaphor," *NM* 85 (1984): 65–75; Frederick M. Biggs, "The Passion of Andreas: *Andreas* 1398–1491," *Studies in Philology* 85 (1988): 413–27; Robert Boenig, *Saint and Hero: Andreas and Medieval Doctrine* (Lewisburg, 1991).

13. Most notably Edward B. Irving Jr., "A Reading of *Andreas*: The Poem as Poem," *ASE* 12 (1983): 215–37. See also T. A. Shippey, *Old English*

Verse (London, 1972), chap. 5; David Hamilton, "The Diet and Digestion of Allegory in *Andreas*," *ASE* 1 (1972): 147–58; and Peter Clemoes, *Interactions of Thought and Language in Old English Poetry* (Cambridge, 1995), 249–72.

14. John P. Hermann, *Allegories of War: Language and Violence in Old English Poetry* (Ann Arbor, 1989), chap. 5; quotation from p. 120.

15. His cameo appearance in the Scriptures is to be chosen by lot to replace Judas in the Acts of the Apostles 1:26, after which he is not mentioned again. In both OE versions, he is called Matthew.

16. The text edited is by Max Bonnet, "Acta Andreae et Matthiae," in *Acta Apostolorum Apocrypha*, ed. Richard Adelbert Lipsius and Max Bonnet, 2.1 (Leipzig, 1898), 65–116. The translation is by Robert Boenig, *The Acts of Andrew in the Country of the Cannibals: Translations from the Greek, Latin, and Old English* (New York, 1991), 1–23. Knowledge of sources is summarized by Frederick M. Biggs, "Acta Andreae et Matthiae," in *Sources of Anglo-Saxon Literary Culture: A Trial Version*, ed. Frederick M. Biggs, Thomas D. Hill, and Paul E. Szarmach, with the assistance of Karen Hammond (Binghamton, 1990), 52–53.

17. The full Latin version is edited by Franz Blatt, *Die lateinischen Bearbeitungen der Acta Andreae et Matthiae apud anthropophagos*, Zeitschrift für die neutestamentliche Wissenschaft, Beiheft 12 (Giessen, 1930), 33–95. The palimpsest is edited by Bonnet, "Acta Andreae," 85–88. They are translated by Boenig, *Acts of Andrew*, 27–55, 25–26.

18. The prose must derive from a Latin source—always likely in Anglo-Saxon England—in view of the incorporation of a Latin fragment at Morris, *Blickling Homilies*, 231.

19. "atol æglæca, yfela gemyndig, / morðres manfrea myrce gescyrded, / deoful deaðreow" (lines 1312–14a). Translations are all my own unless otherwise acknowledged.

20. Thomas D. Hill, "The *Sphragis* as Apotropaic Sign: *Andreas* 1334–44," *Anglia* 101 (1983): 149.

21. "habbað word gearu / wið þam æglæcan eall getrahtod!" (lines 1358b–59).

22. "Ða wearð on fleame, se ðe ða fæhðo iu / wið God geara grimme gefremede" (lines 1386–87).

23. The comedy of this scene has been briefly discussed by Irving, "Reading," 232.

24. See Cynewulf's *Juliana*, ed. Rosemary Woolf (London, 1955; rev. ed., Exeter, 1977), lines 287–558, 627b–34.

25. It includes questioning Andrew's *gilp:* Cassidy and Ringler, *Bright's,* 215, lines 223–25.

26. Ibid., 215, lines 228–30.

27. Boenig, *Acts of Andrew,* 3–11.

28. Ibid., 5.

29. Ibid., 6–7.

30. Ibid., 31–39.

31. Cassidy and Ringler, *Bright's,* 209–10, lines 84–95.

32. E.g., Cassidy and Ringler, *Bright's,* 209, lines 73–74.

33. As described by Irving, "Reading," 220–21, referring to D. K. Crowne, "The Hero on the Beach: An Example of Composition by Theme in Anglo-Saxon Poetry," *NM* 61 (1960): 362–72.

34. Boenig, *Acts of Andrew,* 4.

35. Ibid., 32.

36. *The Old English Version of the Gospels*, ed. R. M. Liuzza, EETS, o.s., 304 (Oxford, 1994), 170.

37. Brooks glosses *bordstæðu* as "the ship's sides" rather than the more obvious shore because "this meaning is unsuitable, as the ship is on the open sea" (Brooks, *Andreas,* 77, line 442). Krapp suggests "the rigging of the ship" (Krapp, *Vercelli Book,* 110, line 442n). In continued hostility to the effect of the passage, Brooks supports the emendation of MS *brim* at line 442 to *brun* "dark (wave)": "[T]his emendation . . . is certain, for the transmitted text scarcely makes sense" (Brooks, *Andreas,* 77, line 442).

38. Boenig, *Acts of Andrew,* 19–22.

39. See, in particular, Hill, "Figural Narrative"; Walsh, "Baptismal Flood."

40. Boenig, *Acts of Andrew,* 20.

41. Hill, "Figural Narrative," 265–66.

42. Exod. 14:15–31; see Walsh, "Baptismal Flood," 141–43.

43. Boenig, *Acts of Andrew,* 51–54.

44. Boenig, *Acts of Andrew,* 51. "Et aqua ipsa salsa erat ad conmedendum, carnes humanas uti, et ipsi prius fuerant conmedentes, et ex ipsa aqua interfecti sunt" (Blatt, *Die lateinischen Bearbeitungen,* 87).

45. Boenig, *Acts of Andrew,* 53. "et statim terra aperuit os suum, et degluctivit aquam, cum illis carnificibus" (Blatt, *Die lateinischen Bearbeitungen,* 91).

46. Cassidy and Ringler, *Bright's*, 216, lines 269–70; cf. Morris, *Blickling Homilies*, 245.

47. Cassidy and Ringler, *Bright's*, 217, line 277; Morris, *Blickling Homilies*, 245.

48. Cassidy and Ringler, *Bright's*, 217, line 293.

49. The pattern of eating in both the prose life and in the poem *Andreas* is discussed by Hugh Magennis, *Anglo-Saxon Appetites: Food and Drink and their Consumption in Old English and Related Literature* (Dublin, 1999), chap. 4. Magennis shows how unusual the positive portrayal of eating is in the poetry but does not center on the humor of the presentation.

50. Cassidy and Ringler, *Bright's*, 217, line 289.

51. Blickling has the correct spelling (Morris, *Blickling Homilies*, 247). It should be noted that the scribe of CCCC 198 makes and corrects the same mistake on two earlier occasions at lines 40 and 142, where the association with bread is harder to make.

52. Boenig, *Acts of Andrew*, 17.

53. Ibid., 17.

54. Accepting Brooks's (*Andreas*, 108) word division and suggested translation of the difficult half-line 1276b, which clearly parallels 1240b, quoted above.

55. These lines overlap with the account of the burning of Beowulf's body, *Beowulf* 3147, and with his fight against the dragon, *Beowulf* 2693, both scenes of deadly earnest. The relationship between *Andreas* and *Beowulf* has been much discussed: see Leonard J. Peters, "The Relationship of the OE *Andreas* to *Beowulf*," *PMLA* 66 (1951): 844–63; idem, "*Andreas* and *Beowulf*: Placing the Hero," in *Anglo-Saxon Poetry: Essays in Appreciation for John C. McGalliard*, ed. Lewis E. Nicholson and Delores Warwick Frese (Notre Dame, 1975), 81–98; Anita R. Riedinger, "The Formulaic Relationship between *Beowulf* and *Andreas*," in *Heroic Poetry in the Anglo-Saxon Period: Studies in Honor of Jess B. Bessinger, Jr.*, ed. Helen Damico and John Leyerle (Kalamazoo, 1993), 283–312.

56. Brooks, *Andreas*, p. 114, taking the second element as a verbal noun *scerwen*, meaning "dispensation."

57. J. R. Clark Hall, *A Concise Anglo-Saxon Dictionary*, 4th ed. (Cambridge, 1990), s.v. *meduscerwen*, based, presumably, on *bescerwan*, "to deprive of." For a recent discussion of the possibilities for the word, see Bruce Mitchell, "Literary Lapses: Six Notes on *Beowulf* and Its Critics," *Review of English Studies* 43 (1992): 4–7.

58. The latter is Brooks's suggested sense for the phrase (*Andreas*, 114).

59. Ibid.

60. Magennis, *Appetites*, 158–59, suggests that the poet misread his source and so generated an expanded scene based on a tradition of consuming bitter drink.

61. Lewis Carroll, *Alice's Adventures in Wonderland*, chap. 9.

11

Aldhelm's Jewel Tones: Latin Colors through Anglo-Saxon Eyes

Carin Ruff

Color terms are among the most frequently studied lexical fields in modern languages. The study of color is attractive to linguists and cognitive psychologists because the semantics of the description of objects goes to the heart of the relationship between thought and language. A lack of live witnesses to interview obviously inhibits the study of color systems in ancient languages. Despite this handicap, a great deal of progress has been made in understanding how color operates in the historical Germanic languages, but the same cannot be said of classical and medieval Latin. As a result of this situation, we can say in broad outline, at least, how the Anglo-Saxons used color terms in their own language, but we know virtually nothing about how they used color when they wrote in their second language. We know enough about the color system of Old English to be convinced that the Anglo-Saxons described the appearances of objects in ways that seem strange to native speakers of Modern English and seem also to differ from the descriptive system of classical Latin. What did the Anglo-Saxons make of the color vocabulary they learned when they adopted Roman culture? Did they find a system similar enough to their own that the description of objects in Anglo-Latin was unproblematic? Did Anglo-Latin authors so assimilate the Latin worldview that their mapping of the new color terms to the perceived spectrum became that of a native speaker of Latin?

Anglo-Saxon authors' use of Latin color terms is necessarily a matter of linguistics and of style, if style includes the literary traditions and personal habits that lead an author to choose from a set of linguistic possibilities.[1] Color-term studies in the Germanic

223

languages have largely been the province of linguistics and of linguistically oriented anthropology. The linguistic and anthropological data on color terms are complicated in the present case by a complex situation of language change and contact. We are interested in the use of color terms by authors working in a second language, Latin, a language that is acquired in most cases through textbooks and textual models, not through contact with native speakers. Moreover, the Latin used for instruction and as models by Anglo-Saxons was of various periods and origins: we have some data on the color-term system of classical Latin, but early medieval authors could and did refer to late antique models at least as often as to classical ones. We would expect some slippage between term and meaning in the internal development of the Latin semantics of color, and we would expect further slippage as non-Latin-speaking writers interpret Latin terms and begin to put them to their own use.

It is in the interpretive space thus opened between Latin color terms and their referents that authorial style comes into play. Style as a nexus of rhetorical choice and personal habit filters the inventory of color terms available in the Latin known to the Anglo-Saxons, and leaves us a personal selection by each author, conditioned by culturally ingrained ways of seeing and by learned traditions of literary description. Because color terms are, in the first instance, descriptive of objects, their deployment also brings into play matters of personal and cultural taste in the objects described. In this paper I would like to explore, if not solve, some of the linguistic and stylistic problems involved in the literary use of color terms by second-language authors, using the first Anglo-Latin author, Aldhelm, as a test case.

The questions raised above about Anglo-Saxon understanding of Latin color terms would be easier to answer if we knew more about the color terms of native Latin speakers. But arguments about Latin color terms are still going on in the tones of frustrated confusion that prevailed in the last century, and although classicists pay lip service to the idea that ancient color systems might not line up neatly with their own, the idea does not seem to have been fully assimilated. Thus, classicists are still arguing questions like "*luteus*: pink or yellow?" Such studies appeal particularly to botanists and are of some use in the interpretation of particular passages, but they contribute little to an understanding of color as a way of seeing or of the range of possible terms available in a culture from which an author potentially chooses. Most importantly,

they make no allowance for the possibility that the terms of greatest salience in another culture may not have been hue terms.[2]

The Old English vocabulary of color has attracted a good deal of attention since the publication of Berlin and Kay's theory of Basic Color Terms.[3] Whether agreeing or disagreeing with Berlin and Kay, investigators have concurred in calling attention to terms in Old English that are either nonbasic (within the Berlin-Kay system) or outside the system of hue terms altogether. Old English is rich in what Berlin and Kay themselves called "secondary color terminology in areas of high cultural interest."[4]

An especially productive account of these "secondary" terms was published by Nigel Barley, a cultural anthropologist, in 1974.[5] Attempting to rationalize the accumulated data on Old English color terms into a culturally comprehensible system, Barley questioned the then-prevailing emphasis on hue terms in accounts of the Old English color system and worked from a broadened definition of "color." "Color" is usually described as encompassing three aspects of perception: hue (wavelength), saturation (purity of hue), and brightness (amount of light transmitted). For simplicity of description, these aspects are usually collapsed into a two-axis system (as in the Munsell color chart): hue is on one axis and saturation and brightness are on the other.

This system works well for the classification of Modern English color terms. Modern English strongly emphasizes hue over brightness, so that white and black, which are scientifically described as belonging to the brightness/saturation axis (presence or absence of light) are treated as hues, and brightness qualifiers (light, pale, dark) are syntactically and semantically subordinated to hue adjectives and nouns. Thus, what we think of as color can usually be adequately described by collocating a hue word with a brightness qualifier or with a concrete referent that links a hue to a thing exemplifying that hue: sky blue or grass green, for example. Other aspects of color (broadly defined) can be described in Modern English, but the descriptors for them are often part of a specialized vocabulary. For instance, qualifiers of reflectivity that can be attached to color terms are available in Modern English but generally belong to the specialized vocabulary of artists or have entered the popular vocabulary through the visual arts, as with matte versus glossy.

Barley found that Old English, in contrast, emphasizes brightness or surface reflectivity over hue. Old English has a large vocabulary to describe what we think of as the light/dark axis. "Black"

may be expressed by *blæc, deorc, dun, sweart, wann;* "gray" by *græg, hasu, har;* and "white" by *blac,*[6] *hwit, beorht, leoht, scir,* and several other words. Old English is not without hue words, of course, and compounding adds significantly to the range of possible color descriptors and allows collocations of hue words with brightness words.

But even more interesting are the words that fit neither into the black-gray-white group nor into the hue group—what Barley calls "the vexed colour terms" *fealo, wann,* and *brun.* These terms all had concrete (and usually animate) referents that explain the qualities of appearance they described. *Fealo,* for example, was originally (in Primitive Germanic) a horse term, like "roan." It could be applied in Old English to horses, glinting shield edges, waves of the sea, flame, and so on. *Blanca* and *dunn* were also originally words for describing horses. Barley shows that these three adjectives, plus *græg* and *brun,* form a group that refers primarily to animal (or human) hair and comes secondarily to apply to metals and to the sea. *Wann,* although it has no identifiable history in Primitive Germanic, is attracted to a similar range of objects. Barley described these as objects "negative for hue but positive for glossiness"; that is, *wann* things are "dark" but have "variegated surface reflectivity."[7] The problem words, then, the horse terms plus *wann,* have similar ranges of application to glossy things of various hue.

Barley's synthesis invites the student of Anglo-Saxon culture to reimagine the Anglo-Saxons as modulating their worldview through a color system in which surface texture descriptors had primacy over hue descriptors. This re-vision of the Old English color system inspired the art historians J. J. G. Alexander and C. R. Dodwell to collate Barley's findings with surviving Anglo-Saxon artifacts and with contemporary descriptions of objects.[8] In search of "Anglo-Saxon taste," Dodwell in particular was interested not only in what sorts of objects Anglo-Saxons made and bought, but in what aspects of objects they felt it worthwhile to describe. He deduced from Anglo-Saxons' descriptions of objects (books, metalwork, ivory, vestments, gems, marble) that they were interested in quality of surface ornamentation to the virtual exclusion of three-dimensional form. Dodwell notes that horse hides and bear hides were used as wall hangings, and their decorative value was commented on. This accords well with Barley's evidence about the horse-hair origins of terms later used in Old English to describe precious objects. Fabric, too, was particularly valued if it had unusual sur-

face quality or reflectivity. Dodwell documents the Anglo-Saxon interest in the fabric they called *purpura*, which he believes was what we now call shot-silk taffeta. The characteristics of this fabric are the changeability of its hues as it moves in the light and its metallic sheen: premodern taffetas were treated with metals to make them stiff, rustly, and shiny, so it is appropriate that some of their surface qualities should share descriptors with metals. Dodwell, in short, reimagines the Anglo-Saxon aesthetic, in part through the vernacular color vocabulary, as being nothing like the usual dun-colored, dung-covered, burlap-wearing world we think of from the mudslinging scene in *Monty Python and the Holy Grail*. The ideal, reflected in Old English literature, was a shimmering, gleaming, gold- and candlelit world, exemplified in highly decorated churches.

To turn to the Anglo-Latin side of Anglo-Saxon culture, we have some external evidence that Aldhelm participated in this cultural aesthetic. Aldhelm, after all, is the man who almost killed a camel[9] by trying to bring back a slab of marble from Rome on its back. Aldhelm the shopper and aesthete was also Aldhelm the author of some of the purplest prose in Latin. His language abounds in color terms. Is it reasonable to look for systematic use of color terms in an author so playful and unconventional in his use of vocabulary? Barley worried that poetry is "exactly where we should expect the most deliberate flouting of the normal collocation restrictions and use of paradigmatic associations."[10] One might make the same objection to hermeneutic prose. But much as we would like to find our color terms in ordinary prose, hermeneutic Anglo-Latin prose offers nothing predictable, pedestrian, or unmannered, and prose that does present those characteristics is regrettably uncolorful in its language. Adjectives of hue or color—in fact, any sort of gratuitous description of objects—are infrequent in the *stilus humilis*.[11] Aldhelm is of course replete with paradigmatic uses of color and with what look like surprising collocations, but on the other hand he is preternaturally interested in the appearances of objects. Moreover, his habit of saying the same thing several times and of piling on near synonyms gives us collocations of multiple color terms that we might not otherwise have. Every time Aldhelm launches a *variatio*, he gives us a sample semantic microfield.

Better yet, Aldhelm's works spawned extensive glossing.[12] Glossing provides both controls and contrasts for the study of one author's (possibly idiosyncratic) vocabulary: the glosses represent the work of many later generations, working (presumably) in different versions of the vernacular, and also show Anglo-Saxon readers

approaching rarer Latin terms through more common ones. Collating Aldhelm's usage and the habits of his glossators is one way to see the Latin vocabulary through Anglo-Saxon eyes.

Ideally, one would want to examine all of Aldhelm's color words in context, in hope of answering some of these questions: does he seem to be using color words to reflect aspects of objects that we would expect to be reflected by the Old English color vocabulary? Does his choice from the Latin color vocabulary reflect Anglo-Saxon aesthetic predilections? Do any of his Latin color terms seem to be coextensive with a particular Old English term in a way that would be unlikely in classical Latin? Do the glosses support such hypothetical equivalences? Unfortunately, it is beyond the scope of this study to do more than suggest these lines of inquiry and to make some tentative steps in their investigation. As a first step, I would like to examine some of the data emerging from a comparison of Aldhelm's color vocabulary with Virgil's,[13] and to correlate Aldhelm's use of a small group of difficult words with what is known about their use in classical and later continental medieval Latin.[14] Virgil, of course, is a source of much of Aldhelm's language, and this is both an advantage and a disadvantage to using Virgil as a point of comparison for Aldhelm. It seems reasonable to expect that the lure of Virgil's phraseology would be strong enough for Aldhelm that deviations by Aldhelm from the Virgilian use of color ought to be, if not profoundly significant, at least worthy of further investigation. As we will see, while Aldhelm quotes often from Virgil, he uses certain color words far more frequently than Virgil does and often in different senses.

First, it should be noted that, among all his color terms, Aldhelm has a strong preference for the following words:[15] *aureus, aurum, caerulus, candeo* (always as the participle *candens*), *candesco, candidus, color, croceus, flaveo, flavesco, flavus, fulvus, glaucus, niger,* and *purpureus.*

The *flavus/flaveo/flavescere* group, *glaucus,* and *purpureus* in particular occur significantly more often in Aldhelm than in Virgil, whose most frequent color terms are *albeo/albescere/albus* and *ater* (which does not appear in Aldhelm at all).[16] As will be seen from the list above, Aldhelm is not without words for black and white, but it is interesting that his preferred group of terms for white is from the "shining" matrix rather than from any of the words in classical Latin that seem unproblematically to mean "white" in the Modern English sense. Aldhelm also leans notably towards the tawny/yellow/gold words.

I would like to consider five words or word groups that present problems of interpretation in the classical Latin corpus, that Aldhelm uses in unexpected ways, or that attract unexpected glosses. These words are *caerul(e)us*, the *flavus* and *fulvus* groups, *glaucus*, and *purpureus*.

caerul(e)us

Caerulus / caeruleus (the form is always -us, -a, -um in Aldhelm and varies according to the requirements of meter in Virgil) is defined in the *OLD* primarily as "blue or greenish-blue," as applied to the sky, rivers, fountains, an island (Crete, by Seneca), and river deities; "glossy greenish-blue," as applied to serpents; and things dyed blue with woad. It is also used of plants (meadows and trees). Definition 9 in the *OLD* is "dark-coloured, dusky," of clouds, night, various kinds of weather. None of these definitions significantly departs from the notion of water-coloredness, including the use of *caeruleus* to describe snakes or serpents. In Virgil, *caerul(e)us* is used of a snake's neck; of fillets; of a rain shower; as a substantive, of the sea; of the dogs of Scylla; of Neptune's chariot; of the prow of Charon's skiff; of Allecto's hair, which is made of snakes; and of Father Tiber.

The *Dictionary of Medieval Latin from British Sources (DMLBS)* defines *caerulus* first as "blue" and second as "dark (green, black, or sim.)." In Aldhelm, it is overwhelmingly used as a substantive meaning "sea"[17] or as an adjective modifying the sea.[18] It is used, as in Virgil, of the snake's neck,[19] but also of thunder,[20] welts or wounds,[21] night,[22] and the *vestigia* of the pen in Riddle 59.[23] Aldhelm seems to use most of the classical Latin range of meanings for *caerulus*. Interestingly, when he collocates *caerulus* with other color words, he uses *glaucus*.[24] Where *caerulus* modifies *vibex* (welt or wound) in the *PrdV*, it is glossed *sweart, nigra, tetra, wan*, and *tunsa;* modifying the *vestigia pennae*, it is glossed *nigra*. As a substantive in Riddle 92, it is glossed *undas*. The Anglo-Saxon glossators seem to be teasing out the meanings appropriate to the context, and "bruise" naturally offers the most difficulty: the glossators use a variety of common Latin words for black and Old English words usually associated with glossy black things (ravens, for example). There is little sense in the glossing that *caerulus* has blue or green overtones.

flavus / flaveo / flavesco

The *OLD* defines *flavus* and its related verbs as "yellow," "blond" (when applied to humans), "to be or become yellow," and so forth. In Virgil, *flavus* is used only once of gold, and otherwise of human hair, an olive branch, and the sandy Tiber. *Flaveo* is used of Dido's hair, of blond Clytius, and the Lycian fields of grain. The *DMLBS*, noting that *flavus* means yellow in classical Latin but is cognate with Old High German *blau*, Old Norse *blef*, and Middle English *bleu*, defines it as pale yellow, golden, and golden haired, and, in a post-Conquest use, as blue, citing Osbern of Gloucester, who equates *caeruleus*, *flavus*, and *glaucus*. *Flaveo/-esco* it defines as to become yellow, to turn yellow, and to turn gold, to gleam like gold.

In Aldhelm, *flavus* is used of hair, of the *species* of the peacock, and of the *gestamina* of bees. *Flava caesaries*[25] is glossed *fulua, giola;* the glossators seem to have had more trouble with the peacock's *flava specie*, which is glossed *of scilfru; uel glæteriendu* (glittering) *uel doxu* (dark-haired, dusky). *Flaveo* is used, as it never is in Virgil, of gold,[26] of metal,[27] of honeycombs,[28] and of a swarm of bees.[29]

Flaventis auri in the *PrdV* is glossed *fulgentis, rubentis, reades.* *Flaventum favorum* (honeycombs) in *PrdV* is glossed *fulgentium rubentium, geolewra* (yellowish). These glosses suggest both the hue aspect of *flavens* (red-gold, red-yellow) and a gleaming quality. It is possible that the *fulgens* gloss on the honeycomb was suggested by its apparently more appropriate use in relation to gold (gold is *fulgens;* gold is described as *flavens*, so *flavens* must be the same as *fulgens*), but the collection of not-quite-synonymous Latin and vernacular glosses suggests that the glossators were trying to capture a less familiar term—or Aldhelm's use of it—more precisely.

Flavesco (never used by Virgil) collocates in Aldhelm very frequently with *croceus*.[30] It is used of feathers,[31] metals,[32] flowers and other plants,[33] grapes,[34] and beehives.[35] This last phrase—*flavescenti cerarum gurgustio*—is glossed *cellula uel tugurio; splendente uel casa; micanti; onscinendre hefe*. Again, *splendens*, *micans*, and *onscinend* point clearly to an understanding of a shining, glittering quality in *flavesco* of which there is little evidence in classical Latin usage.

fulvus

Fulvus is difficult to pin down in classical Latin. Defined by *OLD* and *DMLBS* variously as brown, tawny, sandy, and yellow, *fulvus* is mainly applied to sand and dust, on the one hand, and animal skins on the other. It describes gold three times in the *Aeneid*,

seven times in Ovid, and never in Horace or Catullus. Virgil uses *fulvus* of wolf skin, lion skin, jasper, sands, magic light, gold, human hair, eagles, and the cloud Juno sits on.

In Aldhelm, *fulvus* is used of gold and metals,[36] beauty,[37] and coins,[38] all of which are in line with classical usage; of leaves,[39] and fleeces,[40] which are not entirely unusual; of (glowing) ashes, which can be explained; and very surprisingly, of shadows or darkness.[41] The first occurrence of the ashes, *fulvis favillarum cineribus*[42] is glossed *flavis, fealewum, nigris.* There is some hesitation between darkness and the glowingness of the ashes, and the use of *fealo* suggests that the glossator, at least, thought the ashes were both dark and glowing. *Fulvis tenebris,* perhaps a fanciful collocation, may suggest that *fulvus* was felt to be closer to Old English *fealo,* with its element of darkness, than classical Latin usage would suggest. The *DMLBS* lists as additional glosses for *fulvus flavus, splendidus, niger, geolu, rubeum,* and *rubicundum.*

glaucus

While it is a difficult term to pin a Modern English hue term on (variants of gray, blue-gray, green-gray are the commonest efforts), *glaucus* in classical Latin is unambiguously associated with rivers or other bodies of water. Virgil uses *glaucus* of sedge and reeds on the banks of the Tiber and the Styx, and of the cloaks of Tiber and Juturna (a river deity). *Glaucus* is one of Aldhelm's favorite color terms. He uses it of the reeds,[43] of the sea,[44] of dew,[45] and of the sky.[46] From the association with the sea comes the collocation with *marmor.*[47] In a literally or metaphorically darker sense, it modifies wormwood,[48] gall,[49] and that most troublesome of Latin words, *ferrugo,* "rust."[50] Aldhelm also uses *glaucus* of gems,[51] from which *DMLBS* derives its definition 2, "(?) sparkling, shiny, brilliant." At *PrdV* 237,14, *glauco coloris vigore* describes one of the color changes of the peacock, and is glossed *albo uel rubro; blæhæwenre* "light blue." As an adjective associated with water, classical Latin *glaucus* may have had connotations of reflectivity or changeability of surface, and this sense would account for the unity of Aldhelm's sea, gem, and peacock uses of the word.

purpura / purpureus / purpuresco

Purpureus in classical Latin had the primary meaning "dyed purple," and *purpura* was purple-dyed cloth. The application of the term to

other things of similar hue (chiefly blood) was a secondary development. Even in classical Latin, according to the *OLD*, *purpureus* had acquired the additional sense of "(w. stress partly or wholly on sheen rather than actual colour) of a warm (rosy or ruddy) hue, radiant, glowing." Thus in Virgil, *purpura* is found in a gold-embroidered cloak trimmed in "Meliboean purple," and describes unspecified parts of Lavinia's bride-price; *purpureus* describes flowers and garments (Tyrian buskins, for example), but also magic lights of various kinds. *Purpureus* is so strongly associated with death in the *Aeneid* that it is hard to disentangle its literal from its metaphorical uses.

Purpura in Aldhelm is a substantive. Modified by *rubra*, it is compared to virginity[52] and is used with gold-words of luxury fabrics[53] in a manner very similar to Virgil's usage. In these contexts it is three times glossed *godweb*, "fine cloth."

What is striking about Aldhelm's use of *purpureus* is not so much the range of words it modifies but that it is by far his most commom adjective of color. It modifies blood and gore[54] as often as flowers.[55] It applies to dyes and fabrics.[56] In all of these uses, the element of hue seems predominant. The same might be said of the application to gems.[57] The application to crowns (*purpureis coronis* VdV 2197; *purpureas coronas CarmEcc* IV 3,25; *PrdV* 279,21) and to beauty (*purpurea venustate PrdV* 237,13) may be metaphorical but would also exploit the surface quality/glowing aspect of *purpureus*, as must the surprising association with grass (*purpureo gramine Enig* 47,3). It is striking that *purpureus* collocates more frequently than do other color terms with apparent synonyms and with the word *color* (*purpureus rubor PrdV* 273,19; *purpureo colore* VdV 1966; *purpureis coloribus PrdV* 64,19; *purpureis, immo diversis colorum varietatibus PrdV* 244,13) The sole use of *purpuresco* is in combination with another of the purple/dye words (*sacrosancto cruoris ostro purpurescit PrdV* 296,14).

In the *PrdV*, *purpureus rubor* is glossed *rubicundus ?rubi; purpureae tincturae* is glossed *brunbasum; purpureo ostro* is glossed *brunba(w)ere readnysse; purpureo flore* is glossed *mid basewium; purpurea venustate* and also *purpureis, immo diversis colorum varietatibus* are glossed *brun; purpureis floribus* is glossed *rubris, brunbasum; gemmis purpureis* is glossed *brunbasewum uel readum;* and *cum purpureis totidem rosis* is glossed *mid efenfealum readum.* The OE glossators have a good consensus that a combination of *brun* (a horse/metal word) and *baso* (a dye/fabric word) will render *purpureus.*

That classical Latin *purpureus* embodied some aspect of surface quality as well as hue might suggest that the Latin color system was not totally at odds with the Germanic one. On the other hand, in his excessive use of the word, and especially his combinations of *purpureus* with other color words, Aldhelm might have seized on one of the few words in Latin that could give a glossy spin to his descriptions and capture the elements he wanted to describe. His stretching of the words of the tawny/gold range points in the same direction. More work on the internal rationale of classical Latin colors will be needed before we can see how original Aldhelm really was.

Did the Anglo-Saxons inherit a Latin color system adequate to express what they saw as the interesting features of the appearance of objects? I am not sure that they did. Unfortunately, our understanding of the classical and late Latin color system is not yet sophisticated enough for us to answer the question with any confidence. But one should at least entertain the possibility that Aldhelm's doubling and tripling of color terms was born of an effort to wrap what he described in a new vocabulary that, however rich and varied, did not quite capture what Aldhelm saw. One could dismiss the multiplication of descriptors as so obvious a part of Aldhelm's style as not to warrant mention or overinterpretation. It might be more productive, however, to set the Anglo-Saxon practice of the hermeneutic style in linguistic context: the first generation of Anglo-Latin authors assimilated late antique traditions of *variatio* and patterned description while they were still trying to figure out what Latin words meant in their models and what they were going to mean in a new cultural context. Aldhelm's deployment of color terms, then, could be seen as a symptom of a larger tendency: for Aldhelm, the way of appropriating the descriptive powers of his second language was to wrap himself in the full spectrum of possible words and to let his lexemes dance across the surfaces of objects.[58] Like John Coltrane creating the "wall of sound" by playing every possible note, Aldhelm foliates the *densa silva* with every possible leaf.

Notes

Many thanks to David Townsend, Sylvia Parsons, Roberta Frank, Catherine Karkov, and George Brown for reading this article in various versions and for their suggestions and encouragement.

1. On the relationship between style and linguistics, see for example the essays in *Literary Style: A Symposium*, ed. Seymour Chatman (London and New York, 1971), especially Nils Erik Enkvist, "On the Place of Style in Some Linguistic Theories," 47–61.

2. The situation is little better for medieval Latin. Some tentative steps in the analysis of the later medieval Latin color vocabulary were taken by M. F. Edgerton ("A Medieval 'Tractatus de coloribus' Together with a Contribution to the Study of the Color Vocabulary of Latin," *Medieval Studies* 25 [1963]: 173–208). Since he is chiefly concerned with editing a fifteenth-century German-Latin text on artists' colors, his data are of limited use for an understanding of the early Anglo-Latin vocabulary.

3. Brent Berlin and Paul Kay, *Basic Color Terms, Their Universality and Evolution* (Berkeley, 1969). For a critique of Berlin and Kay with specific reference to OE, see Siegfried Wyler, "Old English Colour Terms and Berlin and Kay's Theory of Basic Colour Terms," in *Modes of Interpretation: Essays Presented to Ernst Leisi on the Occasion of his Sixty-Fifth Birthday* edited by Richard J. Watts and Urs Weidman (Tübingen, 1984), 41–57. C. P. Biggam, accepting Berlin and Kay's framework, examines the distribution of "secondary" hue terms in different classes of OE text in "Sociolinguistic Aspects of Old English Colour Lexemes," *ASE* 24 (1995): 51–65. A. E. Moss, "Basic Color Terms: Problems and Hypotheses," *Lingua* 78 (1989): 313–20, discusses problems in Berlin and Kay's methodology in more general terms.

4. Berlin and Kay, *Basic Color Terms*, 141 (citing the work of Hugo Magnus and Grant Allen in the nineteenth century).

5. Nigel F. Barley, "Old English Colour Classification: Where Do Matters Stand?" *ASE* 3 (1974): 15–28.

6. Unsurprisingly, *blac* and *blæc* were liable to confusion. See *DOE*, s.v. *blac, blæc*.

7. Barley, "Old English Colour Classification," 24.

8. J. J. G. Alexander, "Some Aesthetic Principles in the Use of Colour in Anglo-Saxon Art," *ASE* 4 (1975): 145–54; C. R. Dodwell, *Anglo-Saxon Art: A New Perspective* (Ithaca, 1982).

9. Or other quadruped. William of Malmesbury, *De gestis pontificum Anglorum libri quinque*, ed. N.E.S.A. Hamilton (London, 1870), 373. William reports that Aldhelm was bringing back from his pilgrimage many souvenirs: "inter quae fuit altare ex splendenti marmore, candido colore, sesquipedali crossitudine, quadrupedali longitudine, latitudine trium palmorum. . . . Camelus, ut dicitur, (quod enim nostrae regionis animal tantam sustineret molem?) eius usque ad Alpes baiulus fuit. . . . Ibi camelus, seu quodlibet quadrupes, nec enim refert quae bestia tulerit, vel injusti fascis injuria vel propter praerupta viae declivia concidit. Ruina jumentum

contrivit, et marmor in duas partes effregit" [among which was an altar of
gleaming marble, white in color, seven feet wide, four feet long, and three
hand-widths thick. . . . A camel, as the report has it (for what beast of our
region could carry such a mass?) was its carrier as far as the Alps. . . . There
the camel (or whatever quadruped you will, for it doesn't matter what
beast was doing the carrying) fell, either from the injury of an unreason-
able burden or because of the steepness of the way down. The fall crushed
the beast and broke the marble in two pieces]. Both the beast and the
marble were miraculously repaired.

10. Barley, "Old English Colour Classification," 20. Paradigmatic use
of color is the association of color with moral or other abstract qualities,
as when Aldhelm uses *candidus* as a term of approbation or Virgil uses
purpureus only in contexts associated with death.

11. Moreover, as Edgerton notes, paradigmatic color associations are
not made up out of whole cloth: "It is sensible to suppose that, at least in
the great majority of cases, the extended and metaphorical uses of color-
terms which are to be found with great frequency in medieval alchemical,
medical, and magical writings ultimately rest, at least in large part, on
their less exotic and more prosaic uses . . ." ("Medieval 'Tractatus,' " 175).

12. Glosses to Aldhelm have been edited in Nancy Porter Stork,
*Through a Gloss Darkly: Aldhelm's Riddles in the British Library ms.
Royal 12.C.xxiii* (Toronto, 1990); Scott Gwara, ed. *Aldhelmi Malmesbiriensis
Prosa de virginitate, cum glosa latina atque anglosaxonica,* CCSL 124–
124A (Turnhout, 2001); Arthur Napier, *Old English Glosses, Chiefly Un-
published* (Oxford, 1900); and Louis Goossens, *The Old English Glosses of
MS Brussels, Royal Library 1650 (Aldhelm's De Laudibus Virginitate)* (Brus-
sels, 1974).

13. This comparison is facilitated by Edgeworth's study of color terms
in Virgil: Robert Joseph Edgeworth, *The Colors of the "Aeneid"* (New York,
1992). Edgeworth's work is an exception to the dearth of work on classical
Latin color. Although it is primarily devoted to thematic use of color and
color patterning in the *Aeneid*, Edgeworth's book contains a discussion of
many of the notorious color cruces in classical verse and a tabulation of all
the color words in the *Aeneid*, with frequencies of occurrence for the *Eclogues*
and *Georgics*.

14. References to Aldhelm's works in Rudolf Ehwald, ed., *Aldhelmi
opera,* MGH AA 15 (Berlin, 1919) are as follows: *CarmEcc = Carmina
Ecclesiastica; Enig = Riddles*; *VdV = Versus de virginitate; PrdV = Prosa
de virginitate.* Citations to poems are by line number; citations to *PrdV* are
by page and line number.

15. The frequencies are as follows: *aureus* 2× *Enig;* 17× *VdV;* 7×
PrdV; aurum 2× *Enig;* 1× *CarmEcc;* 4× *VdV;* 11× *PrdV; caerulus* 6×
Enig; 4× *CarmEcc;* 12× *VdV;* 3× *PrdV ; candeo* (always as the participle

candens) 6× *Enig;* 1× *VdV;* 1× *PrdV* ; *candesco* 1× *Enig;* 2× *VdV;* 1×
PrdV ; *candidus* 3× *Enig;* 8× *VdV;* 4× *PrdV* ; *color* 4× *Enig;* 2× *VdV;* 6×
PrdV ; *croceus* 3× *Enig;* 3× *VdV;* 4× *PrdV* ; *flaveo* 5× *VdV;* 2× *PrdV* ;
flavesco 4× *Enig;* 1× *CarmEcc;* 4× *VdV;* 4× *PrdV* ; *flavus* 3× *PrdV* ; *fulvus*
4× *Enig;* 1× *CarmEcc;* 6× *VdV;* 2× *PrdV* ; *glaucus* 5× *Enig;* 2× *CarmEcc;*
9× *VdV;* 2× *PrdV* ; *niger* 6× *Enig;* 1× *CarmEcc;* 9× *VdV;* 1× *PrdV* ;
purpureus 4× *Enig;* 1× *CarmEcc;* 17× *VdV;* 18× *PrdV*. Following
Edgeworth, I take the nouns *aurum* and *color* as part of the color vocabu-
lary, because they often participate in the descriptions of the appearance
of objects. Aldhelm often uses clusters of nouns (adjectives used as sub-
stantives or nouns for objects strongly associated with a color or surface
quality), verbs, and adjectives of color, so groups of cognates must be con-
sidered together.

16. One of Edgeworth's theses is that the *Aeneid* is patterned on a
series of black-white/red-white oppositions.

17. *verrebat caerula remis CarmEcc* 4 5,5; *caerula findunt Enig* 95.8;
qua tundunt caerula cautes Enig 92.1; *trans caerula CarmEcc* 4 5, 13;
turgida caerula CarmEcc 3 20; *caerula alta VdV* 815; and so on.

18. *caerulus fluctus VdV* 2335; *maris caeruli Enig* 48.4; *caeruli ponti
Enig* 17.1. *VdV* 5; 423; 1736; and so on.

19. *caerula colla VdV* 1432.

20. *caerula fulmina VdV* 2520.

21. *caerula vibice PrdV* 307.14; *caerula vulnera VdV* 2313.

22. *caerula nox VdV* 215.

23. *vestigia caerula Enig* 59.4.

24. *ponti caeruli glauci CarmEcc* 4 1.13; *caeruli trans ponti glauca
PrdV* 489.13.

25. *PrdV* 301.14.

26. *flaventis auri PrdV* 254.12; *auri flaventis VdV* 160; *auro flavente
corona VdV* 609.

27. *flaventis metalli VdV* 173.

28. *flaventis favi VdV* 2772; *flaventium favorum PrdV* 252.22.

29. *flaventes uvas VdV* 2790.

30. *crocea flavescunt fercula Enig* 20,3; *de croceo flavescunt culmina
flore Enig* 51.2; *dum croceum iubar flavesceret VdV* 1364.

31. *pennae pulchritudo flavescit* 237.13; *quamquam flavescat penna
pavonis VdV* 227.

32. *flavescunt bulla metallis Enig* 55.5.

33. *flos flavescens VdV* 166; *quamvis flavescant petala VdV* 208; *flavescentes saliculas* 231.18.

34. *flavescentibus uvis Enig* 78.4.

35. *flavescenti cerarum gurgustio PrdV* 234.2.

36. *auri fulvi VdV* 157; *fulvis metallis Enig* 55.5; 96.11.

37. *fulva venustas VdV* 229.

38. *fulvum nomisma CarmEcc* IV 10; *fulvo numismate VdV* 2818.

39. *fulva fronde VdV* 1341.

40. *vellera fulva Enig* 17.2.

41. *fulvis tenebris Enig* 8.4.

42. *PrdV* 321.13, repeated at *PrdV* 484.13.

43. *glauca seges lini Enig* 74.1.

44. *ponti glauci CarmEcc* IV 1.12; *in glauco gurgite VdV* 13; *cum glauco gurgite VdV* 912; *in glaucis undis Enig* 58.4; *in glaucis fluctibus Enig* 100.65; *caerula trans ponti glauca PrdV* 489.13; and so on.

45. *glauco rore CarmEcc* IV 10.12.

46. *aethera glauca VdV* 1066.

47. *marmora glauca VdV* 426; *glauco marmore VdV* 1340.

48. *glauca absinthia Enig* 100.32.

49. *glauco sine felle VdV* 492.

50. *ferrugine glauca Enig* 21.1.

51. *cum glaucis gemmis VdV* 1163.

52. *ut sit virginitas purpura PrdV* 248.19.

53. *veluti rubra purpura regum VdV* 189; *bombicinum purpurae peplum PrdV* 236.17; *ex auro, iacintho, purpura fulsisse PrdV* 244.19.

54. *purpureus sanguis Enig* 98.3; *purpureus cruor VdV* 1751, 1833, 2278; *purpurei cruoris PrdV* 299.14; *purpureum sanguinem PrdV* 294.19; *purpureo cruore PrdV* 254.6; 301.20; *purpureo sanguine VdV* 883, 1313, 2007, 2889; *sanguine purpureo VdV* 1317, 2340, 2726.

55. *purpureum saeculorum florem PrdV* 62.6; *purpureo flore PrdV* 247.9; *purpurei et rubicundi flores PrdV* 237.19; *purpureos flores PrdV* 249.13; *purpureis rosetis Enig* 100.15; *candidis ac purpureis floribus PrdV* 292.22;

purpureis floribus VdV 1669; *purpureis malvarum floribus* PrdV 231.16; *cum purpureis rosis* PrdV 302.7.

56. *purpureis tincturae muricibus* PrdV 316.3; *purpureis peplis* VdV 1146; *purpureo ostro* PrdV 312.19; *purpureae tincturae* PrdV 314.7.

57. *purpureas gemmas* VdV 164; *gemmis purpureis* PrdV 259.2; *purpureis gemmis* VdV 2365.

58. There are affinities between this aspect of Aldhelm's technique and the "jeweled style" of late antiquity that deserve exploration. See Michael J. Roberts, *The Jeweled Style: Poetics in Late Antiquity* (Ithaca, 1989).

12

The Discreet Charm of the Old English Weak Adjective

Roberta Frank

Poetical feelings are a peril to scholarship. There are always poetical people ready to protest that a corrupt line is exquisite. Exquisite to whom? The Romans were foreigners writing for foreigners two millenniums ago; and for people whose gods we find quaint, whose savagery we abominate, whose private habits we don't like to talk about, but whose idea of what is exquisite is, we flatter ourselves, mysteriously identical with ours.

—Tom Stoppard, *The Invention of Love*

Poor little weak adjective—dowdy, belittled, scorned: how she must have trembled to see her name displayed in a conference program. Long invisible, badly roughed up by Hickes, Elstob, and the early Bosworth, she had no name until Jacob Grimm noticed her in 1819.[1] Of unknown origins, a Johnny-come-lately in the Germanic languages, needy and trapped in a codependency relationship with a more significant other: no wonder she has had few admirers.

In the last quarter of the nineteenth century, scholars in Berlin, Breslau, Göttingen, Leiden, and elsewhere looked upon the Old English weak adjective as a handmaiden, a go-between, a way of dating the poetic corpus. In 1873, A. Lichtenheld had observed that the combination "weak adjective plus noun" (not preceded by a demonstrative or by a possessive) was a feature of Old English poetic style, one particularly marked in *Beowulf;* not he but his successors drew the desired conclusion that the older the poetry,

the more common the construction.[2] When weak adjectives turned
out to be fickle, unreliable, self-contradictory guides, interest in
them quickly evaporated. Few now give them a second look. The
occasional appearance in Old English poetry of the weak form of
adjectives where in prose we would expect strong ones remains one
of the mysteries of vernacular poetic style.

Viewing a painted canvas calls for understanding something of
the stylistic conventions of the period, the specific choices made by
the artist, techniques of brushwork and of mixing pigments. E. H.
Gombrich, when he wanted to learn how Constable's *Wivenhoe Park*
created its illusion of reality, placed a grid upon it and then looked
at each little square, deliberately thwarting the integrating tricks
of the human eye.[3] Preliminary work for this paper involved a
similar cell-by-cell, brushstroke-by-brushstroke scanning of the Old
English poetic corpus in order to peer at the verbal designs formed
by "weak adjective plus noun" pairings.

One type, the noun with postposited weak adjective, turns out
to be restricted to *Beowulf* and Riddle 40 (Aldhelm's *De creatura* in
Old English):[4]

Beo	1177a beahsele beorhta (Heorot)
	1243a bordwudu beorhtan (shield)
	1343a hreþerbealo hearde (enmity?)[5]
	1435a herestræl hearda (arrow)
	1553a herenet hearde (byrnie)
	1801a oþþæt hrefn blaca (raven)
	1847a hild heorugrimme (battle)
	1919a wudu wynsuman (ship)
	2474a herenið hearda (battle)
Cf. *Rid* 40	55a hrim heorugrimma (hoarfrost)

The nouns in these "a" verses are masculine or neuter, nominative
or accusative. The disyllabic weak adjective is required by the meter;
a strong monosyllabic adjective cannot take its place. For some
reason, each half-line has double alliteration, except for 1801, which
is also the only verse in which the noun is not in apposition with
a preceding word signifying war or the trappings of warrior society;
furthermore, it is the only half-line in which the noun is animate
and in which insertion of a demonstrative (e.g., *oþþæt se hrafn
blaca*) would not wreck the meter.[6]

The next weak adjective construction, restricted to two femi-
nine nouns in the instrumental case, seems to have no metrical or
euphonic justification. Feminine adjectives do not have a strong

dative/instrumental singular declension distinct from the accusa-
tive or genitive; perhaps, in these formulaic phrases, the weak
adjective chivalrously jumped into the breach:

[ASPR 1]
Gen A	1484 halgan reorde
Ex	257 halgan stefne, 551 hludan stefne
Dan	510 torhtan reorde
Sat	35 weregan reorde, 36 eisegan stefne

[ASPR 2]
And	60 sargan reorde, 1108 cearegan reorde, 96 beorhtan stefne, 56 537 873 1399 1476 halgan stefne, 1360 hludan stefne, 61 1126 geomran stefne
Soul 1	15 cealdan reorde

[ASPR 3]
Christ A	389 hludan stefne
Christ B	510 beorhtan reorde
Christ C	1339 halgan reorde
Phoen	128 beorhtan reorde
Sea	53 geomran reorde
Wid	103 sciran reorde
Soul 2	15 caldan reorde

[ASPR 5]
PPs	92.5 2 hludan reorde

"With x voice" is the only construction in which a weak adjec-
tive can be found modifying a singular feminine noun in an oblique
case. Note the distribution: most examples are in *Andreas* (eleven
times) with *Exodus* next; the type is missing from *Beowulf*[7] and
The Metres of Boethius; there is one example in Cynewulf *(Christ
B)*, and one in the five thousand-plus verses of the *Psalms.* Double
alliteration is conspicuously absent. The combination weak-adjective-
plus noun functions in this half-line formula almost like an adverb:
cf. the fossilized *niwan stefne* "again" or *on / to widan feore / ealdre*
"forever."

Weak adjectives (not preceded by a demonstrative or posses-
sive) occur in the masculine and neuter instrumental singular in
many poems.[8] *Beowulf* provides eleven examples:

561 deoran sweorde, 1746 biteran stræle, 2440 blodigan
gare, 2492 leohtan sweorde, 849, 1423 hatan heolfre, 2347

sidan herge, 141 sweotolan tacne, 2290 dyrnan cræfte, 2482
heardan ceape, 2102 fættan golde

The weak adjective here is a kind of dedicated epithet, gripped
fast by its noun so that it cannot get away. Mapping this type in
Old English poetry is tricky, because the ending *-an* is ambiguous:
final *-um* developed into *-an* occasionally in early West Saxon, and
more generally in late Old English.[9] (The two examples of this
construction in *Maldon*, lines 125 and 319, can, if troublesome in
a late poem, always be explained away as *-um* datives.) The weak
instrumental (all genders) also occurs in the plural. *Beowulf* pro-
vides six examples, all of which have to do with seizure—hard
bonds, baleful fetters, hostile fingers, grim grips, sharp tusks:[10]

963 heardan clammum (cf. 1335 heardum clammum), 1502
atolan clommum, 977 balwon bendum, 1505 laðan fingrum,
1542 grimman grapum, 2692 biteran banum

The use of weak adjectives in the instrumental plural has the
advantage of avoiding suffix rhyme (*grimman grapum* versus
grimmum grapum), an aural decorum recommended and practiced
by some eminent Anglo-Saxons writing in Latin and perhaps by a
few anonymous Old English poets too.[11]

Anglo-Saxon England is distant enough for its stylistic etiquette
to be based on rules very different from our own. We do not know
how Old English poets learned their art, or what they thought good
or bad. It is tempting, if unsafe, to associate metrical exactness in
Old English (versus Old High German or Old Saxon) with the Anglo-
Saxons' skill and training in Latin versification.[12] Learned tradition
supports, if it did not invent, a type of weak adjective construction
widespread in Old English poetry but not in the other Germanic
vernaculars. A succession of Latin poets—from Catullus through
Caelius Sedulius to Aldhelm and beyond—shunned identical declen-
sional endings in adjacent noun-adjective combinations (e.g., *latos
scopulos* or *bellus grammaticus*), a "rule" whose workings are hinted
at by Bede and Byrhtferth, among others.[13] Anglo-Latin poets were
told to put other words between adjectives and the nouns they agreed
too much with. Old English poets could not normally do this, but
they had an option not available to the Latin writer: they might, for
instance, avoid suffix rhyme on hissing genitive sibilants simply by
using the weak adjective declension with strong masculine and neu-
ter nouns, and the strong declension with weak nouns:[14]

and mid hyra fiþrum *frean ælmihtiges*
onsyne wreað *ecan dryhtnes*

[and with their wings cover the face of almighty god, of the eternal lord] (*Christ A* 395–96)

In the genitive singular, weak nouns like *frea* are always accompanied in poetry by a strong adjective: e.g., *eces alwaldan, eces deman, leofes leodfruman, fæges flæschoman, leofes geleafan, eces eadwelan, ealdes uhtflogan, modges merefaran, lænes lichoman, bradre eorðan.*[15] Strong nouns are sometimes accompanied by weak adjectives, sometimes by strong.

In the chart that follows, based on data culled from the *Dictionary of Old English* electronic corpus by Ross Arthur, the column on the left lists all examples of the weak adjective before a masculine or neuter strong noun in the genitive singular (*lænan lifes* "of transitory life"); the right column, all examples of the strong adjective in the same environment (*lænes lifes*). Only "adjectives proper"— those that have a comparative and superlative—are included, not indefinites such as *an, ælc, ænig, agen, eall, hwilc, ilca, manig, micel, nænig, nan, oþer, sum,* and *swilc.*

Distribution of weak and strong adjectives before a masculine or neuter strong noun in the genitive:

[ASPR 1]

Gen A	7, 1885 ecean drihtnes		
	1599 sidan rices	Gen B	303 heardes hellewites
			383 heardes irenes
	2550 laðan cynnes		403 mihtiges godes
	2899 hean landes		
Ex	227 æðelan cynnes	Ex	53 leofes siðes
			96 haliges gastes
			230 cuðes werodes
			268 lænes lifes
Dan	144 soðan swefnes	Dan	30 eces rædes
	245 blacan fyres		155, 732 haliges gastes
	299 halgan lifes		
	340 hatan fyres		
	461 hatan ofnes		
	465 frecnan fyres		
	481 dyglan swefnes		
	627 wodan gewittes		
Sat	327 atolan eðles		

[ASPR 2]

And	721 ecan dryhtnes

And	94 mæres þeodnes
	531, 1000, 1621 haliges gastes
	1088 blates beodgastes
	1238 hæðnes heriges
	1694 gastes gramhydiges

Fates	114 godcundes gastes

El	591 æðeles cynnes

[ASPR 3]

Christ A 21 wlitigan wilsiðes
 58 halgan hyhtes
 165 mæran cyninges
 396 ecan dryhtnes

Christ B 711 ecan dryhtnes

Christ C 868 meahtan dryhtnes *Christ C* 1051 eces lifes
 1637 liþes lifes

Guth A 172, 795 ecan lifes

Guth B 991 deopan deaðweges *Guth B* 1124 ufancundes engles
 1217 ares uncuþes

Az 19 halgan lifes *Az* 173–4 byrnendes fyres
 56 hatan fyres

Phoen 456 lænan lifes
 482 ecan dreames
 600 ecan dryhtnes
 Jul 18 æþeles cynnes
 589 hæðnes herges

Sea 79 ecan lifes
 Wid 91 smætes goldes

 Max I 80 deades monnes
 141 tomes meares

OrW 73 halgan dryhtnes
 Wife 47 feorres folclondes

Res	33 ecan dreames		
	36 halgan	Res	30 halges
	heofonmægnes		heofoncyninges
Ruin	37 bradan rices		
Rid	48 6 readan goldes		
	83 13 dyran cræftes		

[ASPR 4]

Beo	83 laðan liges	Beo	797 mæres þeodnes
	116 hean huses		1994, 2080, 2897 leofes
	133 wergan gastes		monnes
	670 modgan mægnes		2522 heaðufyres/hates
	978 miclan domes		2698 modiges mannes
	1093, 2246 fættan goldes		
	1694 sciran goldes		
	1729 mæran cynnes		
	1747 wergan gastes		
	1859 widan rices		
	2008, 2354 laðan cynnes		
	2234 æþelan cynnes		
	2845 lænan lifes		
Jud	310 laðan cynnes		

[ASPR 5]

PPs	67 3, 67 9 ecean drihtnes	PPs	54 22 seaðes deopes
	68 29 ecean drihtnes		58 1 hefiges niðes
	76 9 haligan drihtnes		58 2 blodhreowes weres
	77 12 halgan drihtnes		62 6 fægeres smeoruwes
	77 50 wraðan yrres		63 1 yfeles feondes
	83 12 ecean godes		67 13 fægeres seolfres
	88 37 fagan sweordes		68 14 deorces wæteres
	89 19 bliðan drihtnes		77 56 hrores folces
	93 16 mihtigan drihtnes		83 6 soðes drihtnes
	97 8 ecean drihtnes		106 31 cristenes folces
	100 1, 106 7, 106 14, 106 42,		118 60 grames modes
	118 3 mihtigan drihtnes		123 4 hludes wæteres
	113 7 ecan dryhtnes		144 3 micelmodes
			mægenes
			144 5 holdes modes

126 4 ecean drihtnes 146 10 cuðes æses
 148 14 holdes folces

 Met 6 16–17 fæstlices weorces
 9 49, 21 43 godes ælmihtiges
 12 13 liðes weðres
 20 270, 24 30 soðes leohtes
 26 34 æðeles cynnes
 26 52 dysiges folces
 26 91 mennisces metes
 27 7 bitres gecyndes

[ASPR 6] *Mald* 217 miccles cynnes
 266 heardes cynnes

 Brun 16 eces drihtnes

 CEdg 12 bremes cyninges

 MSol 140 geonges hrægles
 158 fæges mannes
 330 bittres cynnes
 389 deores dryhtscipes
 410 haliges gastes
 425 fyrenes cynnes
 443 godcundes/gæstes
 452 eadiges engles

 Men 12 eces drihtnes

 JDay II 200 weallendes pices
 210 laðlices fyres
 287 ælmihtiges godes

 Exhort 35 eces leohtes

 Gloria I 43 haliges gastes

LPr III 26 ecan lifes

PsFr 89 19 bliðan drihtnes *PsFr* 58 1 hefiges niðes
 58 2 blodhreowes weres
MPs 93 16 mihtigan
 drihtnes
 KtHy 42 haliges gastes

 GDPref 3 gastlices lifes

> *Instr* 18 eces lifes
> 138 æðeles kynnes
> 176, 189 godes ælmihtiges

Sometimes the distribution of the two adjectival declensions conforms to expectations: *Genesis A* has only weak adjectives in the genitive case; the embedded *Genesis B*, a translation from Old Saxon, only strong. When suffix rhyme is not in question, as in the nominative singular, *Genesis A* always supplies a strong adjective: *ece dryhten* (nine times); but when suffix rhyme is an issue, as in the genitive case, the weak adjective is consistently employed: *ecean dryhtnes* (not *eces dryhtnes*).

Within the same manuscript, however, attitudes to paired genitive sibilants differ dramatically. *Exodus*, for example, has no aversion to *-es/-es* suffix rhyme; indeed, its sole weak genitive adjective (not preceded by a demonstrative or possessive) is sometimes edited out of existence.[16] Yet the poem is not demonstrably later or less serious than the next item in Junius 11, *Daniel*, which uses the weak adjective almost exclusively in the genitive, avoiding weak adjectives in other cases.[17] Each of the two accounts of the angel's arrival (*Dan* 224–82; 333–61) is graced by a weak genitive adjective (*blacan fyres, hatan fyres*), supporting the conclusion reached on other grounds that the duplication is the work of a single poet.[18]

There is only one weak adjective construction of this type in the entire Vercelli Book (*Andreas* 721). The four poems signed by Cynewulf use strong adjectives in the genitive singular; the sole exception, in *Christ B* in the Exeter Book, is the same fossilized phrase that appears in *Andreas*. In the Exeter Book, *Christ A*, like the *Phoenix*, has only weak adjectives; *Maxims*, like *Juliana*, only strong.

Beowulf is rich in weak genitive singular adjectives where prose would use strong. It is the strong declension that seems anomalous in this poem: scribe B writes *leofes mannes* (three times) and *modiges mannes* (one time), although it would have been easy to avoid (if that were the goal) the resulting suffix rhyme: e.g., *leofan mannes* or *leofes mannan*.[19]

The *Psalms* may look evenhanded in their use of weak and strong genitive adjectives (eighteen weak, sixteen strong), but all but two weak adjectives occur in fossilized phrases. King Alfred seems not to have been hostile to suffix rhyme: all adjectives listed under the *Metres of Boethius* are strong. *Maldon* and the *Chronicle*

poems have strong adjectives only, like *Judgment Day II* and both parts of *Solomon and Saturn*.

An overarching pattern is difficult to discern. In Latin poetry, the presence of noun-adjective suffix rhyme has something to do with genre: Virgil's *Eclogues* and *Georgics* avoid such rhymes, while the *Aeneid* does not.[20] In Old English, a few poems based on a Latin source, such as the lyrical and liturgical *Christ A*, consistently avoid suffix rhyme in the genitive singular; others, such as *The Metres of Boethius*, never do. The densest concentration of all weak adjective plus noun constructions in Old English is in *Beowulf*, in Hrothgar's speech (1724–84) on the dangers of pride, a passage rich in phrasing reminiscent of Christian prayer and homily; but the Finnsburh episode in *Beowulf* (1068–1159), usually attributed to native inspiration, has the next greatest frequency of such constructions, comparable to that in Riddle 40 (a translation of Aldhelm's *De creatura*).[21] The settings in which these weak adjectives glitter are various, but never vulgar.

Alistair Campbell concluded ("rightly," says Bruce Mitchell) that "Old English verse admits a freer use of the weak adjective than prose, but the later the verse the less it diverges from the syntax of prose in this matter."[22] One could turn this rule on its head and say that, in general, the earlier the manuscript, the fewer weak genitive adjectives it will display.[23] The Vercelli Book, assigned to ca. 975 and the southeast of England, has one weak construction and nine strong; the contemporary Exeter Book, twenty-one weak and thirteen strong. The ratio is 16:6 for the perhaps early-eleventh-century *Beowulf* manuscript and 15:10 for the Junius 11 manuscript, possibly dating from the second quarter of the eleventh century. *Solomon and Saturn* in CCCC 422, written on quires dating from the mid-tenth century or earlier, and Alfred's *Metres of Boethius* in British Library, Cotton Otho A vi, also from the mid-tenth century, have eighteen strong and no weak genitive constructions;[24] like them, the *Battle of Brunanburh* in CCCC 173 (mid-tenth century) and the *Coronation of Edgar* (in a block of annals written down ca. 1005) have only strong constructions. The *Paris Psalter* from the second quarter of the eleventh century has approximately the same number of weak and strong combinations. Under what circumstances was it permissible for poets to reach out and pluck a perfect weak adjective, turning their backs on the strong?

More than instinctive feeling must have led an Anglo-Saxon poet to choose between the two adjectival declensions. Personal choice, school training, local conventions, and even date could all

have been factors, and are now irretrievable. Perhaps the weak genitive was fostered for a while by poets composing in "high" vernacular style, in imitation of the Caesars. There is a model of sorts in New High German, where, in the course of the eighteenth century, the weak adjective, apparently for euphonic reasons, encroached on the strong in the genitive singular masculine and neuter (just as in Old English): a German-speaker today asks for *ein Glas guten Weines* "of good wine" in order to be *guten Mutes* "of good cheer," not *guotes muotes* as it had been in Middle High German, Old Saxon, or Old High German. Goethe was in favor of the weak form; less than a generation later Jacob Grimm (and before him Gottsched) wanted to reinstate the strong.[25] The poets of *Daniel* and *Exodus* might have had equally passionate opinions about the charm and infinite variety of the Old English weak adjective.

Did the weak form of the Old English adjective have different overtones from those of the strong? Probably, but we cannot discern with any confidence shades of meaning or subtle alterations in linguistic costume in a dead language undescribed by its speakers. We can imagine that, like makeup and dress, unaccompanied weak adjectives invited a certain attitude, a particular sort of attention, even if we no longer catch our breath at the places where breath used to be caught.

Notes

In the epigraph, A. E. Housman, aged seventy-seven, addresses his younger self, aged eighteen to twenty-six.

1. On early attempts to analyze the Old English adjectival system, see Shaun F. D. Hughes, "The Anglo-Saxon Grammars of George Hickes and Elizabeth Elstob," in *Anglo-Saxon Scholarship: The First Three Centuries*, ed. Carl T. Berkhout and Milton McC. Gatch (Kalamazoo, 1982), 123, 126–28, 144–45. According to Peter J. Lucas (ISAS Helsinki, 6 August 2001), the unpublished grammar of Abraham Wheelock (1593–1653) in London, British Library, Add. 34600, art. 6, appears to distinguish two declensions of Old English adjectives. The dual forms of the adjectives are presented in Edward Thwaite's *Grammatica Anglo-Saxonica ex Hickesiano Linguarum Septentrionalium Thesauro excerpta* (Oxford, 1711), 6 (an abridgment and revision of Hickes's chap. 4). But no weak declension is recognized in Edward Lye's grammar prefacing Franciscus Junius's *Etymologicum Anglicanum ex autographo descriptsit et accessionibus permultis auctum*, ed. Edw. Lye (Oxford, 1743), a2, or in Joseph Bosworth, *The Elements of Anglo-Saxon Grammar* (London, 1823), 92–94. Rasmus

Kristian Rask, *Angelsaksisk Sproglære tilligemed en kort Læsebog* (Stockholm, 1817), 32–33, distinguished between a *bestemt* "definite" and an *ubestemt* "indefinite" adjectival declension (as Icelandic and German grammars had since at least 1651). Jacob Grimm in the first volume of *Deutsche Grammatik* (Göttingen, 1819), 248, introduced the terms *schwach* "weak" and *stark* "strong"; this nomenclature is Englished in John Mitchell Kemble's 1833 (unpublished) review of the *Grammatik*, 3 vols. (Göttingen, 1822, 1826, 1831), 37, reprinted in the Old English Newsletter *Subsidia* 6 (1981): 37.

2. See discussion and bibliography in Ashley Crandell Amos, *Linguistic Means of Determining the Dates of Old English Literary Texts* (Cambridge, Mass., 1980), 110–24. In the vocative case, the weak form of the adjective is found in both prose and poetry.

3. Ernst Hans Gombrich, *Art and Illusion: A Study in the Psychology of Pictorial Representation*, 2d ed., Bollingen Series 5 (New York, 1961), figs. 247–48; and see index s.v. "Constable, *Wivenhoe Park*." Cited by Richard A. Lanham, *The Electronic Word: Democracy, Technology, and the Arts* (Chicago, 1993), 81.

4. Here and elsewhere in this essay, I cite texts by the abbreviations used by the *Dictionary of Old English* project in its various publications; see *Dictionary of Old English: Preface and List of Texts and Index of Editions* (Toronto, 1986) and, for a convenient printed text, *A Microfiche Concordance to Old English: The List of Texts and Index of Editions*, comp. Antonette diPaolo Healey and Richard L. Venezky (Toronto, 1980).

5. *Hreþerbealo hearde* is here construed as an accusative, in apposition to *fæhðe* (1340), and not as a loose nominative exclamatory phrase meaning "heartache," as in the standard editions.

6. In Old Norse verse, nouns in this construction (e.g., Haraldr harðráði, *fylkir framlyndi*) generally designate living beings. See Ferdinand Detter and Richard Heinzel, *Sæmundar Edda mit einem Anhang herausgegeben und erklärt* (Leipzig, 1903), 2: 28–29.

7. But cf. *Beo* 1104: *frecnan* (MS *frecnen*) *spræce*.

8. But not in the four poems signed by Cynewulf, in *Guthlac B*, or in *The Phoenix*.

9. See Alistair Campbell, *Old English Grammar* (Oxford, 1959), §378, §656.

10. I have found only seven other examples of this construction in the corpus: *hludan stefnum* (*Ex* 99), *cealdan clommum* (*And* 1212), *deorcan næglum* (*Dr* 46), *caldan clommum* (*Christ C* 1629), *ecan meahtum* (*Rid* 40 90), *hean muntum* (*PPs* 103 17), and *halgan hlioðorcwidum* (*KtHy* 2).

11. On the whole, vernacular poets seem comfortable with dative plural suffix rhymes. *Beowulf*, for example, has sixteen such pairs (lines 21, 167, 275, 585, 1172, 1335, 1874, 1980, 2058, 2140, 2178, 2210, 2332, 2396, 2467, 3140), and the corpus provides several hundred more.

12. See Eric Gerald Stanley, *In the Foreground: Beowulf* (Woodbridge, 1994), 125–26.

13. On the Latin poetic tradition, see D. R. Shackleton Bailey, *Homoeoteleuton in Latin Dactylic Verse* (Stuttgart, 1994); for prose, J. N. Adams, "A Type of Hyperbaton in Latin Prose," *Proceedings of the Cambridge Philological Society* 197 (1971): 1–16. On Aldhelm, Andy Orchard, *The Poetic Art of Aldhelm* (Cambridge, 1994), 10, 96–97. For Celtic-Latin prose, see François Kerlouégan, "Une mode stylistique dans la prose latine des pays celtiques," *Études Celtiques* 13 (1972): 275–97, esp. 281–82; Michael Winterbottom, "A Celtic Hyperbaton?" *The Bulletin of the Board of Celtic Studies*, 27, no. 2 (1977): 207–12. Bede describes the "golden line" in *De arte metrica* 1.11 and homoeoteleuton in *De schematibus et tropis* 3.1, both edited by Calvin B. Kendall, CCSL 123A (Turnholt, 1975), 114–15, 149; for an English translation, see Kendall, *Bede, Libri II "De arte metrica" et "De schematibus et tropis": The Art of Poetry and Rhetoric* (Saarbrucken, 1991); *Byrhtferth's Enchiridion*, ed. Peter S. Baker and Michael Lapidge, EETS, s.s. 15 (Oxford, 1995), 167–69. On these terms in Anglo-Saxon England, see Gabrielle Knappe, *Traditionen der klassischen Rhetorik im angelsächsischen England* (Heidelberg, 1996), esp. 278–81.

14. Gregor Sarrazin, in his 1907 refutation of the Lichtenheld tests ("Zur Chronologie und Verfasserfrage angelsächsischer Dichtungen," *Englische Studien* 38 (1907): 147), was one of the first to note that certain phrases (e.g., *ecan lifes*) could have been created to avoid suffix rhyme.

15. *Eorðan* (f.), which occurs some 470 times in Old English poetry, is never paired with a weak adjective. *Wides/sides* (m.n.gen.sg) is never found in poetry; *widne/sidne* (m.acc.sg.) is found only in poetry.

16. Christian W. M. Grein, *Bibliothek der angelsächichen Poesie*, vol. 1 (Göttingen, 1857), alters to *æðeles;* Ferdinand Holthausen, in Grein, *Sprachschatz der angelsächsischen Dichter*, rev. ed. by Johannes Köhler with help of F. Holthausen (Heidelberg, 1912), suggests *æðel[est]an.*

17. *Eces rædes*, an exception, occurs in the first thirty-two lines of *Daniel*, a section often attributed to a different poet. See Paul G. Remley, *Old English Biblical Verse: Studies in Genesis, Exodus, and Daniel*, CSASE 16 (Cambridge, 1996), 255. For some reason, the epithet "holy," when used in the genitive of the Holy Ghost (*haliges gastes*), is always strong in Old English poetry.

18. Remley, *Old English Biblical Verse,* 334–56. The two weak adjective constructions listed in the chart under *Azarias* correspond to *Daniel* 299 and 340.

19. Both scribes use accusative singular *mannan* (five times).

20. See Shackleton Bailey, *Homoeoteleuton,* 2, 7, 100.

21. *Beo* 1729, 1733, 1746, 1747, 1779 (Hroðgar's sermon); *Beo* 1093, (1104), 1136, 1146 (Finnsburh episode); *Rid* 40: 55, 90, 94.

22. Campbell, *Old English Grammar,* §638; Mitchell, *Old English Syntax* (Oxford, 1985), 1: 56 (§114).

23. Unlike the poetry they contain, Anglo-Saxon manuscripts are datable within fifty years; the acknowledged authority is N. R. Ker, *Catalogue of Manuscripts Containing Anglo-Saxon* (Oxford, 1957; reprinted with a supplement, 1990).

24. Patrick P. O'Neill, "On the Date, Provenance, and Relationship of the 'Solomon and Saturn' Dialogues," *ASE* 26 (1997): 139–68, argues for the common authorship of *Sol I* and *Sol II* (142) and an origin in the same intellectual milieu as Alfred's *Boethius* (154–65).

25. See R. Priebsch and W. E. Collinson, *The German Language,* 4th ed. (London, 1958), 316.

13

Rhythm and Alliteration: Styles of Ælfric's Prose up to the *Lives of Saints*

Haruko Momma

Style is a topic that interests many but allows few to practice it as a distinct field with its own objects of inquiry, methodology, and genealogy of specialists. Perhaps style is considered too diffuse for an established area of study in most disciplines, but for those Anglo-Saxonists who hope to consider the question of style, Old English literature raises particular problems because of its extant corpus: most poems and a great many prose texts are anonymous, the majority of the poetry cannot be dated, its place of origin cannot be proved beyond a doubt, and the distinction between verse and prose is not as clear as it first appears.[1] Even the period is an uncertain criterion when we realize that Old English prose continued to be copied and read after 1066 and may have influenced some authors in the early Middle English period.[2] But such external information is necessary for considering internal information about the texts for the consideration of style. We may undertake, for instance, to analyze the style of a single text, such as *Beowulf*, by contrasting it with other texts, or to examine the style of an author, such as Cynewulf, by comparing his signed poems with other poems. In both cases, however, we are left with the difficulty in interpreting the results thus gained, because we have very little external information about the texts and their authors.

The most concrete external criteria for Old English literature derive from the physicality of the texts. We may discuss, for instance, loanwords in a certain manuscript, the dialectal tendency of a specific scribe, or hypermetric verse in a poetic codex. But

aside from the information offered by the manuscripts—their most immediate context—most of our texts can offer us a very few external criteria. And yet the outcome of stylistic studies depends very much on how precisely we establish the external criteria at the beginning, and a failure to do so may trap us in a circular argument, since style alone is often insufficient for determining such external criteria as authorship, date, and place of origin. Or a vaguely defined external criterion may cause multiplication of the data and uncertainty about their interpretation. One such example may be found in a later and lesser-known work of Eduard Sievers called *Schallanalyse*, an "analysis of (speech) sounds." Unlike his celebrated work on Germanic metrics, in which he first abstracted five basic types from numerous metrical patterns found mostly in *Beowulf* and then applied this efficient system to other Germanic poetry,[3] Sievers devised an infinitely complicated system of analysis in his *Schallanalyse*, because he believed he was able to identify a distinct sound pattern for any author writing in any language.[4] In applying the *Schallanalyse* to Old English, Sievers chose a number of nonverse texts with some poetic features and classified them under the rubric of *Sagvers*.[5] But his overly complex analysis shed little light on the nature of this supposedly alternative type of Old English poetry, and he even failed to recognize that one of the texts he had included was actually composed by Ælfric.[6]

Ælfric's authorship for the legal document now called the *Ely Privilege* was first suggested by Angus McIntosh[7] and became authorized by John C. Pope after his minute examination of the text.[8] Pope conceded that his discussion of the *Ely Privilege* rested solely on internal evidence, but he nonetheless maintained that "if [Ælfric] was not the author, we must postulate a very extraordinary imitator, one who was not only capable of composing rhythmical prose of a precisely Ælfrician sort, but one whose mind was so completely attuned to Ælfric's writings that he could think in Ælfric's words and idioms without once betraying his own idiosyncrasy or reaching out for some other writer's expressions."[9] No one has challenged Pope since the publication of his analysis in 1971. This may seem to serve as an exception to the premise for stylistic studies discussed above, since Pope here determines an external criterion—authorship—on the basis of style. But Ælfric is a true exception in Old English literature. Unlike Cynewulf, Ælfric is more than just a name: we know when and where he lived; we know his educational background and the course of his career; we know his religious convictions and political inclinations. Unlike Cædmon, Ælfric

has left us a wide range and a vast quantity of writing, and enough external evidence allows us to determine its chronology with considerable accuracy.

These external factors make Ælfric an ideal case for stylistic studies in Old English literature, and fortunately for us, Ælfric is known to have written in a distinct style generally known as "rhythmical prose." There has been in fact an impressive array of scholarship dedicated to Ælfric's style, and one of the issues that fascinated scholars for many decades was the question of whether or not Ælfric was a poet. The debate has never come to a close, but it now seems to be agreed that Ælfric's writing is not poetry when placed within the strict regimen of traditional verse in Anglo-Saxon England, although his composition seems to anticipate the new wave of alliterative verse in the early Middle English period.[10] But the question of Ælfric's style is more complex than this. Even if we limit our scope to the earliest part of Ælfric's writing career, we realize that his homilies in the first collection are so different from his saints' lives in the third collection that it would have been a very difficult task to prove the common authorship if what was left of the Ælfric corpus had been just one text each from these two collections. In the rest of this essay I will focus on stylistic changes in Ælfric's writing between these two periods. But I should first define "style" as it will be used in the discussion: style pertains to a predilection for certain textual features—whether linguistic, prosodical, or lexical—that are not required of the genre of the composition in question; or conversely, style pertains to an avoidance of certain textual features that are not prohibited. For example, alliteration is an absolute requirement for *Beowulf*, whereas it is a stylistic feature in Wulfstan's *Sermo Lupi ad Anglos*. If, therefore, we begin with the assumption that Ælfric's composition is not verse in a traditional sense, then the poetic features in Ælfric serve as a touchstone for the development of his writing style.

It is often said that Ælfric's homilies in the First Series are written in "ordinary prose." But many of these homilies are more verse-like[11] than, say, early entries for the *Anglo-Saxon Chronicle*, because Ælfric here uses a poetic feature—namely, rhythm generated by the regular repetition of syntactic units.[12] These are loosely structured rhythmical phrases that usually consist of two stressed words and an unspecified number of unstressed words. Ælfric's rhythmical units are therefore comparable to half-lines in poetry, except that they tend to be longer and more irregular. Some rhythmical passages in Ælfric's First Series even occur with sustained

alliteration, even though Ælfric's alliterative patterns are often different from those used in poetry. In the following example, taken from the homily on St. Clement, I have arranged paired alliterative phrases in long lines:

> On þære niwan gecyðnysse æfter cristes þrowunge
> ond his æriste. ond upstige to heofenum
> wurdon þa iudeiscan mid andan afyllede ongean his
> apostolum.
> ond gebrohton hi on cwearterne;
> On þære ylcan nihte godes engel undyde
> þa locu þæs cwearternes ond hi ut alædde. . . .

[In the New Testament, after Christ's passion and his resurrection and ascent to heaven, the Jews were filled with envy against his apostles and brought them into prison. On the same night, God's angel released the locks of the prison and led them out. . . .][13] (230–33)[14]

Prose of this type is by no means original to Ælfric. Both rhythmical phrases and alliteration are found in earlier homilies, and especially those in the Vercelli Manuscript.[15] There is enough evidence to surmise that Ælfric was familiar with the tradition of existing vernacular homilies, even though he apparently did not approve of their contents.[16] It is also possible that Ælfric was inspired to compose with rhythmical phrases through the writing of the vernacular author he admired most, namely, King Alfred. As Malcolm Godden points out, Ælfric not only praised highly Alfred's translation of patristic authors but also used it in his own writing either directly or indirectly.[17] An example is the following passage:

> Æfter ðison ymbe twelf monað eode se cyning binnon his healle. mid ormætre upahefednysse. herigend his weorc and his mihte. and cwæð; Hu ne is þis seo miccle babilon ðe ic sylf getimbrode. to cynestole and to ðrymme me sylfum. to wlite and to wuldre. mid minum agenum mægene and strencðe; Ac him clypode þærrihte to. swiðe egeslic stemn of heofenum. þus cweðende; Þu nabochodonosor. þin rice gewit fram ðe. and þu byst fram mannum aworpen. (*Dominica XII. post Pentacosten, CH* II, lines 104–9)[18]

[About twelve months thereafter the king went into his hall with excessive pride, praising his work and his power, and

said: "Is this not the great Babylon—this, that I have built myself as my throne and as tribute to myself, with my own power and strength for grandeur and glory?" But at once a very horrifying voice cried out to him from heaven, thus saying: "You Nebuchadnezzar, your kingdom will forsake you, and you will be cast out by the people."]

The monologue of Nebuchadnezzar has been quoted almost verbatim from Alfred's translation of Gregory's *Pastoral Care*:

Hu ne is ðis sio micle Babilon ðe ic self atimbrede to kynestole & to ðrymme, me selfum to wlite & wuldre, mid mine agne mægene & strengo?[19]

As has been pointed out, Alfred is one of the earliest Old English prose writers who seem to have been influenced by the techniques of vernacular poetry,[20] and the quotation above offers an example of his use of loosely constructed two-stress phrases. Ælfric must have been aware of the nature of Alfred's writing, because the quotation does not at all interfere with the rhythmical style he was using to write the entire passage.

When we discuss Ælfric's "rhythmical prose," we usually refer to his composition in the *Lives of Saints*, for we believe that his writing style was perfected in this third collection. But the term "rhythmical prose" is a misleading appellation for the *Lives*, because these texts employ not only rhythmical phrases but also regular alliteration. The *Lives* might therefore be called "alliterative prose," while the term "rhythmical prose" may be used for composition consisting of rhythmical phrases without regular alliteration.

Both rhythmical phrases and regular alliteration occur in Wulfstan's *Sermo Lupi ad Anglos*, too, but Wulfstan uses alliteration mostly to double up words within two-stress phrases for emphasis.[21] It must be noted, however, that alliteration within half-lines is not essential in poetry, as can be seen from the fact that double alliteration is merely optional in the first half-line (the *a*-verse) and absolutely prohibited in the second half-line (the *b*-verse). Ælfric's *Lives* are more verse-like than Wulfstan's *Sermo*, because Ælfric uses alliteration to connect every two rhythmical phrases into an equivalent of the long line in poetry. In this respect Ælfric's *Lives* resemble Old English poems, but a closer look will reveal differences between the paired phrases of Ælfric and the long line of poetry. Since much has been written on this subject,[22] I will largely limit my discussion to prosody, syntax, and the relationship between

the two. The most significant difference between Old English po-
ems and Ælfric's *Lives* pertains to the pattern of alliteration: while
the former are restricted to the pattern $a(a)|ax$, the latter con-
stantly use other patterns, such as $xa|ay$ and $ax|ya$, which are not
permitted in poetry.[23] This deviation disrupts the function of allit-
eration as a welding device for linking two rhythmical phrases into
a "long line." The anomalous pattern $xa|ay$, for example, fails to
indicate the beginning of the long line with an alliterating stressed
word, which the poetry does by keeping to the pattern $a(a)|ax$. In
the following examples taken from the life of St. Oswald, Ælfric
repeatedly uses this pattern, and most noticeably when the first
stressed word of the long line is a proper noun, a word for God, or
an attributive adjective such as *halig* (holy); I have here under-
lined these unalliterating stressed words:

> *Oswold* him com to. and him cenlice wiðfeaht
> mid lytlum werode. ac his geleafa hine getrymde.
> and *crist* him gefylste to his feonda slege.
> *Oswold* þa aræerde ane rode sona
> *gode* to wurðmynte æær þan þe he to ðam gewinne come.

[Oswald came to him and confronted him courageously with
a small band. But his faith fortified him, and Christ upheld
him in defeating his enemy. Oswald then forthwith raised a
cross as honor to God before he proceeded to battle.] (14–18)

> Nu hæfð he þone wurðmynt on þære ecan worulde.
> mid þam *ælmihtigan* gode for his godnysse.
> Eft se *halga* cuðberht þa þa he git cnapa wæs.
> geseah hu *godes* ænglas feredon aidanes sawle
> þæs *halgan* bisceopes. bliðe to heofonum
> to þam *ecan* wuldre þe he on worulde geearnode.

[Now he has honor with Almighty God in the eternal world
for his virtue. Afterwards the holy Cuthbert, when he was
still a boy, saw how God's angels carried the soul of Aidan,
the holy bishop, blissfully to heaven, to eternal glory that
he had earned in this world.] (277–82)[24]

Likewise, the anomalous pattern $ax|ya$ fails to mark the end of the
long line with a nonalliterative stressed word, whereas traditional
poetry never concludes the line with an alliterating word.[25] Ælfric

uses the anomalous pattern $ax\,|\,ya$ less frequently than the anomalous pattern $xa\,|\,ay$. But the following examples, taken again from the life of St. Oswald, also occur with a proper noun, the noun *god*, or attributive adjectives:

wið þone langan weall þe þa *romaniscan* worhtan

[by the long wall that the Romans had built] (41)

and þa leode gebigde to *godes* geleafan

[and converted the people to God's faith] (72)

and genam þæt heafod. and his *swiðran* hand

[and took the head and his right hand] (167)

oft feala wundra þurh þone *halgan* wer

[often many wonders through the holy man] (286)

These prosodical deviations seem to have ramifications for the syntax of the *Lives of Saints*, as well. As I have pointed out elsewhere,[26] Old English poetry places strict constraints on the placement of unstressed personal pronouns, unstressed finite verbs, and other unstressed words that are syntactically detached from the immediately following words: these words must be gathered together and placed in one position, usually at the beginning of the clause. These "detached unstressed words" in the clause-initial position are distinguished from the rest of the clause by the alliteration placed mandatorily on the first stressed word of the clause (that is, the first a of the standard alliterative pattern $a(a)\,|\,ax$). In the *Lives of Saints*, on the other hand, detached unstressed words in the clause-initial position are less clearly distinguished from the rest of the clause, because Ælfric often gives no alliteration to the first stressed word of the "half-line," as indicated by the x in the anomalous pattern $xa\,|\,ay$ or by the y in the anomalous pattern $ax\,|\,ya$. Since Ælfric has obscured the contrast between stressed and unstressed words—which is essential for the operation of syntax in Old English poetry—detached unstressed words begin to spill over to the rest of the clause in the *Lives*. Here are some examples from the life of St. Edmund, which according to Pope is "one of the most carefully composed of the *Lives*":[27]

Þa geseah hingwar se arlease flot-man.
þæt se æþela cyning *nolde* criste wið-sacan.
ac mid anrædum geleafan *hine* æfre clypode . . .

[When Hingwar, the wicked Viking, realized that the noble
king would not forsake Christ but continuously cried to
him with resolute faith. . . .] (119–21)

þa seo hergung geswac and sibb *wearð* forgifen
þam geswenctan folce. þa fengon *hi* togædere . . .

[when the onslaught ceased and peace was granted to the
afflicted people, then they gathered together. . . .] (169–70)[28]

In the first example, the unstressed finite verb *nolde* occurs in the
second "half-line" of the clause. In poetry, *nolde* would have been
placed either in the clause-initial position (after *þæt*) as an un-
stressed word or in the clause-final position (after *forgifen*) as a
stressed word. Likewise, the unstressed pronoun *hine* occurs in the
second "half-line" of the clause, rather than in the first "half-line"
between *ac* and *mid*. In the second example, the unstressed *wearð*
and *hi* each occur in the first "half-line" of the clause, but they are
placed in the clause-medial position, separated from another de-
tached unstressed word in the same "half-line" at the beginning
(*and* and *þa* respectively).

There is another syntactic feature in Ælfric's *Lives* that might
be associated with their irregular alliterative patterns. It has been
pointed out[29] that traditional Old English poetry has a strong ten-
dency to place finite verbs at the end of the long line (and therefore
at the end of the *b*-verse), where alliteration is absolutely prohib-
ited. According to my counting, 55 percent of the finite verbs take
this position in *Beowulf*, 53 percent in *Exodus*, and 51 percent in
Judith. The end of the *a*-verse, on the other hand, is much less
preferred for finite verbs: for example, 13 percent in *Beowulf*, 10
percent in *Exodus*, and 10 percent in *Judith*. In Ælfric's *Lives*, on
the other hand, the distribution of finite verbs between these two
positions is much more even: in *St. Edmund*, for instance, only 26
percent are placed at the end of the "*b*-verse," while almost an
equal number (namely, 22 percent) occurs at the end of the "*a*-
verse." This decrease in syntactic distinction between the *a*-verse
and the *b*-verse may be attributed to the fact that Ælfric allows
alliteration at the end of the "long line," thus obscuring the pro-
sodical distinction between the *a*-verse and the *b*-verse.

It is generally agreed that Ælfric began to develop his signature style in the Second Series of his *Catholic Homilies*, and that the homily on Cuthbert is one of the first to be composed in this new style. This homily seems to represent an experimental stage of Ælfric's writing, because its style varies widely in its degree of similarity to verse. The Cuthbert homily begins with a paragraph in ordinary prose, not even with regular phrase-based rhythm:

CUTHBERHTUS se halga biscop scinende on manegum geearnungum and healicum geðincðum, on heofenan rice mid þam ælmihtigum scyppende on ecere blisse rixiende wuldrað; Beda se snotera engla ðeoda lareow þises halgan lif. endebyrdlice mid wulderfullum herungum. ægðer ge æfter anfealdre gereccednysse. ge æfter leoðlicere gyddunge awrat;

[Cuthbert, the holy bishop resplendent with many virtues and great respects, lives in glory and eternal bliss in the kingdom of heaven with the almighty Creator. Bede, the learned teacher of the English people, described both in prose and verse the life of this holy man in correct order with worshipful praises.] (1–6)[30]

This opening section is gradually taken over by a passage with a mixed degree of rhythm and alliteration. The verse-likeness of the following passage, for example, diminishes from alliterative phrases to nonalliterative rhythmical phrases to nonrhythmical ordinary prose (I have lineated paired alliterative phrases in long lines and other rhythmical phrases in short lines):

Ne gedafenað biscope þæt he beo on dædum
folces mannum gelic; Geswic la leof
swa unðæslices plegan. and geðeod þe to gode.
ðe ðe to biscope
his folce geceas.
þam ðu scealt heofonan rices
infær geopenian;
Hwæt ða cuthberhtus ða gyt
mid his plegan forð arn.
oð þæt his lareow
mid biterum tearum
dreoriglice wepende

ealra ðæra cildra plegan
færlice gestilde;
Witodlice eall se cildlice heap wolde þæs anes cildes
dreorignysse gefrefrian.

["It is not appropriate for a bishop to act like ordinary men.
Desist, indeed, from so unbecoming a play, and submit your-
self to God, who has chosen you as a bishop to his people, for
whom you must open the portal to the kingdom of heaven."
But Cuthbert still ran forward with his play, until his guide
instantly stopped the game of all the children by crying sor-
rowfully with bitter tears. And the entire group of the children
tried to console the distress of that one child.] (16–23)

In the next section Ælfric begins to write with more sustained
alliteration, and some of the rhythmical phrases even form a suc-
cession of "long lines" at a time. In the following passage, only the
first "long line" lacks alliteration:

Ic wolde ðine ðenunge sylf nu gearcian
gif ic me mid feðunge ferian mihte;
Min adlige cneow is yfele gehæfd.
þæt ne mihte nan læcewyrt awiht geliðian.
ðeah ðe heo gelome to geled wære;
Þa gelihte se cuma. and his cneow grapode.
mid his halwendum handum and het hine geniman
 hwætene smedeman . . .

["I would straightaway prepare your repast myself if I could
set myself in motion. My ailing knee is so badly afflicted
that no herb could soothe it by any means even if it were
applied to it frequently." Then the stranger alighted and
touched his knee with his healing hands, and told him to
take fine wheat flour. . . .] (36–41)

After this first succession of "alliterative long lines" Ælfric alter-
nates between alliterative and nonalliterative several times, until,
around line 80 in the modern prose edition, he switches back to the
alliterative and sustains this mode for the rest of the homily. In
this section, which comprises approximately 260 lines in the edi-
tion, the paired phrases often read like alliterative long lines in
poetry. For example:

Se halga ða het. him bringan sæd.
wolde on ðam westene. wæstmes tilian.
gif hit swa geuðe. se ælmihtiga god.
þæt he mid his foton. hine fedan moste;
He seow ða hwæte. on beswuncenum lande.
ac hit to wæstme. aspringan ne moste.
ne furðon mid gærse. growende næs;
Þa het he him bringan. bere to sæde.
and ofer ælcne timan. ða eorðan aseow;
Hit weox ða mid wynne. and wel geripode;

[Then the holy man ordered seeds to be brought to him. He had hoped to obtain crops in the wilderness, if the almighty God would grant it, so that he could support himself with his own hands. So he sowed the wheat on the ploughed land, but it could not bring forth harvest. In fact, not even leaves grew. Then he ordered barley to be brought to him for seeding, and then sowed it over the soil at every opportunity. It then grew happily and ripened well] (176–83)

The above passage shows a regular use of rhythm, alliteration, and the long-line structure. Except for the sixth line, which totally lacks alliteration, all the "long lines" above have alliteration patterns similar to those in poetry: there is no "half-line" without alliteration; none of the "long lines" ends with an alliterating word; alliteration is always placed on the first stressed word of the "long line"; the prosodical status of finite verbs may be ambiguous when they carry alliteration and occur in the clause-initial position (here *wolde* in the second line and *weox* in the last line).[31] The syntax of this passage resembles that of poetry, as well. All but one detached unstressed word here occur immediately before or immediately after the first stressed word of the clause.[32] In the first line the personal pronoun *him* occurs in the medial position of the clause, but it is given prosodical stress and alliteration. The only exception occurs in the fourth line, where the unstressed *hine* is placed in the clause-medial position, a construction that is frequently observed in the *Lives of Saints*. Five out of the ten "long lines" end with finite verbs: *moste* in the fourth and the sixth lines, *næs* in the seventh line, *aseow* in the eighth line, and *geripode* in the tenth line. In fact, of all the finite verbs occurring in the alliterating parts of the Cuthbert homily as many as 40 percent are placed at the end of the "*b*-verses," whereas only 14 percent occur at the end of the

"*a*-verses." These numbers are comparable to traditional Old English poetry: for example, those for *The Seafarer* are 44 percent and 15 percent, respectively. This marks a clear contrast with the *Lives of Saints*, where finite verbs are distributed more evenly in these two positions. With regards to the "metrical" patterns of rhythmical phrases, the alliterative portion of the Cuthbert homily shows a greater tendency towards poetry than does Ælfric's later work. As Pope points out, the average number of syllables per alliterative phrase in the Cuthbert homily is just over 6, and as few as 5.25 in certain parts, whereas the general average is close to 7 for most of the *Lives of Saints* and later pieces.[33] Some of the alliterative phrases in the Cuthbert homily are as short as quadrisyllabic, the shortest variation allowed in poetry. While Pope describes the alliterative portion of the Cuthbert homily to be "rather cramped and bare," he nonetheless concedes that "It is hard to escape the feeling that Ælfric is here imitating the poetical verse a little more closely. . . . "[34]

The Second Series of the *Catholic Homilies* contains several other alliterative homilies.[35] In the homily on the Invention of the Cross, for example, Ælfric experiments with several stylistic possibilities. He begins one passage with rhythmical phrases that are paired with alliteration in the normal pattern *a(a)|ax* (except for the second-to-last line given below):

> Se arleasa gewende. ana of ðære byrig.
> and het ðone here him æfter ridan;
> He ne gemunde ða for ðam micclum graman
> ðære leasan bricge. þa he alecgan het.
> ac rad him ana to. ormæte caflice;
> Þa scipu toscuton. and he ðone grund gesohte.
> mid horse mid ealle. and se here ætstod . . .

[The wicked man went alone from the city and ordered the troop to ride after him; because of the great rage he was not conscious then of the false bridge that he had ordered to set up, but he rode up to it alone with excessive boldness; the ships dispersed and he sought the bottom with his horse and all. And the troop stopped. . . .] (26–31)[36]

These rhythmical phrases consist of relatively few syllables, and some even form regular metrical patterns such as Type B (e.g., *he ne gemunde ða, þa he alecgan het*) and a "heavy verse" with three stresses (*him æfter ridan*). The word order of this passage is also

comparable to that of poetry. In the third line, for example, the detached unstressed *he* occurs in the clause-initial position, whereas the detached word *ða* occurs in the clause-medial position with "stress." Likewise, the fifth line begins with the detached unstressed *rad* and *him*, while the preposition *to* is separated from its object *him* and placed in the clause-medial position, where "stress" is obligatory. Then in the next passage Ælfric concocts rhythmical phrases with all the poetic features he used before, except for alliteration:

> . . . ahred fram frecednysse. for his anes deaðe;
> Swa wearð gefylled þæs caseres ben.
> þæt his hand næs besmiten. þe ða rode heold.
> mid agotenum blode. his agenre burhware;
> Ða wearð eal þæt folc. micclum gegladod.
> þæt hi moston gesunde. cyrran to ðære byrig.

[safe from the danger, because of his death alone. Thus the emperor's prayer was fulfilled, that his hand, which held the cross, not be stained with blood shed by his own citizens. Then all the people were very glad that they could safely proceed to the bridge.] (31–35)

Here again, the rhythmical phrases are relatively short: some of them comprise Type A (e.g., *micclum gegladod*); others comprise Type B (e.g., *þe ða rode heold*); and others are comparable to "light verses"—half-lines with only one stress, which in poetry tend to occur, as they do here, at the beginning of clauses (e.g., *swa wearð gefylled, þæt hi moston gesunde*). The word order of this passage also resembles that of poetry. The only exception is the unstressed finite verb *næs* in the third line, which is separated from another detached unstressed word, *þæt*, and placed in the clause-medial position. After this short experimental passage, Ælfric returns to "alliterative long lines":

> and underfengon ðone cesere. swa swa him gecynde wæs.
> and he mid sige gesæt. siððan his cynestol.
> gefullod on criste. þe his folc geheold;

[and they received the emperor as it befitted him. And thenceforth he occupied the throne triumphantly, exalted in Christ, who had protected his people.] (35–37)

Having observed Ælfric's experimental method of writing in the Second Series of his *Catholic Homilies*, some might hope to resume our earlier debate and ask whether or not some parts of his composition in this collection should be considered poetry. My answer would tend towards the negative, because neither the Cuthbert homily nor any other homily in the collection keeps to consistent alliteration without lapsing into nonalliterative rhythmical prose or further into ordinary prose. In contrast, Old English poetry shows formalistic consistency within each composition, whether it pertains to short "elegies" or long biblical narratives. Even the *Metres of Boethius* and the *Metrical Psalms* of the Paris Psalter—texts often branded "nonclassical"—seem to observe certain prosodical and syntactic regularities within each text, however different their styles might be from those of "classical" Old English poems. It is true that Ælfric's alliterative composition becomes more regulated in the *Lives of Saints* and later homilies, but it still contains inconsistencies unparalleled in poetry.[37] And even when, as Pope points out, Ælfric had come to compose exclusively with alliteration, he does not "seem to have hesitated," when revising his work, "to insert a freshly composed rhythmical passage into an early homily written in ordinary prose . . . , to attach a rhythmical *exemplum* to an ordinary prose admonition . . . , or to include an early piece, partly ordinary, partly rhythmical, in an otherwise consistently rhythmical homily."[38] For Ælfric, the alliterative long line seems to have remained a stylistic device that could be freely mixed with other styles.

To summarize, Ælfric began his writing career with the First Series of *Catholic Homilies*, which are composed in the so-called ordinary prose but with occasional rhythm and alliteration. Within a year or so, in the Second Series, he began to experiment with various writing forms, including one that is very close to traditional verse. In the *Lives of Saints*, Ælfric seems to have settled in a midpoint, with composition that is highly rhythmical and regularly alliterative, but still markedly different from poetry. Ælfric's stylistic odyssey can be traced in these three collections containing more than ten dozen texts, which he wrote probably in less than ten years.[39] But this is not the end of Ælfric's literary excursion. We know enough about *how* Ælfric developed his alliterative style in these three collections (although we still need to fill in details), but we have yet to investigate *what* he did with this style in the rest of his writing career. Ælfric began the translation of the Old Testament while he was still completing the *Lives of Saints*. After

completing the Third Series, he revised homilies in the First and the Second Series, composed more homilies, and wrote in other genres—all in different styles and with different purposes and social functions.[40] Ælfric's writing style is by no means an exhausted subject, and its further investigation will contribute greatly to the literary, cultural, and social history of Anglo-Saxon England, and beyond.

Notes

I would like to thank George H. Brown, Catherine Karkov, and Ursula Schaefer for their generous help, and Lahney Preston for her editorial assistance; all mistakes and deficiencies in this article are, however, mine.

1. For this see Haruko Momma, *The Composition of Old English Poetry*, CSASE 20 (Cambridge, 1997), esp. 1–6.

2. See, for example, R. M. Wilson, *Sawles Warde: An Early Middle English Homily Edited from the Bodley, Royal and Cotton MSS.* (Leeds, 1938), v–xxx; Dorothy Bethurum, "The Connection of the Katherine Group with Old English Prose," *Journal of English and Germanic Philology* 34 (1935): 553–64; N. F. Blake, "Rhythmical Alliteration," *MP* 67 (1969): 118–24; Angus McIntosh, "Early Middle English Alliterative Verse," in *Middle English Alliterative Poetry and Its Literary Background: Seven Essays*, ed. David Lawton (Cambridge, 1982), 20–33.

3. Eduard Sievers, "Zur Rhythmik des germanischen Alliterationsverses," *Beiträge zur Geschichte der deutschen Sprache und Literatur* 10 (1885): 209–314, 451–545, and 12 (1887): 454–82; idem, *Altgermanische Metrik* (Halle, 1893).

4. For Sievers's *Schallanalyse*, see, for example, Gerald Ungeheuer, "Die Schallanalyse von Sievers," *Zeitschrift für Mundartforschung* 31 (1964): 97–124; John C. Pope, "Eduard Sievers," in *Medieval Scholarship: Biographical Studies on the Formation of a Discipline*, vol. 2: *Literature and Philology*, ed. Helen Damico with Donald Fennema and Karmen Lenz (New York, 1998), 184–89.

5. Eduard Sievers, *Metrische Studien*, vol. 4: *Die altschwedischen Upplandslagh nebst Proben formverwandter germanischer Sagdichtung*, part 1, *Einleitung*, part 2, *Texte* (Leipzig, 1918–19).

6. Sievers, *Metrische Studien*, vol. 4, part 1, 575–7.

7. Angus McIntosh, "Wulfstan's Prose," *PBA* 35 (1949): 113, 128–29.

8. John Pope, "Ælfric and the Old English Version of the Ely Privilege," in *England before the Conquest: Studies in Primary Sources Presented*

to Dorothy Whitelock, ed. Peter Clemoes and Kathleen Hughes (Cambridge, 1971), 85–113.

9. Ibid., 110.

10. See, for example, Gordon H. Gerould, "Abbot Ælfric's Rhythmic Prose," *MP* 22 (1924–5): 353–66; Dorothy Bethurum, "The Form of Ælfric's *Lives of Saints*," *Studies in Philology* 29 (1932): 515–33; John C. Pope, ed., *Homilies of Ælfric: A Supplementary Collection*, 2 vols., EETS, o.s., 259 and 260 (London, 1967–68), 1:105, 108–9; Frances R. Lipp, "Ælfric's Old English Prose Style," *Studies in Philology* 66 (1969): 689–718; Sherman M. Kuhn, "Was Ælfric a Poet?" *PQ* 52 (1973): 643–62. See also Momma, *Composition*, 12–13.

11. For the notion of "verse-likeness," see Momma, *Composition*, 7–27.

12. See, for example, Pope, *Homilies of Ælfric*, 1:109–13.

13. All the translations in this essay are my own.

14. P. Clemoes, *Ælfric's Catholic Homilies: The First Series* (Oxford, 1997), 504–5.

15. See, for example, Otto Funke, "Studien zur alliterierenden und rhythmisierenden Prosa in der älteren altenglischen Homiletik," *Anglia* 80 (1962): 9–36; D. R. Letson, "The Poetic Content of the Revival Homily," in *The Old English Homily and Its Backgrounds*, ed. Paul E. Szarmach and Bernard F. Huppé (Albany, 1978), 139–56.

16. See Malcolm Godden, "Ælfric and the Vernacular Prose Tradition," in Szarmach and Huppé, *Old English Homily*, 99–102.

17. Ibid., 102–5.

18. Malcolm Godden, ed., *Ælfric's Catholic Homilies: The Second Series*, EETS, s.s., 5 (London, 1979), 252.

19. Henry Sweet, *King Alfred's West-Saxon Version of Gregory's "Pastoral Care*," EETS 45 and 50, 2 vols. (London, 1871–2), 1:39.

20. Alistair Campbell, "Verse Influences in Old English Prose," in *Philological Essays: Studies in Old and Middle English Language and Literature in Honour of Herbert Dean Meritt*, ed. James L. Rosier (The Hague, 1970), 93–98.

21. See, for example, Dorothy Bethurum, "Wulfstan," in *Continuations and Beginnings: Studies in Old English Literature*, ed. Eric Gerald Stanley (London, 1966), 231–32.

22. See Luke M. Reinsma, *Ælfric: An Annotated Bibliography* (New York, 1987), 115–34.

23. See, for example, Pope, *Homilies of Ælfric*, 1:123–24.

24. Walter W. Skeat, *Ælfric's Lives of Saints*, 4 vols., EETS, o.s., 76, 82, 94 and 114, (1881–1900; reprint, 2 vols., London, 1966), 2:126, 142. Both the lineation and the punctuation are in the edition.

25. Cf. David Lawton, "Middle English Alliterative Poetry: An Introduction," in *Middle English Alliterative Poetry and Its Literary Background: Seven Essays*, ed. David Lawton (Cambridge, 1982), 1–2.

26. See Momma, *Composition*.

27. Pope, *Homilies of Ælfric*, 1:125.

28. Skeat, *Ælfric's Lives of Saints*, 2:322, 326.

29. See Haruko Momma, "The Structure of *Beowulf*," (M.A. thesis, Hokkaido University, 1983), 121–23; idem, "On the Syntactic Structure of OE Poetry," *English Literature in Hokkaido* 30 (1985): 76–78. See also A.C.P. Bethel, "A Reconsideration of Various Aspects of *Genesis B*: Editions, Historical Background, Theology, Vocabulary, Metre, and Syntax" (Ph.D. diss., University of London, 1977).

30. Godden, *Second Series*, 81.

31. See, for example, Haruko Momma, "Metrical Stress on Alliterating Finite Verbs in Clause-Initial A-Verses: 'Some Doubts and No Conclusions,'" in *"Doubt Wisely": Essays in Honour of E. G. Stanley*, ed. M. J. Toswell and E. M. Tyler (London, 1996), 186–98.

32. See Momma, *Composition*, esp. 94–95.

33. Pope, *Homilies of Ælfric*, 1:114–15.

34. Ibid., 1:115.

35. According to Pope, alliteration is used "continuously throughout" in six of the homilies in the Second Series, and intermittently in six others including "St. Cuthbert" (ibid., 1:113).

36. Godden, *Second Series*, 175.

37. See Pope, *Homilies of Ælfric*, 1:116.

38. Ibid., 1:116–17.

39. For the chronology of the three collections, see Godden, *Second Series*, xci–xciv. Cf. Peter Clemoes, "The Chronology of Ælfric's Works," in *The Anglo-Saxons: Studies in Some Aspects of Their History and Culture, Presented to Bruce Dickins*, ed. Peter Clemoes (London, 1959), 212–47, esp. 244–45.

40. I would like to thank John D. Niles for his insightful comments on the cultural and historical aspects of Ælfric's writing style.

14

Both Style and Substance: The Case for Cynewulf

Andy Orchard

As one of the very few named Anglo-Saxon poets whose vernacular work has survived, Cynewulf has attracted much critical comment over a long period of time.[1] The ongoing fascination with Cynewulf's work stems in part from the way in which it seems to blend so many areas of Anglo-Saxon culture that are often seen as mutually exclusive, combining as it does imported, Christian, Latinate, and literary themes, images, diction, and techniques of composition with those drawn from the native, secular, vernacular, and ultimately oral tradition. The signatures themselves symbolize the apparently effortless cultural assimilation that is perhaps the hallmark of Anglo-Saxon literature both in Latin and Old English. On the one hand, the intensely visual aspect of the four runic signatures that provide the basis for ascription seems to suggest that they at least were meant to be privately read, while on the other hand the formulaic phrasing that links both the signatures themselves and the poems to which they are attached clearly suggests a traditional technique of composition that appears to derive from a period of public performance. A similar combination of old and new has been detected in extant literature throughout the Anglo-Saxon period, from Aldhelm's Latin poetry at the end of the seventh century to Wulfstan's Old English prose at the beginning of the eleventh.[2] Moreover, as with Wulfstan, the whole question of Cynewulf's authorship is intimately tied up with the issue of style,[3] itself a vexed question for Old English poetry, where the notion of a clearly definable individual style within the wider poetic tradition is beset with problems.[4] In Cynewulf's case, then, the whole question of style has become a matter of substance.

The four poems apparently signed in runes by one "Cynewulf" or "Cynwulf,"[5] namely *Elene, Juliana, Christ II,* and *the Fates of the Apostles,* are found in two of the four major extant poetic codices of Old English, and are all clearly the result of a literate and Latinate method of composition, using the traditional formulaic diction of Old English verse in new ways.[6] Notwithstanding the continuing debate over the unity of authorship of these poems,[7] it has long been observed that various stylistic and rhetorical tics can be detected across the four texts, for example in the propensity for a limited range of such effects as paronomasia, polyptoton, and homoeoteleuton.[8] The same paronomasia or wordplay occurs throughout these four texts, insistently connecting (for example) the words *rodor* (sky) and *rod* (cross),[9] while a similar fondness can be detected for a particular type of polyptoton consisting of a noun-phrase combining (usually) the genitive plural and nominative (or accusative) forms of the same noun, producing not just the biblical *cyninga cyning* (king of kings) or *drihtna drihten* (lord of lords),[10] but also (for example) *dreama dream* (joy of joys), *þrymma þrym* (power of powers), and even *fula ful* (foulness of foulnesses).[11] Likewise, the homoeoteleuta or rhymes so much in evidence in the runic signatures in particular have also elicited much critical comment over an extended period,[12] but it is important to recognize that these are not the only examples of rhyme in the four signed poems.[13] What has been held to contribute to the distinctiveness of the four signed poems, however, lies not so much in the isolated appearance of paronomasia, polyptoton, and homoeoteleuton, since these devices are to be found elsewhere in Old English verse; rather it is their combination, often in a single brief and self-contained passage, such as (for example) that in which Juliana makes her initial rejection of her unwanted suitor (*Juliana* 26–50).[14]

Notwithstanding several attempts at defining the characteristic style of these texts, however, there is still no scholarly consensus on the precise significance to be attached to such sporadic stylistic connections. Detailed studies, such as those by Daniel Donoghue at a syntactical level, concentrating on the use of the auxiliary verb,[15] and by R. D. Fulk at the metrical level, focusing on patterns of resolution,[16] have produced conflicting results: Donoghue detects differences between the two shorter texts *(Fates and Christ II)* and the others, while Fulk sees greater reason to connect all four. Other, more broadly literary studies, have consistently demonstrated that all four texts are highly figurative in their use of language and insistently allude to a wider tradition

than their immediate sources might suggest.[17] It might be noted in passing that precisely such a figurative technique and precisely the same rhetorical features as polyptoton, paronomasia, and homoeoteleuton are found frequently in the works of the Christian Latin poets Caelius Sedulius and (especially) Arator, both authors whose works were widely studied in Anglo-Saxon schools;[18] the stylistic influence of these and other Latin curriculum authors on vernacular poets seems likely, and is a topic ripe for further research.[19]

But alongside such efforts to isolate other shared aspects of the texts, it has long been recognized that the most obvious feature that links these four poems is their shared formulaic diction; indeed, much effort was expended in the years up to around 1950 specifically towards the isolation of such formulae.[20] Since 1953, however, and the seismic impact of the application of oral-formulaic theory to Old English verse,[21] it has become customary to scoff at the efforts of earlier scholars to associate poems through their shared formulae. R. D. Fulk puts the matter succinctly: "Parallel passages . . . carry little weight now that oral-formulaic theory has shown the pervasiveness of formulae, and their public, conventional nature."[22] Such a conclusion (which is widespread in the field) is perhaps in danger of throwing the baby out with the bathwater, and the wholesale acceptance of oral-formulaic theory without working out the implications of the fact that much Anglo-Saxon literature, not only in Old English and in verse but also in Latin and in prose, is unquestionably formulaic but (equally unquestionably) *not* oral, but literate, seems dangerously oversimplistic.[23] What is required is a way to screen out the "white noise" of traditional and inherited formulae, and only then to attempt to assess what is left. The four signed poems of Cynewulf provide a particularly convenient corpus for an attempt at just such screening, using a variety of techniques not available to earlier researchers, such as machine-readable texts, electronic databases, and customized concordance packages.

The following analysis is based on a relatively simple methodology. The first step was to produce an unlemmatized concordance of the more than 14,500 words in the four signed poems. The concordance was then used to highlight and identify repeated formulae, so producing over 400 different groups of examples that could be divided into groups of formulae repeated within individual poems and those shared by more than one of the four signed poems.[24] This raw analysis confirmed the view of Robert E. Diamond that the four signed poems considered as a corpus are just over 40

percent formulaic.[25] The next step was to cross-check every single group of shared formulae against the entire corpus of Old English verse,[26] discarding those groups in which the formula in question occurs anywhere outside the four signed poems. There remained a residue of around 140 groups of examples, around half of which are unique to the individual signed poems, and the remainder of which are unique to at least two of these four signed poems. To illustrate both the results of the analysis and the level and nature of formulaic repetition, one might cite the following 25 groups of examples of formulae unique to the individual signed poems:[27]

1. *Christ II* 487 sibbe **sawað** on **sefan manna**
 Christ II 663 **seow** ond sette geond **sefan monna**

2. *Christ II* 660 **godes gæstsunu, ond us giefe sealde**
 Christ II 860 **godes gæstsunu, ond us giefe sealde**

3. *Elene* 23 gearwe to guðe. **Garas lixtan**
 Elene 125 Gylden grima, **garas lixtan**

4. *Elene* 211 to widan feore **wergðu dreogan**
 Elene 951 wiðerhycgende, **wergðu dreogan**

5. *Elene* 247 **collenferhðe**, **cwen** siðes **gefeah**
 Elene 848 **collenferhðe**. **Cwen** weorces **gefeah**

6. *Elene* 332 **Elene maþelode ond for eorlum spræc**
 Elene 404 **Elene maðelade ond for eorlum spræc**

7. *Elene* 343 **frod fyrnweota, fæder** Salomones
 Elene 438 **frod fyrnwiota, fæder** minum

8. *Elene* 363 æfter **woruld**stundum **wundra gefremede**
 Elene 778 in **woruld**rice **wundra gefremede**

9. *Elene* 461 **soð sunu meotudes, sawla** nergend
 Elene 564 **soð sunu meotudes**, for **sawla** lufan

10. *Elene* 490 onfeng **æfter fyrste fulwihtes bæð**
 Elene 1033 **æfter fyrst**mearce **fulwihtes bæð**

11. *Elene* 532 **hwæt** eow **þæs on sefan selest** þince
 Elene 1164 **hwæt** him **þæs on sefan selost** þuhte

12. *Elene* 570 fæste **on fyrhðe**, þæt heo **frignan ongan**
 Elene 849 **on ferhð**sefan, ond þa **frignan ongan**
 Elene 1163 frodne **on ferhðe**, ond hine **frignan ongan**

13. *Elene* 609 ***Iudas hire ongen þingode*** (ne meahte he þa
 gehðu bebugan)
 Elene 667 ***Iudas hire ongen þingode***, cwæð þæt he þæt
 on ***gehðu*** gespræce

14. *Elene* 612 ***meðe ond meteleas*** morland trydeð
 Elene 698 ***meðe ond meteleas***, (mægen wæs geswiðrod)

15. *Elene* 679 ***hæleðum to helpe***, þæt me ***halig*** god
 Elene 1011 ***hæleðum to helpe***, þær sio ***halige*** rod

16. *Elene* 708 ond ðæt **soð** to late **seolf gecneowe**
 Elene 807 Nu ic þurh **soð** hafu **seolf gecnawen**

17. *Elene* 1012 ***gemeted wæs, mærost beama***
 Elene 1224 ***gemeted wæs, mærost beama***

18. *Elene* 1053 ***hæleða gerædum to þære halgan byrig***
 Elene 1107 ***hæleða gerædum*** hydde wæron
 Elene 1203 ***hæleða*** cynnes, ***to þære halgan byrig***

19. *Fates* 89 ***þysses*** giddes **begang** **þæt he** geomrum **me**
 Fates 108 ***þisses*** galdres **begang,** **þæt he** geoce **me**

20. *Juliana* 1 Hwæt! We ðæt **hyrdon** **hæleð eahtian**
 Juliana 609 siþþan heo ge**hyrde** **hæleð eahtian**

21. *Juliana* 12 ***þegnas*** þryðfulle. Oft hi **þræce rærdon**
 Juliana 333 ***þegnas*** of þystrum, hateð **þræce ræran**

22. *Juliana* 203 þonne **ic nyde sceal niþa gebæded**
 Juliana 462 þæt **ic nyde sceal niþa gebæded**

23. *Juliana* 250 **þa wyrrestan witu** gegearwad
 Juliana 340 ond **þa wyrrestan witu** geþoliað
 Juliana 572 þurh **þa wyrrestan witu** meahte
 Juliana 152 þam **wyrrestum wites** þegnum

24. *Juliana* 327 **ahwyrfen from halor**, we beoð hygegeomre
 Juliana 360 **ahwyrfan from halor**, þæt þu heofoncyninge

25. *Juliana* 390 **hean**mod hweorfan, ***hropra bidæled***
 Juliana 681 **heane** mid hlaford, ***hropra bidæled***

It will be clear that such formulaic repetition operates at several different levels, as here, and can involve not only the verbatim repetition of entire lines (examples 2, 6, and 17) or half-lines (examples 3–4, 14, and 24), but most often involves repetition across the caesura (examples 1, 5, 7–13, 15–16, 18–23, and 25). Such a factor perhaps highlights the structural role that such formulaic repetition within poems has been argued to play not simply for the four signed poems, but also more widely in Old English verse.[28]

But formulaic repetition can be observed not only within, but between the four signed poems; one might cite the following 20 groups of examples of formulae shared by at least two of the four poems:[29]

1. *Christ II* 588 ***gefreode ond gefreopade*** folc under wolcnum
 Juliana 565 ***gefreode ond gefreoðade*** facnes clæne

2. *Christ II* 803 ***hwæt him æfter dædum deman wille***
 Juliana 707 ***hwæt him æfter dædum deman wille***

3. *Christ II* 815 ***Forþon ic leofra*** gehwone ***læran wille***
 Juliana 647 ***Forþon ic, leof*** weorud, ***læran wille***

4. *Elene* 249 ofer lagofæsten ***geliden hæfdon***
 Christ II 857 ***ærpon*** we ***to londe geliden hæfdon***
 Juliana 677 ***ærpon*** hy ***to lande geliden hæfdon***

5. *Elene* 356 ***feodon þurh feondscipe***, nahton foreþances
 Juliana 14 ***feodon þurh*** firencræft ***Feondscype*** rærdon

6. *Elene* 418 ***gidda gearosnotor, (ðam wæs Iudas nama)***
 Elene 586 ***giddum gearusnottorne, (þam wæs***
 Iuda nama)
 Christ II 713 ***giedda gearosnottor*** gæstgerynum

7. *Elene* 427 þæt we ***fæstlice ferhð staðelien***
 Elene 796 ond þy ***fæstlicor ferhð staðelige***
 Juliana 270 Ongan þa ***fæstlice ferð staþelian***

8. *Elene* 472 þæs unrihtes ***ondsæc fremede***
 Christ II 655 þe þæs upstiges ***ondsæc fremedon***

9. *Elene* 480 on **galgan his gast onsende**
 Juliana 310 þæt he of **galgan his gæst onsende**

10. *Elene* 606 **swa lif swa deað, swa** þe **leofre bið**
 Christ II 596 **swa lif swa deað, swa** him **leofre bið**

11. *Elene* 663 **Wiðsæcest ðu to swiðe** soðe ond rihte
 Juliana 99 **Wiðsæcest þu to swiþe** sylfre rædes

12. *Elene* 810 **þrym**sittendum **þanc butan ende**
 Christ II 599 þrynysse **þrym, þonc butan ende**

13. *Elene* 838 þær hie **leahtra** fruman **larum** ne **hyrdon**
 Elene 1209 ond þæs latteowes **larum hyrdon**
 Juliana 371 **leahtrum** gelenge, **larum hyreð**

14. *Elene* 897 **to feorhnere fira cynne**
 Christ II 610 **to feorhnere fira cynne**

15. *Elene* 1147 Ongan þa **geornlice gastgerynum**
 Christ II 440 Nu ðu **geornlice gæstgerynum**

16. *Fates* 46 hæðen **ond hygeblind, heafde beneotan**
 Juliana 61 **hreoh ond hygeblind, haligre** fæder
 Juliana 595 **hreoh ond hyge**grim, ongon his hrægl teran
 Juliana 604 on **hyge halge, heafde bineotan**

17. *Fates* 53 **hige onhyrded, þurh** his **halig** word
 Elene 840 **hige onhyrded, þurh** þæt **halige** treo

18. *Fates* 63 **Hwæt, we þæt gehyrdon þurg halige bec**
 Elene 364 **Hwæt, we þæt gehyrdon þurh halige bec**
 Elene 670 **Hwæt, we ðæt hyrdon þurh halige bec**
 Elene 852 **Hwæt, we þæt hyrdon þurh halige bec**

19. *Juliana* 211 **awyrged womsceaða,** ne þinra wita bealo
 Elene 1299 **awyrgede womsceaðan,** in þæs wylmes grund

20. *Juliana* 448 **geþrowade, þrymmes** ealdor
 Elene 858 **geþrowode, þrymmes** hyrde

Once again, one notes the repetition between poems of whole lines (examples 2, 14, and 18) and half-lines (examples 1, 8, 11, and 19), and (especially) across the caesura (examples 3–7, 9–10, 12–13, 15–17, and 20). But the main result of this analysis is to underline the extent to which the four signed poems share a high degree of formulaic phrasing. The twin facts that more than 40 percent of the lines in the four signed poems are formulaic and that one-third of the groups of formulae identified are unique to these four poems offer impressive testimony to their uniformity of diction.

But perhaps the most striking product of this exercise was the generation of a lengthy list of what might be termed "near misses," where the formula in question is unique to the four signed poems and only one or two others in the extant corpus, since such formulae might be held to help isolate those poems the diction of which most closely resembles that of the four signed poems. I have detected no fewer than sixty-eight such groups of examples, as follows:

1.	*Andreas* 57	of **carcerne**. Him **wæs Cristes lof**
	Guthlac A 393	ceargesta cirm. Symle **Cristes lof**
	Elene 212	þa **wæs Cristes lof** þam casere
	Juliana 139	þæt þu mec acyrre from **Cristes lofe**
	Juliana 233	to **carcerne**. Hyre **wæs Cristes lof**
2.	*Andreas* 66	**georn on mode**; nu ðurh geohða sceal
	Elene 268	**georn on mode** þæt hio Iudeas
	Juliana 39	goldspedig guma, **georn on mode**
3.	*Andreas* 74	**engla eadgifa**, eðelleasum
	Andreas 451	**engla eadgifa**, yðum stilde
	Juliana 563	ecra **eadgiefa**. ða cwom **engel** godes
	Christ II 546	eorla **eadgiefan englas** togeanes
4.	*Andreas* 189	**ædre him Andreas agef andsware**
	Andreas 285	**Him þa Andreas agef ondsware**
	Andreas 572	**Him ða Andreas agef andsware**
	Andreas 617	**Him ða Andreas agef andsware**
	Andreas 643	**Edre him Andreas agef ondsware**
	Andreas 1184	**Him þa Andreas agef ondsware**
	Andreas 1345	**Him þa** earmsceapen **agef ondsware**
	Andreas 1375	**Him þa Andreas agef ondsware**
	Guthlac B 1163	**Him se eadga wer ageaf ondsware**
	Guthlac B 1224	**ða se eadga wer ageaf ondsware**

Elene 455	ealdum æwitan, **ageaf ondsware**
Elene 462	*ða* me yldra min **ageaf ondsware**
Elene 662	**Him seo æðele** cwen **ageaf ondsware**
Juliana 105	**Him þa seo eadge ageaf ondsware**
Juliana 117	**Hyre þa þurh** yrre **ageaf ondsware**
Juliana 130	**Him þa seo eadge ageaf ondsware**
Juliana 147	**Him seo** unforhte **ageaf ondsware**
Juliana 175	**Him seo æþele** mæg **ageaf ondsware**
Juliana 319	**Hyre** se aglæca **ageaf ondsware**

5.
Andreas 204	**þæs siðfætes sæne weorpan**
Andreas 211	Ne meaht ðu **þæs siðfætes sæne weorðan**
Fates 34	**siðes sæne**, ac ðurh sweordes bite
Elene 220	**þæs siðfates sæne weorðan**

6.
Andreas 291	**neregend fira**, of nacan stefne
Andreas 1286	**nerigend fira**, næfre wille
Elene 1077	**nerigend fira**. Mec þæra nægla gen
Elene 1172	**nerigend fira**. Þu ðas næglas hat
Juliana 240	in þam nydclafan, **nergend fira**

7.
Andreas 351	on merefaroðe **mod geblissod**
Andreas 892	**þa wæs modsefa myclum geblissod**
Elene 839	**þa wæs mod**gemynd **myclum geblissod**
Elene 875	on **modsefan miclum geblissod**
Elene 989	þurh þa mæran word **mod geblissod**
Juliana 608	ond þæs mægdnes **mod miclum geblissad**

8.
Andreas 363	**þeodnas þrymfulle, þegnas** wlitige
Christ II 541	**þegnas þrymfulle þeodnes** gehata
Juliana 12	**þegnas þryðfulle**. Oft hi þræce rærdon

9.
Andreas 398	**lid** to lande **ofer lagufæsten**
Andreas 825	leofne mid lissum **ofer lagufæsten**
Elene 249	**ofer lagofæsten geliden** hæfdon
Elene 1016	**ofer lagufæsten** leofspell manig

10.
Andreas 458	Forþan **ic eow to soðe secgan wille**
Elene 574	**Ic eow to soðe secgan wille**
Juliana 132	**Ic** þe **to soðe secgan wille**

11. *Andreas* 548 **gasta geocend**, þine gife dælest
 Elene 682 **gasta geocend**. Hire Iudas oncwæð
 Elene 1076 **gasta geocend**, godes agen bearn

12. *Andreas* 555 Him ða of **ceole** oncwæð **cyninga wuldor**
 Andreas 854 In þam **ceole** wæs **cyninga wuldor**
 Menologium 1 Crist wæs **acennyd**, **cyninga wuldor**
 Elene 5 **acenned wearð**, **cyninga wuldor**
 Elene 178 **acenned wearð**, **cyninga wuldor**
 Christ II 508 **cyninga wuldor**. Cleopedon of heahþu
 Juliana 279 þæt þu me gecyðe, **cyninga wuldor**

13. *Andreas* 605 þa he **gefremede nalas feam siðum**
 Elene 817 **þara þe ic gefremede nalles feam siðum**
 Juliana 354 **þara þe ic gefremede, nalæs feam siðum**

14. *Andreas* 631 **þurh snyttra cræft** soð oncnawest
 Elene 154 snude to sionoðe, þa þe **snyttro cræft**
 Elene 374 **þurh snyttro cræft** selest cunnen
 Elene 1171 sawle sigesped ond **snyttro cræft**
 Christ II 667 ond secgan þam bið **snyttru cræft**

15. *Andreas* 640 **godbearn on grundum**. Gastas hweorfon
 Christ II 499 **godbearn of grundum**. Him wæs geomor sefa
 Christ II 682 **godbearn on grundum**, his giefe bryttað

16. *Andreas* 671 herme hyspan, hord**locan onspeon**
 Elene 86 þæs halgan hæs, hreðer**locan onspeon**
 Juliana 79 þære fæmnan fæder, ferð**locan onspeon**

17. *Andreas* 752 ðone **on fyrndagum fæderas cuðon**
 Exodus 560 **in fyrndagum fæderyn**cynne
 Elene 398 þa **on fyrndagum fæderas cuðon**
 Elene 425 **in fyrndagum fæderas** usse
 Elene 528 ðus mec **fæder** min **on fyrndagum**

18. *Andreas* 805 **egesan geaclod**, þær þa æðelingas
 Elene 57 **egsan geaclad**, siððan elþeodige
 Elene 1128 **egesan geaclod**, ond þære arwyrðan
 Juliana 268 **egsan geaclad**, þe hyre se aglæca

19. *Andreas* 932 ofer wega gewinn. **Wast** nu **þe gearwor**
 Elene 945 worde awehte. **Wite** ðu **þe gearwor**
 Juliana 556 on wita forwyrd. **Wiste** he **þi gearwor**

20. *Andreas* 1144 **halig of hehðo**, hæðenum folce
 Guthlac B 938 **halig of heahþu**. Hreþer innan born
 Guthlac B 1088 **halig on heahþu**. Þær min hyht myneð
 Christ II 760 **halig of heahðu**, hider onsendeð
 Christ II 789 **halig of heahþu**. Huru ic wene me
 Christ II 866 **halge on heahþu**, þa he heofonum astag
 Juliana 263 **halig of heahþu**. Þe sind heardlicu
 Juliana 560 heredon **on heahþu** ond his **halig** word

21. *Andreas* 1155 hlud heriges cyrm. **Hreopon friccan**
 Elene 54 Hleopon hornboran, **hreopan friccan**
 Elene 550 to þam heremeðle. **Hreopon friccan**

22. *Andreas* 1165 **on sefan snyttro**. Nu is sæl cumen
 MPref to CP 7 **ðurh sefan snyttro**, searoðonca hord
 Elene 382 **on sefan snyttro**. Heo to salore eft
 Christ II 442 **þurh sefan snyttro**, þæt þu soð wite

23. *Andreas* 1200 **wordum wrætlicum** **for wera menigo**
 Elene 596 **for wera mengo** wisdomes gife
 Christ II 509 **wordum wrætlicum** ofer **wera mengu**
 Juliana 45 ond þæt word acwæð on **wera mengu**

24. *Andreas* 1278 wundum werig. Þa cwom **wopes hring**
 Guthlac B 1339 wine leofne. Him þæs **wopes hring**
 Elene 1131 wifes **will**an. Þa **wæs wopes hring**
 Christ II 537 hyra **wil**gifan. Þær **wæs wopes hring**

25. *Andreas* 1313 **morðres manfrea** myrce gescyrded
 Elene 941 **morðres manfrea**, þæt þe se mihtiga cyning
 Juliana 546 **morþres manfrea**. Hwæt, þu mec þreades

26. *Andreas* 1398 Ongan þa geomormod **to gode cleopian**
 Fates 115 Ah utu we þe geornor **to gode cleopigan**
 Elene 1099 gastes mihtum **to gode cleopode**
 Juliana 270 geong grondorleas, **to gode cleopian**

27. *Andreas* 1461 magorædendes ***mod oncyrran***
 Juliana 226 þæt he ne meahte ***mod oncyrran***
 Juliana 326 þurh misgedwield ***mod oncyrren***
 Juliana 338 þurh myrrelsan ***mod*** ne o**ð**cyrre**ð**
 Juliana 363 þurh mislic bleo ***mod oncyrre***
 Juliana 439 þæt ic in manweorcum ***mod oncyrre***

28. *Andreas* 1618 ***in wita forwyrd,*** wuldre bescyrede
 Hom Frag 1 10 ***in wita forwyrd,*** weoruda dryhten
 Elene 764 ***in wita forwyrd,*** þær hie in wylme nu
 Juliana 556 on ***wita forwyrd.*** Wiste he þi gearwor

29. *Andreas* 1688 ***deofulgild*** todraf ***ond gedwolan fylde***
 MB 26.54 drifan drycræftas. Hio ***gedwolan fylgde***
 Elene 371 dryhtna dryhten, ***ond gedwolan fylgdon***
 Elene 1040 ***deofulgildum, ond gedwolan fylde***
 Juliana 202 þurh þin dolwillen ***gedwolan fylgest***

30. *Andreas* 1709 ***hat æt heortan hyge weall***ende
 Guthlac B 1209 ***hat æt heortan, hyge*** gnornende
 Elene 628 ***hat æt heortan,*** ond gehwæðres wa
 Christ II 500 ***hat æt heortan, hyge*** murnende
 Christ II 539 ***hat æt heortan,*** hreðer innan ***weoll***

31. *Beowulf* 1825 guðgeweorca, ***ic beo gearo sona***
 Juliana 49 ongietest ***gæsta*** hleo, ***ic beo gearo sona***
 Juliana 365 to godes willan, ***ic beo gearo sona***
 Juliana 398 onginne ***gæst***lice, ***ic beo gearo sona***

32. *Beowulf* 2796 ecum dryhtne, ***þe ic her on starie***
 Christ II 521 ond æþeleste, ***þe ge her on stariað***
 Christ II 570 ne ilcan þreat ***þe ge her on stariað***

33. *Christ I* 71 Eala wifa ***wynn*** geond ***wuldres þrym***
 Christ I 83 weorðlicu wunade, nu þu ***wuldres þrym***
 Guthlac B 1364 winemæga ***wyn,*** in ***wuldres þrym***
 Christ II 740 ***wynnum*** geworden. Gesawan ***wuldres þrym***
 Juliana 641 Gemunað wigena ***wyn*** ond ***wuldres þrym***

34. *Christ I* 263 ***þæt*** þu hrædlice ***helpe gefremme***
 Juliana 696 ***þæt*** seo halge me ***helpe gefremme***
 Juliana 722 ***þæt*** me heofona helm ***helpe gefremme***

35. *Christ III* 885 eastan ond westan, ***ofer ealle gesceaft***
 Fates 122 ece ond edgiong, ***ofer ealle gesceaft***. Finit
 Juliana 562 ***ofer ealle gesceaft*** ana weolde

36. *Christ III* 948 ***hlud gehyred*** ***heofon***byman stefn
 Christ II 492 ***hlud gehyred***. ***Heofon***engla þreat
 Christ II 834 ***hlud gehyred*** bi ***heofon***woman

37. *Christ III* 1035 ***geara gongum***, hafað ætgædre bu
 Elene 648 ***geara gongum***. Ge þæt geare cunnon
 Juliana 693 ***geara gongum*** godes lof hafen

38. *Christ III* 1355 mid ***modes myne***. Eall ge þæt me dydon
 Juliana 379 ***þurh modes myne*** minum hyran
 Juliana 657 ***þurh modes myne***. Þonne eow miltse giefeð

39. *Christ III* 1446 ða ic wæs ***ahongen*** ***on heanne beam***
 Phoenix 112 heahmod hefeð ***on heanne beam***
 Elene 424 þurh hete ***hengon*** ***on heanne beam***
 Christ II 678 hreran holmþræce. Sum mæg ***heanne beam***
 Juliana 228 ***ahon*** ond ahebban ***on heanne beam***
 Juliana 309 ***ahon*** haligne ***on heanne beam***

40. *Christ III* 1594 ***lacende leg*** laðwende men
 Daniel 475 ***lacende lig***, þam þe his lof bæron
 Elene 580 ***lacende lig***, þæt eow sceal þæt leas
 Elene 1110 ***lacende lig***. Leode gesawon

41. *Christ III* 1640 ac þær symle forð ***synna lease***
 Elene 497 ***synna leasne***, Sawles larum
 Elene 777 sunu ***synna leas***, næfre he soðra swa feala
 Juliana 188 ond mid sweopum swingan ***synna lease***
 Juliana 614 ***synna lease***. Ða cwom semninga

42. *Daniel* 199 ***gasta*** hyrde, ðe ***him gife sealde***
 Guthlac A 100 ***gæstum*** gearwað, ***ond him giefe sealde***
 Elene 182 geomre ***gastas***, ***ond him gife sealde***
 Christ II 660 ***godes gæstsunu***, ***ond us giefe sealde***
 Christ II 860 ***godes gæstsunu***, ***ond us giefe sealde***

43. *Daniel* 739 ***rice under roderum*** oðþæt se ræswa com
 Elene 13 ***rice under roderum***. He wæs riht cyning

Elene 147	*rice under roderum*, þurh his rode treo
Elene 631	*rice under roderum*, ge he ða rode ne tæhte

44. *Genesis* 1278 — *æðelinga ord*, þa he Adam sceop
 Elene 393 — *æðelinga ord*. Þeah ge þa æ cuðon
 Christ II 515 — *æþelinga ord*, mid þas engla gedryht
 Christ II 741 — *æþelinga ord*, eðles neosan
 Christ II 845 — *æþelinga ord*, eallum demeð

45. *Genesis* 2313 — Sete *sigores tacn* soð on gehwilcne
 Elene 85 — *sigores tacen*. He wæs sona gearu
 Elene 184 — *sylfum* on gesyhðe, *sigores tacen*
 Elene 1120 — Nu we *seolfe* geseoð *sigores tacen*

46. *Genesis* 2331 — godcunde gife *gastes mihtum*
 Elene 1069 — þæt hire þa gina *gastes mihtum*
 Elene 1099 — *gastes mihtum* to gode cleopode

47. *Guthlac A* 628 — þæt *ge blindnesse bote* fundon
 Elene 299 — fram *blindnesse bote* gefremede
 Elene 389 — ða *ge blindnesse bote* forsegon

48. *Guthlac A* 654 — *breostum inbryrded* to þam betran ham
 Elene 841 — *inbryrded breostsefa*, syððan beacen
 Elene 1045 — *inbryrded breostsefa* on þæt betere lif
 Juliana 535 — *breostum inbryrded*, bendum fæstne

49. *Guthlac A* 777 — let his *ben* cuman *in þa beorhtan gesceaft*
 Fates 116 — *sendan* usse *bene* on *þa beorhtan gesceaft*
 Elene 1088 — þine *bene* on*send in ða beorhtan gesceaft*

50. *Guthlac A* 783 — *fore onsyne eces deman*
 Guthlac B 1188 — *fore onsyne eces deman*
 Elene 745 — *fore onsyne eces deman*
 Christ II 796 — *fore onsyne eces deman*
 Christ II 836 — *fore onsyne eces deman*

51. *Guthlac A* 832 — ealra *leahtra leas*, longe neotan
 Guthlac B 947 — *leahtra leasne* longfyrst ofer þæt
 Guthlac B 1189 — *leahtra lease*. Þær sceal lufu uncer
 Juliana 566 — *leahtra lease*, ond þone lig towearp
 Juliana 583 — *leahtra lease* in þæs leades wylm

52. *Guthlac B* 909 minne mansceaþan on **mennisc hiw**
 Elene 6 in middangeard þurh **mennisc heo**
 Christ II 721 mægeð unmæle, ond þær **mennisc hiw**

53. *Guthlac B* 1063 wine leofestan **wordum negan**
 Elene 287 **weras Ebrea wordum negan**
 Elene 559 **weras Ebresce wordum negan**

54. *Guthlac B* 1103 **ealra þrymma þrym**, ðreata mæstne
 Phoenix 628 **ealra þrymma þrym**, þines wuldres
 Elene 483 **eallra þrymma þrym**, þreo niht siððan
 Christ II 726 **ealra þrymma þrym**. Wæs se þridda hlyp

55. *Guthlac B* 1105 Swa se eadga wer **in þa æþelan tid**
 Elene 786 geywdest þam eorle on **þa æðelan tid**
 Christ II 455 **in þa æþelan tid**, swa hie eft dydon

56. *Guthlac B* 1113 willan **gæst**gerynum **in godes temple**
 Guthlac B 1149 **gæst**haligne **in godes temple**
 Elene 1021 girwan **godes tempel**, swa hire **gasta** weard
 Elene 1057 þurh **gastes** gife to **godes temple**
 Christ II 707 **gæstes** þearfe, ac hi **godes tempel**

57. *Guthlac B* 1115 **þurh gæstes giefe** **god**spel bodian
 Elene 199 **þurh gastes gife georne** cyðan
 Elene 1057 **þurh gastes gife** to **godes** temple
 Elene 1156 **þurh gastes gife georne** secan
 Christ II 649 **þurh gæstes giefe** grundsceat sohte
 Christ II 710 **þurh gæstes giefe godes** þegna blæd
 Juliana 316 **þurh gæstes giefe**, Iuliana

58. *Guthlac B* 1198 **þream forþrycced**, þurh þæs þeodnes word
 Elene 1276 **þream forþrycced**.
 Juliana 520 **þream forþrycte**, ær þu nu þa

59. *Guthlac B* 1264 to þam **soþan gefean** sawel fundað
 Fates 81 sigelean secan, ond þone **soðan gefean**
 Christ II 451 sægdon **soðne gefean**, þætte sunu wære

60. *Guthlac B* 1346 fæges forðsið. Fus**leoð agol**
 Elene 27 For folca gedryht. Fyrd**leoð agol**
 Elene 342 ðam Dauid cyning dryht**leoð agol**
 Juliana 615 hean helle gæst, hearm**leoð agol**

61. *Judith* 60 geðafian, **þrymmes hyrde**, ac he him þæs
 ðinges gestyrde,
 Elene 348 **þrymmes hyrde**. Þanon ic ne wende
 Elene 858 geþrowode, **þrymmes hyrde**
 Juliana 280 **þrymmes hyrde**, hwæt þes þegn sy

62. *MB* 11.30 **heofon and eorðan** **and** eall **holma begong**
 Elene 727 **heofon ond eorðan** **ond holm**þræce
 Juliana 112 **heofon ond eorðan** **ond holma bigong**

63. *Phoenix* 95 fæder fyrngeweorc **frætwum blican**
 Christ II 507 fægre ymb þæt frumbearn **frætwum blican**
 Christ II 522 ond in frofre geseoð **frætwum blican**
 Juliana 564 **frætwum blican** ond þæt fyr tosceaf

64. *Phoenix* 503 **ade onæled**. Weorþeð anra gehwylc
 Juliana 580 **ad onælan**, se wæs æghwonan
 Elene 950 **ade onæled**, ond þær awa scealt

65. *Phoenix* 506 eorðan æhtgestreon, **æpplede gold**
 Elene 1259 **æplede gold**. [Y] gnornode
 Juliana 688 **æpplede gold**. Ungelice wæs

66. *Phoenix* 665 **middangeardes** **ond mægenþrymmes**
 Christ II 557 **middangeardes** **ond mægenþrymmes**
 Juliana 154 **middangeardes** **ond mægenþrymmes**

67. *PPs* 71.20 **þurh his wuldres miht**. Wese swa, wese swa.
 Elene 295 þe eow of wergðe **þurh his wuldres miht**
 Elene 726 ond þu geworhtest **þurh þines wuldres miht**

68. *PPs* 118.120 þæt **ic me ondræde** **domas** ðine
 Juliana 134 Næfre *ic me ondræde* **domas þine**
 Juliana 210 Ne **ondræde ic me** **domas þine**

The distribution of examples above can be summarized in the accompanying table, which takes account of three criteria—namely, the number of times the poem in question is the only one in the group outside the four signed poems to share the formula (my "single-groups"), the number of times the poem is one of two in the group outside the four signed poems to share the formula (my "double-groups"), and, finally, the total number of lines in the poem

that share formulae with the four signed poems alone or with just one other poem.

Poem	No. of "single-groups"	No. of "double-groups"	No. of lines
Andreas	20	10	43
Guthlac B	8	8	20
Guthlac A	3	4	7
Christ III	5	2	7
Phoenix	4	2	6
Genesis	3	—	3
Daniel	1	2	3
Christ I	1	1	3
Beowulf	2	—	2
Paris Psalter	2	—	2
Metres of Boethius	1	1	2
Judith	1	—	1
Exodus	—	1	1
Homiletic Fragment I	—	1	1
Menologium	—	1	1
Met. pref. to the Cura pastoralis	—	1	1

The distribution revealed in the table is striking, to say the least. That in more than twice as many cases as the next most frequent poem (and in more than six times as many cases as the third-placed poem) *Andreas* should uniquely share formulae with the four signed poems is a remarkable statistic, and surely suggests some particularly close link far beyond any notional appeal to a shared inherited tradition: such figures strongly suggest either unity of authorship or conscious literary borrowing in one direction or other. The distribution of other examples seems also to raise the possibility of similarly close connections between the four signed texts and the poems *Guthlac B*, *Guthlac A*, *The Phoenix*, and *Christ III*, the more so since in the case of all four texts (as well as in the case of *Andreas*) extensive lists of further unique parallels with the four signed poems are easily compiled.[30]

The notion, however, that *Andreas* and the four signed poems are the work of a single poet can be swiftly dismissed: R. D. Fulk, developing a line of argument originally put forward by George Philip Krapp, has addressed several features of both meter and diction that clearly distinguish *Andreas* from the four signed poems,

although it is important to note that such studies only further underline the individuality of diction that unites the signed poems themselves.[31] The supposed direction of borrowing between *Andreas* and the four signed poems is less easily settled by the consideration of single formulaic phrases, however, and can best perhaps be settled by the analysis of pairs of passages from individual poems. So, for example, the passage in *Andreas* that describes the bold resolution of the tortured and incarcerated Matthew, who carries on worshipping God from the confines of prison (lines 54–58), shows a striking similarity to the parallel passage in *Juliana* that describes the bold resolution of the saint as she is put into prison by the wicked governor (lines 227–35); both passages follow (that from *Andreas* first), with parallels indicated:

> Eadig ond onmod, he mid elne forð
> wyrðode wordum wuldres aldor, 55
> heofonrices weard, halgan stefne,
> of *carcerne*. Him *wæs Cristes lof*
> on *fyrhðlocan fæste bewunden.*

[Blessed and resolute, he keenly carried on worshipping with words the prince of glory, the guardian of the heavenly kingdom, with a pious voice from the prison. In him was the praise of Christ fast entwined in the enclosure of his heart.]

> He bi feaxe het
> ahon ond ahebban on heanne beam,
> þær seo sunsciene slege þrowade,
> sace singrimme, siex tida dæges, 230
> ond he ædre het eft asettan,
> laðgeniðla, ond gelædan bibead
> to *carcerne* Hyre wæs *Cristes lof*
> in *ferðlocan fæste biwunden,*
> milde modsefan, mægen unbrice. 235

[He had her hung and hauled up by the hair on a high beam, where, sun-bright, she suffered a beating, ever-grim punishment, for six hours of the day, and he, cruel persecutor, had her forthwith taken down, and ordered her brought to a prison. In her was the praise of Christ fast entwined in the enclosure of her heart, and in her mild spirit an unquenchable strength.]

Nor are these the only formulaic phrases in the passage from *Andreas;* a fuller analysis would look as follows:[32]

> ***Eadig ond onmod,*** he ***mid elne*** forð
> ***wyrðode wordum wuldres aldor,*** 55
> ***heofonrices weard, halgan stefne,***
> of ***carcerne.*** Him ***wæs Cristes lof***
> on ***fyrhðlocan fæste bewunden.***

Not only is the intensely formulaic phrasing of *Andreas* apparent in this passage, but the general currency of most of its formulaic phrases helps to set the parallel from *Juliana* into still sharper relief, the more so when one considers a fuller formulaic analysis of the relevant passage from *Juliana:*[33]

> He bi feaxe het
> ***ahon*** ond ***ahebban on heanne beam,***
> þær seo sunsciene slege þrowade,
> sace singrimme, siex tida dæges, 230
> ond he ædre ***het*** eft ***asettan,***
> ***laðgeniðla,*** ond gelædan bibead
> to ***carcerne.*** Hyre wæs ***Cristes lof***
> in ***ferðlocan fæste biwunden,***
> milde modsefan, mægen unbrice. 235

Not only is this passage in *Juliana* measurably less formulaic than its counterpart in *Andreas,* but the poems with which it shares formulae have a familiar ring (*Elene, Christ II, Christ III, Juliana, Phoenix,* and *Andreas*). In short, the very pattern of parallels in these two passages would suggest that the *Andreas*-poet is far the more likely borrower, a conclusion strengthened when it is realized that yet another striking parallel to *Juliana* occurs in the immediately preceding few lines to the relevant passage from *Andreas:* we are told that Matthew "praised in his heart the ruler of the heavenly kingdom" (*herede in heortan heofonrices weard* [*Andreas* 52]) in a line that clearly matches one from *Juliana,* whose heroine "praised in her heart the god of the heavenly kingdom" (*herede æt heortan heofonrices god* [*Juliana* 239]). Kenneth R. Brooks has also indicated that the *Andreas*-poet's use of the word *bewunden* here is at variance with its use elsewhere in the poem,[34] apparently the result of influence from the parallel passage in *Juliana.* Certainly, there are many other phrases and scenes in common between the

two poems, and both Krapp and Schaar independently conclude that in each case it is the *Andreas*-poet who is the borrower.[35]

Likewise, the passage in *Andreas* in which the saint answers the question from the (as yet unrecognized Christ) as to why he has no possessions with him by quoting Christ's injunction to his disciples to travel light (lines 332–39) clearly matches the parallel passage in *Christ II*, when Christ instructs his disciples to preach the Gospels throughout the world (lines 481–90); again, both passages follow (that from *Andreas* first, with similarities highlighted):

> "*Farað nu geond ealle* eorðan sceatas
> emne swa *wide* swa wæter bebugeð,
> oððe stedewangas stræte gelicgaþ.
> *Bodiað* æfter burgum *beorhtne geleafan* 335
> ofer foldan fæðm. *Ic eow freoðo healde.*
> Ne ðurfan ge on þa fore frætwe lædan,
> gold ne seolfor. *Ic eow* goda gehwæs
> on eowerne agenne dom est ahwette."

["Go now throughout all the corners of the earth, even as widely as the water encircles, or the plains describe a path. Preach throughout the towns the glittering faith, across the bosom of the earth; I shall keep you safe. You need not bring trappings on that traveling, gold or silver; I shall afford you the favor of every good thing, according to your own estimation."]

> "*Farað nu geond ealne* yrmenne grund,
> *geond wid*wegas, weoredum cyðað,
> *bodiað* ond bremað *beorhtne geleafan,*
> ond fulwiað folc under roderum.
> Hweorfað to hæþnum, hergas breotaþ, 485
> fyllað ond feogað, feondscype dwæscað,
> sibbe sawað on sefan manna
> þurh meahta sped. *Ic eow* mid wunige,
> forð on frofre, ond *eow friðe healde*
> strengðu staþolfæstre on stowa gehware." 490

["Go now throughout all the expansive earth, throughout the wide paths, and make known to the masses, preach and proclaim the glittering faith, and baptize the people under the

skies. Turn to the heathens, shatter the idols, cast them down and treat them with contempt, wipe out enmity, sow peace in men's hearts, through the abundance of your powers. I shall remain with you henceforth as a comfort, and shall keep you in peace with a steadfast strength in every place."]

In this case, the direction of borrowing seems even more certain: in *Andreas*, the reference to preaching is incidental, an addition to an explanation as to why Andreas is traveling without money or supplies; no such reference is to be found in any of the putative sources, whether in Latin or Greek.[36] The two imperatives (*Farað . . . bodiað*) are wholly isolated within this part of *Andreas*, part of a speech within a speech. In *Christ II*, by contrast, the imperatives form just part of an extraordinary series of no fewer than eleven such commands (*Farað . . . cyðað, bodiað ond bremað . . . ond fulwiað . . . Hweorfað . . . breotaþ, fyllað ond feogað . . . dwæscað . . . sawað*), the very style of which, with its paired and alliterating finite verbs, might be said to exemplify preaching style.[37] Once again, Schaar gives an extensive (and often tendentious) analysis of parallel passages between *Christ II* and *Andreas*, again concluding that the *Andreas*-poet is the borrower.[38]

The notion that in both of the above cases it is the *Andreas*-poet who is the borrower is made still more attractive by recent attempts to revive the notion that the *Andreas*-poet knew and consciously borrowed from *Beowulf*.[39] Indeed, the second of the passages quoted lends support to the notion, given that Christ's injunction to travel widely "as the water encircles" (*swa wæter bebugeð* [*Andreas* 333]) is uniquely matched in the extant corpus by two lines from *Beowulf* (*swa wæter bebugeð* [*Beowulf* 93]; *swa sæ bebugeð* [*Beowulf* 1223]). This is but one of dozens of formulae uniquely shared by *Andreas* and *Beowulf*.[40] Moreover, in his celebrated opening passage, the *Andreas*-poet seems to be combining borrowings from the openings of both *Beowulf* and *The Fates of the Apostles*, as the following series of highlighted correspondences might suggest, given here in the order in which the poems seem to have been composed, with parallels highlighted:

(a) *Beowulf* 1–3
Hwæt! We Gardena **in** gear**dagum,**
þeodcyninga, **þrym gefrunon,**
hu ða æþelingas ellen fremedon.

[Listen! We have heard of the power of the mighty kings of
the spear-Danes in days long gone, how those noblemen did
deeds of courage.]

(b) *Fates* 1–15
 Hwæt! Ic þysne sang siðgeomor fand
 on seocum sefan, samnode wide
 hu þa æðelingas ellen cyðdon,
 torhte ond **tireadige.** **Twelfe** wæron,
 dædum domfæste, **dryhtne** gecorene, 5
 leofe on life. Lof wide sprang,
 miht ond mærðo, ofer middangeard,
 þeodnes þegna, þrym unlytel.
 Halgan heape **hlyt** wisode
 þær hie **dryhtnes** æ deman sceoldon, 10
 reccan fore rincum. Sume on Romebyrig,
 frame, fyrdhwate, feorh ofgefon
 þurg Nerones nearwe searwe,
 Petrus ond Paulus. Is se apostolhad
 wide geweorðod ofer werþeoda! 15

[Listen! Sad at departing, I, sick at heart, put together this
poem, collected far and wide how those noblemen, famed
and honor-blessed, revealed deeds of courage. Twelve there
were, glory-fast in deeds, chosen by the Lord, beloved in
life. The praise spread wide, the might and esteem, across
the world, of the prince's thegns, no little power. Their lot
directed the holy band, to where they had to glorify the
Lord's law, tell it before men. Some in Rome, bold, battle-
brave, gave up their lives through Nero's narrow plotting:
Peter and Paul. That apostolic state is widely honored among
men.]

(c) *Andreas* 1–11a
 Hwæt! We gefrunan on fyrn**dagum**
 twelfe under tunglum **tireadige** hæleð,
 þeodnes þegnas. No hira **þrym** alæg
 campræddenne þonne cumbol hneotan,
 syððan hie gedældon, swa him **dryhten** sylf, 5
 heofona heahcyning, **hlyt** getæhte.
 Þæt wæron mære men ofer eorðan,
 frome folctogan ond **fyrdhwate,**

rofe rincas, þonne rond ond hand
on herefelda helm ealgodon, 10
on meotudwange.

[Listen! We have heard of twelve honor-blessed heroes under
the stars in days gone by, prince's thegns. Their power did
not fail in fighting, when banners clashed, after they de-
parted as the Lord himself, the high king of the heavens,
directed their lot. They were men famed across the earth,
bold war-leaders and battle-brave, daring warriors, when
shield and hand defended the helmet on the battlefield, on
the plain of fate.]

There are a number of factors that point to this sequence of bor-
rowing, which seems to imply that the author of *The Fates of the
Apostles* knew and consciously echoed *Beowulf*, while the *Andreas*-
poet knew and consciously echoed both *Beowulf* and *The Fates of
the Apostles*. Apart from the general similarity of the openings of
the latter two poems, it has long been noted that line 3 of *Beowulf*
(hu ða æþelingas ellen fremedon) is uniquely close within the ex-
tant corpus to line 3 of *The Fates of the Apostles (hu þa æðelingas
ellen cyðdon)*. The likely direction of borrowing in this case seems
secure: the language of secular heroic society *(æþelingas* and, espe-
cially, *ellen)* that is the staple of *Beowulf* has been appropriated
and set in a new Christian context in *The Fates of the Apostles*.
One notes in passing that even this brief passage from *The Fates
of the Apostles* exhibits two of the three stylistic characteristics
noted above as being shared by the four signed poems, namely
paronomasia *(leofe ... life ... Lof,* line 6; *geweorðod ... werþeoda,*
line 15) and homoeoteleuton *(torhte ... tireadige ... Twelfe ...
domfæste, dryhtne gecorene, leofe ... life,* lines 4–6; *nearwe searwe,*
line 13). The rhetorical sophistication implied by the use of such
devices is also evident in other aspects of this passage. *Beowulf*
begins with two abstract nouns *(þrym ... ellen),* both in the accu-
sative, while *The Fates of the Apostles* opens with an impressive
litany of no fewer than eight abstract nouns *(ellen ... Lof ... miht
and mærðo ... þrym ... hlyt ... æ ... apostolhad),* including both of
those found in the opening lines of *Beowulf,* but all but two of
which *(ellen ... æ)* are in the nominative. The opening of *Andreas*
again includes two abstract nouns *(þrym ... hlyt),* both found in
the opening lines of *The Fates of the Apostles,* but only one of which
is found in the corresponding lines of *Beowulf,* of which one is in

the nominative, the other accusative. As with the comparison above between two parallel passages in *Andreas* (lines 332–39) and *Christ II* (lines 481–90), it is notable that the *Andreas*-poet again seems to have simplified an extended sequence in borrowing from one of the four signed poems; Schaar has focused on the ways in which the *Andreas*-poet appears likewise to have produced "weakened and diluted" borrowings from *Elene* and *Juliana* also.[41]

Indeed, the very fact that the *Andreas*-poet should borrow so extensively and in such a similar way from not only *Christ II* and *The Fates of the Apostles* but also from *Elene* and *Juliana* surely helps to bring into still sharper relief the possibility of the common authorship of the four signed poems, notwithstanding the other evidence of shared stylistic tics and (overwhelmingly) shared formulaic diction shown above. The simplest solution would be to assume that the four signed poems are indeed what they appear to be: the finished products of a single poet, whose works were known to and borrowed from by the poet of *Andreas* in precisely the same spirit of homage and imitation that the *Andreas*-poet also employed with regard to *Beowulf*. If the precise historical context that produced the author of the four signed poems remains obscure,[42] we do at least know his name, albeit in variant forms: let us call him Cynewulf.

Such a banal conclusion conceals the exciting possibilities promised by the preceding analysis, and implicit in the summary table of shared formulae above. If the close connection suggested between Cynewulf's signed poems and *Andreas* is the most striking result of the analysis of shared formulae, similar links between the signed poems of Cynewulf and *The Phoenix*, *Christ III*, and *Guthlac A* and *B* in particular are also indicated, and highlight the possibilities for future research. The case of *Guthlac B* is perhaps the most intriguing, since successive studies have consistently noted many parallels between the language and diction of *Guthlac B* and that of the four signed poems, and shared formulae strongly support such a connection.[43] The ending of *Guthlac B* is of course missing in the Exeter Book, and any runic signature there might have been attributing the poem to Cynewulf (or anyone else) is long gone, but on the basis of the existing evidence the notion that Cynewulf wrote *Guthlac B* is an attractive one. As Fulk notes: "[T]he similarity of the vocabulary of *Guthlac B* to that of the signed works is far more remarkable than that of the few possibly significant dissimi-

larities."[44] Similarly suggestive in this regard may be the relationship between *Guthlac B* and *Guthlac A;* the most recent editor of both poems, Jane Roberts, is commendably cautious, but (pointing out the significant differences between the two texts) concludes, "Those parts of the first two sections of *Guthlac B* dealing with events of the saint's life show similarities in content and phrasing with *Guthlac A*, and the possibility that the [*Guthlac B*-] poet had heard or read *Guthlac A* cannot be ruled out."[45] Indeed, the list of formulae shared between *Guthlac A* and *Guthlac B* is long.[46] The idea that *Guthlac B* was consciously composed as a companion-piece to *Guthlac A* is, moreover, particularly interesting in the light of the (revived) suggestion that Cynewulf composed *Christ II* specifically to connect the preexisting *Christ I* with *Christ III*.[47] It is clear from the Junius manuscript both that Anglo-Saxon poets composing in the vernacular were well capable of incorporating preexisting poems into their own work,[48] and that poems on related themes could be consciously juxtaposed in a given manuscript;[49] indeed, the respective roles of poet, scribe, and manuscript-compiler here as elsewhere seem (from a modern perspective) somewhat hard to distinguish.[50] Roy M. Liuzza has considered the sequence of five poems (*Christ I, II,* and *III; Guthlac A* and *B*) that opens the Exeter Book and makes the same point, arguing that lines 1–29 of *Guthlac A* seem as well suited to the end of the sequence of *Christ*-poems as to the beginning of the *Guthlac*-sequence.[51] Patrick W. Conner has gone further, suggesting that these five poems comprise a distinct codicological unit within the Exeter Book, making up what he terms "Booklet I."[52]

Other connections seem to extend beyond "Booklet I." The loss of at least a gathering before its end (including any runic signature it may have contained) means that it is impossible to be certain that *Guthlac B* was always followed in the Exeter Book by *Azarias*, as now, but it has been pointed out that the theme of deliverance from flames in that poem fits perfectly the theme of the next two poems, namely *The Phoenix* and the signed poem *Juliana*.[53] Likewise, the similarity of formulaic diction between *The Phoenix* and the signed poems of Cynewulf has long been a matter of note,[54] although (as with *Andreas*) there are a number of lexical and metrical features that appear to rule out the possibility of common authorship.[55] Even though *Christ II* and *Juliana* are the only poems in the Exeter Book signed (or, at least, still signed) by Cynewulf, the notion that a chain of "Cynewulfian" connections links its first eight poems may well be worth further study.

Now, it might well seem that the related (and still tentative) suggestions that Cynewulf was the author of *Guthlac B* (but not *Andreas*) and that in the opening of *The Fates of the Apostles* Cynewulf (like the *Andreas*-poet) consciously borrowed from *Beowulf* run counterintuitively to the results of the table of shared formulae, in which more parallels were found unique to *Andreas* and the four signed poems than to the signed poems and *Guthlac B*, and in which *Beowulf* appeared only ninth in the list of sixteen poems in which such parallels to the four signed poems were detected at all.[56] In the latter case in particular, further research would seem useful, building on the work of a number of earlier commentators who noted the existence elsewhere of other formulae uniquely shared between *Beowulf* and the four signed poems.[57] But Anglo-Latin poetry provides useful analogues for each of the scenarios outlined above, and may indeed prove the best model overall for the methods of composition employed by at least some vernacular poets. Precisely the kind of analysis of repeated formulae proposed here has produced interesting results when applied to Anglo-Latin poetry, as well as parallel apparent anomalies.[58] So, for example, it is clear that Aldhelm knew and consciously echoed the verse *Vita S. Martini* by Venantius Fortunatus, although there is only one unique borrowing that is found in more than one of Aldhelm's extant poems; fuller analysis reveals no fewer than twenty-three unique borrowings in Aldhelm's poems taken together.[59] Likewise, a number of poems by later poets clearly borrowing from Aldhelm contain a denser selection of "Aldhelmian" formulae than some of Aldhelm's own:[60] Boniface's *Enigma V* ("Caritas"), for example, contains Aldhelmian echoes in fifteen out of its seventeen lines (= 88.24 percent), while "only" eighteen of the first twenty-five lives of Aldhelm's *Carmen de uirginitate* (= 72 percent) are similarly Aldhelmian.[61] Such analogues strongly suggest that the "Aldhelmian" model might be the most appropriate in considering Cynewulf, specifically a model of a literate and Latinate Anglo-Saxon who chose to compose in the traditional formulaic diction of the ultimately oral past, who adopted and adapted traditional formulae and combined them with deliberate echoes from poems he had read and heard read, and who in turn became a source of formulae for later poets familiar with his work, and composing in the same style. In Cynewulf's case, as with Aldhelm (as I hope the above analysis has helped to show), the style is the substance, and the formulaic diction is the framework on which the individual poet's own poetic art depends. Computer technology, on-line data-

bases, and machine-readable texts all offer the opportunity to appreciate more fully the precise role that such formulae played: notwithstanding the acceptance or otherwise of recent attempts to shift Cynewulf's dating from the ninth century into the tenth,[62] it is surely time to usher the study of Cynewulf's style (and that of Old English poetry in general) out of the nineteenth century and into the twenty-first.

Notes

1. For a useful collection of essays discussing many of the key issues relating to Cynewulf's poetry, see Robert E. Bjork, ed., *Cynewulf: Basic Readings* (New York, 1996). There have also been a number of monographs on Cynewulf in recent years: see in particular Earl R. Anderson, *Cynewulf: Structure, Style, and Theme in His Poetry* (Rutherford, 1983); Daniel G. Calder, *Cynewulf* (Boston, 1981); Alexandra Hennessey Olsen, *Speech, Song, and Poetic Craft: The Artistry of the Cynewulf Canon* (New York, 1984). Anderson, Calder, and Olsen are each responding in different ways to perhaps the two most controversial works on Cynewulf published in modern times, namely, Satyendra Kumar Das, *Cynewulf and the Cynewulf Canon* (Calcutta, 1942), and Claes Schaar, *Critical Studies in the Cynewulf Group* (Lund, 1949). Among the numerous strong reactions to both works, one critique on the work of Das deserves special mention: Sharon E. Butler, "The Cynewulf Question Revived," *NM* 83 (1982): 15–23.

2. See, for example, Andy Orchard, "Crying Wolf: Oral Style and the *Sermones Lupi*," *ASE* 21 (1992): 239–64; idem, *The Poetic Art of Aldhelm*, CSASE 8 (Cambridge, 1994), 73–126.

3. Compare the approaches taken within a few years of each other of the following two groundbreaking articles on each author: Angus McIntosh, "Wulfstan's Prose," *PBA* 35 (1949): 109–42, reprinted in E. G. Stanley, ed., *British Academy Papers on Anglo-Saxon England* (Oxford, 1990), 111–44; Kenneth Sisam, "Cynewulf and His Poetry," in his *Studies in the History of Old English Literature* (Oxford, 1953), 1–28. It is likewise instructive to note the similarity in general approach of Schaar, *Critical Studies*, and Karl Jost, *Wulfstanstudien*, Schweizer anglistische Arbeiten 23 (Bern, 1950), published the following year.

4. For an overview of some of the problems associated with the analysis of style in Old English poetry, see Daniel G. Calder, "The Study of Style in Old English Poetry: A Historical Introduction," in *Old English Poetry: Essays on Style*, ed. Daniel G. Calder (Berkeley, 1979), 1–65.

5. On the poetic artistry of the runic signatures, see, for example, Dolores W. Frese, "The Art of Cynewulf's Runic Signatures," in *Anglo-Saxon*

Poetry: Essays in Appreciation, ed. Lewis D. Nicholson and Dolores W. Frese (Notre Dame, 1975), 312–34, reprinted in Bjork, *Cynewulf*, 323–45.

6. In addition to the editions found in The Anglo-Saxon Poetic Records, ed. G. P. Krapp and E. V. K. Dobbie, 6 vols. (New York, 1931–42), I have also consulted a number of editions of individual texts, particularly N. F. Blake, ed., *The Phoenix* (Manchester, 1964); Kenneth R. Brooks, ed., *"Andreas" and "The Fates of the Apostles"* (Oxford, 1961); Albert S. Cook, *The Christ of Cynewulf: A Poem in Three Parts* (Boston, 1909); P.O.E. Gradon, ed., *Cynewulf's "Elene,"* rev. ed. (Exeter, 1977); George Philip Krapp, ed., *"Andreas" and "The Fates of the Apostles": Two Anglo-Saxon Narrative Poems* (Boston, 1905); Bernard J. Muir, ed., *The Exeter Anthology of Old English Poetry: An Edition of Exeter Dean and Chapter MS 3501*, 2 vols. (Exeter, 1994); Jane Roberts, ed., *The Guthlac Poems of the Exeter Book* (Oxford, 1979); Rosemary Woolf, ed., *Cynewulf's "Juliana,"* rev. ed. (Exeter, 1977).

7. An excellent overview is offered by R. D. Fulk, "Cynewulf: Canon, Dialect, and Date," in Bjork, *Cynewulf*, 3–21.

8. See, for example, Joseph D. Wine, *Figurative Language in Cynewulf: Defining Aspects of a Poetic Style* (New York, 1993), 29–53 ("Schemes of Verbal Repetition") and 55–73 ("Schemes of Aural Repetition"). The issue of whether such rhetorical devices were native in origin or derived from Latin is complex; see Gabriele Knappe, "Classical Rhetoric in Anglo-Saxon England," *ASE* 27 (1998): 5–29; idem, *Traditionen der klassischen Rhetorik im angelsächsischen England*, Anglistische Forschungen 236 (Heidelberg, 1996).

9. *Christ II* 727; *Elene* 147, 206, 482, 624, 631, 855, 886, 918, 1022, 1066, 1074, 1234; *Juliana* 305, 447. Outside these poems, this instance of paronomasia is rare; it is found, however, in *Riddle 55*, line 5. See further Roberta Frank, "Some Uses of Paronomasia in Old English Scriptural Verse," *Speculum* 47 (1972): 207–26, esp. 210; Wine, *Figurative Language*, 71–73.

10. So, for example, *Juliana* 289 *(cyninga cyning)* or *Elene* 371; *Christ II*, 405; *Juliana* 594 *(dryhtna dryhten* or similar). Such phrases are, of course, found elsewhere, in *Christ and Satan* 203; *Andreas* 978, 1192; *Christ I* 136, 215; *Guthlac A* 17; *Judgment Day I* 95; *Summons to Prayer* 19; *Kentish Hymn* 15 *(cyninga cyning* or similar), and in *Genesis* 638, 2255; *Paris Psalter 135.3*, line 2 *(dryhtna dryhten* or similar).

11. So, for example, *Christ II* 580 *(dreama dream)*; *Elene* 483; *Christ II* 726 *(þrymma þrym)*; *Elene* 768 *(fula ful)*. Such phrases are, of course, found elsewhere, in *Christ and Satan* 313; *Phoenix* 658 *(dreama dream)*; *Guthlac B* 1103; *Phoenix* 628 *(þrymma þrym)*.

12. For a recent (not uncontroversial) view of the rhymes in the four signed poems, see Patrick W. Conner, "On Dating Cynewulf," in Bjork, *Cynewulf,* 23–55, esp. 24–35. For a wider survey, see E. G. Stanley, "Rhymes in English Medieval Verse: From Old English to Middle English," in *Medieval English Studies Presented to George Kane,* ed. Edward Donald Kennedy (Woodbridge, 1988), 19–38.

13. See, for example, Wine, *Figurative Language,* 56–68.

14. So, for example, we find polyptoton (not surprisingly, given the context) on words with the root *luf-* (love) in lines 27, 31, 41, and 48; paronomasia (*lufast . . . gelyfest . . . lof*) in line 48; and rhyme (*lufast . . . gelyfest . . . rærest ongietest*) in lines 48–49; see further Wine, *Figurative Language,* 48 and 61.

15. Daniel Donoghue, *Style in Old English Poetry: The Test of the Auxiliary* (New Haven, 1987), 107–16.

16. R. D. Fulk, *A History of Old English Meter* (Philadelphia, 1992), esp. 351–52.

17. The secondary literature is vast. See, for example, Marguerite-Marie Dubois, *Les Éléments latins dans la poésie religieuse de Cynewulf* (Paris, 1943); Thomas D. Hill, "Sapiential Structure and Figural Narrative in the Old English *Elene,*" *Traditio* 27 (1971): 159–77, reprinted in Bjork, *Cynewulf,* pp. 207–28; Daniel G. Calder, "The *Fates of the Apostles,* the Latin Martyrologies, and the Litany of the Saints," *Medium Ævum* 44 (1975): 219–24; John P. Hermann, "The Theme of Spiritual Warfare in the Old English *Elene,*" *Papers on Language and Literature* 11 (1975): 115–25; E. Gordon Whatley, "Old English Onomastics and Narrative Art: *Elene* 1062," *MP* 73 (1975): 109–20; Joseph Wittig, "Figural Narrative in Cynewulf's *Juliana,*" *ASE* 4 (1975): 37–55, reprinted in Bjork, *Cynewulf,* 147–69; R. C. Rice, "The Penitential Motif in Cynewulf's *Fates of the Apostles* and in His Epilogues," *ASE* 6 (1977): 105–19; James E. Cross, "Cynewulf's Traditions about the Apostles in *Fates of the Apostles,*" *ASE* 8 (1979): 13–75, reprinted in Bjork, *Cynewulf* 79–94; Thomas D. Hill, "Bethania, the House of Obedience: The Old English *Christ II,* 456–67," *N&Q* 27 (1980): 290–92; D. R. Letson, "The Homiletic Nature of Cynewulf's Ascension Poem," *Florilegium* 2 (1980): 192–216; Martin Irvine, "Cynewulf's Use of Psychomachia Allegory: The Latin Sources of Some 'Interpolated' Passages," *Harvard English Studies* 9 (1981): 39–62; Frederick M. Biggs, "*Englum gelice: Elene* Line 1320 and *Genesis A* Line 185," *NM* 86 (1985): 447–52; Charles D. Wright, "The Pledge of the Soul: A Judgment Theme in Old English Homiletic Literature and Cynewulf's *Elene,*" *NM* 91 (1990): 23–30; Andrew Breeze, "*Æpplede gold* in *Juliana, Elene,* and the *Phoenix,*" *N&Q* 44 (1997): 452–53.

18. On the Anglo-Saxon curriculum and the study of Latin texts, see in particular Michael Lapidge, "Latin Learning in Ninth-Century England," and "The Study of Latin Texts in Late Anglo-Saxon England," in his *Anglo-Latin Literature, 600–899* (London, 1996), 409–54, 455–98; Michael Lapidge, "Schools, Learning, and Literature in Tenth-Century England," in his *Anglo-Latin Literature, 900–1066* (London, 1993), 1–48. For knowledge of the poems of both Caelius Sedulius and Arator in Anglo-Saxon England from an early period, see Orchard, *Poetic Art of Aldhelm*, 163–70.

19. See, for example, Peter Clemoes, *Interactions of Thought and Language in Old English Poetry*, CSASE 12 (Cambridge, 1995), 431–35. I have in hand a monograph entitled *The Poetic Craft of Cynewulf*, part of which will address such questions concerning the stylistic influence of Latin poetry on Old English verse.

20. For lengthy lists of such parallels, see, for example, Gregor Sarrazin, *Beowulf-Studien* (Berlin, 1888), 110–17, 121–28, 141–43, 152–53, 155–89; Schaar, *Critical Studies*, 235–309; Krapp, *Andreas*, lvi–lvii; Cook, *Christ*, lx–lxv; F. Klaeber, ed., *"Beowulf" and "The Fight at Finnsburg,"* 3d ed. (Lexington, 1950), cx–cxiii.

21. The groundbreaking study is that of Francis Peabody Magoun Jr., "The Oral-Formulaic Character of Anglo-Saxon Narrative Poetry," *Speculum* 28 (1953): 446–67; see Alexandra Hennessey Olsen, "Oral-Formulaic Research in Old English Studies: I," *Oral Tradition* 1 (1986): 548–606; Alexandra Hennessey Olsen, "Oral-Formulaic Research in Old English Studies: II," *Oral Tradition* 3 (1988): 138–90; Andy Orchard, "Oral Tradition," in *Reading Old English Texts*, ed. Katherine O'Brien O'Keeffe (Cambridge, 1997), 101–23. For an alternative view of particular relevance to the discussion below, see Claes Schaar, "On a New Theory of Old English Poetic Diction," *Neophilologus* 40 (1956): 301–5.

22. Fulk, "Cynewulf," 5.

23. For a discussion of the problems, see Orchard, "Oral Tradition," 103–9.

24. It should be stressed that, in the interests both of simplicity and of ease of comparison with similar formulaic analyses in Latin verse in particular, the definition of what constitutes a formula here is based on the identity of at least two lexically significant elements within a half-line, if not on the identity of an entire half-line or more; the number of formulas identified would rise sharply if the notion of the "formulaic system" (which is certainly a feature of the Old English poetic) had been applied, as outlined by Anita Riedinger, "The Old English Formula in Context," *Speculum* 60 (1985): 294–317.

25. Robert E. Diamond, "The Diction of the Signed Poems of Cynewulf," *PQ* 38 (1959): 228–41, reprinted in Bjork, *Cynewulf*, 309–22.

26. The essential tool remains J. B. Bessinger Jr. and Philip H. Smith, eds., *A Concordance to the Anglo-Saxon Poetic Records* (Ithaca, 1978), but I have also made extensive use of the on-line access to the DOE Project in Toronto (at *http://www.doe.utoronto.ca/*), as well as of my own electronic version of the corpus.

27. A fuller list of such groups of formulae unique to the individual signed poems might run as follows: *Christ II* 484, 526; *Christ II* 487, 663; *Christ II* 493, 554; *Christ II* 660, 860; *Christ II* 745, 747; *Elene* 5, 178; *Elene* 23, 125; *Elene* 32, 52; *Elene* 34, 45; *Elene* 110, 406; *Elene* 121, 232; *Elene* 143, 148; *Elene* 174, 990; *Elene* 199, 1156; *Elene* 211, 951; *Elene* 247, 848; *Elene* 260, 997; *Elene* 262, 551; *Elene* 287, 559; *Elene* 303, 311; *Elene* 304, 543; *Elene* 332, 404; *Elene* 333, 1168; *Elene* 343, 431, 438; *Elene* 363, 778; *Elene* 372, 406; *Elene* 418, 586; *Elene* 453, 933; *Elene* 461, 564; *Elene* 490, 1033; *Elene* 532 , 1164; *Elene* 570, 849, 1163; *Elene* 609, 667; *Elene* 612, 698; *Elene* 654, 658; *Elene* 674, 1242; *Elene* 678, 1010; *Elene* 679, 1011; *Elene* 708, 807; *Elene* 841, 1045; *Elene* 865, 1090; *Elene* 1012, 1224; *Elene* 1053, 1107, 1203; *Elene* 1077, 1172; *Elene* 1087, 1100; *Fates* 89, 108; *Juliana* 1, 609; *Juliana* 12, 333; *Juliana* 49, 398; *Juliana* 50, 428; *Juliana* 58, 90, 582; *Juliana* 61, 595; *Juliana* 67, 184; *Juliana* 174, 251; *Juliana* 203, 462; *Juliana* 152, 250, 340, 572; *Juliana* 313, 494; *Juliana* 327, 360; *Juliana* 351, 455; *Juliana* 390, 681; *Juliana* 457, 615; *Juliana* 566, 583.

28. For attempts to explain the structure of the four signed poems through formulaic repetition, see James L. Boren, "Form and Meaning in Cynewulf's *Fates of the Apostles*," *Papers on Language and Literature* 5 (1969): 115–22, reprinted in Bjork, *Cynewulf*, 57–65; James Milhaupt, "The Structure of Cynewulf's *Christ II*," *Studies in Medieval Culture* 4, no. 1 (1973): 70–77; Earl R. Anderson, "Cynewulf's *Elene*: Manuscript Divisions and Structural Symmetry," *MP* 72 (1974): 111–22; Constance B. Hieatt, "*The Fates of the Apostles*: Imagery, Structure, and Meaning," *Papers on Language and Literature* 10 (1974): 115–25, reprinted in Bjork, *Cynewulf*, 67–77; V. Fish, "Theme and Pattern in Cynewulf's *Elene*," *NM* 76 (1975): 1–25. For the wider application of the technique, see Andy Orchard, "Re-Reading *The Wanderer*: The Value of Cross References," in *Via Crucis: The Way of the Cross: Essays on Sources and Ideas in Memory of J. E. Cross*, ed. Thomas N. Hall, Thomas D. Hill, and Charles D. Wright (Morgantown, 2002), 1–26.

29. A fuller list of such groups of formulae shared by at least two of the four signed poems might read as follows: *Christ II* 481, *Juliana* 10; *Christ II* 569, *Juliana* 545; *Christ II* 588, *Juliana* 565; *Christ II* 671, *Juliana* 498; *Christ II* 737, 866, *Elene* 188; *Christ II* 768, *Juliana* 471; *Christ II* 780, *Juliana* 727; *Christ II* 803, *Juliana* 707; *Christ II* 815, *Juliana* 647; *Elene* 10, 482, *Christ II* 692, *Juliana* 305; *Elene* 96, *Juliana* 420; *Elene* 147, 206, 855, *Juliana* 447; *Elene* 197, 445, 718, *Juliana* 212; *Elene* 218, 625, 842, 975, *Christ II* 658; *Elene* 221, *Christ II* 459; *Elene* 224,

412, *Juliana* 11; *Elene* 249, *Christ II* 857, *Juliana* 677; *Elene* 279, 1147, *Christ II* 440; *Elene* 281, 1041, *Christ II* 671, *Juliana* 297; *Elene* 333, 1168, *Juliana* 656; *Elene* 341, *Juliana* 103; *Elene* 356, *Juliana* 14; *Elene* 392, *Christ II* 618; *Elene* 418, 586, *Christ II* 713; *Elene* 427, 796, *Juliana* 270; *Elene* 447, *Juliana* 255; *Elene* 472, *Christ II* 655; *Elene* 480, *Juliana* 310; *Elene* 482, 1066, *Christ II* 865, *Juliana* 305; *Elene* 554, *Christ II* 662; *Elene* 606, *Christ II* 596; *Elene* 608, *Juliana* 108; *Elene* 663, *Juliana* 99; *Elene* 665, *Juliana* 561; *Elene* 712, *Juliana* 532; *Elene* 768, *Christ II* 726, *Juliana* 289; *Elene* 775, *Christ II* 444; *Elene* 804, *Christ II* 540; *Elene* 810, *Christ II* 599; *Elene* 813, *Christ II* 774, *Juliana* 666; *Elene* 838, 1209, *Juliana* 371; *Elene* 865, 1090, *Juliana* 279; *Elene* 889, *Juliana* 693; *Elene* 897, *Christ II* 610; *Elene* 904, *Juliana* 623; *Elene* 916, *Juliana* 8; *Elene* 920, *Juliana* 323; *Elene* 975, *Christ II* 658; *Elene* 1005, 1053, 1203, *Christ II* 461, 534; *Elene* 1049, *Juliana* 259; *Elene* 1105, *Christ II* 728, *Juliana* 724; *Elene* 1109, *Juliana* 242, 614; *Elene* 1119, *Juliana* 139, 411; *Elene* 1123, *Christ II* 598; *Elene* 1124, *Juliana* 239; *Elene* 1131, *Juliana* 600; *Elene* 1191, *Christ II* 715; *Elene* 1207, *Juliana* 107; *Elene* 1243, *Christ II* 736; *Elene* 1302, *Juliana* 391; *Fates* 7, *Elene* 15; *Fates* 27, *Elene* 72; *Fates* 46, *Juliana* 61; *Fates* 46, *Juliana* 604; *Fates* 53, *Elene* 840; *Fates* 63, *Elene* 364, 670, 852; *Fates* 102, *Elene* 1268; *Juliana* 60, *Elene* 1160; *Juliana* 80, *Elene* 686; *Juliana* 211, *Elene* 1299; *Juliana* 240, *Elene* 711; *Juliana* 346, *Elene* 589; *Juliana* 448, *Elene* 858; *Juliana* 550, *Elene* 1286.

30. For earlier attempts at such lists of parallels, see Schaar, *Critical Studies*, 235–309 and Krapp, *Andreas*, lvi–lvii. I am in the process of verifying the parallels discovered by these and other previous scholars, and augmenting them with lists of my own. I note more than three hundred formulae connecting *Andreas* with the four signed poems, of which around half appear of particular significance; I hope to publish these and other correspondences in *The Poetic Craft of Cynewulf* (forthcoming).

31. Krapp, *Andreas*, xlvi–xlix; Fulk, "Cynewulf," 8. Earlier attempts to distinguish the language and meter of *Andreas* from those of the signed poems include Matthias Cremer, *Metrische und sprachliche Untersuchung der altenglischen Gedichte Andreas, Gûthlâc, Phoenix (Elene, Juliana, Crist): Ein Beitrag zur Cynewulffrage* (Bonn, 1888), 4–41; Frank Jewett Mather, "The Cynewulf Question from a Metrical Point of View," *Modern Language Notes* 7 (1892): 97–107.

32. Evidence (selection only):

[54]	**eadig ond onmod** eardes brucan	*Guthlac A* 745
	eorlscype efnde. Ic **mid elne** sceall	*Beowulf* 2535
[55]	**wuldres aldor**, ond þus **wordum** cwæð	*Andreas* 354
	wuldres aldor. **Word**hleoðor astag	*Andreas* 708
	wordum weorðodon wuldres aldor	*Andreas* 806
	þa he **worde** cwæð, **wuldres aldor**	*Andreas* 913

wille *weorþian wordum* ond dædum	*Guthlac A* 619	
welum *weorþian, wordum* lofian	*Juliana* 76	
ac ic *weorðige wuldres ealdor*	*Juliana* 153	
and þæt *word* acwæð *wuldres aldor*	*Genesis A* 639	
Ða *worde* frægn *wuldres aldor*	*Genesis A* 1002	
þæt ge *gewurðien wuldres aldor*	*Exodus* 270	
Hwæt, me þa *geweorðode wuldres ealdor*	*Dream of the Rood* 90	
þæt he usic *geweorþade wuldres ealdor*	*Seafarer* 123	
þæt *word* þe gecwæð *wuldres ealdor*	*Partridge* 4	
Geweorðie wuldres ealdor	*Paris Psalter* 65.3, ln 1	
þa þe *weorðiað, wuldres aldor*	*Paris Psalter* 85.8, ln 2	
Word þu min onfoh, *wuldres ealdor*	*Psalm Fragment* 5.1, ln 1	
wordes ond weorces, *wuldres ealdor*	*Seasons for Fasting* 190	
[56] *herede in heortan heofonrices weard*	*Andreas* 52	
ond hyhta nihst *heofonrices weard*	*Elene* 197	
ahangen wæs, *heofonrices weard*	*Elene* 445	
ahangen wæs, *heofonrices weard*	*Elene* 718	
Hæbbe ic me to hyhte *heofonrices weard*	*Juliana* 212	
herede æt heortan, heofonrices god	*Juliana* 239	
þa hleoðrade *halgan stefne*	*Andreas* 537	
heredon on hehðo *halgan stefne*	*Andreas* 873	
heard of hæfte, *halgan stefne*	*Andreas* 1399	
ofer hereciste *halgan stefne*	*Exodus* 257	
[57] þa wæs *Cristes lof* þam casere	*Elene* 212	
of carcerne, swa him seo cwen bebead	*Elene* 715	
þæt þu mec acyrre from *Cristes lofe*	*Juliana* 139	
to *carcerne*. Hyre wæs *Cristes lof*	*Juliana* 233	
on ferðlocan fæste getimbre	*Andreas* 1671	
in ferðlocan fæste biwunden	*Juliana* 234	

33. Evidence:

[228] þurh hete *hengon on heanne beam*	*Elene* 424	
hreran holmþræce. Sum mæg *heanne beam*	*Christ II* 678	
Ða ic wæs *ahongen on heanne beam*	*Christ III* 1446	
ahon haligne *on heanne beam*	*Juliana* 309	
Ðær he *heanne beam* on holtwuda	*Phoenix* 171	
ofer *heanne beam* hus getimbreð	*Phoenix* 202	
[231] sigebearn godes ær he *asettan heht*	*Elene* 862	
Heht þa *asettan* sawlleasne	*Elene* 876	
[232] Nis þær on þam londe *ladgenidla*	*Phoenix* 50	
[233] of *carcerne*. Him *wæs Cristes lof*	*Andreas* 57	
on fyrhðlocan fæste bewunden	*Andreas* 58	

34. Brooks, *Andreas*, 65.

35. Krapp, *Andreas*, lvi–lvii; Schaar, *Critical Studies*, 267–72.

36. On the sources of the poem, see Brooks, *Andreas*, xv–xviii.

37. On the use of such alliterating pairs of finite verbs in preaching, see, for example, Clemoes, *Interactions*, 43–45.

38. Schaar, *Critical Studies*, 272–74.

39. See Anita R. Riedinger, "The Formulaic Relationship between *Beowulf* and *Andreas*," in *Heroic Poetry in the Anglo-Saxon Period: Studies in Honor of Jess B. Bessinger*, ed. Helen Damico and John Leyerle (Kalamazoo, 1993), 283–312.

40. See, for example, Krapp, *Andreas*, lvi; Klaeber, *Beowulf*, cxi; Schaar, *Critical Studies*, 275–87. I have detected nearly two hundred formulae shared by *Beowulf* and *Andreas*; see my *A Critical Companion to "Beowulf"* (Cambridge, 2003), 163–68, 274–326, which detail not only formulaic repetition within *Beowulf* but also formulae shared with other poems. See further Alison M. Powell, "Verbal Parallels in *Andreas* and its Relationship to *Beowulf* and Cynewulf" (Ph.D. dissertation, University of Cambridge, 2002).

41. Schaar, *Critical Studies*, 261–72 (quotation at 269). Compare the lists produced by Krapp, *Andreas*, lvi–lvii.

42. For a recent attempt, based on a putative source for *The Fates of the Apostles*, and suggesting the possibility of a tenth-century date for Cynewulf's poems, see Conner, "On Dating Cynewulf." Connor's conclusions have been challenged by John M. McCulloh, "Did Cynewulf Use a Martyrology? Reconsidering the Sources of the *Fates of the Apostles*," *ASE* 29 (2000): 67–83.

43. See, for example, Fulk, "Cynewulf," 5–6; Roberts, *Guthlac Poems*, 60–62. I count more than 200 parallel formulae between *Guthlac B* and the four signed poems.

44. Fulk, "Cynewulf," 6.

45. Roberts, *Guthlac Poems*, 41.

46. I count several dozen such formulae, most of which are shared with the four signed poems.

47. See, for example, Colin Chase, "God's Presence through Grace as the Theme of Cynewulf's *Christ II* and the Relationship of This Theme to *Christ I* and *Christ III*," *ASE* 3 (1974): 87–101; the idea is also central to Frese, "The Art of Cynewulf's Runic Signatures."

48. On the relationship between *Genesis A* and *Genesis B*, see, for example, A. N. Doane, ed., *Genesis A: A New Edition* (Madison, 1978), 38–44; A. N. Doane, ed., *The Saxon Genesis* (Madison, 1991), 55–64.

49. See Paul G. Remley, *Old English Biblical Verse*, CSASE 16 (Cambridge, 1996), 1–93.

50. For an overview of the problems, see, for example, Fred C. Robinson, "Old English Literature in Its Most Immediate Context," in *Old English Literature in Context: Ten Essays*, ed. John D. Niles (Woodbridge and Totowa, 1980), 11–29.

51. Roy M. Liuzza, "The Old English *Christ* and *Guthlac* Texts, Manuscripts, and Critics," *Review of English Studies* 41 (1990): 1–11.

52. Patrick W. Conner, *Anglo-Saxon Exeter: A Tenth-Century Cultural History* (Woodbridge and Rochester, 1993), 143–47, 163–64.

53. See, for example, Roberts, *Guthlac Poems*, 49–50. For the notion that *Azarias* has a specific thematic connection to the *Guthlac*-poems (and that therefore little has been lost from the manuscript), see R. T. Farrell, "Some Remarks on the Exeter Book *Azarias*," *Medium Ævum* 41 (1972): 1–8, esp. 5–7.

54. The most exhaustive study to date is that of Hermann Gaebler, "Ueber die Autorschaft des ags. Gedichtes vom 'Phoenix,'" *Anglia* 3 (1880): 488–526; see too (for example) Schaar, *Critical Studies*, 111–12; Blake, *Phoenix*, 22–24. I note over a hundred parallel formulae between *The Phoenix* and the four signed poems; the fact that the vast majority of these parallels should come from that part of the poem which is *not* based on Lactantius (i.e., *after* line 380) is particularly striking.

55. Fulk, "Cynewulf," 6–7.

56. The actual formulae are given as examples 31 and 32 in the third of the three lists of examples given above.

57. See, for example, Klaeber, *Beowulf*, xi–cxii; Schaar, *Critical Studies*, 239–51.

58. Orchard, *Poetic Art of Aldhelm*, 73–292. Just as in the study of Old English, so in Anglo-Latin studies such recent work has built and developed on that of previous scholars compiling extensive lists without the benefit of computerized assistance. For a highly influential and deeply impressive example of such endeavor, see, for example, Max Manitius, "Zu Aldhelm und Baeda," *Sitzungsberichte der phil.-hist. Classe der kaiserlichen Akademie der Wissenschaften zu Wien* 112 (1886): 535–634.

59. Orchard, *Poetic Art of Aldhelm*, 191–95, 235–36.

60. For Aldhelm's central role in later Anglo-Latin poetic composition, see Andy Orchard, "After Aldhelm: The Teaching and Transmission of the Anglo-Latin Hexameter," *Journal of Medieval Latin* 2 (1992): 96–133.

61. Orchard, *Poetic Art of Aldhelm*, 106–7, 248–50.

62. See n. 42 above.

Contributors

Michelle P. Brown, Ph.D., FSA, is the Curator of Illuminated Manuscripts in the Western Manuscripts department of the British Library. She is a Fellow of the Courtauld Institute and a Visiting Research Fellow of the School of Advanced Studies of the University of London. Her publications include *A Guide to Western Historical Scripts* (1990, reptd 1999); *Understanding Illuminated Manuscripts: A Guide to Technical Terms* (1994); *The Book of Cerne: Prayer, Patronage and Power in Ninth-Century England* (1996); co-ed. *The Transformation of the Roman World* (1998); co-ed. *Mercia: an Anglo-Saxon Kingdom in Europe* (2001); *The Lindisfarne Gospels: Society, Spirituality and the Scribe* (forthcoming).

Carol A. Farr, Ph.D., F.S.A., is an independent scholar who researches and publishes on the art of Britain and Ireland, c. 400–1100. Formerly Associate Professor of Art History at the University of Alabama in Huntsville, she now lives in London. Her publications include *The Book of Kells: Its Function and Audience*, *Mercia: An Anglo-Saxon Kingdom in Europe*, which she co-edited with Michelle P. Brown, and other contributions on Anglo-Saxon women and sculpture and on early illuminated gospel and bible manuscripts.

Roberta Frank, Douglas Tracy Smith Professor of English at Yale University, writes on and teaches Old English and Old Norse literature. She is a former Director of the Centre for Medieval Studies, University of Toronto.

Jane Hawkes, Ph.D., F.S.A., is a lecturer in the History of Art at the University of York and the Centre for Medieval Studies at York. She has published widely on Anglo-Saxon art and material culture, is joint editor of *Northumbria's Golden Age* (1999), and author of *The Sandbach Crosses: Sign and Significance in Anglo-Saxon Sculpture* (2002).

Nicholas Howe is Professor of English at the University of California, Berkeley. He is author of *The Old English Catalogue Poems, Migration and Mythmaking in Anglo-Saxon England*, and *Across an Inland Sea: Writing in Place from Buffalo to Berlin*. He is currently at work on two

books: *Writing the Map of Anglo-Saxon England* and *The Yale Guide to Old English Literature*. He was formerly Director of the Center for Medieval and Renaissance Studies at the Ohio State University.

Sarah Larratt Keefer is Professor of English and teaches Old English and History of the English Language at Trent University; her area of research focuses on the liturgy of the Anglo-Saxon Church.

Perette Michelli is an independent scholar. After receiving her doctorate in Early Medieval Art from the University of East Anglia in 1989, Perette relocated to America. She has taught at Lake Forest and St. Olaf Colleges, the University of Wisconsin-Parkside, Northwestern University, the School of the Art Institute of Chicago and the Milwaukee Institute of Art and Design.

Haruko Momma is Associate Professor of English at New York University. She teaches Old English and other medieval subjects. Her publications include *The Composition of Old English Poetry* (Cambridge, 1997) and "A Man on the Cusp: Sir William Jones's 'Philology' and 'Oriental Studies,'" in *Texas Studies in Literature and Language* (1999). She is currently finishing her book project on the history of English philology in the nineteenth century.

Andy Orchard is Professor of English and Medieval Studies, and Associate Director of the Centre for Medieval Studies at the University of Toronto. He has published widely on Anglo-Saxon, Norse, and Celtic topics.

Fred Orton is Professor of Art History and Theory at the University of Leeds. His research interests include aspects of Anglo-Saxon stone sculpture, nineteenth and twentieth century European art, U.S. art post-war modernism to post-modernism, and the appropriation of contemporary critical theory to art history.

Carin Ruff is Assistant Professor of English at John Carroll University in Cleveland, Ohio. Her research interests include Anglo-Latin grammars, glosses, and syntax. She is working on a book on Aldhelm's prose style.

William Schipper is Associate Professor of English at Memorial University, St. John's, Newfoundland. Most of his research and publication focuses on Rabanus Maurus, and on the uses of early manuscripts.

Leslie Webster is Keeper in the Department of Prehistory and Europe, The British Museum. She has published widely on Anglo-Saxon metalwork and ivory carving, as well as on the iconography of Anglo-Saxon art.

Jonathan Wilcox, Professor of English at the University of Iowa, works mostly on homilies and humor in Anglo-Saxon England. He is the author

of *Ælfric's Prefaces* (Durham, 1994) and editor of the essay collection, *Humour in Anglo-Saxon Literature* (Cambridge, 2000). He is also the editor of the *Old English Newsletter*.

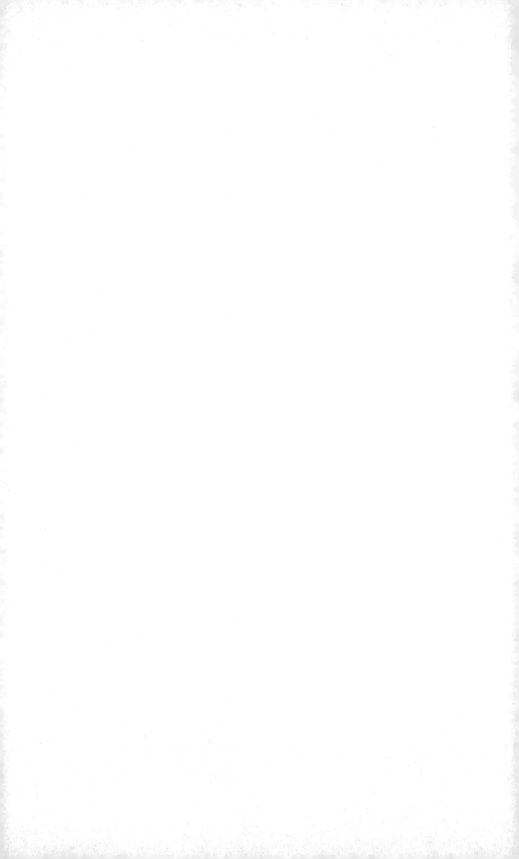

Index

Index of Manuscripts Cited